# Beyond Wilderness

Edited by **JOHN O'BRIAN & PETER WHITE**

The Group of Seven, Canadian Identity, and Contemporary Art

McGILL-QUEEN'S UNIVERSITY PRESS | Montreal and Kingston

© McGill-Queen's University Press 2007
ISBN 978-0-7735-3244-1

Legal deposit third quarter 2007
Bibliothèque nationale du Québec

Printed in Singapore

*10058626 34*

This book is supported by grants from the Canada
Council for the Arts Millennium Arts Fund and Visual
and Literary Arts sections, and from the Social Sciences
and Humanities Research Council of Canada.

McGill-Queen's University Press acknowledges the
support of the Canada Council for the Arts for our
publishing program. We also acknowledge the financial
support of the Government of Canada through the Book
Publishing Industry Development Program (BPIDP) for
our publishing activities.

LIBRARY AND ARCHIVES CANADA CATALOGUING IN
PUBLICATION

Beyond wilderness : the Group of Seven, Canadian
identity, and contemporary art / edited by John O'Brian
and Peter White.

Includes bibliographical references and index.
ISBN 978-0-7735-3244-1

1. Landscape painting, Canadian--20th century.
2. Canada--In art.   3. Nature in art.   I. O'Brian, John
II. White, Peter

ND1352.C3B49 2007      758'.1710904      C2007-902375-4

Set in *Dolly* by the Underware type foundry, NL (body)
and *Mustardo* (headings) by the Fountain type foundry,
Sweden.

BOOK DESIGN & TYPESETTING
Zab Design & Typography, Winnipeg

COVER IMAGE
Michael Snow, *Plus Tard*, 1977 (detail)

BEYOND WILDERNESS

# Contents

BEYOND WILDERNESS

Tom Thomson sketching in a
canoe, 1914 (detail)

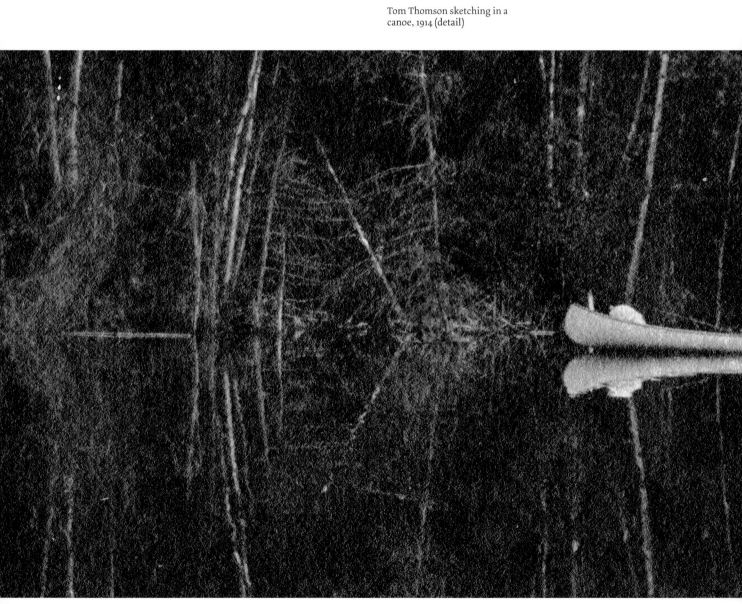

# Introduction

JOHN O'BRIAN & PETER WHITE

**THIS BOOK IS ABOUT THE REINVENTION** of landscape art in Canada. Since the 1960s artists have investigated social relationships within landscape as a way of moving beyond the legacy of the Group of Seven. Historians, critics, and curators have likewise engaged in rethinking the connections between landscape, Canadian identity, and art. The art and writings we have selected challenge traditional meanings of "landscape" and "nation" by placing them in a different relationship to one another from that associated with the Group. *Beyond Wilderness*, the book's title, indicates its dominant theme. The images and the ideas are reflected in the content and structure of the book, which begins with two essays by the editors deliberating on what has been at stake in the representation of landscape in this country. The art consists of major works executed from the late 1960s to the present by twenty-six artists; the texts consist of introductions to each chapter, five commissioned essays, one interview, and thirty-four reprinted essays and excerpts.

In the first half of the twentieth century, art in Canada was focused on a wilderness painting movement. Supported by the National Gallery of Canada and private patrons, the Group of Seven and their associates set about unmaking and remaking the prevailing conventions of landscape painting for the purpose of producing a national art. They wished to develop an independent aesthetic – homegrown, northern, and free of foreign influence. With one eye fixed on the idea of North, a Canadian analogy to the idea of West in the United States, and the other on the counter-example of the European avant-garde, characterized as "Futuristic" and "Bolshevistic," the artists and their supporters argued that national identity was inseparable from the geography and climate of Canada's boreal land mass. For them, Canadianness was defined by way of northernness and wilderness. The nation, in their view, should shed its Eurocentrism and embrace

its northern identity. Wilderness was a source of power.[1]

Wilderness and northernness figure prominently in Canadian writing as well as in Canadian art. In "Death by Landscape," Margaret Atwood's chilling story about a fatal canoe trip at a girls' camp somewhere to the north of Toronto, the two overlap. Atwood opens her narrative with a description of a collection of paintings hanging in an apartment overlooking Lake Ontario. "There are pictures of convoluted tree trunks on an island of pink wave-smoothed stone, with more islands behind; of a lake with rough, bright, sparsely wooded cliffs; of a vivid river shore with a tangle of bush and two beached canoes, one red, one grey; of a yellow autumn woods with the ice-blue gleam of a pond half-seen through the interlaced branches."[2] The artists responsible for these refulgent representations of Ontario's near-north, writes Atwood, uninhabited save for the implied paddlers of the beached canoes, include Lawren Harris, A.Y. Jackson, Arthur Lismer, and J.E.H. MacDonald, four founding members of the Group of Seven, and Tom Thomson, the drowned godfather of the Group and now a state-sponsored hero-artist. Like the poems, plays, and novels of Canadian writers, their paintings played a significant role in the nationalization of nature in Canada, particularly in the development of foundational ideas about northernness and wilderness.[3]

In Canada the artists that Atwood enumerates have been canonized. (Atwood is also canonical, but her reputation is now global while theirs is local.) They are celebrated for the expressive force of their work, on the one hand, and for their contributions to the formation of a national identity, or the circumlocutions of such an identity, on the other. The model of nationhood constructed by Thomson and the Group of Seven positions Canada between the Old World "other" of Europe and the New World "other" of the United States, while insisting on its distinctiveness from both. In several respects, the model is similar to conceptions of nationhood constructed by landscape painters and writers in other settler nations such as Argentina, Ecuador, Mexico, South Africa, New Zealand, and Australia in the aftermath of colonization.

In all these postcolonial countries, landscape has functioned as a powerful political unifier. It has helped to consolidate the drive toward national sovereignty, as well as to contain prior aboriginal claims to the land. Through the fiction of wilderness, a fiction that should not be confused with nature's wild unpredictability or with a condition unique to Canada, "empty" land was declared to be there for the taking – and then it was mythologized.[4] An inhabited land is not what the Group of Seven and artists in other countries were looking for, and it is therefore not what they saw.[5] But it is what the post-1960s artists discussed in this book focus on. Whether they are photo-based artists (Marlene Creates, Christos Dikeakos, Jin-me Yoon) or painters (Eleanor Bond, Peter Doig, Lawrence Paul Yuxweluptun) or conceptual and mixed-media artists (Iain and Ingrid Baxter, General Idea, Mike MacDonald), the signs of habitation are everywhere present in their work.

One of the questions asked in this book is how the peculiarity of one landscape rather than another becomes fetishized in the name of unity. In Argentina, for example, it was the pampas grasslands of the River Plate basin that came to symbolize national identity. In Ecuador it was the Andean highlands. If in Canada it was the Precambrian Shield and the Rocky Mountains, this is not to say that the two parts of what was celebrated about these landscapes – the paintings themselves as aesthetic objects and the paintings in the service of nation – always add up. Just as events in "Death by Landscape" are permeated with uncertainty, so the ways in which landscapes become national are suffused in contradictions between the local and the whole, the past and the

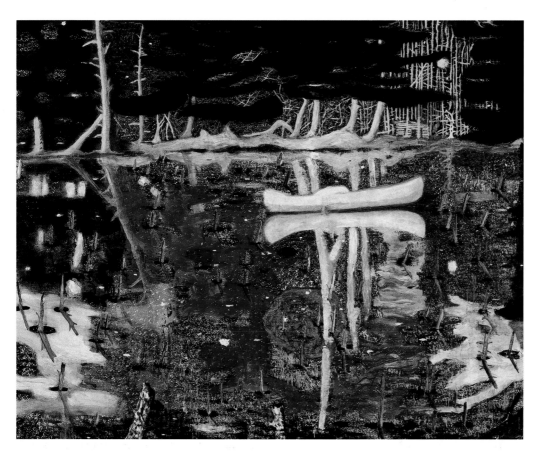

Peter Doig, *Swamped*, 1990,
oil on canvas

present, the nation as an entity and the nation as a collection of affiliations and ethnicities.

We find it striking how readily landscape and the work of the Group of Seven and contemporary artists who address issues of landscape can be appropriated for conflicting purposes. It is often difficult to disentangle the contradictions, for it requires looking askance at the spaces of landscape. Since the 1960s, writers and contemporary artists in Canada have understood the importance of looking critically at landscape as a symbolic category; this is why we begin this book with writings and art from that transitional decade. As Fredric Jameson and others have pointed out, the 1960s brought about shifts in conceptions of nationality (they became less cohesive) and identity politics (they expanded and splintered).[6] Marshall McLuhan's catchphrases, such as "the medium is the message" and "the global village," were not merely aphorisms coined during the period; they were also insights pointing to the ubiquity of the mass media and new conditions of global interdependence.[7] The writers and artists we have chosen to bring together in the book, including McLuhan, have in one way or another all challenged the myth of wilderness by offering counter-narratives and counter-images of a "post-wilderness" landscape and its social relations. Those who have worked within the myth and its assumptions have not been included. Charles C. Hill's book *The Group of Seven: Art for a Nation* and David Silcox's *The Group of Seven and Tom Thomson*, for example, focus on the traditional relationships between landscape and nation that were promoted by the Group.[8]

As Jody Berland argues, the way trees are traded and represented counts for as much as the trees themselves.[9] The natural world and the exploitation of its resources are always mediated by technological, economic, and political forces. In the act of looking askance, of averting their eyes from the familiar in order to gaze upon landscape with alien eyes, the artists and writers we are including have asked themselves a series of questions. Why did discussions around landscape in Canada before the 1960s tend to champion national difference and distinctiveness, often under the banner of exceptionalism, while more recent debates have focused on issues of colonial power and dispossession, transnational crossovers, and regional idiosyncrasy? What relevance do traditional landscape tropes have in a world of vastly

altered political, technological, demographic, and environmental circumstances? And if traditional tropes continue to persist, what does it say about the relationship between contemporary realities and the authority, power, and influence of conventional understandings of nationhood?

The book has seven chapters. Except for chapter 1, in which each of us reflects broadly on "wilderness myths," the chapters follow a loose chronological progression. Chapter 2, "Extensions of Technology," begins with an excerpt from McLuhan's essay "Technology and Environment," published in *artscanada* in 1967, and focuses on pivotal debates around landscape and technics that first emerged in the 1960s and early 1970s. The writings collected in chapter 3, "Post-Centennial Histories," all date from the 1970s. They represent the first concerted effort to provide a history of art in Canada in a scholarly way. The informing relationship of landscape art and natural resource exploitation is investigated in chapter 4, "Northern Development," and three major controversies that erupted between 1990 and 2000 around historical landscape painting are treated as case studies in chapter 5, "Contest and Controversy." Chapter 6 addresses the old question, "What Is Canadian in Canadian Landscape?" by skewing the question's rhetorical assumptions. The distinct experiences of Quebec and of the First Nations are considered in chapter 7, "The Expression of a Difference." Here matters of locality, ecology, nationalism, rights, and ownership are articulated.

The landscape paintings of Thomson, Harris, Jackson, Lismer, and MacDonald, to repeat Atwood's list, have helped to shape how the nation-state of Canada, or at least a significant part of it, has collectively imagined itself up to the present time. They have provided audiences with wilderness images that reinforced and responded to governing values of Canadian modernity. The appeal by Prime Minister John Diefenbaker to Canada's "northern destiny" in the late 1950s was cut from much the same cloth as the canvases executed by the Group of Seven in the 1920s. Since the 1960s, however, the values expressed by Diefenbaker and the Group have been under pressure. When Prime Minister Pierre Elliott Trudeau declared during parliamentary discussions on the Multicultural Policy in 1971 that in Canada "there is no official culture, and nor does any group take precedence over any other," he acknowledged that a radical shift had occurred in socio-economic and cultural priorities.[10] A Canada with "no official culture" was, in effect, a pluralistic culture in which the Group of Seven was just one group among others, even if it was a group possessing special status. The shift in values that occurred between the prime ministership of Diefenbaker and that of Trudeau marked a major change. Since that time the country has continued to experience intense social and economic diversification. While the idea of wilderness demonstrates remarkable resilience in Canada's national life, it is no longer the authoritative source of power the Group and their associates once claimed it to be.

Arthur Lismer, *The Happy Isles*,
1924, oil on canvas, Kenderdine Art
Gallery, University of Saskatchewan

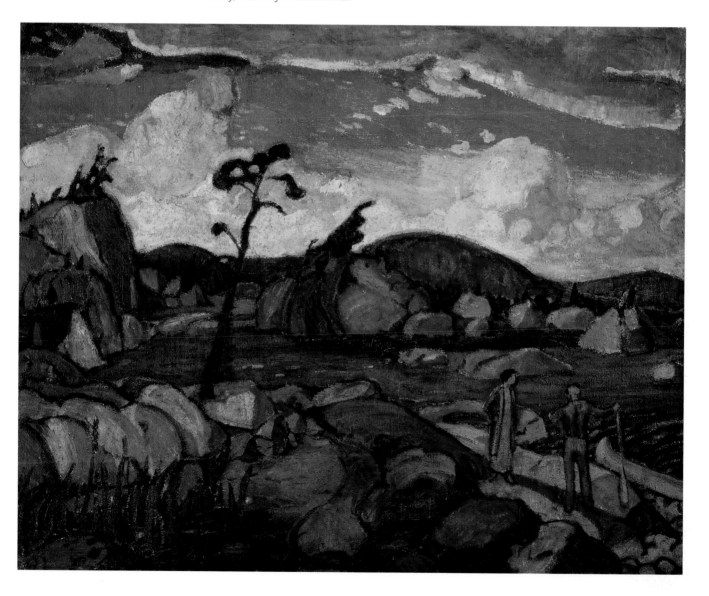

# Wilderness Myths

# Chapter 1

PETER WHITE

JOHN O'BRIAN

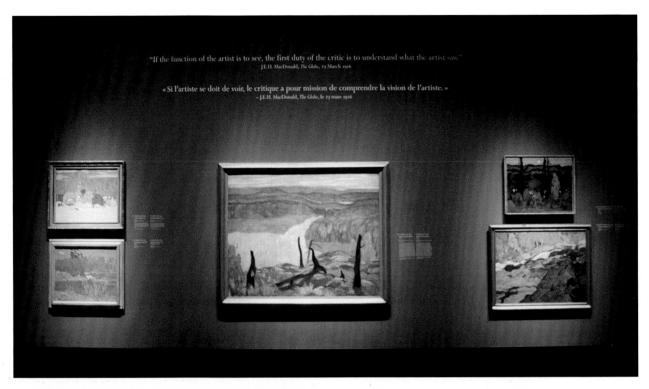

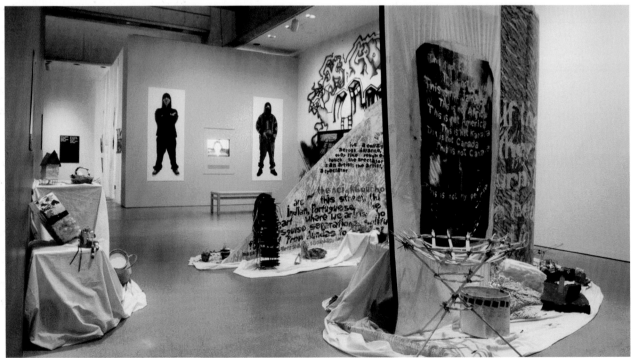

*The OH! Canada Project*, Art Gallery
of Ontario

# Out of the Woods

**PETER WHITE**

THIS PUBLICATION HAS ITS GENESIS in a contradiction that is near, if not at, the heart of how Canada has conventionally understood itself. While the strongly romantic vision of the Canadian landscape epitomized by Tom Thomson, the Group of Seven, their followers, and contemporary acolytes may be acknowledged to be a dated and limited vehicle for the representation of national identity and feeling, emotionally this perception nonetheless continues to retain a powerful hold on the national imagination. Indeed, whether it is measured by the unrelenting flow of exhibitions and books on these artists; the extraordinary, continuously appreciating financial value of their works; the myriad Canadian novels, films, and television programs set in this landscape; the scenery adorning Canadian currency; the endless commercial spinoffs it generates, from calendars, postcards, and coffee-table books to advertising and the Roots lifestyle; or the uproar over the Art Gallery of Ontario turning off the lights on the Group of Seven eighteen months in advance of a general gallery closure for expansion, it is clear that the association of this image of landscape with national spirit and meaning is deeply ingrained in Canada's national psyche.[1]

The sheer depth of this attachment was perhaps never more apparent than in 1996 when the Art Gallery of Ontario hosted *The Group of Seven: Art for a Nation*, a large-scale exhibition organized the previous year and circulated across the country by the National Gallery of Canada to mark the seventy-fifth anniversary of the Group's first show. At the AGO, *Art for a Nation* was coupled, under what turned out to be the all-too-ironic title of *The OH! Canada Project*, with a concurrent program of initiatives by a number of local ethnic and community groups, interactive presentations, workshops, and events that seem to have been staged to recognize that identifying the nation so closely with the Group of Seven might not be without its critical problems at that point in time. Whereas responses to *Art for a Nation* were highly positive and appreciative in the mainstream media, as they were, for the most part, elsewhere, the AGO program, despite its modest intentions, came off as a noisy sideshow of complaint and protest. Not only was it admonished, but in being held up to what at times amounted to public ridicule, it seemed only to further reinforce the idea that Canadian national identity was still very much located in the woods associated with the Group of Seven.[2]

The AGO's programming was, admittedly, a gesture, and a hastily arranged, somewhat haphazard one at that. Set in a perhaps too simple opposition to the Group exhibition, it could not possibly compete with that exhibition's *gravitas*, if only on the basis of the latter's size, polished presentation, prime location within the AGO, and substantial publication.[3] Nevertheless, the critical animosity generated by the AGO's intervention was out of all proportion to its purpose and ambition. Although the dichotomy between how it and the Group of Seven show were received was discussed in terms of distinctions between populism and the elitism associated with fine art,[4] there also seemed to be something here, in its absence from the discussion, like a wish that multiculturalism had not been a reality of Canadian life, not to mention a cornerstone of federal cultural policy, since the 1960s; that the 1980 Quebec referendum had not taken place, or the Mackenzie Pipeline debate, or Oka, or the dramatic social and physical transformations of Vancouver and Toronto – including in the AGO's own immediate neighbourhood – as a result of increasing immigration from non-European parts of the world, to name only a few instances when landscape, directly and indirectly, had intersected in highly public and contested ways with lived experience in Canada's recent past.

Since then, while the country has continued to diversify socially and the traditional values that have historically under-

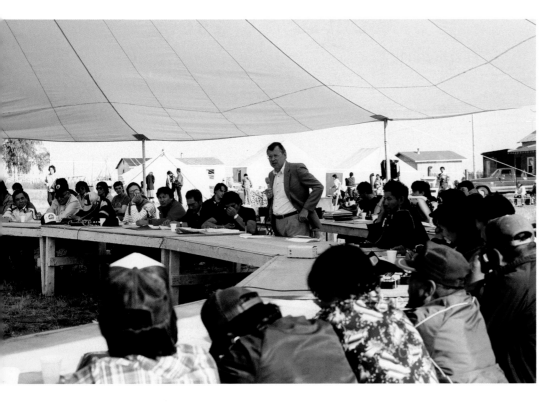

Thomas Berger meeting with the Dene National Assembly, Fort Good Hope, Mackenzie Valley Pipeline Inquiry, 1987

girded Canadian modernity have been further eroded and transformed, it has been more of the same. Two of the largest and most visible historical exhibitions mounted in Canada in this period have been the Tom Thomson retrospective organized jointly by the National Gallery and the Art Gallery of Ontario and the Glenbow Museum's *The Group of Seven in Western Canada*. Both exhibitions opened in 2002 and subsequently toured nationally. The scale of the publications for these shows was matched the following year by a massive, encyclopedically detailed book on the Group and Tom Thomson.[5] At issue is not merely fetishization but the official sanction this girth connotes. The year 2005 marked the Group's eighty-fifth anniversary. To "celebrate" it, the Ontario Association of Art Galleries, in collaboration with the Art Gallery of Ontario, mounted *The Group of Seven Project*, a year-long "festival of 29 exhibitions" involving the participation of most of the province's public art galleries and museums. The same year the *Literary Review of Canada* compiled a list of the one hundred most important Canadian books. The only book on art in the period since 1984 was *The Group of Seven: Art for a Nation* catalogue. This was followed in 2006 by *Emily Carr: New Perspectives*

*on a Canadian Icon*, a blockbuster organized and toured nationally by the Vancouver Art Gallery and National Gallery of Canada. *New Perspectives* was built on the foundation of heated debates that took place in the 1990s about Carr and Canada's wilderness culture (see chapter 5), yet it is difficult to see how this immersion in British Columbia's once relatively untouched forests could not also help but reiterate a very Canadian identification with a very romanticized notion of wilderness landscape.

It is not as if views that challenged what the Group of Seven represented have not existed. Quite the contrary. Since the 1960s, artists, art historians, critics, writers and cultural theorists, among others, have been actively engaged in a process of re-examining landscape in the context of its traditionally instrumental, universal and strongly sentimental role in the construction of Canadian identity. At the same time, new approaches both to Canadian identity, so called, and to identity in Canada have been evolving steadily. Employing postcolonial and feminist perspectives, poststructural historiographies, and the methodologies of cultural geography and social art history, these projects have scrutinized many of the most cherished meanings

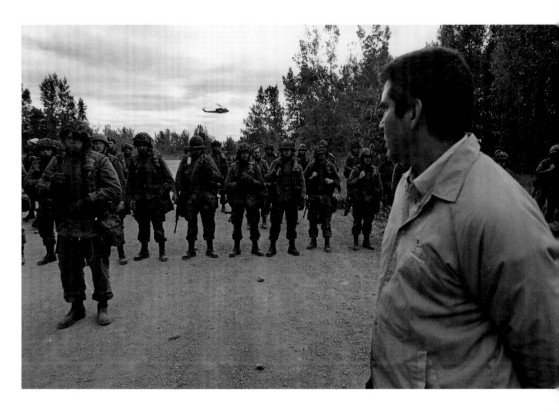

Oka, Quebec, 1990

landscape has enjoyed in Canada, reinterpreting them as expressions of power with deep-seated ideological implications. Though the traditional aesthetic vocabulary of landscape has not been altogether eschewed, the key words here have been territory, ownership, rights, place, the local. In the process these critiques have brought to light repressions, disavowals, and discontinuities produced by this vision of landscape. Notable among these are the decidedly different understanding of "landscape" for Canada's indigenous peoples, its absence from the expression of nationalist outlook in Quebec, the concerns and aspirations of a growing citizenry of non-European origins, and the blatant degradation of the natural environment itself.

This body of criticism, as noted above, has nevertheless continued to have difficulty sticking publicly. In pulling together strands of what has been a dispersed discourse for the first time, this book has no illusions that it can, in itself, significantly dislodge a vision that is so profoundly entrenched. The objective, rather, is to make it possible to take stock of the investments and values that have given this vision such iconic status, identify the grounds on which it has and may continue

to be questioned, and redirected, and, importantly, expose and examine work that has dealt with landscape in more relevant – indeed, productive – ways than the romantic and nationalist paradigms that govern thinking about landscape in Canada have encouraged or allowed. First, however, it may be worth attempting to clarify what this vision is and to consider some of the reasons for its extraordinary resilience, in particular in its role as a quasi-official image of Canadian national identity.

As Douglas Cole notes in his essay in this volume, when the aesthetic of Tom Thomson and the Group came together in the second decade of the twentieth century, it did not emerge *sui generis* but was responsive to a "wilderness ethos" that had been developing in central Canada since well before the turn of the century. Most commonly featuring lakes and forests remote from the country's emerging modern urban culture, these paintings identified Canada with its extraordinary natural patrimony and geographic "northernness." Significantly, they carried a tone much softened from the often harsh and fearful themes of survival that had characterized responses to the physical Canadian environment in the nineteenth century, substituting instead

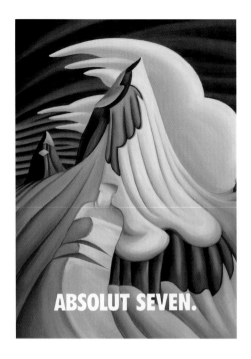

ABSOLUT SEVEN.

Advertisement for Absolut Seven
vodka featuring Lawren Harris's
painting *Mt. Lefroy*

a nature that may have been wild but was essentially non-threatening, accessible, and well suited to both recreation and, as Paul Walton argues in his essay here, economic development.

It has, of course, not gone unnoted that what the Group actually depicted in their signature paintings was, for the most part, a few limited areas of the Precambrian Shield in central and northern Ontario, in particular Algonquin Park, the north shore of Lake Superior, and Algoma. Devoid of human presence, these works also eschewed the industrial development of the land that often existed just outside the picture frame. It is unlikely the artists' claims of creating a national art from this restrictive subject matter would have been realized were it not for their connection to a tight network of patronage and personal relationships drawn from Toronto's social and economic elite that initially came to be anchored institutionally by the National Gallery of Canada. Through the efforts of Sir Edmund Walker, chairman of the Board of Trustees, and Eric Brown, director, the fledgling National Gallery was the first major art institution in Canada to support and acquire the Group's work, which it exhibited not only in Canada but also abroad. Through it, as Ann Davis writes, the National Gallery seized control from the Royal Canadian Academy to speak for Canadian art and, as Joyce Zemans's research has demonstrated, in ensuing years the gallery contributed to the Group's elevation to canonic status through the dissemination nationally of a series of printed versions of

Canadian art steeped in the Group's aesthetic. In due course, the Art Gallery of Toronto, in part through the influential teaching and writing of Group member Arthur Lismer, also came to play an instrumental role in consecrating the Group's invention of a national art.

In a recent essay, the political theorist Partha Chatterjee has noted that once national images are officially sanctioned, they tend to become self-sustaining. "What is interesting," Chatterjee writes, "is the special way in which a particular national culture turns an image into an icon, to be reproduced, distributed, displayed, and sacralized." While the ideological function of turning such images into national icons "is supervised and directed by the state," it "is not necessarily confined only to formal state institutions. When successful, the official ideology proliferates in the practices of non-state institutions such as schools, clubs, professional associations, cultural organizations, media, etc."[6] As the record shows, the process Chatterjee describes, with its imbrication of official and non-official forms of representation, has, in essence, been in place since the Group's early years. In any attempt to understand how such a fixed and circumscribed idea of the country has sustained itself in the face of changing realities, this process of dissemination must be taken into account.

In his influential work on nationalism, Benedict Anderson has argued that countries are not the product of inherent qualities and or a given character but are literally "imagined into existence."[7] In his essay included in this book, Anderson writes that it is not surprising the Group of Seven generated such interest in its early years. As a relatively new nation-state that was still very much attached through its imperial connection to Britain, Canada was actively in need of signs and symbols with which to assert a distinctive national identity. If considered in

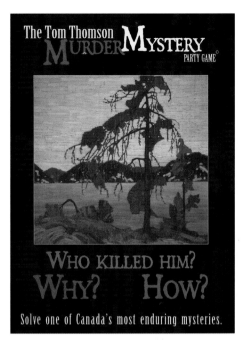

*The Tom Thomson Murder Mystery Party Game* (Globalinkage Publications, 2003)

relation to the refined, picturesque English landscape, the raw beauty of the Precambrian Shield could readily constitute such a vehicle of national meaning and feeling in Canada. Although, as Leslie Dawn also argues here, the Group of Seven's interest in landscape itself and the formal style used to represent it was far more dependent upon British representational conventions than has been generally assumed – echoing in aesthetic terms the inherent conservatism of this vision of the national project – the vitalism of the Group's work nonetheless struck a very deep chord in Canada. That the country would cling to such images in more recent times, however, requires a rather different explanation.

What might be thought of as a renewed wave of interest in the Group of Seven took place in the late 1960s and early 1970s. Following J. Russell Harper's publication of the first comprehensive history of Canadian painting in 1966,[8] Dennis Reid, then a curator at the National Gallery, organized what at the time was the most extensive exhibition of the Group to date.[9] Its catalogue was the first publication to provide a really comprehensive study of the Group's development and activities. This was followed by a dissertation on the Group's philosophy by Ann Davis,[10] Reid's own history of Canadian painting,[11] another by Barry Lord,[12] Northrop Frye's reflections on the mythic foundations of Canadian character in what he termed "the bush garden,"[13] and the beginning of a stream of exhibitions that looked in closer detail at the work of individual members of the Group.

Until this time, most writing about the Group had been of an anecdotal or partisan nature. There is no doubt that the motivation for much of this new work was not only to fill in the many gaps left by this patchwork process but also, in general, to bring to this subject a level of academic credibility and authority that had been previously lacking. In a larger sense, however, it can be argued that Canadian nationalism and identity were at the forefront of this renewal. Most evidently, this work was produced in the period immediately following Canada's one-hundredth anniversary as a country in 1967. More than a celebration, the Canadian Centennial turned into a massive outpouring of national pride. Though heavily orchestrated by government, the Centennial was nevertheless a deeply felt popular expression of optimism about the country. Canada had never been so economically prosperous or internationally respected. The past could be seen as a source of pride and accomplishment, and embodied by the staggering success of Expo 67 and the coming of age of a highly educated new generation, its future prospects – indeed, its destiny – had never seemed so promising. In this surge of feeling, few areas of national life were left untouched, not least its art history.

The Canadian Centennial has turned out to be a landmark, but for different reasons than might have been anticipated at the time. Indeed, even as Canada crystallized as a modern nation, the modernity that it expressed had already begun to unravel. In its broader outlines this shift to what, for lack of better terms, has been variously referred to as post-industrialism, late capitalism or more generically as postmodernism, has been analyzed extensively and need not be repeated here. However, several of its key characteristics are directly germane to the subject at hand. Notably, it involved a recognition that belief in progress, in a teleologically unfolding process imbued

with meaning and purpose, was no longer an adequate way to understand history. If sustaining conviction that time was moving forward in an orderly and positive way towards the future seemed increasingly difficult, it was in part because the future – the pole star of meaning and continuity for modernity – seemed more and more to connote not possibility and hope but something much more uncertain and altogether less positive.

Modernity measured time chronologically and understood in terms of the history of the forces – nations, institutions, and the accomplishments of individuals, the latter overwhelmingly male – that marked its advance. In this shift, which transposed to the present the focus that modernity had placed on the future, traditional history was displaced or superseded by the less codified and personal imperatives of memory in understanding or relating to the past. Contemporary memory discourses and practices have proven to be extraordinarily pervasive and complex. While their subjects include what and who have been repressed or simply written out by modernist history, they also have enormous reactionary potential to reinscribe the biases and prejudices of the past. These competing claims and their interplay have led the cultural theorist Andreas Huyssen to characterize the contemporary preoccupation with the past as itself a "struggle for memory."[14]

The actual nature and extent of this transformation continues to be debated and has been further inflected by the end of the Cold War and rise of global capitalism. Nonetheless, with the distance of almost forty years, it is clear at least that Canada's modernist destiny has largely gone unrealized. If Expo 67 might be thought of as its apogee, then another landmark event in Montreal, the inflated, overbuilt, and, until recently, debt-ridden 1976 Olympics, can be taken as a sign of its collapse. Unified theories or understandings of national meaning today are not so much

impossible as irrelevant. In a country enjoying such a national high in the late 1960s and early 1970s, however, not only was this understanding not apparent, but as one of modernity's essential formations, the nation-state was perhaps the pre-eminent point of reference for the examination of culture. How this worked itself out can be seen in the very different but nonetheless related work of Reid and Lord.

In the case of Reid's history of Canadian painting, the point was not simply to valorize the Group of Seven, which even in its own time was, by the standards of advanced modern art, relatively conservative and populist. Reid's concern with the Group, rather, seems to have been to provide an important but nonetheless somewhat parochial history of Canadian artistic practice as a point of departure for the emergence of successive schools of dynamic contemporary Canadian art. Consonant with the nation's own maturation, the implication was that this art – principally the abstraction of the *Automatistes*, the Painters Eleven, various artists and groups who pursued a range of abstract styles and, coming to the present, the Pop-related painting of such artists as Michael Snow, Joyce Wieland, Jack Chambers, and Greg Curnoe – participated in an avant-garde practice that was international in scope. One of the features that defined this work is that, while it may have been shaped by Canadian experience, its subjects and meanings were not necessarily tied or even related to understandings of the country itself. Lord, on the other hand, interpreted the Group in wholly nationalist terms. At the time an avowed Marxist, he conflated contemporary threats to Canadian sovereignty from American economic and political pressure with the internationalism of contemporary Canadian art, notably as influenced by the formalist theories of the American art critic Clement Greenberg. In Lord's telling, the Group threw off the conservatism of nineteenth-century European pictorialism

then fashionable in Canada in favour of an art that expressed the essence of the country on its own terms. Unlike Group hagiographers, however, Lord did point out that their national vision primarily reflected the outlook of Canada's emerging "bourgeois" class of power brokers in Ontario, remaining at odds with the concerns and attitudes of the nation's working and non-privileged classes. Within the hyper-nationalist context of Lord's reading, the Group represented a critical precedent for the development in Canada of what he projected as "a people's art."

Whatever their wants from a current perspective, these texts were written as deeply committed modernist histories and remain serious, significant works that say a great deal about what Canada and Canadian identity meant at the time. How then to approach what continue to be modernist readings after the fact? In her review of *The Group of Seven: Art for a Nation* included here, Lynda Jessup writes that the exhibition did not just celebrate the Group but made a case for the artists as heroic, underdog avant-gardists fighting against the Old World prejudices of their day. This is not conservative history, Jessup contends, but "poor art history." It misapplies the modernist concept of the avant-garde to uphold a discredited modernist version of history. Not only does it ignore those excluded by the Group's vision, but in echoing on a blockbuster scale the perceptions of the elites whose view of the country it did express, the exhibition effectively reasserts those views. More than simply irrelevant, the exhibition was seriously misleading and deeply insensitive.

In keeping with Anne Whitelaw's analysis of the relationship between the National Gallery and Canadian identity, *Art for a Nation* could be examined as an instance of the gallery protecting its enormous investment in its mandate and prestige as keeper and arbiter of a national vision. More charitably, perhaps, the exhibition can be related to broader questions that

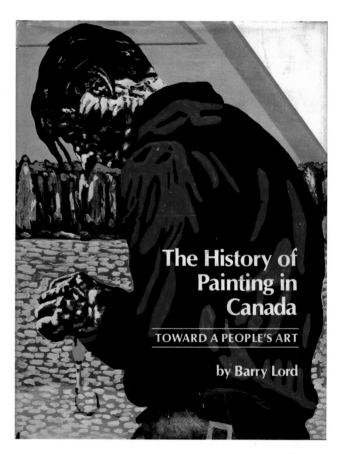

Barry Lord, *The History of Painting in Canada: Toward a People's Art* with John Boyle's *Midnight Oil (Thomson in My Backyard)* (detail) on the cover

are being asked today about the museum. An institution that is itself a product and medium of modernity, it counts among its most significant driving forces a responsibility to justify its own historical narratives in terms of the overarching criteria of aesthetic value and quality. This requirement has produced what might be characterized as a kind of residual drag or inertia which has led to widespread criticism that museums essentially lack the capacity, not to mention the will, to close the yawning gap that so often separates them from contemporary life and experience.

While the National Gallery has played the dominant institutional role in the contest of Canadian identity, the McMichael Canadian Art Collection in Kleinburg, Ontario, and the controversies that have surrounded it in recent years have been a lightning rod for these issues. As Richard Hill wryly points out in his essay, not only is the McMichael dedicated to the Group of Seven and their art, but with all but one of the members buried on the grounds, the gallery memorializes them literally. In what might strike some as the absurdity of this macabre appropriation, there may be a clue to the popularity, despite their remove from contemporary experience, of *Art for a Nation* and those similarly weighty exhibitions, studies, and monographs that have followed it. In his discussion of the extent of the present's preoccupation with the past, Huyssen has coined the term "present pasts" to describe today's memory discourses.[15] On their negative side, they tend to recirculate the past in the form of nostalgia and such anodyne concepts as heritage. Emotionally complex and stripped of historical specificity, escapism of this kind can and does have the effect of smoothing away the rough edges, tensions, and contradictions of the past, occluding both it and, more to the point, the forces that animate contemporary life and history. As an emblem of what is problematic with the perpetuation of the concept of national meaning being considered here,

it is difficult to think of anything that could be more palpable or vivid than the internment of the Group of Seven in the hallowed ground of the McMichael.[16]

Memory of this kind is, in effect, a form of forgetting. In terms of the present, it is selective avoidance. On the other side – and despite manifold shadings and ambiguities, when it comes to memory, there really does seem to be a clear divide drawn along competing political or ideological lines – memory has proven to be a powerful stimulus for the articulation of other kinds of social formations and structures of knowledge than those that produced past injustices, exclusions, and traumas. In terms of the subject of this book, these discourses have put great pressure on what is meant by landscape. Historically, landscape has been understood within the tradition of nineteenth-century European romantic idealism as a "natural" representation of nature mediated by the individual sensibility of the artist. In this mode, landscape is essentially an intransitive form subdivided into a more or less fixed set of categories, including the picturesque, the beautiful, and the sublime, each of which carries a set of iconic meanings or associations that vary along a sliding scale of emotional intensity and spiritual significance. As critics argue, this form of landscape has become so familiar and conventionalized in Western aesthetics that it has come to seem natural. More to the point, not only is this image of landscape not natural, but it is an ideological construction directly related to the rise in Europe, from the seventeenth to nineteenth centuries, of forms of individualism and liberty whose social transformations broadly extended the right to own land.[17] Implying human sovereignty over nature, landscape in this form is a sign of possession, of social standing, and of power. As W.J.T. Mitchell has written, in this process landscape became a critical instrument for enlisting nature in the legitimation of modernity.[18] Despite claims that the

landscapes of the Group of Seven were an original or indigenous art form, not only are they a product of this history, as Dawn demonstrates, but they have been used to instill and sustain its values in the Canadian context.

In naming landscape a particular historical construction, Mitchell and others have noted that it was inextricably tied as an artistic genre to painting, a medium that denotes permanence and the privilege of ownership and whose creation and reception are customarily typified by measured process and contemplation. In *Understanding Media*, Marshall McLuhan, Canada's own midwife of postmodernism, implied, in contrast, that the instantaneity of new technological media both upset modernism's steady flow of time and dissolved the stability of its geometrically ordered representation of space.[19] Important insights can be drawn from his observations. One, to use McLuhan's own metaphor, is that not only are these changes radical but they are also painful. Because they affect the entire body of modernity, it is not surprising that they should be resisted so strongly, often in the form of a turn to or recovery of the past in highly romanticized form. Two, although these new media are not generally regarded as artistic media, it is artists who will exploit them in negotiating this new sense of (dis)order. The latter issue has been especially important to the formulation of this book. Proclamations that artists are society's innovators are something of a cliché, but on this subject McLuhan was absolutely prescient. Many of the most significant critiques of the historic meanings and uses of landscape in Canada are to be found in the work of visual artists. Whether it was in the conceptual art of those artists whose work first marked a break with modernist relationships to landscape and nature or work that has followed it, most of this art involves the use of new technologies and artistic forms. Where the medium is painting, it is heavily mediated by these technolo-gies. Featured throughout the book, these works are presented not to illustrate written texts but as critical analyses in their own right that have been integral to the formation and development of this discourse.

As early as 1966, Cole Harris argued in his essay reprinted here that the idea of landscape associated with the Group of Seven was a myth that functioned in the service of a time-honoured understanding of Canadian identity of questionable contemporary relevance. Since then, this subject has been taken up widely. In some instances it has been poked and prodded, though not fundamentally disturbed. In some, such as Scott Watson's powerful dissent, it has been carved up and left in tatters. In others it has simply been discarded. In this book, most of this work has been organized within three subject areas. In the section titled "Northern Development," the interaction between economic use of the land and this form of representation is explored. Although Eleanor Bond's paintings and Rosemary Donegan's consideration of industrial imagery set in the landscape point to significant ambiguities, for the most part the rule seems to hold here that aesthetic appreciation of the landscape is in direct proportion to its economic exploitation and destruction. In light of doubts raised about anything so essentialist as a Canadian identity, another major focus has been the question of whether the landscape of Canada can any longer be thought about in any way as "Canadian." Here a whole gamut of Canadian landscape tropes, from Peter Doig's canoes and Liz Magor's cabin in the snow to the question of Canada's northernness, come in for examination. Finally, in some of the most far-reaching, moving, and, from a contemporary perspective, pertinent work – gathered here under the theme "The Expression of a Difference" – values, beliefs, and even ways of life that have been damaged and repressed by Canada's national vision of landscape are asserted in ways which

make it clear that if Canadian landscape continues to be thought about the same way, it is done so only in blatant contempt of the country's contemporary character. In harmony with Canada's changing demographics and the world in which it finds itself, this work is very much at the forefront of today's never-easy efforts to produce more fluid and useful understandings of realities of contemporary national life.

To conclude these introductory remarks, one final observation. If this book is concerned, as its title suggests, with what has taken the discussion of landscape and Canadian identity beyond the Group of Seven archetype, it might be asked why the members of the Group are so central to it. A related question is whether it is fair to judge the Group by the standards not of their time, but those of the present. Indeed, as Joyce Zemans points out here, it is debatable whether as artists many members of the Group would be altogether sympathetic to the ideological edifice that has been erected in their name. The answer is that this would be its own act of decontextualization. What the Group of Seven have come to mean and represent is so integral to how Canada is understood, from all positions within the national polity, that to evade it would, in itself, be misleading. Whether directly or indirectly, the Group are inescapable as a point of reference, not only for evaluating the work that has moved this discourse outside its historic framework but also for making clear what is at stake in its production and creation. There may be a struggle for memory, but remembering will not have much present benefit if, as Huyssen has argued, acceptance of "the fundamental shift in structures of feelings, experience and perception that characterize our … present" is not understood as more than compensation for something that has been lost.[20] By placing the Group of Seven within the dynamics of this shift, this book, it is hoped, does justice to this principle.

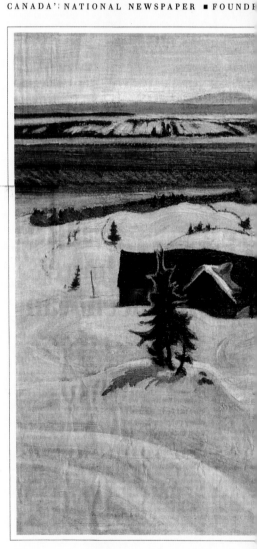

… B.C. EDITION VANCOUVER WEATHER: LIGHT RAIN, HIGH 12. MA

SPECIAL HOLIDAY EDITION • 8 SEC

THE GLO

CANADA'S NATIONAL NEWSPAPER ■ FOUNDE

The St. Lawrence Winter by A.Y. Jackson. Oil on canvas from the collection of Kenneth

# Wild Art History

**JOHN O'BRIAN**

ıomson.

**UNTIL THE EARLY TWENTIETH CENTURY,** much of the art produced in Canada followed the direction of European art movements. Artistic exchange between colonial Canada and the metropolitan centres of Europe flowed largely one way – from east to west. Caught in a cycle of copycat repetition and adaptation, art in Canada was a product of political and cultural subordination. With the arrival of Tom Thomson and the Group of Seven, the repetitive rounds of colonial importation were broken, and the art executed by them was seen, by defenders as much as by detractors, as a product of cultural *insubordination*. Supported by the National Gallery of Canada and a handful of private patrons, the Group of Seven promoted a wilderness painting aesthetic that claimed to be authentically Canadian and free of European influence. National identity, contended the artists and their apologists, was indivisible from the nation's northern geography and climate. To coin a term, national identity was "wildercentric."[1]

The artists and art writers of few other countries – possibly of no other country – expended as much energy in the twentieth century debating the expressive potential of landscape as a subject for art. At a time when discourses around landscape were taking a back seat in Europe and the United States to discourses around figuration and abstraction, in Canada they were ascendant.[2] The authority of landscape representation was contested in Canada, as I shall discuss, but it remained dominant long after it had been demoted in the art of most other Western nations. It continues to be influential to this day. The Canadian fixation on wilderness is not easily dislodged.

In this essay I want to investigate why a desire for wilderness in Canadian art has persisted for so long. My concerns can be framed as a series of questions. Why have representations of an "empty," northern habitat been so readily embraced by viewing audiences? What was the particular appeal of Lawren Harris's

description of the spiritual geography of Canada as "the great North and its living whiteness," and what ethnic and racial conflicts were painted over by it?[3] What mongrel versions of the landscape, of the industrialized north with its mining and lumber enterprises requiring the use of immigrant labour in order to succeed, were disavowed in the name of purity? What was the advantage of promoting Canadian modernity in terms of a wilderness ethos instead of an urban, multi–ethnic ethos? And what, precisely, were the epistemological shifts in the 1960s and early 1970s that undermined and complicated the construction of an idealized wilderness without conflict as the defining characteristic of Canadian identity?

The Group of Seven had a predatory desire for wilderness. They wished to possess the wild side of the Canadian landscape by means of representation and to match its prodigiousness with paint. The Group's wildercentric values and the way in which these values were circulated and received were grounded in their commitment to a Nordic national identity. But they were also grounded in the social and economic arrangements governing postcolonial Canada. The Group's paintings were as closely tied to the industrial growth produced by mining and lumber interests as they were to the perception of the north as uninhabited, pristine territory. The paintings, as one critic remarked in 1936, gave "expression to what more vulgar fellow-Canadians were expressing in skyscrapers and railway extensions and International Nickel at 73."[4] Wilderness and capitalist modernity in Canada went hand in hand.

The defining of Canada by way of northernness has had remarkable longevity. It dates from the earliest days of colonial contact. In the twentieth century it was advanced by the visual representations of Thomson, the Group of Seven, Emily Carr, and other artists, and then extended well beyond the lives of these artists and, in diluted form, on to the present. The trope of nordicity began to lose some of its dominance only in the 1960s and 1970s, when economic and demographic diversification contributed new metaphors to the construction of identity in Canada, notably that of multiculturalism. At the time, Marshall McLuhan observed that there had been a shift from a mechanical to an electric age. He argued that Canadians functioned within an intricate network of international exchange and that electronic media had profoundly altered the environment and how it was being experienced.[5] Within this changed environment, identity formed along different lines from those that had characterized the mechanical age. It focused more on personal affinities – ethnicity, gender, sexual orientation – and less on markers of nationality and class.[6] The shared symbols of the nation, which Benedict Anderson has identified as components of an "imagined community," were challenged by the rituals and affinities performed in everyday culture.[7]

Only a short time earlier, Canada had seemed to be more cohesive as an entity. In a 1951 presentation to the Royal Commission on National Development in the Arts, Letters and Sciences, the painter Charles Comfort wrote that "the characterful Canadian spirit [is] essentially northern, individualistic, conservative, loyal, independent, virile, and industrious."[8] Comfort was in no doubt about what constituted national identity. Nor was the English artist and writer Wyndham Lewis. A few years earlier, in an article called "Canadian Nature and Its Painters," he reflected upon the Group of Seven artist A.Y. Jackson and his determination to overcome "the hard puritanic land" in which he lived, comparing it to Captain Ahab's obsession with the great white leviathan.[9] Jackson rationed pleasure in his painting, Lewis observed, and was not the sort of artist to go gathering nuts in May. Jackson pursued his desire for wilderness (a desire I think of,

pathologically, as a mania) throughout most of his painting life, attempting to track every contour and corner of Canada, forcing the landscape to yield up the images he wanted. By one count, the country provided him with material for six thousand paintings.[10]

Jackson's works helped to shape how the nation imagined itself. They provided Canadian audiences with "a shared image of their communion," to cite another famous phrase introduced by Anderson.[11] The communion – which is to say, the imagined collectivity of Canada – was largely Protestant at the time, notwithstanding large Catholic populations in Quebec and disenfranchised aboriginal populations everywhere. The imagined collectivity, like the wilderness myth itself, was also largely male, signified by the no-nonsense wooden tables and the wreaths of tobacco smoke at the Arts and Letters Club in Toronto, where the Group of Seven and their friends met to socialize.[12]

The ethic of hard work and deferred pleasure identified by Max Weber as fundamental to the rise of capitalism in his book *The Protestant Ethic and the Spirit of Capitalism*, published in 1904–05, just a few years before future members of the Group began to congregate in Toronto, characterized the governing values of Canadian modernity. Weber was a strong proponent of entrepreneurialism, and Jackson and his circle applied themselves to producing a national art and then selling it with Weberian determination.[13] Their large, bold paintings overwhelmed the alternatives on offer. By the time Jackson died in 1974, his paintings had been installed across the country in every kind of private and institutional setting, including government offices, union headquarters, corporate reception rooms, galleries of art, hospital corridors, and school foyers. The Group of Seven's wildercentric obsessions had by then long since become officially sanctioned.

Until the 1970s, it would have been considered heresy in many circles to suggest that representations of the Canadian landscape by Jackson and the other members of the Group of Seven often-concealed more than they revealed about the social life of the nation and its tensions. Landscape is the primary stimulus of the Canadian imagination, it is commonly asserted, and has been so at least since Confederation in 1867. "The great purpose of land-scape art is to make us at home in our own country," stated a wall maxim at a 1919 exhibition.[14] Although the idea of landscape has been performing less of the nation's dreamwork in recent decades than it did previously, it remains a powerful component of the iconography of Canadian nationhood. For more than a century, invocations of rock, water, trees, and mountains have helped to consolidate nationalist ambitions at home, while underwriting claims to sovereign independence abroad. ("When they said Canada," Marilyn Monroe confessed, "I thought it would be up in the mountains somewhere."[15] Monroe is not the only visitor to Canada who has been surprised to discover herself in urban surroundings.) Landscape has been a container with deep reserves of material for the Canadian imaginary. Industrial development and the extraction of natural resources may have eaten into the wilderness physically, but they have not eaten into it psychically.

## ABOUT WORMS

In 1995 the National Gallery of Canada mounted an exhibition called *The Group of Seven: Art For a Nation*. No irony was intended by the gallery about what constituted the "nation" mentioned in its declarative subtitle. For the gallery, as well as for some viewers, it was as if ongoing debates around postcolonialism and feminism bore no relation to how the Group of Seven was being re-evaluated by various audiences at the end of the twentieth century.[16] Had the gallery inserted a question mark after the word "nation," it would have at least signalled there was some doubt about the matter.[17]

It needs to be asked whose "nation" the gallery thought it was referring to in its subtitle. Was it that of aboriginal populations, who use the term First Nations to describe themselves and who have long been negotiating the recovery of appropriated heredi-tary lands? Or that of sovereignist Quebecers, who had recently voted in large numbers to secede from the Canadian nation-state? Or that of women, who occupied space at the edges of the Group of Seven but who were not invited to join the fraternity?[18] Or that of recent Asian immigrants, perhaps, whose experience of Canada was predominantly urban? Evidently it was none of these. Instead it was the imagined community formed around 1920, the year the Group of Seven officially established itself, a time much more Protestant and "imagined," in Benedict Ander-son's sense of the term, than it was in 1996.

The psychic distinctiveness of the nation-state, the artists and their apologists such as the literary critic Northrop Frye insisted, mirrored the physical distinctiveness of the landscape within it. For them, Canada found rather than lost itself in the idea of wilderness. The practice of ascribing psychic value to the myth of an unpossessed wilderness reflected the values of the dominant social classes of the time, as well as of the Group of Seven itself. The preference of audiences was for uninhabited – in other words, for wildercentric – landscape paintings such as A.Y. Jackson's *Terre Sauvage* of 1913. (This painting was executed in a studio above a bank in Toronto, a reminder, if any were needed, of the connections between wilderness art and urban commerce.)

*Terre Sauvage*, at 129 by 154 centimetres, was the largest work produced by Jackson during the 1910s. It represents a fall scene on the eastern shore of Georgian Bay, in southern Ontario, a landscape of windswept pine, spruce, and granite rock scoured

A.Y. Jackson, *Terre Sauvage*, 1913,
oil on canvas, National Gallery of
Canada

smooth by glacial action. Although the region was dotted with summer cottages, some of which Jackson visited, the artist chose to ignore the signs of human habitation and to concentrate on the qualities of a pristine nature. In the painting, the heavy autumn clouds that are lodged above the open blue sky and the long bent horizon, a horizon punctured by red and green scatterings of trees, seem as fixed and unchangeable as the granite rocks they visually mirror in the foreground. It seems to me that the balanced weight of the clouds and the rocks still the image, so that only the faint curve of the rainbow on the left side of the painting hints at the ephemeral. The quality of stilling, or of timelessness, helped the painting to become an icon, a representation of nordicity and emptiness. *Terra nullius.* Jackson even carried the language of *terra nullius* into his title, whether he intended the connection or not.

The painter J.E.H. MacDonald, the oldest member of the Group of Seven and an admirer of *Terre Sauvage* as an allegory of Canadian northernness, called it Mount Ararat because "it looked like the first land that appeared after the Flood subsided."[19] Critical allusions to biblical narratives were not uncommon in discussions of *Terre Sauvage* or the Group of Seven's work in general. When MacDonald and Jackson showed together in Montreal, in an exhibition that included *Terre Sauvage*, the critic Albert Laberge wrote that their work was infused with an "atmosphere of apocalypse." "They paint their canvases in a fugue, in a kind of fury. It's as if, vibrating before untamed nature, savage and wild, they can scarcely find colours strong enough, gestures vigorous enough, to express the emotions they feel. An atmosphere of apocalypse breathes through the paintings of these artists. They are the visionaries of Art."[20] Laberge's encomium, which is on the edge of being delirious, suggests that an erotic bond existed between the artists and the Canadian wilderness they represented. Jackson and MacDonald are imagined as "vibrating before untamed nature." The bond made them "visionaries of Art," by which Laberge meant visionaries of a national art. *Terre Sauvage* was exemplary.

As I have said, wilderness landscape representation in Canada has proved persuasive and durable as the source of a symbolic narrative.[21] However, the discourses around it have produced a far more conflicted history than is generally acknowledged. The disagreements that course through what follows about how landscape should be represented – if it should be represented at all – underscore what has been at stake. If the Group of Seven and their associates have for a long time rivalled the popularity of the Impressionists in Canadian museum exhibitions and everyday representational culture, as can be seen in recurring exhibitions of their work, in holiday editions of newspapers, and in calendars marking the months and seasons with their paintings, it is not because audiences have been unanimous in thinking that their nationalist vision of Canada is the only one worth valuing. Some audiences have responded to the wilderness idiom more like Estragon in Samuel Beckett's *Waiting for Godot* than like a director of the National Gallery of Canada. "You and your landscapes!" Estragon shouted at Vladimir. "Tell me about the worms."[22] The wild art history of Canada also includes worms.

## TRANSNATIONALISM

Despite the patriotic claims made on behalf of Canada and its attachment to its northern environment, the nation has not been alone in its wilderness preoccupations. The landscape narrative in which Canadian artists participated was transnational and shared by artists in other countries. It has involved the northern nations of Europe and the southern nations of the Antipodes, not to mention several nations in the Americas. Symbolist landscape

painting in the late nineteenth and early twentieth centuries was produced by artists as varied as Edvard Munch and Harald Sohlberg (Norway), J.F. Willumsen (Denmark), Akseli Gallen-Kallela (Finland), Prince Eugen, Gustaf Fjaestad, and Karl Nordstrom (Sweden), Ferdinand Hodler (Switzerland), Piet Mondrian (The Netherlands), Margaret Preston (Australia), and Marsden Hartley and Georgia O'Keeffe (United States).[23]

Like all modern traditions of art, the evolution of the Canadian tradition arose by processes of aesthetic mutation. Despite some assertions to the contrary, which have been discredited, the Group of Seven looked carefully at foreign art, including the work of several of the artists mentioned above. Examples from abroad were assimilated by the Group – and then transformed by them in their engagement with the local environment.

Members of the Group travelled to the United States and Europe and were devoted readers of art periodicals, especially of *The Studio*. One of the most popular international art journals of the time, *The Studio* published two articles on Scandinavian art in 1913.[24] In that same year, J.E.H. MacDonald and Lawren Harris travelled from Toronto to Buffalo to see a large exhibition, *Contemporary Scandinavian Art,* held under the auspices of American-Scandinavian Society, at the Albright Gallery. The Scandinavian subject matter and painting techniques galvanized them. "Here were paintings of northern lands created in the spirit of those lands," Harris wrote later. "Here was a landscape as seen through the eyes, felt in the hearts, and understood by the minds of the people who knew and loved it. Here was an art, bold, vigorous, and uncompromising, embodying direct experience of the great north."[25] The affinity felt by MacDonald for contemporary Scandinavian art was no less intense, as he underscored in a lecture delivered in 1931. Referring to the Albright exhibition, he stated, "Except in minor points, the pictures might all have been

Canadian, and we felt, 'This is what we want to do with Canada.'"[26] And that is what they did do.

The members of the Group of Seven were disinclined, however, to confess much affinity for American art. As the unruly elephant on the Canadian doorstep, the United States was already a large presence in the Canadian imagination. Lawren Harris rejected it as insufficiently northern and insufficiently white. To quote him more fully, "We [Canadians] are on the fringe of the great North and its living whiteness, its loneliness and its replenishment, its resignations and release, its call and answer, its cleansing rhythms." The racial overtones in this sentence were not accidental. Later in the same article, Harris asserted that Canada's spiritual purpose should be to "shed clarity on the growing American race."[27]

Harris's assumption that a pure version of modernity in Canada stood apart from the polyglot version in the United States was as false as it was prejudicial. Both countries were polyglot and racially mixed. Both encouraged immigration in order to support capitalist industrialization. And both registered anxiety about not only race but also technological intrusions into the natural landscape.

The impact of new technologies on the land and on the social fabric was a recurring theme in art and literature on both sides of the border. In the United States, as Leo Marx points out in *The Machine in the Garden*, the concern intensified following the devastation of the First World War.[28] It was reflected not only in the work of the Group of Seven but also in that of Hartley, O'Keeffe, and Ansel Adams. Although his medium was photography rather than paint, Adams's work in several ways ran parallel to that of the Group of Seven. In *Winter Sunrise, Sierra Nevada, from Lone Pine, California,* a black and white photograph of jagged peaks rising above a half-shadowed valley bottom, Adams removed

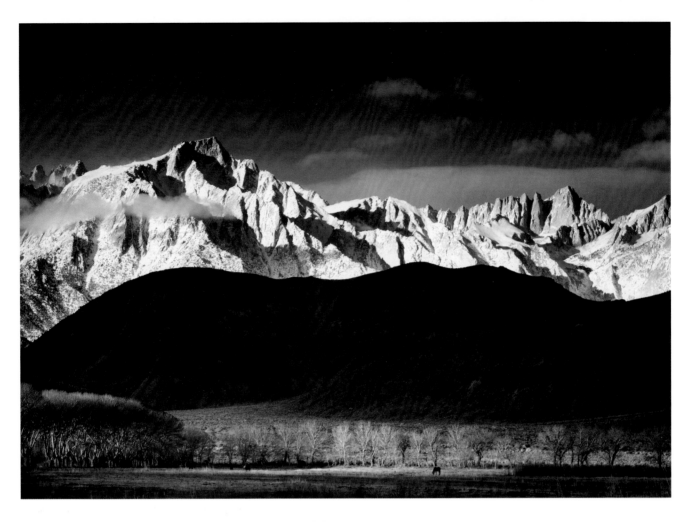

from his image the letters "LP," which stood for the name of the nearby town of Lone Pine and which had been carved into the side of the mountain by local residents.[29] As he saw it, the worm of human and technological contamination in the landscape had to be suppressed, just as Jackson thought that signs of human habitation had to be suppressed in *Terre Sauvage*.

The favourable reception in Canada to the paintings of the Group of Seven, like the positive response to Adams's photographs in the United States, was in part a product of technological anxiety. The anxiety did not subside as the twentieth century advanced. The subordination of nature to technology accelerated during the Second World War, and then during the Cold War, with its buildup of nuclear weapons. As discussed in chapter 2, the entanglement of the natural world with the forces of technological change figured prominently in the information and communication theories of Canadians Harold Innis and Marshall McLuhan.[30] By the 1960s McLuhan's ideas about new spatial

consciousness in the electric age were being discussed both in Canada and globally. Unlike the Group of Seven, younger postwar Canadian artists began to see nature as being within technology rather than apart from it. In the opinion of Michael Snow, wilderness had become an "extreme rarity." "I want to make a gigantic landscape film," he wrote in a 1969 funding proposal sent to the Canadian Film Development Corporation, "equal in terms of film to the great landscape paintings of Cézanne, Poussin, Corot, Monet, Matisse, and in Canada the Group of Seven."[31] He shot *La Région Centrale* with a specially fabricated camera north of Sept-Îles, as if it were a "record of the last wilderness on earth." As Johanne Sloan observes in her essay for this book, the film can be seen as an attempt to aesthetically rebut the spatially extended environment posited by McLuhan. In the film, which is not readily separable from the rotating camera used to shoot it, Snow bundled the mechanical and the natural together, refusing to give the one authority over the other.

The first government of Pierre Elliott Trudeau, working on policies aimed at creating a "just society," also refused to allow entrenched lines of authority (for which read anglophone or Protestant authority) to prevail. Supported by the findings of the Royal Commission on Bilingualism and Biculturalism, the Official Languages Act was passed in 1969, thus acknowledging Quebec's special position within federalism. The language bill was followed by the Multicultural Policy of 1971 and the establishment of a minister of state for multiculturalism in the following year, both of which underscored the presence of ethnic and cultural heterogeneity across all sectors of Canadian society. The Multicultural Policy was a response both to calls for recognition from the indigenous peoples of Canada and to demands that the state reflect the nation's ethnic pluralism. During parliamentary discussions on the policy, Prime Minister Trudeau declared that "although there are two official languages [in Canada], *there is no official culture*, and nor does any group take precedence over any other" (emphasis added).[32]

This policy pressed home a radical shift in cultural priorities. A Canada with "no official culture" was, in effect, a postmodern culture *avant la lettre*. The shift signalled that iconographies of Canadian nationalism, especially iconographies of wilderness landscape produced by a single ethnic group in what had become a multi-ethnic society, were likely to change. It also signalled that the time had arrived for Tom Thomson, the Group of Seven, Emily Carr, and other prominent figures in Canadian culture to be historicized. J. Russell Harper had already published a Centennial commission, *Painting in Canada: A History*, in 1966, and four years later Peter Mellen published *The Group of Seven* and Dennis Reid mounted a retrospective exhibition for the National Gallery of Canada, *The Group of Seven/Le Groupe des Sept*, to analyze and commemorate the inaugural exhibition of the Group in 1920.[33]

Reid followed the exhibition with *A Concise History of Canadian Painting*, published in 1973, and a year later Barry Lord released *The History of Painting in Canada: Toward a People's Art*, a Marxist-Leninist-Maoist account of art in Canada described by one critic at the time as "evangelical."[34] A few years later Harold Town and David P. Silcox co-wrote *Tom Thomson: The Silence and the Storm*, Jeremy Adamson wrote *Lawren S. Harris: Urban Scenes and Wilderness Landscapes 1906–1939*, and Doris Shadbolt published *The Art of Emily Carr*. The books were all historical reckonings.[35]

## LANDSCAPE AND CAPITAL

Landscape has never been an innocent word, though it is sometimes treated that way. "Look at that landscape!" we may say. It is worth asking what we are talking about when we gesture at a landscape or pass an aestheticizing hand over it. Are we talking about the land itself, or are we talking about the representation of it? In one sense we are talking about neither, for ideas about the land cannot easily be separated from its representations; paintings, songs, and poems about territory and place are not readily detached from what they refer to. In another sense we are talking about both. The land and its representations are knotted together, not unlike two other agitated words with an affinity to landscape in contemporary thought – nation and nationalism. Landscape encompasses the land as well as its representations: the Rockies and the photographs of William McFarlane Notman; Algonquin Park and the paintings of Tom Thomson; the West coast and the paintings of Emily Carr; the Arctic and the videos of Zacharias Kunuk; Newfoundland and the work of Marlene Creates.

In shaping the Canadian imaginary, landscape has been a hard-working noun. It has functioned more like an active verb than a descriptive noun, mediating not only between the land and its representations but also between nature and culture in

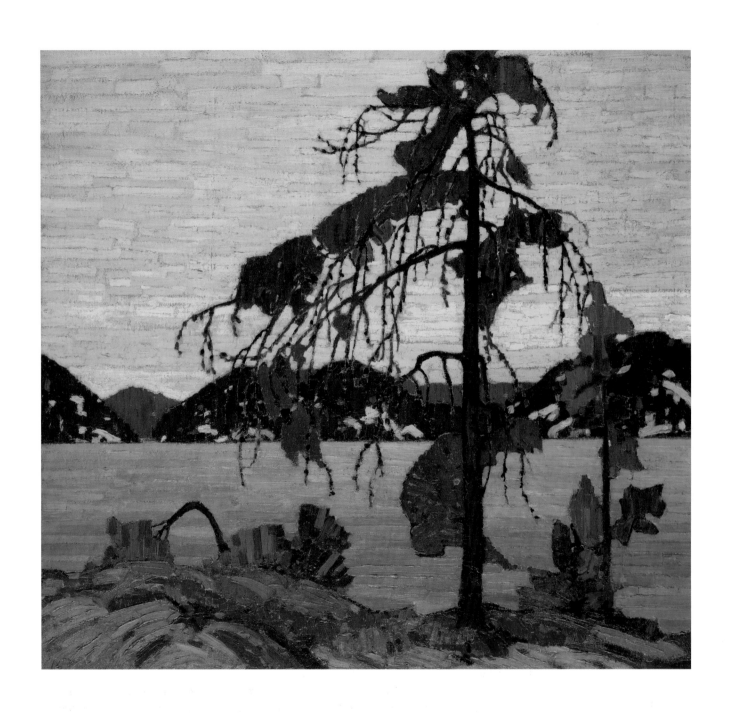

Tom Thomson, *The Jack Pine*, 1917,
oil on canvas, National Gallery
of Canada

a broader sense. That is to say, it has mediated a relationship between the natural world and the human world that is often difficult and messy. In recent decades, the predisposition of critical theorists, anthropologists and historians has been to insist that nature and culture are not free of one another or static in their interactions. Michael Pollan has observed: "In the years since Darwin published *The Origin of Species*, the crisp conceptual line that divided artificial from natural selection has blurred. Whereas once humankind exerted its will in a relatively small arena of artificial selection (the arena I think of, metaphorically, as a garden) and nature held sway everywhere else, today the force of our presence is felt everywhere. It has become much harder, in the past century, to tell where the garden leaves off and pure nature begins."[36]

Four books published in the 1990s addressed landscape with the intention of complicating how it is understood. All wished to demythologize landscape's romantic underpinnings. The titles of the books indicate the directions taken and their emphasis on landscape's verb-like instrumentality. *Landscape and Power*, edited by W.J.T. Mitchell, investigates how landscape works as a cultural practice, focusing on it as an agent of power. In particular, the book examines landscape as an ideological category that disguises the social relations that exist within it.[37] *Landscape and Memory*, by Simon Schama, also emphasizes landscape's lack of neutrality. "Even landscapes that we suppose to be most free of our culture may turn out, on closer inspection, to be its product," Schama writes.[38] The message is that landscape cannot escape the social beliefs and aspirations of its time. This insight is central to W.H. New's *Land Sliding* as well, which explores why so many Canadian writers have taken the land as a comprehensive reference point of nationhood.[39] And in *Landscape and Western Art*, Malcolm Andrews traces the genealogies of landscape as a subject

for art, pointing out that the principal inspiration for landscape representation is landscape representation; a painting of a tree, in other words, is more like a painting than it is like a tree.[40] Tom Thomson's *The Jack Pine*, notwithstanding F.B. Housser's assertion that when Thomson executed the work, nature was speaking through him – "his master was Nature," Housser wrote – is no exception.[41] European examples of Post-Impressionism and Art Nouveau were also his master.

The Group of Seven's wildercentrism was tied symbiotically to capitalism and its postcolonial extensions. Landscape representation is always attached in some way to economic and social circumstances. When the nineteenth-century art critic John Ruskin reflected on the contemporary taste for landscape in Britain, he expressed the hope that audiences would form some suspicion of it. On the one hand, he celebrated the rise of landscape painting as a category of art; on the other, he worried that it revealed a condition of complacency, an attitude of superiority over other peoples and other places. He cautioned against assuming that landscape painting was always a positive social instrument.[42] What Ruskin did not say, but his countryman John Berger did say a century later in his television series *Ways of Seeing*, is that our attitude to a landscape painting will often depend on how the painting appears from the place we are standing.[43] If a painting represents pre-empted land, for example, it makes a difference if our viewing position is that of the pre-empted or the pre-emptor.

Northrop Frye wrote from the position of the pre-emptor, that is, from the position of Canada's immigrant settler population. He argued that each part of Canada was cut off from its other parts by geography and that all its parts were affected by the harshness of the environment. For Frye, the land mass of Canada was an "obliterated environment," largely empty and unnamed.

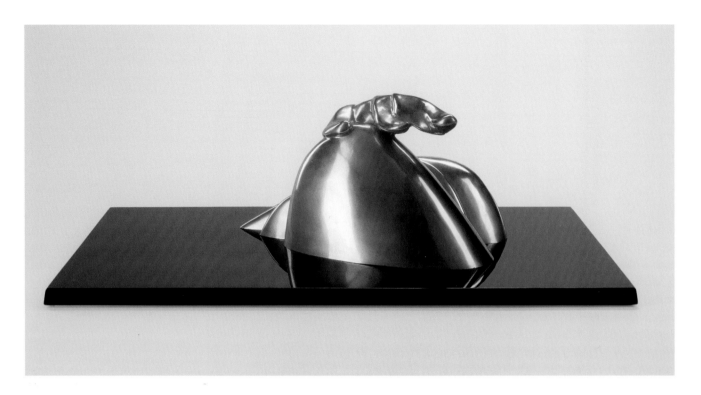

It was *terra nullius*. "Everywhere we turn in Canadian literature and painting, we are haunted by the natural world. Even the most sophisticated Canadian artist can hardly keep something very primitive and archaic out of our imagination."[44] In Frye's opinion, the most important task and therefore the greatest challenge for artists and writers was to visualize the territory they occupied, to confront the landscape and take psychic possession of it. That is why he called the Group of Seven the "poets" of a wilderness not yet absorbed and wrote in favour of their formation of a national school of landscape painting.

Working against the grain of these notions of physical and psychic possession, Scott Watson has rejected Frye's formulations, especially their colonialist implications for aboriginal populations. (In a bizarre act of displacement, his rejection appeared in an article written for an American audience.) "In his analysis of the essentially Canadian in Canadian literature and art," Watson writes, "Northrop Frye emphasized the unvisualized territory, as if picture-making, in poems or oil paintings, could enact a conquest for the imagination of what was already conquered by commerce and the state."[45] What was already conquered was not *terra nullius* but First Nations territory. By the

time the Group of Seven travelled to the regions of Algoma and Lake Superior in the years immediately following the First World War, mines, lumber operations, railways, and mill towns were widely dispersed across the industrial north of Ontario.[46] Lawren Harris, A.Y. Jackson, Frank Johnston, Arthur Lismer, and J.E.H. MacDonald reached Algoma not by canoe but by the Algoma Central Railway. There they executed some of the "wilderness" paintings for which they are best known, landscapes with layered waterfalls and lake-filled vistas, within steps of a railway boxcar that had been made over for them to live in through Harris's arrangements with the rail company. A photograph from one of the trips shows MacDonald, sketch box on his knees, with his back to the train tracks.

To repeat: miners and lumbermen, to say nothing of indigenous peoples, were in Algoma before the Group of Seven. This was the case wherever the Group went to sketch and paint. The mapping and dividing up of Canada for national and commercial interests, therefore, were acts of possession and dispossession that preceded rather than followed the "visualizing" work of landscape artists. "The management of dispossession," as the geographer Cole Harris calls it, relied on a grouping of disci-

Elizabeth Wyn Wood, *Northern Island*, 1927, cast tin on black glass base, National Gallery of Canada

plinary technologies that included maps, numbers, and law.[47] Robert Houle, an artist of Ojibwa and Saulteaux heritage and one of the curators of the 1992 exhibition *Land, Spirit, Power* at the National Gallery of Canada, has also addressed landscape as a dispossessing visual and linguistic category. In the catalogue for the exhibition, he wrote that "to the indigenous people of the New World, the loss of *land* has meant not just the losing of farmland, hunting grounds, and fishing areas: it has simultaneously led to [destruction and desecration] … There is no word for 'landscape' in any of the languages of the ancient ones still spoken. In Ojibwa, whenever the word *uhke* is pronounced, it is more like an exaltation of humanness than a declaration of property."[48]

## THE ABUSED CAT

Exaltations of humanness and declarations of property were pivotal in debates about landscape in Canada during the Depression years of the 1930s. In a review of the 1936 *Yearbook of the Arts in Canada*, edited by Bertram Brooker, Frank H. Underhill declared that he would feel more comfortable if a note of "rustic rumination" were not so prevalent among Canadian artists. He would prefer that artists demonstrate some social awareness, he said, about the economic and social convulsions then shaking the world. Underhill reserved the force of his animus, however, for the false promises that had been issued in 1929, when the first yearbook was published. He stated that the landscapes painted at the time by the "Men of the North" on the Precambrian Shield, landscapes that occupied a significant place in the yearbook, were not so much aesthetic works inspired by the untamed north as they were representations of the financial boom. The paintings, he contended, were expressing what other Canadians were manifesting in real estate, railways, and the stock market.[49]

Underhill's linking of wilderness landscape painting to railway profiteering and the stock-market price of International Nickel, a mining and smelting-conglomerate, elicited a strong rebuke from Elizabeth Wyn Wood. The connection, it seems, cut too close to the bone. By making explicit the relationship between the industrialization of the Precambrian Shield and the visual representations produced by the Group of Seven and other landscape artists, including Wood herself, Underhill put into doubt the claims made for the symbolic purity and mysticism of their work. He contaminated what should have remained above contamination, sullying the image of Canadian artists as bush heroes cutting their way through the wilderness in the national interest. Wood responded to Underhill's iconoclasm with an ad hominem attack, stating that he was like "a little boy who has taken the cat to the boiler room to tie a length of lead pipe to its tail."[50] The abused cat in this scenario was the artist, of course, and the boiler-room the place of industrial manufacturing and financial deal-making where no self-respecting artist ought to be found.

According to Wood, Canadian artists should take themselves as far away from the boiler room as possible. They should trail-blaze the hinterland in search of "spiritual stimulation and nourishment." As evidence, she offered a brief inventory of bushwhacking Canadian artists, starting with Cornelius Krieghoff and Paul Kane. "On through the years, the pioneers trooped to the wilds," she wrote, "[Frederic Marlett Bell-Smith went] to the mountains, [George A.] Reid to Algoma, J.W. Beatty to Algonquin. Many have felt the lure from across the seas. Tom Thomson grew like a pine tree on the rocks. The Group of Seven, inspired, shouted their triumph. Jackson and Harris touched the Arctic."[51] According to Wood's narrative of visual conquest, it was as if the artists cried "Excelsior!" at each new encounter with nature. (Some Canadian landscape painters, of course, failed to recognize

Cover of *artscanada*, June/July 1967,
with N.E. Thing Company's *Bagged
Canada Coasts*

themselves in Wood's description. David Milne wanted no part of a fetishized landscape painted in the name of national identity – the valorization of wild things and empty spaces, the smell of turpentine in the wilderness.)[52]

Wood's riposte echoed anxieties voiced in the late 1910s and the early 1920s, when the success of the Group of Seven and its program was still being negotiated. Among the first apologists were Eric Brown, Barker Fairley, and F.B. Housser. Brown, director of the National Gallery of Canada (and therefore a central figure for the Group), was the first into print. He attacked the degeneracy of "futurism" in Europe and the anglophilia of a preceding, backward-looking generation of artists in Canada. Charles C. Hill is correct to insist in *The Group of Seven: Art for a Nation* that the writings of the Group's supporters exhibited a puritan streak – Wyndham Lewis recognized it, too, as we have seen – and Brown is a case in point.

Hill's reference was to the artistic realm, but a Protestant cleansing streak was also evident in the attitudes of supporters (and of the artists themselves) toward racial miscegenation and radical politics.[53] "Modern art is not to be confounded in any way with Futurism," Brown wrote in 1921, "because all movements which degenerate into ugliness and distortion have just the same relation to true art that Bolshevism has to true government."[54] His anxious association of "true art" with sound political hygiene had a growing number of adherents in Canada. In the name of authenticity, Brown distinguished between right-thinking Canadian artists who were in pursuit of the distinctive in the Canadian landscape, the phenomenon of "scarlet maples ablaze among the dark pines," and artists of "a generation ago, mostly born in Great Britain or brought up on ultra-British traditions, [who] did not want pictures of their country of adoption but of 'home.'"[55] The latter rarely condescended to paint scenes of Canada, he argued,

and if they did they were of Canada on a "grey" day.

In Brown's opinion, the new generation, "apostles of the decorative landscape" exemplified by Thomson, had created a uniquely Canadian art. This art expressed "the spirit of the Canadian northland – its dignified and splendid calm and its pathetic aloofness and isolation."[56] Like most polemicists in a hurry, Brown was rather loose with his facts. The painters he admired, no less than those he denigrated, were themselves British immigrants or the children of British immigrants; Thomson's so-called isolated painting grounds in Algonquin Park were the site of logging operations, railway lines, and tourist activities;[57] and the paintings claimed as indigenous to Canada were, as I have already discussed, heavily modelled on European painting methods and subjects.[58]

As a subject of investigation, landscape is a vexed category. "[It] is both a represented and presented space," Mitchell has observed, "both a signifier and a signified, both a real place and its simulacrum, both a package and a commodity inside the package."[59] Whether those who write on landscape acknowledge it or not, they are standing on controversial ground. Barker Fairley was the Group of Seven's most perceptive critic in the years around 1920, and he did not shrink from controversial judgments any more than Brown did. But it was an article written by him in

1939, well after the Group had disbanded in 1933 and its landscape paintings had become iconic, that proved the most troublesome to some readers.

In "Canadian Art: Man vs. Landscape," Fairley charged that Canadian artists painting portraits and the human figure were tired and timid compared to their counterparts painting landscapes, thus allowing landscape production to dominate. The result was a steady, unvarying diet of paintings of the natural world. "[N]ot one Canadian in a hundred goes into an art gallery looking for anything but hills and trees and lakes and clouds and flowers and fruit," Fairley complained, adding that in "this age of intense human conflict and suffering" to concentrate so much on landscape was an act of moral blindness.[60]

Notwithstanding the dissenting positions of Underhill and Fairley, in the 1940s two international art critics found more to admire than to damn in the Canadian example. In the first Marxist history published on the art of any nation, *Place, Taste and Tradition: A Study of Australian Art since 1788*, Bernard Smith endorsed the national consciousness reflected by the work of the Group of Seven and its adherents.[61] Smith was not blind to the predatory pressures then being placed on aboriginal populations and their land in Australia and, by extension, to comparable pressures being exerted in Canada, but his eye was fixed more on his country's evolving postcolonial relationship with Great Britain than on the neocolonial relationship within it. The place of landscape art in Canada's process of decolonization was what interested him.

Wyndham Lewis also extolled what he called the militancy of the Group of Seven and their large, "rude" works. "They chopped out their paintings as if they had been chopping wood," he informed a postwar British audience in *The Listener*, and by such means produced a representational equivalent of the landscape they inhabited. But instead of recommending that Canada and its artists take a step back from the national fixation with a "monstrous, empty habitat" – from, to use a phrase I relish for its irony, "the virgin beauty of Mississauga" – he feared that the country might turn its back on the rugged northland that defined it.[62] Lewis did not want Canada to keep moving along the path of modernization; he wanted it to turn back the clock and embrace the "primitive."

## MONGREL LANDSCAPES

Lewis's nostalgia for a myth in which he was no longer required to participate – he had spent the war years in the Toronto area, and had returned to England following the war – was at odds with the postwar mood in Canada. The worm in the wilderness, so to speak, had already started to turn. Instead of seeing nature as "a god-govern'd machine," Canadian artists and writers were beginning to observe that the machine was governing nature.[63] But change took a while. Jack Bush was an intermediary figure in the transition. In a 1976 interview, well after he had acquired an international reputation as an abstract color-field painter, he recalled the influence on him of the Group of Seven at the beginning his career: "I still can't get over the habit that we got into, which was to go out into the field to make sketches Saturday and Sunday, with a little pad, just like A.Y. Jackson, with a little painting kit and all the rest of it. We would also go on two trips a year, one in the spring and one in the fall, to the North country, Haliburton or Belfountain or some such place and come home with a batch of twenty sketches that we had painted up there."[64]

The artists Iain and Ingrid Baxter and Jeff Wall are a generation or so younger than Bush. Although their work often engages with landscape, as students they were not persuaded of the merits of producing weekend field sketches in the manner of A.Y. Jackson.

A.Y. Jackson, *Smoke Fantasy*, 1932,
oil on canvas, Magna International

Like other contemporary artists, they were more interested in a rapidly globalizing world and in the changing social spaces of Canada as the country moved from industrial capitalism towards an information-based economy.[65] They shared a desire to unpack landscape as a genre and to reconsider its shopworn conventions in order to reinvent it.

The landscapes produced by the N.E. Thing Company, the incorporated business that the Baxters operated in Vancouver from 1966 to 1978, focused primarily on the vernacular spaces and new technologies of consumer society. Like entrepreneurs in search of property to develop, the Baxters "bagged" and "claimed" landscapes. At a high water mark of Canadian national optimism during the summer of 1967 – ironically, also a high water mark of Quebec nationalism – when the world was beating its way to Expo 67 and its spectacle of technological advancement, a work by the N.E. Thing Company was illustrated on the front cover of *arts-canada*. The piece was *Bagged Canada Coasts*, an inflatable artwork made from the everyday technology of plastic. This synthetic landscape contained miniature red boats, snow-capped grey mountains, a one-dimensional blue sky, and three-dimensional water on which to "float" the boats. (The boat located off the East coast is on the ocean floor.) The ephemerality of the work plays on the fragility of nature as well as the fragility of boats.

Jeff Wall's *Landscape Manual* of 1969–70, priced at 25 cents and printed on the cheap paper stock of an instructional workbook, also insisted upon conditions of ephemerality. The throwaway cheapness of the book mirrors the suburban landscapes Wall shot with his camera from a moving automobile. The manual is a catalogue of modern technologies – cars, roads, cameras, buildings – which were then being deployed, as they still are, to expand the reach of the urban over the natural. Wall's book is a manual not only of landscapes but also of capital.

Asked on a CBC radio program in 1950 whether he painted portraits, A.Y. Jackson replied, "No, sir, I'm a landscape man."[66] Artists rarely declare their commitments so decisively, and perhaps Jackson would have been wise to hesitate before announcing his artistic identity with such confidence. In 1932 he executed a Neoimpressionist (or, more precisely, a neo-Neoimpressionist) painting of a Sudbury nickel mine spewing smelter smoke. Jackson's *Smoke Fantasy* raises a question that brings us full circle, back to the symbiotic relationship between capitalist modernity and wilderness I proposed at the beginning: Why, until recently, did industrialized Canadian landscape paintings by the Group of Seven and others, of which there are a sizable number, not also become part of the national imaginary, part of the dominant iconography of nationhood?[67] Why did they not find a significant place in installations at the National Gallery of Canada, or in the president's office of Local 598 of the Mine, Mill, and Smelters Workers union in Sudbury, or in the corporate reception rooms of Eldorado Resources Limited?[68]

By depicting an impure vista, *Smoke Fantasy* and paintings like it represented a mongrel version of the Canadian landscape. Paintings of the industrialized North fitted uneasily with Lawren Harris's description of the spiritual geography of Canada as white and unsullied. With their mine buildings and smokestacks and defoliated surroundings, such works gave the lie to Harris and the nation's wilderness idealizations. They represented the technological empire within capitalism, the contaminated other to the "hard puritanic land" celebrated by Wyndham Lewis and the Protestant elite who supported the ascendancy of wilderness landscape painting. That is why they were not given prominence at the National Gallery, the Mine, Mill, and Smelters Workers union, and Eldorado Resources. Instead, the demand was for an iconography of purity – and, famously, that was what Thomson, the Group of Seven, and Carr provided.

# Extensions of Technolo

# Chapter 2

gy

JEFF WALL

MARSHALL McLUHAN

MICHAEL SNOW

GREG CURNOE

NANCY SHAW

IAIN BAXTER

N.E. THING COMPANY

JOHANNE SLOAN

JOYCE WIELAND

JODY BERLAND

RODNEY GRAHAM

# Extensions of Technolo

**MARSHALL MCLUHAN ASSERTED** that art has a special capacity to interpret the messages of technological change. "Each new impact shifts the ratio among the senses," he wrote in *Understanding Media*, published in 1964. "No society has ever known enough about its actions to have developed immunity to its new extensions and technologies. Today we have begun to sense that art may be able to provide such immunity."

McLuhan's promise that art could inoculate society against the effects of technology may now seem misplaced, but his observation that the potential and/or violence of technological change could be self-critically represented through art does not. In the article that leads off this chapter, "Technology and Environment," he explains why this is this case. A range of evidence for his argument is visible in the remainder of the chapter. Artists in the late 1960s and 1970s set about undoing the traditional conventions of landscape art in Canada, with one eye trained on the new extensions of technology and the other on the shifting forces of global capital. Iain and Ingrid Baxter, Greg Curnoe, Rodney Graham, Michael Snow, Jeff Wall, and Joyce Wieland were among the artists engaged in this undoing. Their purpose, as Johanne Sloan says of Snow and Wieland, was "to anatomize, explore, and reinvent the legacy of landscape art in Canada."

The activities of the N.E. Thing Company, the corporation operated by Iain and Ingrid Baxter in Vancouver from 1966 to 1978, were influenced by the proposition that art could be produced by non-artists and that, under the right circumstances,

technology could also function as a source of art. For the Baxters, as for McLuhan, the old categories of art and artist needed to be reimagined. Focusing primarily on the vernacular landscape and drawing on consumer technologies such as telex machines and moulded plastics, the N.E. Thing Company made it its business to "bag," "reflect," "inflate," "map," and "claim" landscapes. "[The] Company's landscapes," writes Nancy Shaw, "investigated how information technologies, corporate relations and institutions ... interact to redefine 'landscape' as a product of human interest."

Greg Curnoe's 1970 manifesto, "Amendments to Continental Refusal/Refus Contintental," is more overtly political than the work of the N.E. Thing Company. In addition to demanding that all atomic weapons in Canada be returned to the United States from a high altitude, the manifesto insists, "A 100 mile wide defoliated-depopulated zone along the old Can.–U.S. border" be created. Curnoe's satirical call for a denatured landscape, an unpopulated wasteland between Canada and the United States that is kept under tight surveillance, was the antithesis of the Group of Seven's glorification of the North and the wilderness that defined it. Technology overpowers nature, in Curnoe's caustic equation, not the other way round.

Nature and the exploitation of natural resources are always mediated by economic, political, and technological forces. To rehearse Jody Berland's observation, it is not so much the trees themselves that count but how the trees are traded and represented. Jeff Wall has made a related point. The exchange of commodities and the creation of economic surplus value involve not only systems of measurement but also systems of contestation. The representation of landscape involves systems of measurement and contestation too.

# Jeff Wall

LANDSCAPE MANUAL, 1969

# LANDSCAPE

## MANUAL

## J. WALL

25¢

## THE CONTROLS

Art controls experience by structuring our most profitable involvements with the environment, whatever this might happen to be. As art, all language immediately, consistently and emphatically points beyond itself, beyond its own state to the region of the first order experiences which give language life in the first place.

Once our experiences on many levels are almost ~~totally~~ totally shaped by the quality & structure of the existing language (as they are at present) then the process can be seen in many ways to work "in reverse": the shape of the language determines the shape of our reactions to interactions with the physical etc. world of interrelated systems.

The dangers k inherent in this arrangement proceeding unheeded and unconsciously in the minds and hearts of all of us are readily apparent & here we have the basis of the theory of controls.

loose gravel spread out

---

### AWAKEN PHOTO

Car speeding over the roads---36 black & white photo-cards, turning over, one after the other, in sequence. Each time, the sequence x is definite. The sequence is speeding over the road, the sequence finding point after pm point, stitching indistinguishable ▓▓▓ relationships with the houses, trees, sidewalks, lawns, poles, apartment houses, gravel paths etc. Each time a photo-card is turned over, the same possibility arises, presents itself for (our) inspection: (here was) D. eating ice cream with his spoon (--holding a heavy silver flashlight to reveal a distant quarry--) was riding this time in a red Ford truck---miles and miles of grey roads with ▓▓▓▓▓▓▓▓ white lines, sidewalks (concrete or loose grey gravel spread out), corners, and, beyond, more--expanding--intersections dense & flat---intersections of apparently possible points moving away and away etc. (photo: houses of the housing ░##░ development type)(photos: grocery stores, supermarket, unfinished sidewalks). --intersections below a network of wires. These continuous dense areas concentrations, drifting

across the side-mounted rear-view mirrors--"the intersections on the windshield"---the truck has a mirror mounted on the right-hand door. The ball and socket support is broken, and the mirror is permanently tilted down at an acute angle with the ground ▓▓▓▓▓▓▓▓▓▓▓▓▓▓ ▓▓▓▓▓▓▓▓▓▓▓▓▓) From the driver's seat, the mirror is----"useless". From the passenger's seat the mirror offers up the most distinct opportunities for an unsentimental passage (silent, devoid of constraint, devoid of necessity) through terminals of related flatness & <u>unconstructed</u> networks of---only "relative"---importance---i.e., the rooftop across the street from my window here at the <u>present time</u>--maybe this yellow page itself.

terminal

From the passenger's seat, what usually can
be seen is the very edge of the road, when the
lane is nearest the right-hand curb or shoulder.
For example, when you are riding on a road with-
out curbstones etc., the ragged edge of the bl-
acktop rips through the mirror-frame like the
brown magnetic tape in my tape-recorder here ᴂx
proceeding past the silvery tape heads. This
makes it easy to see what you're riding on.

photo attached

*Notes houses of the housing
development type*

clear pattern-frame for the contin-
uous surfaces

Stopped at an A & W hamburger drive-in, I
noticed that the mirror was registering a frag-
ment of a thick white line painted on the coar-
se black pavement. Unfortunately, I didn't have
my camera with me at the time. (see photo atta-
ched) The segment of the white line was a clear,
innocuous point in of course space & of course
time (length of coarse blacktop running past
the ᵱ tape heads). This funny language---funny
talk---papers, books, etc., matchbooks on the
dashboard for example---would be the language
of such points of view (funny points of view:
funny funny talk) As a matter of fact, the blue
seats of the Dadge Monaco convertible, the och-
re-metallic seats of the little Chevrolet Cama-
ro make funny funny language with the grey seats
of the red Ford truck---funny funny intersection
in the location of specific, funny, seated, fi-
erce activity.

photo: houses of the housing
development type

*– difficulty restraining impulse
to drawing circles & other
indications to distinguish regions
(in this concrete disc also → housing
development) on the photo*

12

Marshall McLuhan and Quentin Fiore, *War and Peace in the Global Village*, 1968

# Technology and Environment

MARSHALL McLUHAN

**THE REALLY TOTAL AND SATURATING** environments are invisible. The ones we notice are quite fragmentary and insignificant compared to the ones we don't see. The English language, for example, as it shapes our perceptions and all our habits of thought and feeling, is quite unperceived by the users of the English language. It becomes much more perceptible if we switch suddenly to French. But in the case of environments that are created by new technologies, while they are quite invisible in themselves, they do make visible the old environments. We can always see the Emperor's old clothes, but not his new ones.

If the new environment is invisible, it does serve to make very visible the preceding environment. The obvious and simple illustration of that is the late show. On the late show on television we see old movies. They are very visible; they are very noticeable. Since television, the movie form has been reprocessed. The form of movie that once was environmental and invisible has been reprocessed into an art form, and, indeed, a highly valued art form. Indirectly, the new art films of our time have received an enormous amount of encouragement and impact from the television form.

The television form has remained quite invisible – and will only become visible at the moment that television itself becomes the content of a new medium. The next medium, whatever it is – it may be the extension of consciousness – will include television as its content, not as its environment, and will transform television into an art form; but this process whereby every new technology creates an environment that translates the old or preceding technology into an art form, or into something exceedingly noticeable, affords so many fascinating examples I can only mention a few.

It is plain that the content of Plato's work, of his new written form, was the old oral dialogue. The content of the print technology of the Renaissance was mediaeval writing. What got printed in the main, for two centuries and more after the printing press, was the mediaeval tale, mediaeval Books of Hours, mediaeval liturgies and mediaeval philosophy. Shakespeare lived in the Renaissance world, and the content of Shakespeare's plays, as everybody knows, is mediaeval.

The Middle Ages were the late show for the Renaissance. By the nineteenth century the Renaissance had come into full view. As the industrial environment formed, this progressive time firmly and squarely confronted the Renaissance. The content of the nineteenth-century mind was the Renaissance; the content of the twentieth-century mind is the nineteenth century. We are obsessed with it. It is not as easy to banish that mirage as one might wish.

But one of the most bizarre growths in this development occurred when railways and factories came in. The content of this new industrial, mechanical environment was the old agrarian world, and there was this upsurge of awareness and delight in the old agrarian environment of arts and crafts – the pastoral world. This discovery of the receding age was called the "romantic movement."

The sudden discovery of nature was made possible by the railway and the factories that were so very different from nature. The romantic movement was a product of the mechanical age by way of a contrapuntal environment. It was not a repeat of the mechanical age; rather it was the content of the mechanical age, and the artists and poets turned to processing the old agrarian world into delightful landscapes and delightful pastoral poems. This was in turn altered by the rise of electric technology that went around the old mechanical world of a few decades ago. When the electric technology jacketed the machine world, when circuitry took over from the wheel, and the circuit went around the old factory, the machine became an art form. Abstract art, for example, is very much a result of the electric age going around the mechanical one.

In our time we can see that Pop Art consists in taking the outer environment and putting it in the art gallery, or indoors somewhere, suggesting that we have reached the stage where we have begun to process the environment itself as an art form. We may be catching up with ourselves. When we begin to deal with our actually existing new environment as an art form, we may be reaching that stage the planet itself seems to have reached. With satellite and electronic antennae as probes, the planet ceases in a way to be the human environment and becomes a satellite itself – a probe into space, creating new space and environments for the planet.

If the planet itself has thus become the content of a new space created by its satellites, and its electronic extensions, if the planet has become the content and not the environment, then we can confidently expect to see the next few decades devoted to turning the planet into an art form. We will caress and shape and pattern every facet, every contour of this planet as if it were a work of art, just as surely as we put a new environment around it. Even as the Romantics began to deal with the old pastoral, agrarian world as an art form when machinery was new, so we will now begin to deal with the planet itself as a work of art.

I think the computer is admirably suited to the artistic programming of such an environment, of taking over the task of programming the environment itself as a work of art, instead of programming the content as a work of art. This situation suggests some considerable changes in the human state. It suggests that the role of art in the past has been not so much the making of environments as making of counter-environments, or anti-environments. Flaubert, a hundred years ago, said: "Style is a way of seeing." Ever since that time the painters and artists have been quite conscious of their jobs as teaching people how to perceive the world they live in. "It is above all that you may see," said Conrad, apropos the meaning of his work.

The training of perception upon the otherwise unheeded environment became the basis of experimentation in what is called modern art and poetry. The artist, instead of expressing himself in various patterns and packages of message, turned his senses and the work of art to the business of probing the environment. The Symbolists, for example, broke up the old romantic landscape into fragments that they used as probes to explore the urban and metropolitan environments. Then they turned to probing the inner life of man with the same verbal instruments in hand. Instead of using the verbal as a way of expression, they turned it inward for the purpose of exploring and discovering the contours of the inner life.

The psychiatrist took over in the same pattern and began to erode the unconscious. If the unconscious has an important and irreplaceable function in human affairs, we had best look to it – it is being eroded at a furious pace; it is being invaded by dazzling investigations and insights; and we could quickly reach a stage in which we had no unconscious. This would be like dreaming awake. Such may well be the prophetic meaning of *Finnegans Wake* by James Joyce: his idea, among many others, that tribal man lived a dream and modern man is "back again Finnegan" into the cycle of the tribal involvement, but this time awake. This possibility that we are actively engaged in liquidating the unconscious for the first time in history behooves us to pay some attention to how it is structured, and to what function it serves in human affairs. It may prove to be indispensable to sanity.

One overall consideration for our time is to consider how, in the past, the environment was invisible in its operation upon us. Environments are not just containers, but are processes that change the content totally. New media are new environments. That is why the media are the message. One related consideration is that anti-environments, or counter-environments created by

the artist, are indispensable means of becoming aware of the environment in which we live and of the environments we create for ourselves technically. John Cage has a book called *Silence* in which, very early in the book, he explains that silence consists of all of the unintended noises of the environment. All the things that are going on all the time in any environment, but things that were never programmed or intended – that is silence. The unheeded world is silence. That is what James Joyce calls thunder in the *Wake*. In the *Wake* all the consequences of social change – all of the disturbances and metamorphoses resulting from technological change – create a vast environmental roar or thunder that is yet completely inaudible. It is like heat that in organic or other systems creates "noise" [...]

* * * * * * *
Reprinted from Marshall McLuhan,
"Technology and Environment,"
*artscanada*, no. 105 (February 1967): 5-6.

Joyce Wieland, photograph of
Michael Snow during filming
of *La Région Centrale*

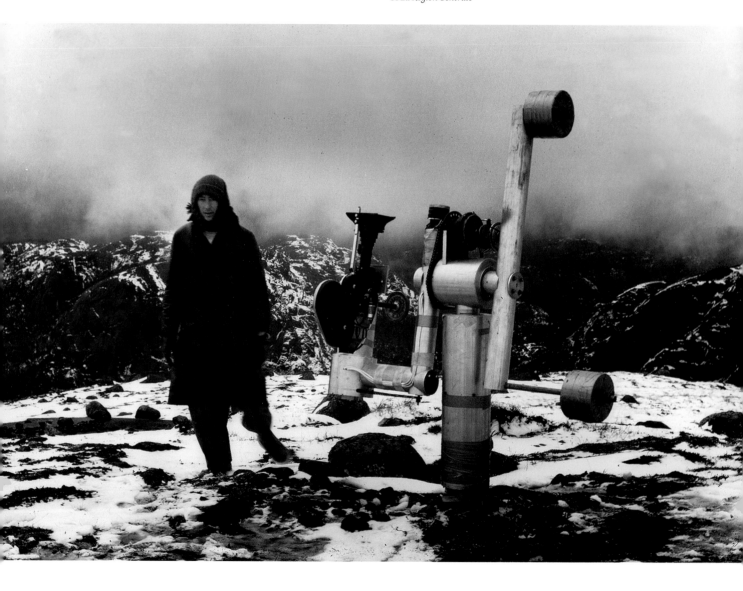

# La Région Centrale

MICHAEL SNOW

AFTER FINISHING *WAVELENGTH*, which is in its entirety a single camera movement (a zoom), I realized that the movement of the camera as a separate expressive entity in film is completely unexplored. In 1967 I made diagrams and wrote plans for sets of possible camera movements and made a short film (*Standard Time*, 8 minutes) as a first investigation of the effects of a particular set of repeated camera movements. After that I started on ideas for a longer film using a repeated scanning back-and-forth pan and a repeated up-and-down pan as the only camera movements. This film was shot in July 1968 while I was teaching at Fairleigh Dickinson University in New Jersey and completed in March 1969. It is titled ← →, is 50 minutes long and will have its premiere at the Whitney Museum in New York on May 22. It is almost impossible to describe the effect of this film. Visual rhythms (in film) can have as infinitely varied qualities as rhythms in music. The camera pans continuously at various tempi, starting at a medium speed, then gradually going slower and slower, then gradually rising in speed to very, very fast. It is set in a classroom and the activity therein was scripted by myself.

This film has opened up incredible possibilities, and this is what this essay is all about: I would like to make a three-hour film "orchestrating" all the possibilities of camera movement and the various relationships between it and what is being photographed. The movement can be an imperceptible part of the activity, can accent it, can counterpoint or contradict it and be independent from it. Since I'm sure nothing has been done in this area, perhaps I should clarify the sense in which I can say that camera movement is an unexplored potentially rich part of cinema: camera movement has generally been allied to the dictates of the story and characters being presented and follows what has been assumed to further these things, e.g., someone leaves the room, the camera follows this action. I give the camera an equal role in the film to what is being photographed.

The camera is an instrument which has expressive possibilities in itself. I want to make a gigantic landscape film equal in terms of film to the great landscape paintings of Cézanne, Poussin, Corot, Monet, Matisse and in Canada the Group of Seven [...]

The scene and action will be shot at different times of day and in different weather, although all in the spring or summer.

The film will become a kind of absolute record of a piece of wilderness. Eventually the effect of the mechanized movement will be what I imagine the first rigorous filming of the moon surface. *But* this will feel like a record of the last wilderness on earth, a film to be taken into outer space as a souvenir of what nature once was. I want to convey a feeling of absolute aloneness, a kind of *Goodbye to Earth* which I believe we are living through. In complete opposition to what most films convey, this film will not present only human drama but mechanical and natural drama as well. It will preserve what will increasingly become an extreme rarity: wilderness. Perhaps aloneness will also become a rarity. At any rate the film will create a very special state of mind, and while I believe that it will have no precedent I also believe it will be possible for it to have a large audience [...]

I have two general areas in mind for the location. I am familiar with the country north of Chicoutimi (my mother's birthplace) in Quebec, and to familially balance it out, in 1912 and 1914 my father was in surveying parties which mapped what are now partly the chief mining districts in Northern Ontario (Kapuskasing, Timmins). I have his notebooks and snapshots from that time and they have always had a fascination for me. Enclosed is a snapshot (mine) of the type of typically Canadian northern landscape I would like to use.

* * * * * * *
Reprinted from Michael Snow, "La Région
Centrale" (1969), in *The Collected Writings
of Michael Snow* (Waterloo: Wilfrid Laurier
University Press, 1994), 53-7.

# Michael Snow

FROM *PLUS TARD*, 1977

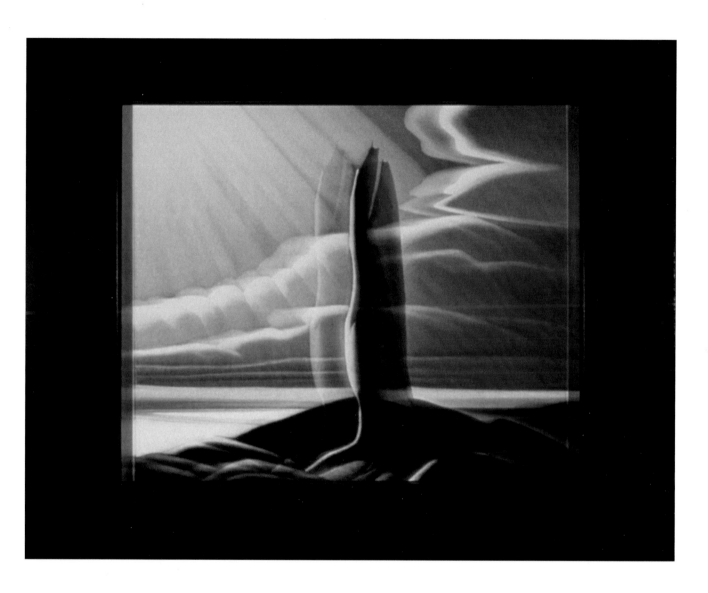

GREG CURNOE

# Amendments to Continental Refusal / Refus Continental

1. **THAT WE THE CITIZENS** of the 2nd largest country in the world should sever all connections with the smaller country immediately south of us.

2. Electric shock treatment to be used on all businessmen … politicians … musicians etc. who have U.S. content in their heads … more than 2 per cent.

3. That Americans are not North Americans … the return of the Alaska panhandle … the Oregon territory … Maine … & the annexation of Alaska as an integral part of the true north strong & free. All to be done without the use of arms.

4. All trade unions to sever all connections with U.S. unions.

5. All Canadian atlases must show Canada's southern border to be with Mexico. Bridges & tunnels must be built between Canada & Mexico.

6. Canadian U.S. customs abolished – no goods to be brought into Canada from the U.S. and none to be exported.

7. 50 mile high electric fence to be built along old Canada–U.S. border.

8. No more emigration directly from U.S. into Canada. Must go to another country & then come to Canada from there. No birds to fly between the 2 countries free passage of Indians between the 2 countries abolished.

9. No animals … germs … insects … spores … seeds etc to be allowed to pass between the 2 countries.

10. Resolution presented to the UN that all countries should follow Canada's lead or that People's Republic of China be substituted for the U.S. in the UN.

11. Complete control of the Great Lakes.

12. Scrapping of all U.S. made computers & replacement with latest Japanese models.

13. Complete Canadian content in all computer memory banks.

14. Scrapping of all U.S. made or designed autos & replacement with Renaults & Volvos.

15. Revival of the Avro Arrow.

16. All Bomarcs & other atomic weapons on Canadian soil to be returned to the U.S. by dumping from a high altitude.

17. A 100 mile wide defoliated-depopulated zone along the old Can.–U.S. border.

18. Large fans to be installed along the old border to blow back polluted American air & to serve as an exhaust for Canadian pollution e.g. Hamilton. To also be used to dispose of Canadian germ warfare stock.

19. Visiting the U.S. to be a capital offense.

20. All NHL teams to be repatriated.

21. American accents to be banned from all media.

22. Use of American spelling of words to be punishable by strapping.

23. Coca-Cola to be banned.

24. Canadians with American blood to have 3 notches clipped in their left ear.

Greg Curnoe, *Map of North America*, 1972, ink on paper, Dalhousie University Art Gallery

25. A huge canvas tarp to be suspended over the sky of Canada ... to make our weather independent of our gracious southern neighbour.

26. The name of baseball to be changed back to rounders.

27. Jazz to be banned from Canada and all rock.

28. Faulkner ... Burroughs ... Melville ... Whitman ... Kerouac ... Ginsberg ... Williams ... etc. to be burned.

29. All American art in Canada to be exhibited in a degenerate art exhibit & then to be auctioned off in the States.

30. Return of all Canadians from American concentration camps.

31. Rules of Canadian football to be changed to their pre-American state e.g. middle ... outside ... snap etc. & all imports banned.

32. CKLW to play O Canada 24 hours a day except on Sunday when The Maple Leaf For Ever will be played.

33. Canada to recognize the sovereignty of all Indian reserves ... all Eskimo communities ... Quebec ... any community or group that wishes to assert its independence.

34. All factories to be organized along the anarcho-syndicalist lines ... workers own factories & make all decisions regarding internal working of factories.

35. Columbia River to be turned off.

36. All restaurants & motels with American place names to be required to change them to something more suitable.

37. Any restaurants or motel owners who flies U.S. fl

* * * * * * *

Reprinted from Greg Curnoe, "Amendments to Continental Refusal/Refus Continental," *20 Cents Magazine* 4 (April 1970). Nos. 1 through 10 read at Kingston, 11 March 1970; nos. 1 through 37 read at Windsor, 19 March 1970.

Greg Curnoe in his studio, 1968

# Greg Curnoe

VIEW OF VICTORIA HOSPITAL, FIRST SERIES:
NOS. 1-6, 1968-69

FROM THE LEFT = PUTTY SMU
DGES ON THE GLASS, A DARK
GREEN FRAME HOUSE WITH
WHITE TRIM, ITS LEFT SIDE IS
ALSO VISIBLE THROUGH SEV
ERAL SMALL TREES, A GROUP
OF LARGE TREES OBSCURE TH
E HOUSES TO THE RIGHT OF I
T, THE EAST (THIS IS TRULY GR
EAT ART) WALL OF A ONE STO
RY BRICK COTTAGE, ITS EAST
WINDOW WITH AN AWNING,
IN FRONT OF IT A DEAD ELM T
REE, ACROSS THE STREET PART
OF THE FRONT OF A WHITE FR
AME HOUSE, ABOVE IT PART O
THE JACK-TAR BUILDING AND

A BIT OF THE HURON & ERIE &
ITS FLAG POLE - THE FLAG IS A
MOVING SPOT, A TALL ,COOL
GREEN TREE, A 1 STORY HOUS
E WITH A GREY UPPER PART
& A WHITE FRAME FIRST STO
RY - THE UPPER WINDOW IS
ISIBLE WITH A BLIND HALF DR
AWN -(ARE YOU READING OR
JUST LOOKING ?)-TO THE RIG
HT A TALL, WARM GREEN TREE
WITH THE SUN SHINING THRO
UGH IT, MAKING THE OUTER L
EAVES TRANSLUCENT. A GROU
P OF BUSHY TREES IN FRONT T
OF IT. TO THE RIGHT, ON THE H
ORIZON, A CORNER OF A TALL

BUILDING. TWO TALL CHIMNE
YS SIDE BY SIDE-THE RIGHT O
NE HAS TWO RINGS AT THE T
OP. IT IS A YELLOW BRICK TUB
E. THE LEFT ONE IS OLDER. I CA
N COUNT II. EQUALLY SPACED
RINGS ON IT. TWO MORE AT
THE TOP, WEST OF THEM. TW
O ROWS OF TREES-THEIR TO
PS LIT BY THE SUN, EAST OF T
HEM, A TREES. THEN THE LEFT
END OF A TALL WHITE BUILDIN
G -ELEVEN TOP FLOOR WIND
OWS ARE VISIBLE-ABOVE IT T
HE TOP OF THE RED BRICK C.I.
A. BUILDING, BELOW IT AN OL
D RED BRICK BUILDING WITH

AN ALUMINUM VENT ON THE
PEAK OF THE ROOF. A TREE. TH
E FACE OF AN OLDER BRICK BU
(THIS IS TRULY GREAT ART BEC
AUSE IT WAS NOT MADE BY A
N AMERICAN!) LDING, IT HAS T
WO BUTTRESSES ON EACH SI
DE OF & A BIG HALF CIRCULAR
WINDOW ABOVE THE FRONT
DOOR. IN FRONT OF IT, THE BA
CK OF AN OLD YELLOW BRICK
BUILDING WITH A SLATE ROO
F OVER IT, A DEAD ELM TREE-J
UST IN FRONT OF IT ANOTHER
SLATE ROOFED BRICK BUILDIN
G, TREES IN FRONT OF ALL OF T
HEM. A LIGHT GREEN TREE A H

OUSE, A TREE ABOVE IT, A CHI
MNEY ABOVE IT. LOTS OF TRE
ES ("GORDON JEFFREY, MEET
GEOFFREY GORDON.") IN FRO
NT & BELOW, MANY LIGHTER,
YELLOWER TREES. PART OF TH
E NURSES' RESIDENCE. VICTOR
IA HOSPITAL-I THINK. NOT IN TH
E WHITE STRING COVERS THE
MULLION WHICH COVERS PA
RT OF THE EAST WING. CARS
IN THE PARKING LOTS & CURV
ED STREET LIGHTS ON COLBO
RNE ST. TREES & THE LAST HO
USE ON THE EAST SIDE OF COL
BORNE-ABOVE IT A RED MAPL
E & PART OF A BUILDING. A CRI

SASH & A BRICK ONE WI
TH WHITE TRIM, PART OF BLA
CKWOOD LODGE-A YELLOW T
REE IN THE FOREGROUND CO
RNER. IT. THE PUBLIC PARKING
LOT. THE BACK OF A HOUSE &
ITS GARAGE. THE BACK OF AN
OTHER HOUSE. A FORKED LIG
HT STANDARD. A MODERN AP
ART MENT-YELLOW BRICK, AN
ELM TREE (WE ARE REALLY R
IEL), IN THE FOREGROUND -A
TALL, EMERALD GREEN TREE.
THE DARK OR BROWN SASH. E
ARTHQUAKE.

N.E. Thing Company, *Reflected Arctic Landscape*, 1969, Cibachrome transparency and wooden box, Canada Council Art Bank

# Siting the Banal

NANCY SHAW

## The Expanded Landscapes of the N.E. Thing Company

The concept of everydayness does not therefore designate a system, but rather a denominator common to existing systems including judicial, contractual, pedagogical, fiscal, and police systems. Banality? Why should the study of the banal itself be banal? Are not the surreal, the extraordinary, the surprising, even the magical, also part of the real? Why wouldn't the concept of everydayness reveal the extraordinary in the ordinary?

HENRI LEFEBVRE

By making life more interesting for others, we may indirectly help to alleviate the human condition. We up your aesthetic quality of life, we up your creativity. We celebrate the ordinary.

N.E. THING COMPANY

"To change life-style," "to change society," these phrases mean nothing if there is no production of an appropriated space.

HENRI LEFEBVRE

THROUGHOUT THEIR COLLABORATION (1966-1978), Iain and Ingrid Baxter utilized the N.E. Thing Company – their incorporated business and artistic moniker – as a vehicle through which to investigate artistic, domestic and corporate systems in relation to their everyday life. Like typical West Coast and Canadian artists, the Baxters made landscapes, though theirs were expanded to include the sites of work and leisure, and urban and suburban spaces. They were uninterested in painting pictures of Canadian wilderness as a hostile, unexplored territory full of myth, mystery or awe-striking grandeur – all that is other to the obvious and banal spaces of the everyday. Instead the Company's landscapes investigated how information technologies, corporate relations and institutions such as the art world and the nuclear family interact to redefine "landscape" as a product of human interest, an element of subjectivity, and charted its relationship to forms of identity and national positioning. NETCO's reversals, reflections, inflatables, mappings, punnings, and measurements, disrupted unidimensional, unidirectional hegemonic annexations of space. The Company actively appropriated and transformed these spaces to allow for creative possibilities and critical potential. At the same time as the Baxters' landscapes attempt to map out a coherent picture of fragmented realms, in a move that is characteristic of the contradictions explored in their work, these landscapes stake out a social topography in the emerging, geo-politically peripheral city of Vancouver in the late sixties.

Although the Baxters were contemporaries of the Situationists (who were among the first to incorporate Henri Lefebvre's analysis of everyday life into their practice), it is necessary to distinguish NETCO from its French counterparts. Lefebvre and the Situationists saw everyday life as a site of revolutionary potential to be liberated through aggressive reversals and

combative tactics of negation – a space from which to undermine the corporate state through dialectical analysis of and critical intervention in consumer society that revealed the stakes capital has in maintaining a separation between the realms of work and leisure, the political and the everyday.[1] Although the Baxters attempted to integrate the spheres of work and leisure, they aimed to open potential spaces of creativity within existing economic and political constraints by breaking down habitually assumed modes of perception in order to up the quality of life – a life that took account of family, business, and art activities. The Baxters proposed an agency that was expansive, inclusive and celebratory in place of the Situationists' disruptive and radically motivated interventions. They playfully questioned their roles as entrepreneurs, artists, educators, parents and spouses, collapsing and infecting systemic boundaries in order to reinvestigate the elusive and taken-for-granted.

The Baxters were ambivalent about their roles as artists – they viewed art as only one of several means through which to explore their ecological and educational interests. By investigating these interests within systems of meaning, they hoped to set an example for others by creating an integrated life for themselves. Not surprisingly, the Baxters did not enter the art world through the standard art college route. The two met at Washington State University in Pullman. Ingrid studied music, recreation and education while Iain studied biology and zoology and enjoyed wildlife illustration. After Iain obtained a MFA, he began investigating contemporary materials and methods of object-making, expanding upon modernist conventions.[2] His bagged and vacuum-formed landscapes were significant early work which employed up-to-date industrial techniques such as heat sealing and moulding: the idea of bagging played on consumer packaging as well as hunting procedures. The landscapes were stylized and toylike, captured and preserved in the most modern of materials – plastic. Mixing and matching the materials and motifs of consumer culture, this work enlisted Pop Art strategies and highlighted links between fine art, consumer durables, industrial processes and advertising techniques.

While incorporating Pop Art procedures, NETCO produced landscapes that provided innovative images of a West Coast lifestyle mimicking notions of leisure and industry promoted by the likes of *Beautiful British Columbia* – a government-sponsored magazine fashioned after *National Geographic* which painted a picture of BC and Vancouver as a natural resource and recreational wonderland. In the late sixties Vancouver was changing from a frontier town and colonial outpost – appropriately known as Terminal City – to a growing metropolis reflective of BC's booming resource-based economy. It acquired a dual identity represented on the one hand by young executives and on the other by disaffected groups. A new breed of upwardly mobile executives emerged to promote and support the development of primary industry and urban growth. In some senses, the maverick traders, the penny stocks and fly-by-night operations of the Vancouver Stock Exchange exemplified the city as a corporate frontier. The scenery and leisure activities afforded by Vancouver's natural splendour was an added bonus for such up-and-coming executives who could boat, ski and golf year round. As well as a port city and the western periphery, Vancouver attracted a conglomeration of misfits looking for a better life, among them hippies and American draft dodgers. Although outdoor recreation took precedence over the arts, alternative sensibilities in one way or another challenged prevailing, parochial and colonial, and genteel modernist traditions.

The Baxters were not a typical family – they actively participated in Vancouver's flourishing interdisciplinary, counter-cultural

and avant-garde art scene in the late sixties. Perhaps their domestic, artistic and company headquarters in the wooded suburbs of North Vancouver, just past the Second Narrows Bridge – a location midway between the more affluent suburbs of the North Shore and the reprieve for transient and counter-cultural elements, the Dollarton Mud Flats and Deep Cove – literally locates the Baxters' position. Their home, starting as a small cottage, eventually resembled a hybrid version of West Coast architecture. The typical homes used post and beam construction based on modernist architectural principles where clean, functional spaces mixed with commanding views to create a safe and clean environment with an abundance of fresh air and recreation – a well-deserved tonic after the malaise and confusion of the modern work-a-day world.[3] The Baxters disrupted this suburban pastoral by using the family abode as company headquarters and artistic playground for the business of living and working rather than contemplative escape and repose. Their dwelling was in a state of constant transformation, whether in the form of ongoing additions to the house or in its use as living space, studio and office. The Baxters treated their home, which they called the Seymour (see more)[4] Plant, as a sculptural assemblage; adding elements of industrial, recreational and commercial architecture – a corrugated tin roof used on barns, large wooden floor planks from a warehouse, a section of a supermarket awning over the deck doors, and a prefab, built-in, vacuum-formed pool in the front yard.[5] The spectacular view enjoyed by more affluent neighbouring suburbs was replaced with the Baxters' working vista – a large back yard – framed with trees and edged by the Seymour River. They hosted parties and studio visits: many local and international artists, curators, funding officials and critics attended for fun and the often heated debate that took place at social gatherings on a regular basis. Regardless of the Baxters' investments

in the ideals of corporate, family and suburban life, they transformed the rigid boundaries of this life to accommodate artistic possibilities. And, unlike most nuclear families, they paid attention to the link between making a living, art-making and the domestic and social base that is integral to such production.

As well as facilitating this interface between the art world and the suburbs, they further traversed conventional boundaries by making art in their yard and using their yard as aesthetic landscape. Much of their yard work involved puns on and experiments with conventions of image-making and measurement. For example, *Single Light Cast* (1968) and *Double Light Cast* (1968) were about light and angles of reflection. In each work mirrors were placed in the river and photos were taken at different angles and distances: the intent was to provide a comparison of how mirrors and water interact to create an image of light, and to show how this light is recorded by the camera. *Reflected Landscape* (1968) also employed a mirror piece in water, but this time the mirror reflected the tree tops and sky, providing a picture within a picture: this included what would otherwise be outside the photographic frame while, at the same time, deferring and deflecting perspectival recession to frustrate easy visual movement through the pictured landscape. In *VSI Formula #5* (1969) algebraic formulas determine the location and angles of mirrors placed in grass, trees and the river to reflect water, sky, land and the house. The equations mimic systematic codification; however the formulations are arbitrary and unresolved. [...]

In addition to proposing environmental works and claiming industrial architecture for the aesthetic record and vacation memories, NETCO incorporated concepts of the North and snow as spatial motifs associated with myths about Canadian landscape. For the Baxters, snow doubled as a blank page or canvas to be shaped and moulded. Iain made snow drawings while skiing,

using his body as drawing implement and snow as support. Drawings such as *One Mile Ski Track* (1968) and *Converging Drawing* (1968) were carried out on Mount Seymour, the neighbourhood ski slope. In *Snow* (1968), the substance was brought to the gallery by placing a photograph of it on the floor covered with bullet-proof glass for patrons to walk over. And, in *P-Line Straight* (1968), drawings were made by peeing in the snow, evoking infinite jokes about the staking out of artistic and spatial territory and, by extension, the forging of industrial frontiers. These drawings were small, personal gestures that on an everyday scale made fun of the grandeur and more instrumental process involved in shaping the land for exploits of tourism and industry.

To further its investigation of Northern motifs, the Company travelled with Lucy Lippard and Lawrence Weiner to Inuvik, NWT to make works for a show organized by Bill Kirby at the Edmonton Art Gallery.[6] The Baxters explored mythic notions of the Arctic as a barren, unexplored wilderness, unpopulated, open and infinite, subject to the extremes of daylight and dark night. While carrying out Company work, NETCO implicitly acknowledged – through the making of maps and the claiming of landscapes – that conceptions of the North as an unpopulated wilderness overshadows and inadvertently legitimizes exploitation of the North as one of the last industrial frontiers.[7]

As a means of recording their explorations while making artistic and personal, everyday alternatives to the rationalized grid of land surveys and maps, the Baxters undertook mapping projects on their expeditions in and around Inuvik. Most maps are made to identify geographical terrain and settlements and to facilitate travel by presenting an abstract, instrumental image of the land with knowledge necessary for extraction, production, distribution and accumulation. Although the Baxters mimicked the conventions of mapmaking, their maps were composed of gestures that made navigational marks on the landscape, documenting space they actually traversed, and through performances, exploring concepts of directionality. In *Black Arctic Circle* (1968), NETCO planned to transpose mapping notations onto the landscape. For the piece, a low-flying jet would release black dye at one-minute intervals – laying down the Arctic Circle as it appears on maps. By transcribing systems of mapping onto the actual landscape, the Company enacted a reversal, revealing the arbitrary and calculated nature of cartography while claiming the landscape as a work of Company art.

As urban and corporate explorers, the Baxters set out on many sightseeing expeditions. In *Circular Walk Inside the Arctic Circle Around Inuvik, NWT* (1969) the Company presidents wore pedometers to scientifically mark the seven km or 10,314 steps travelled around the circumference of Inuvik. They documented *16 Compass Points Inside the Arctic Circle* (1969), and *Lucy Lippard Walking Toward True North* (1969) through a quarter mile of tundra. In these and other pieces they literally performed, in banal acts, the abstract and totalizing concepts of directionality. *Territorial Claim* (1969), situated inside the Arctic Circle, was dedicated to Farley Mowat and his book about the North, *Never Cry Wolf* – a Canadian classic. The narrative explores the existential and physical machinations and rites of passage involved in eking out boundaries that differentiate between the self and extremes of nature. As an extension of *P-Line Straight* – from North Vancouver to the Arctic – Iain made his personal artistic mark by pissing in the snow. He planned to make this decisive gesture time and time again in other significant locales thereby "marking his personal life-time in territorial space."[8] Pissing was considered a transgressive act, illegitimate artistic medium and polluting gesture. When the piss work is considered in relation to plans for ecological pieces, such as the dye drops and "earthworks,"

it becomes clear that the Baxters were interested in an ecology of space, time and viewing processes rather than with environmentalist concerns for preserving nature as a wilderness free of unfriendly human presence. The Company's plans for sculptures and markings assumed free range in annexing landscape and if the prefects were realized they might have met the same fate as Robert Smithson's proposed *Glass Island* in 1970 on one of the Gulf Islands, which was cancelled because environmentalists felt that the project would cause permanent and irreparable damage.

The Arctic work and other landscape pieces were accompanied by standard road and geographical maps that the Baxters marked with instructions and drawings. In doing so they transformed official maps from representations of regulated and unidimensional space into dynamic and contingent space. By inflecting mapmaking practices with their actual experience of and activities in Inuvik, the Baxters transformed abstract and instrumentalizing concepts into the realm of the everyday, disrupting the objectivity of the rationalized grid that presupposes a homogeneous subject, and a static space that ignores time and history.

*Reflected Arctic Landscape* (1969) was another joke on transparency and objectivity in picture-making. Masquerading as a typical picture sunset by taking a photograph of it as it was reflected in a mirror placed on the ground. The resulting image was presented as a back-lit transparency – illuminating a constructed image, reflecting and refracting the sun, demonstrating the difficulty for and limitations of photography in simultaneously capturing the sunset and landscape due to intense and extreme lighting conditions. *Reflected Arctic Landscape* was eventually published in Peter Mellen's coffee table book, *Landmarks of Canadian Art*. While presenting itself as a typical Canadian landscape recording the grandeur, extremes and impossibility of this landscape,

they foregrounded technical finesse and pictorial construction humourously noting the artifice involved in making such pictures.

As tourists, cartographers and artistic investigators, the Baxters carried out Company activities by dispatching NETCO communications such as the *Telexed Triangle* (1969): the transmission spanned from Inuvik to Halifax to Vancouver, using a geometrical form to illustrate spatial concepts constructed by electronic communication. This challenged existent perceptions of time and space by conflating the two to create a sense of simultaneity and the projection of geographical homogeneity. Telexes were also sent to classes at Nova Scotia School of Art and Design instructing students to make art.[9] In this and other work, the Baxters were influenced by Marshall McLuhan. According to McLuhan, artists were early warning systems who perceived shifts in sensory perception effected by technological change. In what McLuhan called the Global Village, a shift was taking place from print technology that favoured visual and linear perception, to electronic and communications media that employed all the senses and favoured simultaneity. In the Company's interpretation of McLuhan, communications media were used to an advantage by sending telex and telecopier messages from geographic, political and economic peripheries, creating what Ingrid called an aesthetic of distance[10] – a means through which the Company could traverse time and space, inserting its presence in territories that it would otherwise be excluded from. As with McLuhan, the Baxters saw themselves as probes – eclectic and eccentric – asking the types of questions that would lead to the collapse of established and official boundaries, setting the groundwork for, and encouraging and advising others to continue with, systematic and scientific studies. Furthermore, communication works were also a cheap, easy, quick and portable

means of artistic demonstration which allowed for an infiltration of national and international corporate and artistic systems that traverse geo-political boundaries.

The Baxters' hybrid sensibilities were evident in their landscape investigations: those investigations encompassed anything, including nature, mapping, environmental and communication systems, the body, the suburban and urban. Their work resided within the gaps and boundaries of established systems that foregrounded the banal and taken-for-granted. The Company poked gentle fun at existing boundaries in order to improve the quality of life for themselves and others while inadvertently leaving a partial social document of their hybrid and polymorphic milieu. Through wit and play they appropriated established and rigidified conceptions of landscape to reread it as constellations of collapsing and interacting territories, calling attention to the hidden interdependence of corporate, artistic and domestic spheres. The agency required to redefine these boundaries was transformative, hinting at possibilities for other kinds of intervention.

* * * * * *
Reprinted from Nancy Shaw, "Siting the Banal: The Expanded Landscapes of the N.E. Thing Co.," in *You Are Now in the Middle of a N.E. Thing Co. Landscape*, ed. Nancy Shaw and William Wood (Vancouver: UBC Fine Arts Gallery, 1993), 25–7, 31–5.

# Iain Baxter

*LANDSCAPE WITH TREE AND 3 CIRRUS CLOUDS, 1965*

# N.E. Thing Company

*SIMULATED PHOTO OF THE MOON'S "SEA OF TRANQUILITY..." FILLED WITH WATER AND THE N.E. THING COMPANY'S SIGN PLACED BESIDE IT, AUGUST 1969, 1969*

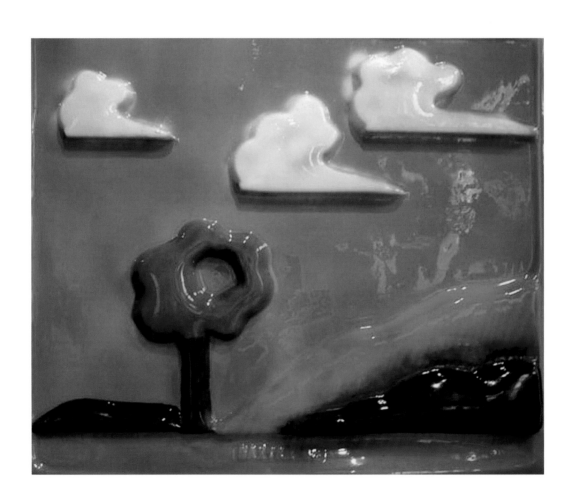

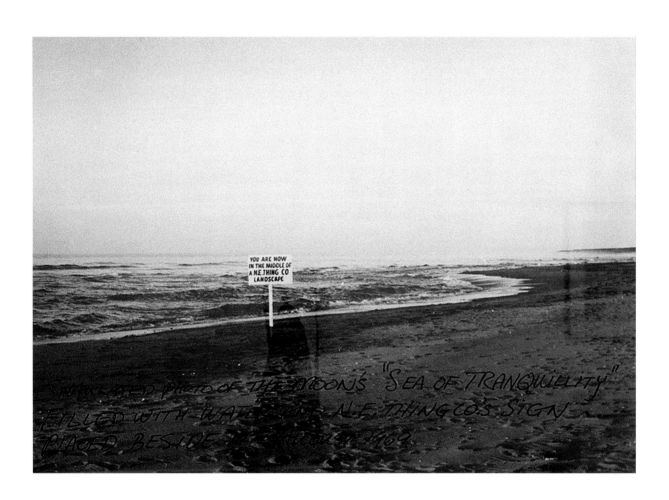

SIMULATED PHOTO OF THE MOON'S "SEA OF TRANQUILLITY"
FILLED WITH WATER WITH N.E. THING CO'S SIGN
PLACED BESIDE IT. ... MARCH 1969

Joyce Wieland, *109 Views*, 1971,
cloth assemblage, York University

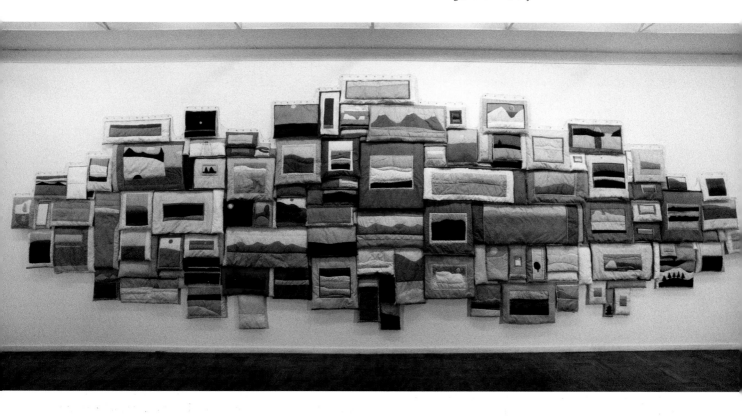

# Conceptual Landscape Art

JOHANNE SLOAN ## Joyce Wieland and Michael Snow

BETWEEN 1969 AND 1977, both Michael Snow and Joyce Wieland made remarkable works of art using photography, film, and, in Wieland's case, various unconventional materials to anatomize, explore, and revitalize the legacy of landscape art in Canada. Snow began work on *La Région Centrale* (1970), saying: "I want to make a gigantic landscape film equal in terms of film to the great landscape paintings of Cézanne, Poussin, Corot, Monet, Matisse and in Canada the Group of Seven."[1] Wieland had by then just completed her own "gigantic" cross-country landscape film *Reason over Passion* (1969), soon to be followed by the multimedia *True Patriot Love* exhibition at the National Gallery (1971), which itself included fragments of a script for another feature-length film about Canadian landscape (which would eventually get made and released with the title *The Far Shore* in 1976). In Wieland's case, the passionate espousal of landscape aesthetics in its Canadian incarnation is perhaps more obvious, and it can be said that the gentle spectre of Tom Thomson presides over her entire production from this time. Snow's work is more often described in formal and technological terms, but the artist's boast about making landscape art equivalent to the masterpieces of European art as well as to that of Canada's homegrown heroes should be taken seriously; we can indeed compare *La Région Centrale* to the Euro-Canadian tradition of painting natural scenery. And then the Canadian content became explicit with Snow's *Plus Tard* (1977), a panoramic series of colour photographs showing the Group of Seven paintings in situ at the National Gallery.

Snow and Wieland were a married couple who collaborated at times and otherwise helped each other out extensively during this period (even if they rarely commented publicly on each other's work), and yet most film and art historians seem to shy away from the question of mutual influence.[2] My purpose here is not to judge precisely how much Wieland influenced Snow or vice versa, but rather to suggest that looking at these bodies of work side by side is extremely instructive. In somewhat different ways, both artists strove to bring the Canadian preoccupation with landscape up to date, resituating it in relation to a technologically expanded visual culture, a shifting sense of nationhood, and a destabilized natural world.

Wieland's and Snow's idiosyncratic explorations of landscape aesthetics at this time did develop in tandem with international movements in Land Art and Conceptual Art, while other avant-garde filmmakers shared an interest in landscape. The artworks under discussion can be profitably compared with multimedia experimental landscape projects from the late 1960s and early 1970s by Canada's N.E. Thing Company, the British artist Richard Long, and the American artist Robert Smithson, for instance, and with the films of Chris Welsby and Pat O'Neill. This generation of artists were interested in the structural and theoretical basis of traditional landscape art, and their work shares an impulse to dismantle the landscape genre, as it were, in order to lay bare its conventions, to reveal its inner mechanisms. With this conceptual making and unmaking of landscape images, fundamental questions are raised – about how the multi-sensorial experience of nature becomes intelligible, how nature is transformed into an object of visual pleasure, and how it is possible to evoke human consciousness when what appears on the canvas or screen is wholly vegetable or mineral. It should be noted that both Wieland's and Snow's projects from this period announce what would become a dominant strain of deconstructive, postmodern art practice of the latter part of the twentieth century. But I want to emphasize that this built-in critical apparatus is only part of the story of what might be called "conceptual landscape art." This is because the critique of inherited paradigms coincides with an ongoing desire to aesthetically interpret the natural world; in

other words, dismantling the traditional landscape genre can also result in new forms of landscape art.

## "THE PRIMACY OF THE RECTANGLE"

The writings of the artist Robert Smithson are particularly insightful regarding this paradoxical reinvention of landscape art for the post-painting, conceptually oriented generation. In an important formulation, he described his artistic projects as the staging of a dialectic between sites and non-sites, whereby "sites" refer to specific geographic locations, to the phenomenological materiality of things, and to the often sublime experience of being immersed in an actual environment. And then "non-sites" refer to the maps, codes, texts, images, and various other modes of representation that are deployed to try and describe a given site. These can never match up exactly, and so the work of art resides neither in one realm nor the other, but is rather the setting in motion of a productive, dialectical relationship. "Between the actual site ... and the non-site exists a space of metaphoric significance," the artist suggested.[3] Likewise, artworks by Snow or Wieland are unlikely to consist of a singular and fixed visual representaion of a given site; rather, images are serial; they subtly morph and mutate; they continually reposition the spectator and suggest multiple points of view; they conjure up pre-existing images; they create tension between still and moving images; they evoke the passage of time. The book-work Wieland made to accompany the *True Patriot Love* exhibition proposes a kind of visual network involving hundreds of images, for instance, while Snow's *Plus Tard* disturbs the boundaries between what are normally distinct and still images. Instead of seeing only the end product of the artist's interaction with a particular environment, we are drawn into an ongoing, multi-layered process of representation which opens up that "space of metaphoric significance." Unlike so many landscape painters who came before them, these artists acknowledge an already-mediated perceptual field, even while the artist/spectator continues to be captivated by the potential wildness, mystery, and unintelligibility of the natural world. In opposition to this sensibility, we might remember the kind of all-natural, undialectical rhetoric that often accompanied the modern landscape movement in Canada and elsewhere. Writing about Tom Thomson in the 1920s, for instance, the writer Frederick Housser would insist that "his master was Nature," and that his paintings revealed "no trace of an intellectual philosophy, nor of a trace of esthetics."[4] This comment is in accord with the European exemplar described by Richard Shiff (writing about Cézanne): "The modernist claims freedom from any grounding in convention ... If his works should happen to resemble those of past masters, he would maintain that this indicates no dependency, but a sensitivity to an immutable and original truth, rediscovered in his own sensation."[5]

Against such disavowals, Smithson insisted on "the primacy of the rectangle" as part of the artwork's dialectical operation, and Snow, too, wrote about the "edifying dialogue between the rectangle and all its specifically human content, with the nature (that might be) pictured through the camera or in the rectangular result."[6] In other words, art-making in the Western tradition, however naturalistic or convention-flouting it might aim to be, has depended upon deeply embedded pictorial conventions and especially on the rectangular framing device. This convention is especially true of landscape art because the horizontally positioned frame, with its built-in horizon line, is the key structural element, allowing the natural scene to be laid out for visual consumption. With the landscape genre, form and content are thoroughly interlocked. And so the Smithson-Wieland-Snow generation of artists set out to explore both the natural world

and the conceptual parameters of the landscape experience. This critical reflexivity does suggest a rupture with the modern and romantic schools of landscape art, including the Group of Seven.

## JOYCE WIELAND'S BOOK OF NATURE, CIRCA 1971

Joyce Wieland's exhibition *True Patriot Love/Veritable amour patriotique* opened at the National Gallery in 1971, with an array of "Canadiana" for the late twentieth century – not the usual display of rustic or nostalgic stuff that might conventionally bespeak the nation but, rather, colourful, satirical objects made out of stitched and embroidered cloth or plastic, with the occasional political slogan slyly appearing on harmless-looking quilts and cushions. Landscape was evident everywhere in this exhibition, in different modes and materials. Returning to Canada after a long sojourn in the United States, Wieland was at this time espousing a New Left brand of nationalism that was utopian in its ambitions to reinvent the prevailing discourse about Canadian nationhood.[7] For the artist this meant responding imaginatively to some of the nation's symbolic forms such as the anthem and the flag, as well as to the iconic landscape imagery that has been deemed so crucial to a sense of Canadian identity. The unusual renditions of landscape imagery in the exhibition included *Arctic Cake*, an enormous iceberg-like cake covered in white frosting; quilted fabric works, such as *109 Views* and *Water Quilt*; a quasi-ecosystem in the form of several ducks splashing around in a makeshift pond; and the aforementioned artist's book, which I want to argue is a coherent and important work of landscape art on its own terms.

The eight-metre-long fabric assemblage *109 Views* consists of a proliferation of little cloth landscapes sewn together. It has been written about this work that "the scenes are landscapes in the tradition of the Group of Seven – unspoiled, uninhabited,"[8] but this characterization does not quite get at the essence of these cartoon-like images, each miniature scene coming complete with its own frame also constructed out of a brightly coloured swatch of fabric. Rather, *109 Views* exaggerates the pictorial structure of the landscape genre as a whole, reducing it to a formula requiring only the basic shape supplied by the frame and two or three horizontal bands to suggest earth, sky, and an all-important horizon line. If anything, this work seems to parody the Group of Seven legacy and the clichéd view of Canadian art as an innumerable sequence of similar-looking landscape views. *Water Quilt* was a rather more serious investigation of landscape: this blanket-like object incorporated pages from James Laxer's contemporaneous book *The Energy Poker Game*, which alerted readers to the extent of foreign investment in Canada and criticized the plan to sell "bulk water" from Canada's northern lakes and rivers to our ever-thirsty American neighbours.[9] The first impression with *Water Quilt* is of the Arctic's fragile little flowers embroidered in a decorative grid, but the viewer who interacts with the work by lifting up the individual squares of fabric discovers the underlying text and learns how geopolitics lie just below the surface in the representation of even the most diminutive of natural phenomena. Wieland's characterization of the North as an ecologically threatened environment and her way of connecting ecological concerns to questions of national sovereignty were unique among artists at this time. There was a shifting tone in her depictions of northern scenery, so that comic landscapes are followed by politicized ones, but there is throughout these permutations an awareness of how prominently "the North" has featured in Canadian cultural imaginings.[10] If the northern part of the continent was to remain a source of fascination and aesthetic interest, however, this was not because the North was a timeless or untouched wilderness or

because, in Lawren Harris's famous words, "the top of the conti-
nent is a source of spiritual flow"[11] that Canadian artists have
the privilege to tap into. Rather, in Wieland's work we are made
aware of presences, voices, and gazes criss-crossing the northern
terrain and continually intersecting with natural ecosystems.

In the book-work and film script bearing the title *True
Patriot Love* and in the film *The Far Shore*, Wieland forged a
strong connection with Canada's art-historical past, primarily
through the figure of Tom Thomson. By the time she and Snow
came into their own as artists, the wild-looking scenery painted
by Thomson and the Group of Seven was being relentlessly
reproduced on calendars, stamps, school books, government
publications, and so on.[12] A major National Gallery exhibition
of 1970 only reconfirmed this canonization. And so by the 1970s,
the art of Thomson and his cronies could seem banal or, worse
still, informed by conservative values. Nonetheless, Wieland's
*The Far Shore* resurrected Thomson as a genuinely freethinking
and heroic figure, and if the characterization she presented was
in some respects hippie-like, he was not the naive child of nature
described by Housser. Tom Thomson's early death and unful-
filled promise as an artist have accorded him a unique stature in
this country, and it is possible to convince oneself that he died
for the cause of modern (landscape) art. Wieland's film offered
a new version of this traumatic event; instead of a lone artist
confronting a harsh natural environment, this was a showdown
that pitted aggressively exploitative commercial values against
ecologically, erotically, and aesthetically attuned individuals.
This replotting of Canadian art is accomplished through the ruse
of a romantic triangle involving the landscape painter Tom, his
lover Eulalie, who is a pianist (a fellow artist, in other words) and
a displaced Québécoise (and therefore possibly not "Canadian"
at all), and her husband, Ross, who is the very embodiment of

bourgeois capitalism, interested only in discovering new ways to profit financially from the land.

The finished film was not universally admired, and it certainly is very different from Wieland's earlier, more formally experimental film work, although Lauren Rabinowitz has argued that *The Far Shore* was indeed structurally innovative in that the artist's inventive redeployment of the melodrama genre "ruptures the smooth illusion of cinematic realism."[13] The melodrama and pathos of the film should not be underestimated as an intervention into the aesthetics of landscape in Canada. The idea of introducing heightened emotion, torrid sex, financial greed, and murder into the story of Canadian art is anomalous and pleasurably shocking; who would have thought that the Canadian landscape was permeated with libidinal energy just like Arcadian landscapes of old? And the film does carry forth many of Wieland's thematic preoccupations, if not all of her formal ones: the plot of the film can be regarded as a kind of clash between "passion" and "reason," whereby these are not presented as universal, timeless categories, but are instead historically specific forms of consciousness.[14] *The Far Shore* asks us to recognize Thomson's art as a passionate and socially engaged kind of modernism – in opposition, perhaps, to cool, abstract, and de-politicized forms of modern art. By reclaiming Thomson (along with Eulalie, his feminine counterpart), Wieland was producing a revisionist art history, and so too was she inventing an artistic genealogy for herself. Scott Watson has remarked about the sexual coding implicitly written into Canadian art history: "the Group of Seven painter is chaste in the wild. He takes no female companion there and finds no native princess or prince in the woods, only 'that sweet loneliness which is exaltation.'"[15] With Wieland's retelling, Thomson's attachment to the land is no longer an austere masculine enterprise. And with the entirely invented

character of Eulalie, Wieland gave body to what is so often missing in conventional accounts of the Group, and in histories of landscape art generally – a woman viewer and artist whose desire for the land is as strong and as passionate as any man's.

The original screenplay for *The Far Shore* first appeared in the *True Patriot Love* book-work of 1971, and it is very effective in this format, where the snatches of overblown dialogue are interspersed with a wealth of other images and texts. Whereas the *True Patriot Love* exhibition as a whole was brash and colourful, Wieland's book was more restrained in its effect, with its black and white photographs overlaid onto the pages of a government publication about Arctic flowers. The simple line drawings and dry scientific prose of the original book are largely obliterated by a display of images, apparently attached to the pages in a haphazard way with paper clips or sometimes stitched to the page. There are fragments of commentary, description, and song, printed and handwritten in English, French, Inuktitut, and sometimes Gaelic. There are horizontal stretches of blurry scenery, the pattern of snowshoe tracks, and repeated reproductions of Thomson's *The West Wind*. When we leaf through the book, it becomes questionable, however, whether we are indeed confronting natural scenes and spaces. The blank whiteness of the page becomes a melancholic snowdrift, which then becomes an overexposed photographic expanse. Wieland gives us a range of options, between probably real and patently fake landscapes. Snapshot-like images that are readable as landscapes on first viewing are evidently details of quilting, cushions, or other stitchery. Somehow, though, a slightly gaping seam suggests geological stratification, the unanticipated play of light and shadow seems to recreate flaring northern lights in another image, and a horizon-like glow insistently appears. In such instances, the artist did not deliberately set out to create a landscape representation, but rather she allowed it to emerge in a dreamlike, associative process. The close-up photographs in the *True Patriot Love* book-work show that the aesthetic experience of landscape can happen accidentally. The utopian promise of landscape art can, we discover, be the outcome of a technological glitch or a photographic blur.

This book-work has been recognized as an important contribution to the international phenomenon of Conceptual Art, and further, I would describe it as an exemplary work of conceptual landscape art.[16] Attempting to come to terms with Land Art in 1970, Dave Hickey compared this new art form to the experience of driving a car across the continent, because in so doing, "you become acutely sensitized to the conceptual spaces through which you are plummeting – time zones, states, counties, water districts, flyways, national parks, weather systems."[17] This understanding of how landscape is perceived is reminiscent of Wieland's interest in creating complex temporal and spatial configurations. The film *Reason over Passion* introduced fractured movement through a sequence of zones, and the *True Patriot Love* book-work presented maps, graphs, and scientific information juxtaposed with pages showing paths, tracks, and lines of stitchery that lure the viewer across and into the fictional landscape space. In the hands of conceptually oriented artists such as Wieland, "objective" systems for measuring and quantifying the territory are objects of fascination, but they are not taken at face value, perhaps because, as Sol Lewitt once remarked: "conceptual artists are mystics rather than rationalists."[18] By bringing together such different modes and moods, Wieland produced landscape art that was a complex form of visual knowledge. She showed that the meaning and value of the natural environment is linked to politics and the social world, but also that nature becomes a kind of screen onto which desires and dreams are projected. In

Wieland's artwork, landscape as art form was inevitably speculative, personal, even hallucinatory. Indeed, it is through these diverse but overlapping manifestations – the overt political message of *Water Quilt*, the comical proliferation of *109 Views*, the accidental sublimity of the book-work's photographs – that we begin to understand the imaginative dimensions of Candian landscape art.

## *LA RÉGION CENTRALE*: NORTHERN DELIRIUM

In 1970 Michael Snow installed a camera in a remote part of Quebec, and the resulting three hours of edited footage became *La Région Centrale*, a film that has been hailed as a "masterpiece."[19] The camera was capable of spinning completely around on its axis, and so the work promised, it seemed, to capture the panoramic immersion of a person being there, then, embedded in a particular landscape space. In fact, this custom-made television camera would be capable of performing a repertoire of more extreme and more disorienting movements. Snow's artwork was an extraordinary perceptual experiment that seemed to test how the embodied experience of nature inevitably comes up against pictorial, ideological, and technological constraints.

It could be said that in *La Région Centrale* Snow set out to investigate a dialectical tension between a rocky geographic site somewhere north of Sept-Îles and a camera that could move in "delirious" ways (to adopt Robert Smithson's characterization of Snow's project).[20] To begin with, the camera moves slowly and close to the ground, so that the viewer becomes intimately acquainted with the morphology of specific rocks and other fragments of scenery. But this initial grounding reality effect is soon replaced by one of disorientation as the camera movements shift and accelerate and the component parts of this natural site take on fantastical identities. An early sequence in the film is reminiscent of A.Y. Jackson's painting *Night, Pine Island* (1924), but this kind of conventionally beautiful framing is the exception. As the camera changes speed and direction, the rocks loom like Stonehenge monoliths, until the camera turns the world completely upside down, dark above and light below, so that the rocks jut down like so many jagged teeth. At other times, when the camera runs parallel to the horizon line, the rocky terrain becomes a skyline of surrealist buildings, like something out of Max Ernst. But when the camera starts turning faster and faster, there is an effect of travelling through space, and then the landscape image shatters into honeycombs and butterflies and ultimately melts into streaks of multicoloured energy. The last several sentences of this text are my own reading of Snow's film, and so the particular references to artists, objects, and effects are admittedly arbitrary and subjective. But if one person's description of what she or he sees when watching a screening of *La Région Centrale* is associative and metaphoric, I want to argue that the response to this hypnotic film could not be otherwise.

When Snow said he wanted to make a landscape film equivalent to "Cézanne, Poussin, Corot, Monet ... and the Group of Seven," he was claiming his kinship with the great landscape painters of the past. He apparently meant that he planned to aestheticize this remote piece of land, transforming his experience of it into something that was semantically and art-historically identifiable as landscape art. But then, paradoxically, *La Région Centrale* seems to deliberately challenge many of the precepts of landscape painting, as if the artist were determined to drain this art form of its capacity to make the natural world intelligible and beautiful. Still, Snow's announcement that he would match in film the accomplishments of the Group of Seven is fairly reasonable, in the sense that his subject matter (vaguely defined as the northern wilderness) was nominally theirs.[21] On the other hand,

Michael Snow, still from
*La Région Centrale*

for Snow to compare himself to artists such as Nicolas Poussin and Camille Corot seems ludicrous at first. These European artists did paint wilderness in some guise or another, however, and it is therefore interesting to consider such instances. In Poussin's pendant paintings, *Landscape with St. Matthew* and *Landscape with St. John on Patmos* (c. 1640), for instance, a single human figure is pictured in a vast depopulated and ruined landscape, at least provisionally cut off from humankind. Corot's remarkable *Hagar in the Wilderness* (1835) shows the biblical heroine stranded in a barren wasteland. These paintings illustrate religious stories, wherein it could be said that the primary question being posed is whether or not the wilderness in question is a godforsaken place; we can disregard the religious connotations, however, and still appreciate that these artists strove to inscribe human consciousness and human doubt onto the natural world.[22] In contemporary secular terms, the presence or absence of meaning in the nonhuman world remains an important epistemological and ethical issue. These historical examples offer a striking contrast to Snow's project, which, unlike its predecessors, does not introduce those familiar narratives, signifiers, and pictorial constructs that serve to anchor the representation of nature. Indeed, Snow's purported ambition as a master of structural film was to de-narrativize the cinematic experience.[23]

Returning to Snow's list of illustrious predecessors, we get to Claude Monet, and if he and later generations of modern landscape artists seem qualitatively different from the earlier artists just mentioned, it is worth remembering that Impressionist artists often took as their subject matter the *terrains vagues* of Paris (the modern, urban equivalent to wilderness) and transformed these despised sites into experiments in sensation and perception.[24] There are neither saints nor hamadryads nor Native people wandering through Snow's representation, but the

Michael Snow, still from
*La Région Centrale*

problem of representing the non-human natural world remains, and "wilderness" can be understood to some extent as the outer limit of the known, symbolizable environment. For aside from the iconographic considerations (ie., whether the picture is all green space, or whether there is an allegorical figure inhabiting the scene, or whether there is some small fragment of road, house, or other cultural artifact to at least suggest human occupation), the landscape image acquires meaning, emotional depth, and aesthetic value through the artist's ability to frame the image in ways that resonate with previously viewed landscapes.

In *La Région Centrale* the camera was set up and programmed, and then Snow exited the scene. The artist's deliberate withdrawal served to "de-authorize" the project, in Thierry de Duve's words, because "what the film conveys is not his experience. It is nobody's experience until it exists as projected light on a screen."[25] Alain Fleischer describes Snow's camera as a "bachelor cinemachine ... in the form of a disembodied, exorbited automated eye."[26] It is not the photographic or cinematic machine in itself that is responsible, of course, for this forfeiture of artistic presence. After all, there is a massive corpus of machine-made landscape photography that achieves the familiarly picturesque or poetic effects perfected by previous generations of artists armed only with pencils, burins, and brushes. What is most striking about *La Région Centrale*, I want to emphasize, is precisely that this dehumanized, machinic, inexpressive process *fails* to result in a landscape image that is entirely drained of narrative, affect, and memory. And Snow knew it would fail in this respect, that it had to fail in some sense as a structural film and as a bachelor machine, if it was going to measure up to the great landscape art of the past.[27]

And then there is an extraterrestrial quality to *La Région Centrale*. At a certain point in the film, the movement of the

camera is so fast and "delirious" that the landscape really becomes dematerialized, and it is as if the viewer is located inside a spaceship with meteors looming up suddenly into his or her field of vision. (This special-effect point of view is familiar from science fiction movies.) Snow himself pointed to these extraterrestrial connotations in describing his film: "this will feel like a record of the last wilderness on earth, a film to be taken into outer space as a kind of souvenir of what nature was. I want to convey a feeling of absolute aloneness, a kind of Goodbye to Earth which I believe we are living through."[28] The implications for landscape art are striking: the late twentieth-century artist's imagination must expand far beyond the immediate ground-level site. And the impetus for this new landscape approach is both perceptual and ecological, in the sense that technology has changed the way we view the earth, while the appearance of "wildness" cannot be taken for granted.

It is interesting that the same year that Snow was making his "goodbye to earth" film, *National Geographic* magazine devoted an issue to a newly perceived phenomenon: "our ecological crisis."[29] The editors attempted to arouse a kind of collective, planetary thinking about environmental problems with a cover photograph of an oil-drenched bird, but they emphasized that the catalyst for this new global awareness came from another photograph – the picture of planet Earth as seen from space, which had recently become available to all of humanity via the eyes and cameras of American astronauts. But if this point of view was in the process of being naturalized, especially for American viewers, it is worth considering Marshall McLuhan's comments about "counter-environments," which he conceived of as cultural forms that could (and should) be invented in response to the largely invisible techno-ideological environments that people live in and move through on a daily basis. McLuhan speculated about a new kind

of artwork/counter-environment that might come about as space travel and prosthetic viewing devices introduced a radically new spatial consciousness about the planet. In 1967 he wrote, "If the planet itself has thus become the content of a new space created by its satellites, and its electronic extensions, if the planet has become the content and not the environment, then we can confidently expect to see the next few decades devoted to turning the planet into an art form."[30] And so we can regard *La Région Centrale* as an attempt to aesthetically "counter" (in McLuhan's terms) the new spatially expanded technological environment by introducing radical dislocation into the representation of a specific geographic site and by positing another, less earthbound gaze to interrupt the ground-level embeddedness of the camera itself.

If this new space-consciousness was somehow integral to the conceptually oriented transformation of the landscape genre, we can regard as something more than a joke Wieland's comment in 1971 that even if "I were living on the moon … all I would be doing would be about Canada."[31] The possibility of an extra-planetary perspective was also taken up by Wieland's *Man Has Reached Out and Touched the Tranquil Moon* (1970); the work spelled out this phrase, with individual fabric letters packaged in clear plastic, while discreetly flopping at the bottom of the wall hanging was a small Canadian flag, also bagged.[32] Shown alongside explicitly Canadian landscapes in the National Gallery exhibition, this work disturbed the understanding of what it means to situate oneself within a landscape; now the moon was closer to home, in close proximity to the body, although the "inappropriate" Canadian flag is a reminder that it was not "Man" in any universal sense but rather Homo Americanus who had laid claim to that silvery entity. Once again, Smithson's turns of phrase are relevant: he sarcastically referred to the moon shot as a "very expensive non-site," the aftermath of which was a "strange demoralisation."[33] In contrast

to the bathos of such grandiose and imperialistic excursions, the artworks under discussion suggest a heightened awareness of everyday spatiality; perhaps space travel ultimately served as a reminder that the planet Earth was itself still so unknown, so uncanny, so full of aesthetic and utopian potential. These are not nostalgic images by any means, however, and indeed, it is the use of up-to-date materials and technologies which allows these works to function as "counter-environments." As Richard Cavell comments, "McLuhan does not posit a way outside the environment except through technology itself."[34] Wieland's use of shiny new plastic sheathing for *Man Has Reached Out* is telling here, while it was photography that allowed the low-tech textures and stitched materials of her other artworks to be incorporated into a high-tech visual regime. Snow's work, meanwhile, would often highlight processes of technological remediation,[35] thereby introducing a new kind of tension between still and moving images or between painted and photographed images. Even while *La Région Centrale* zeroed in and framed a few details of a specific site, therefore, the artwork ends up forging links to much larger circuits of visuality and representation.

Michael Snow's *Plus Tard* consists of a series of twenty-five large colour photographs of the Group of Seven section in the old National Gallery building, re-presented from the point of view of someone positioned in the middle of the room, turning around. He allowed the photographic process in *Plus Tard* to range from clarity to blurriness, meaning that some paintings can be identified while others have become barely recognizable abstract compositions. The effect of the artwork is to defamiliarize the experience of viewing this well-known collection. With this project Snow came close to sharing Joyce Wieland's critical perspective on the legacy of landscape painting in Canada; she had at this juncture finally finished her revisionist Thomson film, while she too, with her 1971 exhibition, had undertaken a site-specific project at the National Gallery of Canada. While the emphasis in their work is different, neither artist regarded the national archive of landscape art as aesthetically inert or valuable only as comforting and nation-affirming images. Instead, the paintings remain fascinating in part because as quasi-monuments they can become exemplary reflective surfaces, allowing contemporary questions about neocolonialism, ecology, and nationhood to be rethought or allowing aspects of technology, embodiment, and perception to be explored. Somewhere in the middle of the *Plus Tard* sequence, for example, the shadow of the artist looms quite prominently, and Snow's body-double alerts us to the usual absence of the human figure within the Group of Seven corpus. *Plus Tard* insists upon the embodiment of vision in relation to landscape art, through the play of shadows and through the work's panoramic effect.

If the great thing about the paintings of Thomson, Jackson, Harris, and their colleagues was ostensibly how they managed to capture an individual response to the natural world at a specific time and place, Snow's artwork added to this previous history of subjective inscription the immediacy of his own experience, albeit photographing inside the National Gallery rather than painting outdoors. With *Plus Tard*, artist, medium, and location are now doubled: early twentieth-century artist meets late twentieth-century artist; painting meets photography; outdoor natural environment comes up against indoor cultural space. The remote location chosen by Snow for *La Région Centrale* had quite possibly never before been drawn, painted, or photographed and so was desirable to the artist precisely because it was "uncooked," not already encoded and infused with cultural meanings. With *Plus Tard*, on the other hand, there is no doubt that "what we see has already been formed by a gaze prior to our act of seeing."[36]

And if these already-seen landscapes have acquired the status of national monuments, Snow introduced temporality, movement, and immersion onto the landscape, where previously there was institutional stasis, a sense of nature as timeless, and a singular point of view.

The panorama as a pictorial device was evoked by *La Région Centrale*, but it is even more relevant to *Plus Tard*. And it is interesting that, historically, panoramas had set out to surpass landscape art's habitual kind of illusionism based on single-point perspective.[37] Most visitors to the National Gallery of Canada's Group of Seven rooms proceed to gaze at one small rectangle of scenery after another in the normative, proscribed manner, but Snow used the technological means at his disposal to create a much more spectacular, immersive visual experience. Still images start to move; the viewer in turn is impelled to pivot; and somehow, in spite of the work's layers of artifice and reflexivity, one can momentarily have the realistic impression of being bodily situated inside a landscape.

Snow's *Plus Tard*, like Wieland's multi-faceted *True Patriot Love* project, staked out a critical position vis-à-vis Canada's legacy of landscape painting, but these artworks should also be regarded as a sort of homage. In Snow's photographs the aura of the original artwork might be eroded through the process of reproduction, but this erosion need not be lamented, since contingent, ancillary aesthetic effects spring up, compensating for this loss. The integrity of a Lawren Harris painting is compromised, in other words, but then again perhaps the movement and blur in *Plus Tard* enhance the painter's original intent, making the snowy paintings snowier, the autumnal ones blowier, by adding new modes of spatial illusion and atmospheric effect. This aspect, too, of Snow's *Plus Tard* is reminiscent of Wieland's approach in the *True Patriot Love* book-work, in that both artists used photography's (usually unwanted) side effects to expand the imaginative purview of landscape aesthetics.

Looking at the work of these artists side by side does reveal the range of aesthetic preoccupations they shared. Michael Snow's *La Région Centrale* and *Plus Tard* are indeed more "passionate" (in Wieland's terms), more engaged with the affective and subjective aspects of landscape art, and more interested in questions of nationalism than is usually acknowledged. And Joyce Wieland's projects, including the *True Patriot Love* exhibition and related films, while clearly focusing on the politics of nation, ecology, and gender, maintain a rigorous engagement with the perceptual, pictorial, and material constituents of landscape art. Adding layers of mediation and narrative to the representation of natural sites and phenomena, these artists successfully laid the foundation for a new generation of Canadian landscape art.

# Joyce Wieland

*TRUE PATRIOT LOVE, 1971*

cinema...while she plays...we cut to Tom painting West Wind, trying to hold his canvas in the wind and such...and to him showing her his work...in other words a flashback. We cut to a close up of the front of her dress...the bosom with the locket... we cut to Tom and gain access to his fantasy of embracing her at the piano - grabbing her locket - opening it to find his picture in it and one of the Prime Minister - he breaks off the side with the Prime Minister's photo and throws it on floor...Beside Tom where he is seated is a picture of a semi-nude woman on the wall...other things happen in this scene - a flash of Turner playing Tennis - Turner driving in the rain. (very Marmeau here).

Scene Nine

...ene sets itself apart from

---

Séquence neuf

Bruit de raquettes - whomp! Cette scène est à part de toutes les autres, comme celle du P.M.

Paysage d'hiver glacé...le chalet de la famille Turner dans les bois...Tom apparait en raquettes; marchant dans le paysage vers l...

---

...nd du plancher vers le piano nous entendons (au allées de foule qui parle) les sons du piano. Entaile joue le Vent d'ouest de Debussy - faisant ainsi savoir à Tom qu'enfin elle le comprend lui et ses tableaux et qu'elle voudrait qu'il la presse...le titre de son dernier et plus célèbre est Vent d'ouest. Cette scène peut avoir une grande force sentimentalité...elle doit avoir plusieurs niveaux...dont l'un est la commercial...pendant qu'elle joue...nous coupons au tableau mais doit avoir plusieurs niveaux...elle fait partie intégrante du cinéma de Tom, Vent d'ouest, en essayant de tenir ce tableau au vent et ainsi de suite...puis à Tom lui montrant ses oeuvres...en d'autres mots un type de sa robe...son buste et le locket...nous gros plan du devant de sa robe...son buste et le locket...nous recoupons à Tom et nous accédons à son fantasme, où il l'embrasse au piano - prenant son locket, l'ouvrant et y trouvant son portrait à lui et celui du Premier Ministre et se jetant sur le plancher... A côté de Tom, là où il est assis, se trouve au mur un tableau d'une femme à demi-nue...d'autres choses se produisent dans cette scène - un flash de Turner jouant au Tennis - Turner conduisant sous la pluie. (Très Marmeau ici.)

Christos Dikeakos, *xa'ywá'esks*
*"separated points."* From *Boite Valise,*
*Sites and Place Names, Vancouver,*
1991-94. Valise of cherry wood
containing 43 C-print panorama
photographs. Museum of Contemporary Canadian Art

sole

crab

xaʹ ywáʔesk̲s

# Space at the Margins

**JODY BERLAND** ## Colonial Spatiality and Critical Theory after Innis

ducks

## separated points

[...] **THE CONCEPT OF "EQUALIZATION** of spaces" has an easy set of visual referents: the golden arches, Hollywood, Sony, automated bank machines, cars, computers. This aspect of globalization depends on the ability to free the profitable capacities of a particular location from its physical or geographic specificities. Differentiation, on the other hand, involves learning new ways to derive profit from spatial or geographical difference. Here too images spring readily to mind: lakes and snowy mountains, animals and trees, beaches or monuments (so long as they appear ancient and unchanged, like mountains) in various parts of the world. As we are so often reminded, the wealth of nations now depends less on sovereignty over natural resources (except in tourist zones), and more on access to information and information technologies. In traditional modernization theory, regional disparities are potentially abolished by this change. All countries can have microchips, if they manage development properly, and so any country can join the first or at least the second world.

The flawed logic here is presupposing that it is the originary presence of natural resources (fish, lumber, ivory, uranium, beaches) that produced a marginal national economy dependent upon them to the advantage of other interests and the exclusion of other economic activities. If geography and nature account for the marginal economic status of dependent countries, then technological development – the transcendence of nature – will, it is thought, transform that status. Canadian experience makes this claim dubious at best. We need to demolish both propositions in this hypothesis – not only because Harold Innis has (wrongly, I think) been accused of being a geographical determinist, but more importantly because this demolition has implications for thinking about nature and technology in relation to marginal spaces.

Neither the discovery of natural resources, nor the presence of the colonist explorers and settlers who discovered them, were

fortuitous events in the colonies of Europe. The "age of discovery" betrayed its medieval origins by endowing far-off places with extraordinary cosmological and magical powers. When travellers reached the New World, their encounter was shaped by a readiness to find a natural paradise suffused with both abundant riches and savage wilderness.[1] By the eighteenth century, when Jesuits and entrepreneurs were travelling up the St Lawrence and setting out to cross the Canadian Shield, the powerful, magical qualities projected onto the inhabitants of these newly discovered worlds had been taken over by the travellers themselves. Eighteenth-century travellers found themselves candidates for immortality as "'second creators' of distant worlds which for them were newly established and newly regarded not only with fear and fantasy, but also with the confident superiority of men, who, now God-like as much as God-fearing, having conquered the ocean with their bravery, skills, and intelligence, believed they could conquer whatever else they encountered."[2] This association of exploration and conquest was conveniently reinforced by more worldly incentives. In 1817, frustrated with the failure of previous expeditions, the British Admiralty offered twenty thousand pounds to the discoverer of the Northwest Passage. Successive expeditions did much to popularize the vision of the Canadian North as a rich but dangerous place requiring great heroism and perspicacity to conquer.[3]

What they encountered was fish (mainly cod), fur (mainly beaver), lumber, and briefly, gold. These, as we have seen, were exported back to Europe in exchange for manufactured goods which enabled settlers (Innis uses the less romantic term, "migrants") to maintain "the cultural traits of a civilization … [with] the least possible depreciation."[4] This pattern of trade came to dominate the economic, spatial, and administrative shape of Canada as a colonial nation, or what Innis termed a "staple economy." This concept now requires our closer attention. In the same text, Innis writes:

> The economic history of Canada has been dominated by the discrepancy between the centre and the margin of western civilization. Energy has been directed toward the exploitation of staple products and the tendency has been cumulative. The raw material supplied to the mother country stimulated manufacturers of the finished product and also of the products which were in demand in the colony. Large-scale production of raw materials was encouraged by improvement of technique of production, of marketing, and of transport as well as by improvement in the manufacture of the finished product. As a consequence, energy in the colony was drawn into the production of the staple commodity both directly and indirectly … Agriculture, industry, transportation, trade, finance and governmental activities tend to become subordinate to the production of the staple for a more highly specialized manufacturing community.[5]

Innis' famous "staples theory" has engendered a long debate concerning the nature of Canadian political economy and the place of natural resources in that economy. The theory has been criticized for two types of determinism: geographical determinism, in which nature determines trade and economic patterns; and economic determinism, in which economic patterns determine politics. If staples theory is indeed a marriage of these two types of determinism, then it deserves critique as a reductionist and pessimistic view of Canada's politics, history, and potential future. Where colonial exploitation is naturalized through reference to nature ("as though every cod holds the seeds of its own commodity and labour market")[6] then Canada's landscape and resources become one with its marginal economic status.

But this is not Innis' argument. Criticizing it on this ground reifies the role of nature in order to reject Innis' more complex paradigm and nature's more partial effectivity. In passages like the following, Innis provides a more subtle analysis of the relationship between geographical, administrative, economic and political factors:

> The fur trade left a framework for the later Dominion ... Into the moulds of the commercial period, set by successive heavier and cheaper commodities, and determined by geographic factors, such as the St. Lawrence River and the Precambrian formation; by cultural considerations, such as the English and French languages; by technology, such as the canoe and the raft; by business organization, such as the Northwest Company and Liverpool timber firms; and by political institutions peculiar to France and England, were poured the rivers of iron and steel in the form of steamships and railways which hardened into modern capitalism.[7]

Nature and geography are not absent here, but they are mediated by economic, political and technological forces, like boats and trains. While there is no denying Canada's physical nature (everyone knows it's large, gorgeous and cold), this difference, this nature, like any biological trait – human gender or race for instance – exists in a social setting whose power dynamics determine its meanings and effects. It's not trees that create colonialism, but how trees are traded. Of course trees can be traded in lots of ways. Representations and myths of landscape have also contributed to the production of Canada's marginal identity. In the tree-filled, uninhabited landscapes dominating its favourite paintings and postcards, Canada appears as a wilderness whose pristine nature counterposes a civilization that is presumably elsewhere. In these representations, the economic and technological factors contributing to Canada's formation are transformed into what Rob Shields terms an "imaginary geography," through which mountains, lakes, and beavers are identified with national history, values, and sentiments.[8] Historians, writers and artists, and the tourism industry have all colluded with colonial history by contributing to the image of Canada as a wilderness, variously welcome, rich and forbidding, but always "Other," whose destiny is defined by – and limited to – its beauty, wildness and natural wealth.[9] In this mythos, economic development becomes either the sacrilegious plundering or the inevitable outcome of what nature has to offer.

In the latter view, Canada's economic development continues to be shaped by its importance as provider of natural resources. The problem arises not from patterns of economic imbalance or political subservience associated with this role, but from the anticipated limits of the natural resources themselves. Canadian policy advisors draw attention to this potential crisis in a recent discussion of the shift from resource to technology export. Their discussion helps to demolish the second flawed proposition in the modernization hypothesis: that technologies eliminate dependency. They argue that the expansion of "high technology sectors" is needed to compensate for anticipated crises in the export of natural resources, which remains Canada's major source of wealth.[10] The problem with this scenario is that Canada devotes proportionately smaller funds to research and development than any other nation in the G-7 group of allied western nations. "Assuming that Canadian industrial R&D is affected by the country's economic structure," the aforementioned study observes, "the heavy reliance on resource-based industries seems to be the major reason for Canadian industry's apparent lack of propensity to perform R&D."[11]

In other words, Canada's already-produced position of

relative dependency – its "natural" role as a de-industrialized marginal space – shapes its move into high technology in such a way that Canada's role as a marginal economy is perpetuated. Technological investment and innovation cannot in themselves transform Canada from a marginal to a powerful first world economy: indeed they reproduce the very relationship they claim to transcend. While government publicity now images Canada as a technologically sophisticated nation, celebrating its achievements in telecommunications and aerospace optical technologies – most recently, with a billboard campaign featuring photographs of Canadarm, Canada's contribution to NASA space exploration, to mark the anniversary of Canada's flag – such achievement does little to alter Canada's de-industrialized branch-plant economy or its submission to the geopolitics of transnational capital.[12] The country may be technically and economically "advanced" in its use of communication technologies, and its means of production and consumption may partake of late twentieth-century technicality. Nonetheless, it remains a strategically underdeveloped economy in relation to the overall structure of global industry. Like less-developed nations it is unable to consume what it produces, or produce what it consumes.

The nagging question that surrounds this representation is how well we understand its relationship to the territoriality known as Canada. Like our policy advisers, we are predisposed to read these portraits of technological innovation and economic growth in relation to a homogeneous understanding of the territorial/economic space of the nation state. Yet that space is being fractured and fissured by worldwide, increasingly interdependent changes in finance, communication systems, industrial growth. Is it still appropriate or useful to represent a national entity as an object of natural history? Given new patterns of "postindustrial" marginalisation, is marginality still a valid spatial concept? [...]

* * * * * * *
Reprinted from Jody Berland, "Space at the Margins: Colonial Spatiality and Critical Theory after Innis," *Topia*, no. 1 (spring 1997): 70–4, 80–1.

# Rodney Graham

*ILLUMINATED RAVINE, 1979*

# Post-Centennial Histo

# Chapter 3

ries

# Post-Centennial Histo

THE CENTENNIAL OF 1967 and the patriotic enthusiasm it
engendered across Canada coincided with a watershed in the
kind of research undertaken on historical Canadian art. Until
the late 1960s, serious scholarship on the subject was close to
non-existent. Dennis Reid remarked in 1970 that much of what
was published on the Group of Seven amounted to little more
than propaganda, often written by Group members themselves.
J. Russell Harper's *Painting in Canada: A History* (1966), a book
commissioned by the Canada Council for the Arts and the Univer-
sity of Toronto Press for the national centenary, announced a
major change in direction. More than 400 pages in length, and
containing a comparable number of illustrations, *Painting in
Canada* set a standard for historical comprehensiveness. Even
though some of its arguments and supporting facts were chal-
lenged by subsequent histories, including the post-Centennial
histories of art represented in this chapter, the book's signifi-
cance is not in doubt.

Two book-length investigations on the Group of Seven were
released soon after the Centennial. In 1970 both Dennis Reid and
Peter Mellen produced volumes called *The Group of Seven*; they
were the first full histories of the movement to be published. In the
book-cum-catalogue he wrote for the National Gallery of Canada,
Reid self-reflexively observes that members of the Group and the
gallery worked hand in hand from the early twentieth century
on to promote a national modern art. (By implication, of course,
the gallery was continuing to hold up its part of the bargain by

ries

celebrating the fiftieth anniversary of the Group's founding with an exhibition.) The ambitions and successes of the one intersected with the ambitions and successes of the other. Caught in the middle of this "institutional power-play," Ann Davis writes, was the Royal Canadian Academy. The National Gallery owed its existence in part to the RCA, but this connection did not prevent the gallery from dominating the other body when it came to deciding on which contemporary artists should be exhibited in Canada and internationally. In the international sphere, the gallery was highly successful in promoting the wilderness aesthetic of the Group in England. But its attempt to promote the Group, Leslie Dawn demonstrates in a revealing new essay, failed in France where the work was regarded as aesthetically *retardataire*.

Barry Lord's 1974 Marxist-Leninist-Maoist history of painting in Canada, subtitled *Toward a People's Art*, dispenses with the usual politesse of art-historical exchange. A history informed by issues of class and colonialism, it is punctuated with strong conclusions and opinions. Lord observes the lack of convergence between the Winnipeg General Strike of May 1919, for example, "the high point of working class struggle," and an exhibition of work by future members of the Group held the same month, an exhibition heralding the attainment of a new national landscape art. He also attempts to place Canadian art within an international context, something generally ignored in other histories of the time. "Landscape historically is a bourgeois art form," Lord writes, with regard to matters of patronage. "To achieve a national art of the Canadian landscape, therefore, the support of a *national bourgeoisie* was needed."

The concluding text in the section is a sociological history of Group of Seven patronage. In the article, Douglas Cole refuses to take the idea of "wilderness" for granted, as the Group and its supporters did, by demonstrating that the formation of a wilderness ethos in Canada was spurred primarily by rapid urbanization, especially in Toronto. Paterson Ewen also refused to take received notions of wilderness for granted. His roughly gouged plywood pieces from the early 1970s, which he called "phenomenascapes," broke with traditional categories of landscape to produce an intensely physical body of work.

Franklin Carmichael, *Autumn Hillside*, 1920, oil on canvas, Art Gallery of Ontario

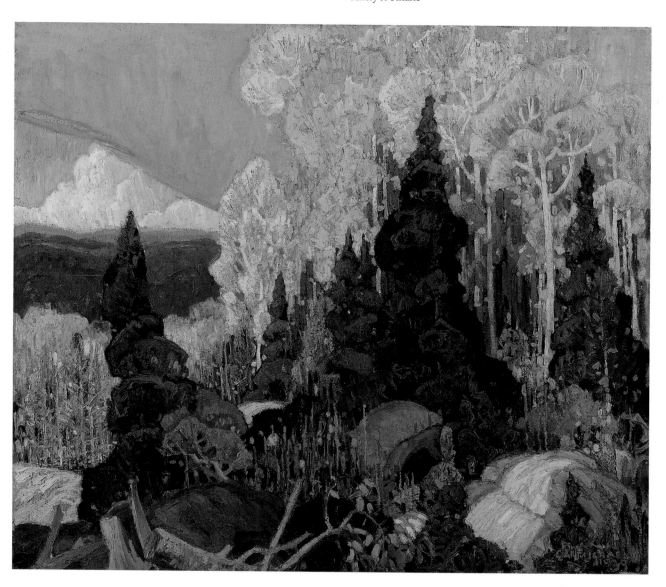

# Introduction to
# *The Group of Seven*

**DENNIS REID**

**THE BEGINNINGS OF THE GROUP** of Seven can be traced back to November 1911 and the first private showing of the sketches of J.E.H. MacDonald, which brought him to the attention of Lawren Harris. The end is marked by the event of their final exhibition in December 1931 and the announcement then of the intention of founding the Canadian Group of Painters. So at the very most, their active period covers a span of twenty years. Today, fifty years after the first Group of Seven exhibition of May 1920, they still remain the most famous, and to many people the only, "movement" in the history of Canadian art. In terms of considered critical opinion, as far as that can be said to have existed, the measure of their importance has fluctuated. However, in the eyes of the public at large, they have steadily ascended until now they occupy a position in the Canadian cultural pantheon shared only with a few hockey stars and a handful of beloved politicians.

The short history of the Group of Seven which follows leaves off in 1931. [Later] I describe the final "popular" success of these painters. But it must be stressed that that success was still only among those who would bother to read the account of an art controversy, or a news item that so-and-so had won a gold medal for his painting. Their popularity is now much more widespread, and for the vast majority of Canadians, Picasso and the Group of Seven are probably the only modern artists remembered from school art classes or general reading. The distortion by which the members of the Group became the only important Canadian artists occurred mainly during the years after the actual dissolution of the Group of Seven. There are a number of reasons for this incredible staying power.

There had always been a populist streak in the ideas and intentions of the Group. Arthur Lismer, in particular, the former secretary of a working men's sketching club while a student in Sheffield, probably expended more of his energies on art education throughout his life than on painting. As vice-principal of the Ontario College of Art from 1919 to 1927, and as the principal of the Ontario Department of Education's Teachers' Training Courses in Art held every summer in Toronto, he exercised a wide influence. His ideas achieved official support as early as 1926 when he wrote *A Short History of Painting with a Note on Canadian Art*,[1] which is described on the cover as having been "compiled for the use of teachers of art history & art appreciation in the schools and for art students." In 1927 he left the Ontario College of Art to become Educational Supervisor at the Art Gallery of Toronto, but maintained his position as principal of the summer Teachers' Training Courses. In 1930 his *Canadian Picture Study* was published by the Art Gallery for use in schools.[2] The *Short History* had ended with a general discussion of the aims and achievements of Canadian art. They were of course those of the Group of Seven. The *Canadian Picture Study* pamphlet carried the propaganda further. Its thumb-nail sketch of the course of Canadian art ended with what Lismer called the "distinctively Canadian" productions of MacDonald, A.Y. Jackson and Harris. This new official history of Canadian art received very wide circulation throughout the Ontario school systems, and was republished in 1940 with no significant alteration in the opinion that Canadian art culminated in the work of the Group of Seven.

The stance of the Group, regardless of the nature of their production, was attractive to the public. The modern artist is looked upon with suspicion by the man in the street, but the Group's approach to painting stressed rugged virility and hard work, thus appealing to the Protestant ethic. Housser writes of this "new type of artist; one who divests himself of the velvet coat and flowing tie of his caste, puts on the outfit of the bushwhacker and prospector; closes with his environment; paddles, portages and makes camp, sleeps in the out-of-doors under the

stars; climbs mountains with his sketch box on his back. Possibly never before," he adds, "have such physical demands been made upon the artist ..."[3] Of all the painters, Jackson maintained most firmly the stance described by Housser. "I am not going to pretend it is necessary for artists to be explorers," he wrote in 1943, "but it would create a lot more respect for the craft if the artists brought back hard-won impressions of places where the going was tough."[4] Jackson maintained a vigorous programme of field-sketching well into the sixties, criss-crossing the country in search of the "land," and dropping in on ladies' groups, schools and reporters on the way.

Lismer's activities remained more specifically pedagogical. But from 1932 when the National Gallery sent him into the West on an extended lecture tour, he covered almost as much ground as Jackson in promoting an indigenous Canadian art movement, and from the thirties until well into the fifties local newspapers across the nation plotted his energetic travels as thoroughly as Jackson's.

The Group also had a real following in the art community. The Canadian Group of Painters was made up largely of young artists who had begun their careers during the heyday of the Seven from 1925 to 1930. The pioneers' struggle with the forces of tradition and their final triumph for all Canadian art gave hope and direction to these young painters. It is also evident that the main purpose of the Canadian Group of Painters was to sustain and promulgate these hard-won values. The creative years of the Canadian Group came at a difficult time for art, and very few of its members achieved anything approaching fame. The art scene in Canada has never been healthy in terms of public support, and even today very few painters are able to live by their art. But during the thirties and forties the nation went through a depression and a world war, and it is little wonder that our view of the art of this period is of a deep abyss high over which the Group of Seven float to land firmly in the fifties.

This almost mythical status of the Group of Seven notwithstanding, anyone with a serious interest in these painters would be hard pressed to find much detailed and useful information on their activities. There is no full history of the Group, and the few monographs and exhibition catalogues on individual members are mostly out of print. We understand almost nothing about one of our most constant cultural totems. This exhibition and catalogue are presented to help fill this obvious need, and have been conceived as tools towards an understanding of the Group of Seven as a movement at a certain time and place. We must understand what happened during those twenty years from 1911 to 1931 which established the Group of Seven as the exclusive proponents of "advanced" art in Canada, and culminated in what almost amounted to their canonization in the Canadian Group of Painters.

The phenomenon which is known as the Group of Seven has very little to do with the nature of the artists' paintings, and a great deal to do with their stance and their struggle to gain acceptance of that stance. They seldom expressed interest in artistic theories but constantly trumpeted the ideal of a Canadian art for Canadians, underlying which was a profound belief in the necessity of engaging a large segment of the population in an active relationship with a living art of their own making.

This belief the Group of Seven held in common with Eric Brown, then Director of the National Gallery of Canada. Brown, a cultivated Englishman, found himself late in 1910 responsible for a spotty collection of paintings located in a provincial northern city which, through some mystery of political compromise, was the capital of one of the vastest countries in the world. He made remarkable strides towards the improvement of that collection,

but saw the Gallery's national role as also entailing a responsibility for the artistic awakening of the whole country. He believed that this awakening could perhaps be best effected through the involvement of as many Canadians as possible with the contentious edge of an aggressive, indigenous modern art. The Gallery and the Group often worked closely together to pursue these aims, and to a large degree the struggles of the Group became the struggles of the Gallery. One of the main concerns of this catalogue is to trace and clearly document the course of these struggles, establishing in the process the very important, perhaps essential, role of the National Gallery in the final acceptance of the aims of the Group of Seven.

The works in the exhibition are arranged in chronological order in a series of what I have thought of as "situations." Each situation isolates an event or limited number of events, and allows us to examine the works arising from it. There is a short text for each, stating as factually as possible what happened and when it happened, and in some cases suggesting why. All of these situations together give an almost complete record of the painting activities of the Group up until 1931. I have selected the works in the exhibition to define as strictly as possible the essential nature of the Group of Seven. As a consequence, Franklin Carmichael and A.J. Casson are sparingly represented, and with works that are perhaps not their best from the Group period. Casson in particular is shown only as a disciple, and his more distinctive canvases of the twenties have been consciously excluded the closer to define the essential aims of the Group's artistic production. Edwin Holgate is, for the same reasons, represented by only one canvas, and LeMoine FitzGerald, who never exhibited as a member of the Group of Seven, is not represented at all. On the other hand, Thomson's inclusion in the exhibition needs no justification.

Pamphlet for presentation of the 1970 Group of Seven exhibition at the Art Gallery of Ontario

In the text, the chronological sequence is also organized on a broader level, the history of the Group being divided into seven periods. These allow for an examination of those non-painting activities which nevertheless had a strong bearing on their development into the "National School," and it will be seen that the range of their involvement in these art politics generally paralleled the geographical range of their involvement in the topography of the Canadian wilderness.

The first of these seven periods covers the time prior to 1910 and documents the years in which MacDonald, Varley, Lismer, Jackson, Harris and Thomson pursued their formal art studies.

The second period, 1910–1913, is perhaps the most interesting for the historian. These years saw the coming together of the artists from Sheffield, Orillia, Montreal and Toronto. MacDonald's vision of an indigenous Canadian art and Harris's phenomenal energy and aggressive optimism acted as the attracting forces. The "Canadian movement" was clearly established by 1913 with the stated intention of exploring the spiritual resources of Canada's North. The "group" by then consisted of a recognizable number of adherents, it had a future home in the projected Studio Building of Canadian Art, and it had a planned programme of sketching which had already led some of the painters to Georgian Bay, and in isolated cases as far north as Algonquin Park and as far east as the Laurentians. Their intention to go beyond the existing art society and Academy structure in the pursuit of a broader audience had been formulated in the first *Exhibition of Little Pictures by Canadian Artists*. By the end of 1913 they had also first tasted the criticism which their aggressive programme was to lead them to expect at every new departure from accepted practice, and they entered the third period of their history, 1914, as The Hot Mush School.

The year 1914 saw a firm commitment to the particular topographical dependency of the Group, and in their paintings, the first real fruits of this faith in the inspirational qualities of the Canadian North. Their belief in the group effort also reached a peak that year, and if the war had not intervened, the Group of Seven, undoubtedly under another name (probably the Algonquin School), would have made its first appearance.

The war was disruptive, of course, and although the years 1915–1918 saw MacDonald's development into full maturity, and his continuing battle in the public forum for the aims of the Studio Building group, those war years nevertheless mark the lowest point in the spirit of the painters. Thomson's tragic drowning at the moment of his full blossoming as an artist cast them all into despondency and amplified the tragedies of the war.

But positive forces had also been at work during these years, and with the support of Sir Edmund Walker, Trustee of the National Gallery and President of the Art Gallery of Toronto, of Dr. James MacCallum, constant supporter of the Studio Building group and patron of Thomson, and of a small group of sympathizers in the Arts & Letters Club, the "Canadian movement" progressed from the enthusiasm of war-time victory towards an immediate reassertion of its convictions. The artists' intention to paint Canada in all her sublime glory was reaffirmed in the first box-car trip to Algoma in the fall of 1918, and publicly announced in the exhibition of sketches from that trip held at the Art Gallery of Toronto in April 1919. By the early fall of 1919 all of the artists had returned to Toronto, and in May 1920 the Group of Seven held its first exhibition.

The period 1921–1924 saw a constant and concerted effort on the part of the Group, the National Gallery and the Group's other supporters, to gain acceptance of its view of Canada as a suitable, indeed the essential, subject for the progressive development of an advanced Canadian plastic idiom. This concern found

parallels in political, literary and philosophical thought of the period, and the Group was given a platform and additional support in the pages of *Canadian Bookman*, *The Canadian Forum* and *The Canadian Theosophist*. But public interest verged on apathy, and in the case of Hector Charlesworth of *Saturday Night* magazine took the form of outright hostility, and in 1923 and again in 1924 the Group did not exhibit in Toronto. Charlesworth's hostility and the National Gallery's continuing support combined in the end to push the Group of Seven into the limelight after the success of the Group's Canadian brand of modernism at the British Empire Exhibition at Wembley in 1924.

The final period of the history of the Group, 1925-1931, grew directly from this success in the face of Academic disapproval. The Wembley exhibition had precipitated a confrontation between the National Gallery and the Royal Canadian Academy, which continued throughout the period. The Group of Seven, although to some degree the unwitting chess-men in this contest, were the final victors in the public forum, and by the end of the decade were the acknowledged "National School." Their intention to assume responsibility for the creative interpretation of the whole country had been gradually established in an ever widening programme of sketching trips which by 1930 had carried them to the three oceans bounding Canada, and over much of the land between.

This national concern was manifest in the statement in December 1931 of their intention to found the Canadian Group of Painters. The first exhibition of the Canadian Group of Painters in November 1933 firmly established the "National School" on truly national lines, with the stated intention of maintaining within its efforts those values of free expression in the pursuit of a Canadian idiom put forth by the Group of Seven.

The Group of Seven were not professedly involved in bringing "modern" art to Canada. They saw their role as the more fundamental, and at the same time more general, one of presenting the possibility of a profound aesthetic involvement to a large number of people. They believed that the Academy and the art societies, with their basically elitist, European-oriented view of the painter's profession, were doing little or nothing to foster a true and lasting cultural awareness in Canadian society. What was needed, they felt, was a direct and unaffected mode of painting derived from an experience of the Canadian land that all Canadians, if they would only look about themselves, would have to acknowledge as being true and worthwhile. All art, however, is to a large degree about art, and draws most heavily on artistic modes of awareness. The particular stylistic development of the Group consequently has some interest beyond their stated concern to depict Canada "as she is."

The intricacies of their stylistic development as individuals and as a group are poorly understood, and it is hoped that this exhibition will present opportunities to remedy this. Some general tendencies can, however, be blocked in before we view the assembled works.

The Group's art was a reaction against the atmospheric, moody type of painting perhaps best exemplified by those nineteenth-century Dutch paintings that were so popular in Montreal, and to a lesser degree in Toronto. Jackson constantly railed against such art, not only because it was outmoded, but also because it was foreign and had nothing to do with the Canadian experience. The essentially Victorian approach to painting still current in Canadian art exhibitions of the period depended likewise upon pastoral moodiness or atmospheric "sensitivity" for its appeal. The members of the Group generally saw this as also being foreign to the true experience of the Canadian landscape, which, to them, was direct in its impact and almost overwhelming in its suggestion of immense grandeur and power.

All of the members of the Group except Harris had a firm training in the business of commercial art, and this undoubtedly led them to strive for qualities of eye-catching design and immediacy of impact. Mood and atmosphere, on the other hand, were less effective with the methods of commercial reproduction then employed. Harris, Jackson, Lismer, Varley and Carmichael also received a European fine arts training. Second generation Impressionism was then the ubiquitous "advanced" style of the European academies, and so they would all have been thoroughly schooled in the merits of plein air sketching, which stressed the immediacy of colour and light effects, and the necessity of quickly comprehending and capturing the essence of a scene. Returning – or, with Lismer and Varley, first arriving – with eyes conditioned to the European climate and scale, they must have found Canada absolutely unique, and its largely untouched North unbelievably clear and vast.

The Scandinavian art exhibition seen at Buffalo in January 1913 gave Harris and MacDonald an idea of the possibilities available in the northern theme, and encouraged them to go beyond a literal comprehension and towards a symbolic treatment of the order and grandeur of the North. In some of the first works produced after this exhibition, a decorative concern for coherent masses, vast space and enlivening texture is evident. A symbolic concern, in the placement of figures – as in MacDonald's fine *Weather, Georgian Bay* – or the elements of nature itself – as in Jackson's *Terre Sauvage* – can also be seen.

This tendency towards a broad, decorative style, with a flattening of the image, a stressing of large, bold forms and movements, and an emphasis on colour (heightened by the experience of Algonquin's autumn forests in 1914) and on sharp tone contrasts, continued to develop until about 1920 and the peak of the Algoma paintings. MacDonald was in many ways

the leader during this period, and his best works can be dated to these years.

A kind of crisis then seems to have developed during the first half of the twenties. After 1921, Harris made a radical shift in his painting style towards an interest in simplified, almost sculptural masses in deep space. His north-shore paintings are so strong in their individuality and in their quality of spiritual insight that they tend to overshadow the production of the others at this time. During these years Jackson expressed some worry at finding "Christmas-card designs" constantly before his eyes in Quebec, and MacDonald went through a number of stylistic shifts, ranging from the extreme of *Little Turtle Lake* with its moody colouristic effects, to the extreme of *Sea-Shore, Nova Scotia*, with its hard-edged forms and intense clear colour. Visits to the Rockies in 1924 kindled new aspirations in four of the painters, and from 1925, an angular, almost constructivist style, first seen in Harris's *Maligne Lake*, Jackson's *Maligne Lake, Morning*, and MacDonald's *Mount Goodsir, Yoho Park*, led them successfully out of the crisis that had developed after their decorative period.

It is somewhat misleading to talk of the stylistic development of the Group as such, for, except during the crucial years prior to and immediately after the war, their production is diverse, and from about 1920, their interests are clearly personal and tend to run off in a number of directions. They continued to share one attitude, however: a dependence upon the inspirational quality of the Canadian landscape.

It is this unique relationship to the topography of their country that is perhaps the Group's most significant characteristic. They established this bond of dependence from the beginning, and persisted in stressing its significance throughout the twenties. Indeed, the individual members – except for Varley who felt the need the least, and Harris who became involved in

abstraction – continued to follow this path for the rest of their careers.

A number of theories have been advanced to explain this "landscape" fact in Canadian painting, as also in our literature and music. They usually involve the identification of the essentially individualistic, introspective nature of the Canadian psyche, and the consequent need to see oneself in a one-to-one relationship with nature in all of its magnitude. Canada's wealth and the hope of her future, the argument runs, lie in the wilderness, and in this fact can be seen part of her distinctiveness. The wilderness is pervasive in Canada, and in it – in the "frontier" (which lies to the north, rather than to the west as was the case in the United States) – there is the possibility for an individual to discover some relevance and measure in confronting that most stable of antagonists: nature.

This need for a confrontation with fundamentals in the face of the increasing arbitrariness of a complex technological society has also been a basic trait of twentieth-century art. It is in this that the Group of Seven were "modernists," and in fact, one could say that they substituted the problem of depicting the outcrops of the Canadian shield for cubist concern with pictorial and real space, and the problem of depicting autumn foliage for Fauvist concern with colour.

An art involved with the arbitrary manipulation of colour, form and texture could be justified when one could point out that, after all, it depicted Canada – if only people would look. The order of nature underlay the apparent chaos, and ultimately everyone realized that the Group of Seven were modern artists who at least still painted places and things, lakes and trees. This fact allowed them to attain a wide success in Canada at the peak of their powers as painters, but it must also be seen as their great shortcoming with respect to their place in the development of twentieth-century art. Their redirecting, or even avoidance, of the issues inherent in the mainstream of modern art ultimately retarded such concerns in Canada to such a degree that it was not until the mid-fifties and the formation of Painters Eleven in Toronto that English-speaking Canadian artists first successfully approached the problems presented by the most advanced painting of their time [...]

* * * * * * *
Reprinted from Dennis Reid, "Introduction,"
in *The Group of Seven* (Ottawa: National
Gallery of Canada, 1970), 9–16.

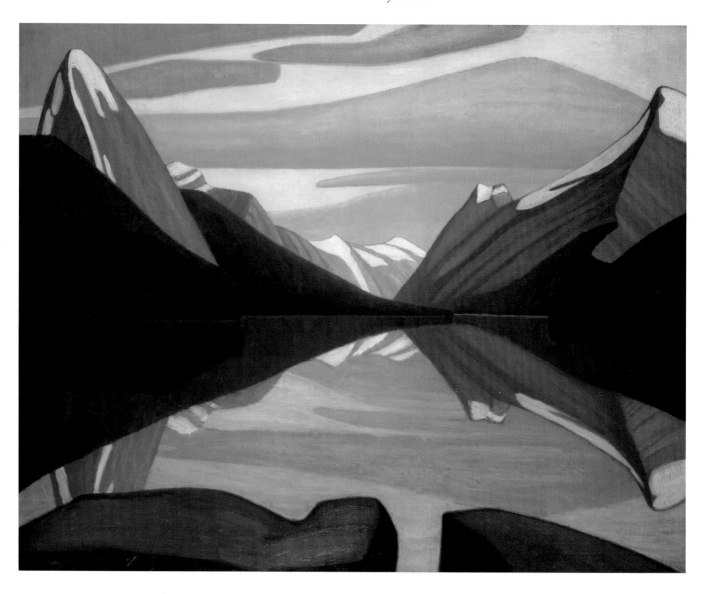

Lawren Harris, *Maligne Lake, Jasper Park*, 1924, oil on canvas, National Gallery of Canada

**NORTHROP FRYE**

# Preface to
# *The Bush Garden*

[...] **THE FAMOUS CANADIAN PROBLEM** of identity may seem a rationalized, self-pitying or made-up problem to those who have never had to meet it, or have never understood that it was there to be met. But it is with human beings as with birds: the creative instinct has a great deal to do with the assertion of territorial rights. The question of identity is primarily a cultural and imaginative question, and there is always something vegetable about the imagination, something sharply limited in range. American writers are, as writers, not American: they are New Englanders, Mississippians, Middle Westerners, expatriates, and the like. Even in the much smaller British Isles we find few writers who are simply British: Hardy belongs to "Wessex," Dylan Thomas to South Wales, Beckett to the Dublin-Paris axis, and so on. Painters and composers deal with arts capable of a higher degree of abstraction, but even they are likely to have their roots in some very restricted coterie in Paris or New York.

Similarly, the question of Canadian identity, so far as it affects the creative imagination, is not a "Canadian" question at all, but a regional question. An environment turned outward to the sea, like so much of Newfoundland, and one turned towards inland seas, like so much of the Maritimes, are an imaginative contrast: anyone who has been conditioned by one in his earliest years can hardly become conditioned by the other in the same way. Anyone brought up on the urban plain of southern Ontario or the gentle *pays* farmland along the south shore of the St Lawrence may become fascinated by the great sprawling wilderness of Northern Ontario or Ungava, may move there and live with its people and become accepted as one of them, but if he paints or writes about it he will paint or write as an imaginative foreigner. And what can there be in common between all imagination nurtured on the prairies, where it is a centre of consciousness diffusing itself over a vast flat expanse stretching to the remote horizon, and one nurtured in British Columbia, where it is in the midst of gigantic trees and mountains leaping into the sky all around it, and obliterating the horizon everywhere?

Thus when the CBC is instructed by Parliament to do what it can to promote Canadian unity and identity, it is not always realized that unity and identity are quite different things to be promoting, and that in Canada they are perhaps more different than they are anywhere else. Identity is local and regional, rooted in the imagination and in works of culture; unity is national in reference, international in perspective, and rooted in a political feeling. There are, of course, containing imaginative forms which are common to the whole country, even if not peculiar to Canada. I remember seeing an exhibition of undergraduate painting, mostly of landscapes, at a Maritime university. The students had come from all over Canada, and one was from Ghana. The Ghana student had imaginative qualities that the Canadians did not have, but they had something that he did not have, and it puzzled me to place it. I finally realized what it was: he had lived, in his impressionable years, in a world where colour was a constant datum: he had never seen colour as a cycle that got born in spring, matured in a burst of autumn flame, and then died out into a largely abstract, black and white world. But that is a factor of latitude rather than region, and most of the imaginative factors common to the country as a whole are negative influences.

Negative, because in our world the sense of a specific environment as something that provides a circumference for an imagination has to contend with a global civilization of jet planes, international hotels, and disappearing landmarks – that is, an obliterated environment. The obliterated environment produces an imaginative dystrophy that one sees all over the world, most

dramatically perhaps in architecture and town planning (as it is ironically called), but in the other arts as well. Canada, with its empty spaces, its largely unknown lakes and rivers and islands, its division of language, its dependence on immense railways to hold it physically together, has had this peculiar problem of an obliterated environment throughout most of its history. The effects of this are clear in the curiously abortive cultural developments of Canada. They are shown even more clearly in its present lack of will to resist its own disintegration, in the fact that it is practically the only country left in the world which is a pure colony, colonial in psychology as well as in mercantile economics. [...]

The essential element in the national sense of unity is the east-west feeling, developed historically along the St Lawrence–Great Lakes axis, and expressed in the national motto, *a mari usque ad mare*. The tension between this political sense of unity and the imaginative sense of locality is the essence of whatever the word "Canadian" means. Once the tension is given up, and the two elements of unity and identity are confused or assimilated to each other, we get the two endemic diseases of Canadian life. Assimilating identity to unity produces the empty gestures of cultural nationalism; assimilating unity to identity produces the kind of provincial isolation which is now called separatism.

The imaginative Canadian stance, so to speak, facing east and west, has on one side one of the most powerful nations in the world; on the other there is the vast hinterland of the north, with its sense of mystery and fear of the unknown, and the curious guilt feelings that its uninhabited loneliness seems to inspire in this exploiting age. If the Canadian faces south, he becomes either hypnotized or repelled by the United States: either he tries to think up unconvincing reasons for being different and somehow superior to Americans, or he accepts being "swallowed up by" the United States as inevitable. What is resented in Canada about annexation to the United States is not annexation itself, but the feeling that Canada would disappear into a larger entity without having anything of any real distinctiveness to contribute to that entity: that, in short, if the United States did annex Canada it would notice nothing except an increase in natural resources. If we face north, much the same result evidently occurs: this happened to the Diefenbaker campaign of 1956, which has been chronicled in books with such words as "lament" and "renegade" in their titles [...]

* * * * * * *

Reprinted from Northrop Frye, "Preface," in *The Bush Garden: Essays on the Canadian Imagination* (Toronto: House of Anansi Press, 1971), i–iv.

# Paterson Ewen

*NIGHT STORM, 1973*

*ICEBERG, 1974*

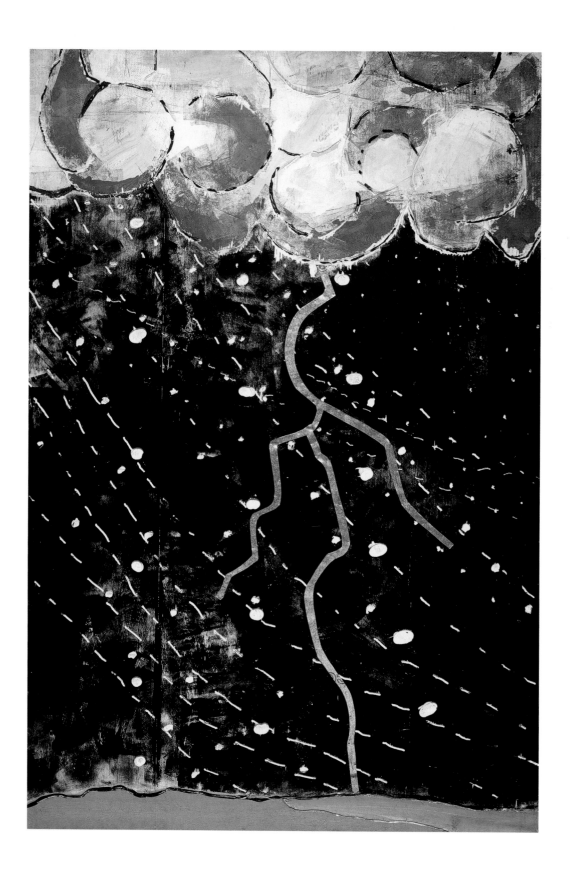

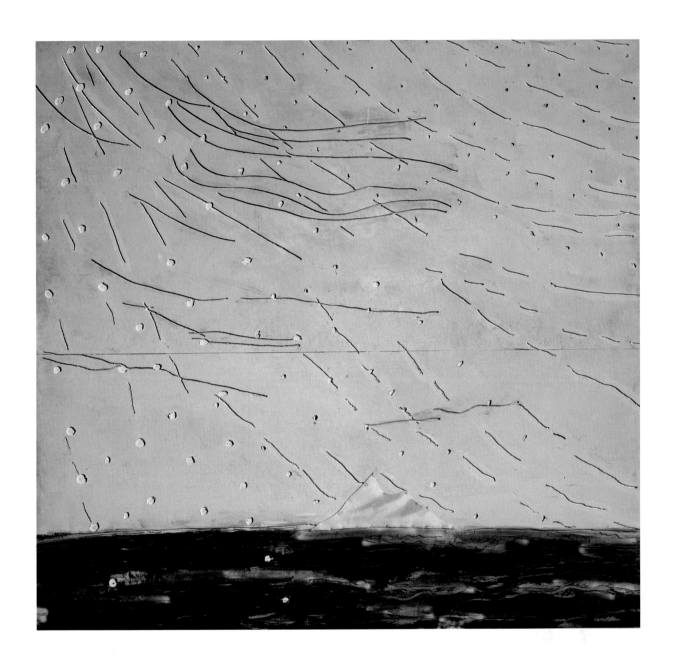

J.H. Weissenbruch, *Landscape with Windmills*, c. 1890, watercolour on paper, Art Gallery of Ontario

BARRY LORD

# The Group of Seven

## A National Landscape Art

It was boasted in Montreal that more Dutch art was sold there than in any other city on this continent. Dutch pictures became a symbol of social position and wealth. It was also whispered that they were a sound investment. They collected them like cigarette cards. You had to complete your set. One would say to another, 'Oh, I see you have not a De Bock yet.' 'No – have you your Blommers?' The houses bulged with cows, old women peeling potatoes, and windmills ... If you were poor and had only half a million, there were Dutchmen to cater to your humbler circumstances. Art in Canada meant a cow or a windmill. They were grey, mild, inoffensive things, and when surrounded by heavy gold frames, covered with plate glass and a spotlight placed over them, they looked expensive.

SO WROTE A.Y. JACKSON IN 1925, recalling the rich Montreal patron class of the last years before World War I. As the global crisis of imperialism heightened the conflicts between the world powers, these English-speaking compradors grew more conservative than ever in the art they selected.

For centuries artists had been applying a clear varnish to their paintings to protect their pigments from dirt and discolouration. After about 75 years, however, this varnish itself starts to discolour, and gradually gives the whole painting a dull yellowish tint.

Nowadays this varnish is usually removed by cleaning and a fresh coat applied, so that we can see the original colours of the painting. At this time, however, most of the museums of Europe were full of paintings covered with this yellowed varnish. Assuming that this tint was part of the artist's intention, gallery-goers called it "Rembrandt glow," after their favourite Dutch artist, and decided that it was one of the attributes of

truly great painting. They looked for contemporary artists whose work had the same dull tint, and in the Dutch painters who were then working around the Netherlands capital at The Hague, they found it.

This Hague School of painters had developed their art from the ideas of the Barbizon group of French artists. They too went to the farmyards and fields (cows and windmills), and tried to catch the atmosphere of the passing moment, the twilight of Millet's pessimism.

The irony is that by the 1920s the resale value of Hague School paintings was already negligible. The Montreal Museum of Fine Arts today has one of the largest collections outside the Netherlands of this decidedly minor school, most of the pictures having been given or bequeathed to the museum by the families of collectors who preferred "immortality" to embarrassment at the auction block.

What did these Anglo-Montrealers think of Canadian art? "It's bad enough to have to live in this country," one rich old woman told Jackson, "without having pictures of it in your home."

Through the 1890s and into the early years of this century, these patrons had supported painters like Homer Watson, whose pictures of Waterloo Country farmland they could associate with Barbizon and Hague School subjects. But by 1907 even Watson's sales had fallen off so badly that he became one of the founding members of the Canadian Art Club, an association of artists formed with the avowed purpose of stemming the inflow of Dutch imports and promoting Canadian art.

By this time the need for a "distinctively Canadian" art based on the land was being consciously discussed. As early as 1894 W.A. Sherwood had tried to define "A National Spirit in Art" in the *Canadian Magazine*. In 1912 the critic Newton MacTavish praised Maurice Cullen as our "Painter of the Snow" in the same

Chester D. Massey's "Gallery" in his house at 519 Jarvis Street, Toronto, early 1900s

publication, and urged Canadian artists to achieve a "style that will be, if not Canadian, at least distinctive."

Yet it was not the Canadian Art Club that was to meet the challenge. "We must show that our things are so much better than most of it," Watson wrote; other members, like James Wilson Morrice, saw the whole problem simply as a lack of high-quality Canadian work combined with a "deficiency of taste" among colonial patrons.

The eight invited other artists to submit work to their exhibitions only if the newcomers' art met their standard of inter-national "quality." In their eyes the Club's highest achievement was its successful 1911 exhibition in England! Not surprisingly, it folded four years later.

Landscape historically is a bourgeois art form. To achieve a national art of the Canadian landscape, therefore, the support of a *national bourgeoisie* was needed.

The national bourgeoisie are the middle-sized capitalists in a colonial country such as Canada. They have a certain regard for the national interest and the land, since their capital and profits are realized principally within the nation. As a class it is extremely unreliable because its members both want to drive out the imperialists (so as to increase profits) and want to exploit the people (so as to increase profits). Its class interests are clearly not served by imperialist domination of the country, and at certain stages of the struggle for liberation the national bourgeoisie or parts of it can be a useful ally for the people.

The establishment of even a small national bourgeoisie in a heavily-dominated colony like Canada was not easy. For thirty years following Confederation it was made even harder by the fact that, except for a few brief periods, the new Dominion had failed to live up to its bourgeois founders' hopes for greater profits. Not until the turn of the century was there a definite upturn in the economy. Then at last the prairies began to be settled in some depth, and industries were established to supply the new immigrant market. These were mostly in Ontario, which already had the industrial labour force, the developed sources of power, and the centres of capital administration. With their new-found wealth, Ontario compradors were now able to finance the discovery and development of the mineral resources of north-eastern Ontario and the Abitibi region of Quebec.

Of course this western settlement, northern exploration and central Canadian industrialization primarily benefited the British and the Americans. But inevitably some national-bour-geois enterprises also got a start, in fields like the manufacture of farm implements. The headquarters of this Ontario-centred small new class was definitely going to be Toronto, rather than Montreal. Their interests in art similarly centred on Ontario, and especially on the newly discovered northland.

An art that reflects the national bourgeoisie will be both bourgeois and national in character, which is precisely what a national landscape art is. The fact that this art depicted primarily a certain region of northern Ontario is not in itself a limitation: the French are known for the Barbizon school, the U.S. for the Hudson River School, and so on. A particular region may very well be selected by the artists of a national landscape school as their subject, depending on the interests of the patron class. The national character of this painting of our northland lies in its break with the imperial traditions about Canada not in

accounting for the entire range of the country. In patronizing an art of the northland, the national bourgeoisie provided the decisive backing necessary to help achieve one major step forward in the struggle for an art of the Canadian people. For the first time we were to see our country in terms that reflected a national outlook on it! [...]

In the spring of 1918 Lawren F. Harris and Dr. MacCallum set out in search of a new northern landscape. After crossing Manitoulin Island, they found what they were looking for in Algoma, the district north of Sault Ste Marie. In the fall they were back with J.E.H. MacDonald and Frank Johnston, sketching the glorious autumn colours of that magnificent region. Harris had chartered a caboose, and arranged with the Algoma Central Railway to have their car shunted onto sidings and moved from place to place as they required. The trip was a great success; in 1919 they returned, with Jackson taking Dr MacCallum's place, and on subsequent trips they brought Arthur Lismer along as well.

*Leaves in the Brook*, painted by MacDonald on the group's second "boxcar trip," is one of the finest of the thousands of sketches in our national landscape tradition. The pigment rushes forward and down the little panel with the stream, and the touches of brilliant yellow and red pick out the fallen leaves. We can sense the varying depths, temperature and motion of the water, as it ranges from a deep dark glow to grey-white froth in the current. The forms of the rocks are brushed in with solid strokes of warm tones that also lend structure to the picture as a whole, with the biggest stones additionally outlined in black. The tangle of brushstrokes never clogs, even on the thickly painted far bank. The rich colour and rapid movement are conveyed to us with all the freshness of the original autumn scene.

"I always think of Algoma as MacDonald's country," Jackson later wrote. "He was awed and thrilled by the landscape of Algoma and he got the feel of it in his painting." In his earlier sketches and canvases based on his Algoma trips MacDonald preferred these intimate, close-up and even closed-in views of nature, where his entire picture surface is suffused with the colour and texture before him. By the second and especially the third year he tended to prefer the panorama, the grand view in which he could evoke the majesty around him.

*The Solemn Land* is undoubtedly the greatest of his large canvases on this noble theme. Based on sketches made during the 1919 trip and on a photograph taken a year later, it reveals a dramatic vista of the Montreal River valley in Algoma. Below us the land slopes steeply off to the left. Near the centre at the bottom edge of the canvas is a red-leafed tree, a vivid note of colour. Behind it, the dark stands of fir trees lead our eyes away upriver.

Beyond the hulking shoreline forms, where more flashes of red are glimpsed among the brown-green and black foliage, a stupendous rocky promontory plunges down to the water, its cliffs and its crown of orange and yellow treetops partly glowing in the strong afternoon sun, partly steeped in the shadows cast by the heavy cumulus clouds overhead. On the right side a series of peninsulas fall dark brown and black into the shining river. In the distance the lower hills gleam, but the higher ranges stand boldly purple against the bright sky.

All the prominent forms, including the clouds, are painted with a strong outline. The effect is one of great deliberateness, as each shape is given its full weight. We sense how solidly rooted we are on yet another clifftop. This feeling of being part of the solemnity of the landscape, of actually standing and observing this great land, reinforces the drama and power of MacDonald's scene.

With paintings like *The Solemn Land*, our artists of the

northern landscape brought our national painting tradition to full realization. Conscious of their historical role, matured by their wartime experiences, sensitive to both the wealth of detail and the massive grandeur of our country, they had achieved an art of the landscape that was equal to the challenge of Canada. They had fulfilled the promise of Thomson's *The West Wind*.

The first group of three painters who returned from Algoma in the fall of 1918 (Harris, Johnston and MacDonald) were so excited about their discoveries and their accomplishment that they wanted to exhibit their sketches and paintings at once. Sir Edmund Walker was again on hand, this time as a board member of the Art Gallery of Toronto (now the Art Gallery of Ontario), and he quickly arranged for a three-man show in its new exhibition rooms for May, 1919.

So in the very month that the General Strike was raging across Canada, our leading painters were exhibiting their scenes of Algoma. It is significant that the high point of the working-class struggle to date came at the same time as the attainment of a national landscape art. The lack of unity between the two is equally apparent.

By the spring of 1920 these artists were ready to take their next great step. Instead of trying to repeat an exhibition restricted to the Algoma themes, they decided to exhibit as a group, consciously putting forward their programme of a national art. Lismer, MacDonald, Johnston, F.H. Varley and Franklin Carmichael gathered at Harris's studio; Jackson was out of town, but they knew they could count on him, so they called themselves *The Group of Seven*. Their first exhibition opened at the Art Gallery of Toronto in May, 1920, and was followed by a second and third exhibition in the same month of the next two years.

The catalogues for these exhibitions all contain a brief statement of purpose. A quotation from the 1921 edition shows how conscious these artists were of their national mission, and what it had to do with the Canadian landscape: "A word as to Canada. These pictures have all been executed in Canada during the past year. They express Canadian experience, and appeal to that experience in the onlooker. These are still pioneer days for artists and after the fashion of pioneers we believe wholeheartedly in the land. Some day we think that the land will return the compliment and believe in the artist, not as a nuisance or a luxury but as a real civilising factor in the national life."

One of the outstanding paintings in this 1921 exhibition was *A September Gale – Georgian Bay* by Arthur Lismer. Here Lismer finally brings to its culmination an epic theme that had recurred in his work since his first visit to Dr MacCallum's cottage eight years earlier, when he had been caught in a sudden storm. In September, 1920 he and Varley were sketching together in the same area when a similar gale blew up, and both artists caught the excitement of the fierce winds and lashed-up waters on their panels.

An earlier attempt by Lismer at painting a tree in a Georgian Bay storm had possibly suggested the subject matter of *The West Wind* to Thomson. Now in turn, Lismer was certainly familiar with Thomson's canvas by the time he painted *September Gale*. In his panel sketch he had caught the rush of the waves, the eddy of the little bay below, and the sharp thrust of the rocks in the foreground. In a further small canvas study he expressed the storm's motion in the massive cloud forms, solving the problem of the sky that Thomson had encountered, and then followed Thomson's example by extending the trunk of his tree beyond the top framing edge of his picture.

In Lismer's finished canvas as in *The West Wind*, the trunk of the tree stands in heroic resistance to the furious force of the gale winds that drive everything else, including its gnarled boughs, off

toward the left. The reeds and the small blowing bush in the foreground accentuate this movement, while the rocks from which we look steeply down and the island across the inlet provide the solid foundation for this profound, elemental drama.

Lismer's version achieves its great power through a masterful organization of line, composition and mass. Varley's *Stormy Weather, Georgian Bay* achieves much the same statement through a passionate use of colour and light.

Again our viewpoint is steeply down; again a tree stands up to the buffeting of a wind that is churning up the waters of the inlet below and scattering clouds across the sky. But in Varley's rendition, also exhibited in the 1921 show, the forms are conveyed to us not by the strong outlines of a Lismer or MacDonald, but by the most rhapsodic mingling of colour, exquisitely responsive to the light as it qualifies and modulates each surface of every wave, boulder and bough. The sun, just beginning to set, lights the clouds from beneath, casts the distant peninsula and islands in darkness, and allows Varley a full range of his favourite light purples and greens. Unlike Thomson and Lismer, Varley keeps the top of his resistant tree in his picture, and draws our attention out to the expanse of the Bay. The top of the tree breaks the distant horizon brushed in with long sweeping strokes of the lightest green and a thin line of blue land. Here is the sensitive, emotional painter of *For What?*, now revealing the grandeur of Canada's northland.

*September Gale* is the title J.B. McLeish used for his biography of Lismer. Certainly we could take the title *Stormy Weather* to describe Varley's life and career. But the titles are significant of even more than the life stories of the individuals who gave them to their paintings. *The West Wind*, *September Gale* and *Stormy Weather, Georgian Bay* embody the notion that the conflict observed in a September storm can mirror the struggles of mankind, and that

the northern Canadian landscape in particular reflects the heroic efforts of the Canadian people. The image is still the national-bourgeois one of a tree that endures and resists rather than one of a people who fight back. But for artists and a public who had recently been given an unforgettable demonstration of courageous tenacity at Passchendaele, the identification of this stark drama of the land with the essential character of Canadians was irresistible. The Canadian Corps had strengthened our confidence in our abilities to fight as a nation; here were paintings to express that heightened spirit of struggle.

"The Dutch patriots are getting scared," Jackson wrote in a 1919 letter. They were scared enough to make some effort to take over the new art. Since the national bourgeoisie had compromised itself in its wartime deal, an unequal bargain from which as a class it was never to escape, the compradors were now in a good position to take charge [...] In the postwar period, even before Sir Edmund Walker had arranged the Group's Algoma showing at the Art Gallery of Toronto, he and Eric Brown took steps to ensure that the National Gallery became the chief exhibitor as well as purchaser of the major Group paintings.

In this new phase of its patronage, the National Gallery revealed its comprador character more clearly. During the first five post-war years, while the Group was establishing itself in Toronto, the Gallery sent no less than three travelling exhibitions to the United States!

The purpose of these exhibitions was made clear when the academic critic Hector Charlesworth again attacked the Group, calling the Gallery "a national reproach" for its patronage of these artists. No less a personage than Sir Edmund Walker replied to Charlesworth's comments that "It is rather a weakness in the force of his criticism of the Canadian modernists that it should be at such complete variance with the opinions of critics of

Arthur Lismer, *A September Gale
– Georgian Bay*, 1921, oil on canvas,
National Gallery of Canada

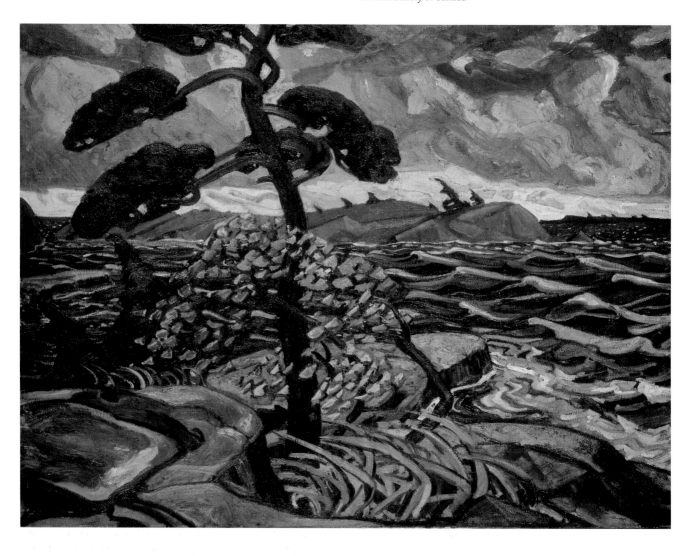

world-wide reputation who have seen them." The main aim of the Gallery's efforts was to associate the Group with international "modernism," by which both Walker and Charlesworth meant formalism, and specifically to submit the Group to the judgment of "critics of world-wide reputation," namely those of the imperial centres.

To Walker and Brown in 1924 this still meant primarily the British. In the dying moments of the British regime in Canada, the imperialists in London had decided to stage a "British Empire Exhibition" at Wembley to recall the old days of the "Colonial and Indian Exhibitions." Brown seized the opportunity to turn it into a British triumph for the Group. The Royal Canadian Academy protested loudly, having reverted to its pre-war role of representing those artists who still thought they could serve the Empire best by imitating out-of-date European styles; after 1924 the Academy stopped exhibiting at the Gallery, and did not show there again until 1961.

The Gallery showed the real purpose of its "international" programme by reprinting and distributing widely the British critics' favourable reviews of the exhibition. "The English notices of our pictures at Wembley have established the newer painters in a secure place," *The Canadian Forum* obediently concluded. The clincher came when London's Tate Gallery bought one of Jackson's works in the show. In 1925 the exhibition was repeated and Brown did it all again, once more reprinting the British reviews: if he could have continued, he might have produced an "annual review" of imperial art criticism for the colony!

But the Group's achievement of a national landscape art remained indelibly and uniquely Canadian, however these comprador agents tried to use it. The artists themselves were concerned to get their works seen by Canadians: in the two years during which their first three major exhibitions were being seen in Toronto, they organized over 40 smaller shows for other Canadian towns and cities. In 1922 they got the National Gallery's backing for a year-long touring exhibition that started in Vancouver, where it caused quite a sensation, and ended in Fort William (now Thunder Bay).

Encouragement from the patriotic petit-bourgeoisie now grew stronger than ever. In February of 1917 (just as the first stage of the revolution was breaking out in Russia), a group of students and professors at the University of Toronto had founded a magazine called *The Rebel*, and in 1920 they had broadened their base among professionals and intellectuals to bring out the first issue of *The Canadian Forum*. Barker Fairley, writing regularly for both publications, became the Group's most perceptive critic.

At about the same time Bess Housser, a friend of Lawren Harris, began to run features on the Group regularly in *Canadian Bookman*. And in 1926 her husband Fred, who was financial editor for the *Toronto Star*, brought out his book, *A Canadian Art Movement: the Story of the Group of Seven*. Still an invaluable source of information, Housser's book was by far the best work of art criticism that had ever been written in Canada: it made clear the character of our national landscape art, and underlined the patriotic nature of the Group's achievement. Over the years it has continued to tell Canadians the Group's story in bookstores and public libraries across the country.

Housser's book came out in the first year that U.S. investment in Canada exceeded British; one regime was ending, another was about to begin. The national bourgeoisie had been effectively cut off from any possible chance at getting control of the country. Their viewpoint, however, had been eloquently expressed in art. In 1919, in a list of quotations from the artists, the *Belleville Intelligencer* printed their simple and profound statement, that "the great purpose of landscape art is to make us at home in our own country."

\* \* \* \* \* \* \*

Reprinted from Barry Lord, *The History of Painting in Canada: Toward a People's Art* (Toronto: NC Press, 1974), 115–16, 135–8.

F.H. Varley, *Squally Weather, Georgian Bay*, 1921, oil on wood, National Gallery of Canada

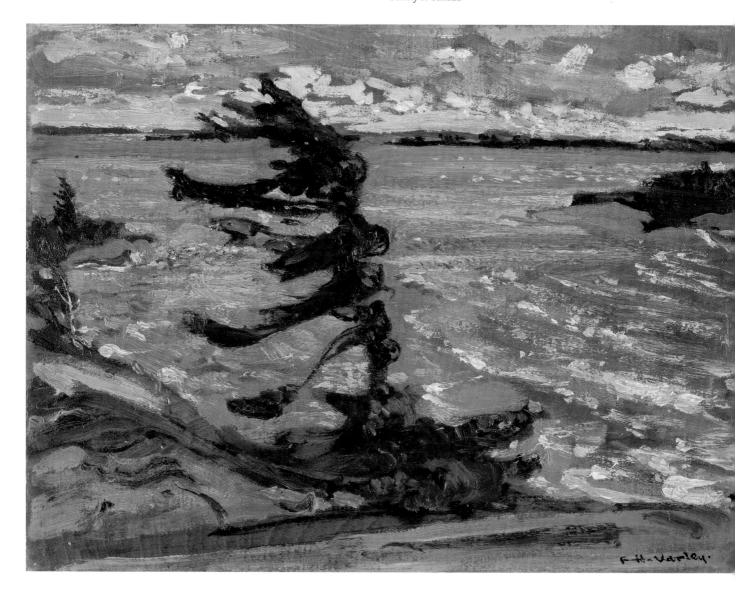

ANN DAVIS

# The Wembley Controversy in Canadian Art

IN 1923 CANADA WAS INVITED to participate in the British Empire Exhibition, the first major international art exhibition since the war. This was to be held the following year at Wembley in London, England. Canada, naturally, was anxious to mount a comprehensive and exciting display. She got more than she bargained for. The composition of that exhibit provoked the worst dispute to date in Canadian art history.

The Wembley controversy has traditionally been explained as a conflict between Canada's conservative painters, housed in the Royal Canadian Academy (RCA), and her modern artists, working under the aegis of the National Gallery of Canada (NG).[1] This interpretation undoubtedly is partly true. The traditionalists wanted to ensure that they were well represented in this art show; the moderns and those backing the Group of Seven were equally determined to receive hanging space. Presented this way the dispute has the appearance of an oft-repeated difference of artistic opinion and temperament. And, to a certain extent, this was in evidence in the pre-exhibition wrangle.

But an examination of the two principal institutions involved, the Royal Canadian Academy and the National Gallery, suggests different though complementary reasons for the dispute. Abstracting the heretofore acknowledged cause of the conflict, the Group of Seven, we see two artistic associations at war. They were battling over their respective Canadian and international rights. By examining this institutional power-play as well as the division of taste, one gets a rather different picture of the dispute.

The roots of the conflict occurred in the creation and early years of these cultural bodies. The existence of the Royal Canadian Academy and the National Gallery of Canada, each aspiring to be acknowledged as the dominant national artistic institution, had, naturally, led to a certain degree of competition between the two. The fact that one of these institutions, the National Gallery, in some respects owed its existence to the other, the Royal Canadian Academy, only encouraged the rivalry and intensified the imbroglio [...]

While the National Gallery–Royal Canadian Academy dispute over power was smouldering, the National Gallery acquired an important new ally, the Group of Seven. This innovative group of Canadian artists, through its association with the government gallery, was to act as the catalyst in the forthcoming dispute. For this reason the group's connection with the gallery is vital.

One might query the nature of the connection. A group of supposedly radical painters seldom concurs with a government, and by implication conservative, institution. But the National Gallery, officially in existence since 1882, had spent most of its life in a dormant state. Only with the creation of the Advisory Arts Council and the appointment in 1910 of Eric Brown as curator, was dynamism and enthusiasm injected into this cultural repository. In reality, then, the gallery was young and potentially innovative. This would be tested in its reaction to the Group of Seven.

In 1913 just such an opportunity occurred. A.Y. Jackson, not yet committed to the "Algonquin School'" composed of future Group of Seven members, wrote a friendly, interested letter to Eric Brown. He suggested the desirability of having a "National Collection which would inspire the Canadian artist and show him the way, and not suffocate him with all the old tradition which Europe herself is trying to shake off ..."[2] Brown replied cordially that he was "quite in accord with [Jackson's] ... policy ..."[3] It was a good beginning.

The next year, when all the future Group of Seven members had gathered in Toronto, Jackson and Harris again wrote to the National Gallery [...] The painters were pleased when Sir Edmund Walker, resident in Toronto and now chairman of the Board of

Trustees of the gallery, came around to hear their criticisms and comments in person.[4] The result was a close and long-lasting bond between the Group and the National Gallery. The most successful method for the National Gallery to cement a friendship of this nature was through purchases. In this way the officials could both acknowledge the skills of these painters and help to alleviate their relatively impecunious state. Though already owning examples of the work of Harris, Thomson, and Jackson, the gallery quickly increased their representation.[5] They bought a Lismer and a Thomson from the Ontario Society of Artists exhibition, a MacDonald from the September Canadian National Exhibition, and a Jackson and a Harris from the November RCA show.[6] Nor was this patronage temporary; it continued throughout the Group's existence.[7]

Such early and consistent support needs explanation, especially as the gallery was virtually the Group's only friend. To Eric Brown, in 1912 renamed director in lieu of curator, must go much of the credit. Brought up in an England verging on Impressionism, he, the younger brother of Arnesby Brown, RA, was aware of recent European painting innovations.[8] Naturally he was most comfortable with Canadian painters who worked in these styles. The members of the Group of Seven were Canadian leaders in impressionistic, post-impressionistic, and Fauve techniques, albeit mixed with a good dose of Barbizon and "art nouveau" flavour.[9] In terms of his own taste Brown could happily accommodate Group canvases in his gallery, which was still, of course, the official repository for RCA diploma works.

Sir Edmund Walker's artistic tastes were less modern but equally or more catholic than Brown's. The chairman's own personal collection was composed of Dutch, Barbizon, Japanese, and late Victorian Canadian works.[10] Many of these, however, befitting their genre, were landscapes. So were the Group's. At the same time both Walker and Brown had become personally interested in and sympathetic to the Group's aims.[11]

The policy adopted by Walker and Brown for running the gallery also permitted and encouraged their support for the artistic rebels. They both felt that one of the prime duties of a gallery was to encourage and promote struggling Canadian artists in preference to recognized European masters. Such theories were not beyond question and received adverse comments even within the Board of Trustees. Walker justified his position:

... we should often purchase for the National Gallery pictures which might not be attractive to us individuals, but which would be fair expositions of the conditions of art in Canada as shown by the leading artists; but in doing this it would follow that while some of the pictures would be as good representations of the work of the particular artists as we were ever likely to get, some again – especially those of the younger artists – would not be as good examples as could in subsequent years be obtained. In this event, however, we should have the satisfaction of knowing that the Government had aided the career of an artist ...[12]

Another, not unrelated factor, attracted Walker and Brown to the Group: their nationalism.[13] Neither nationalism nor nationalism in Canadian art were strikingly new phenomena, but both were unquestionably on the rise. Walker and Brown approved. By 1915 Brown explained that "A younger generation is coming to the fore, trained partly in Canada, believing in and understanding Canada and to some small though quite insufficient extent, encouraged by Canadians. These artists are painting their own country and realizing its own splendours and its character ... Many are convinced that they are looking into the dawn of a new era in Canada which will glorify their country and help its people towards a better understanding of one of the greatest refining

influences in the national life."[14] To the gallery officials and later to other Canadians the Group's nationalism was a strong and appealing force [...]

If the National Gallery had an ally in the Group of Seven, the Royal Canadian Academy had an equally firm friend in Hector Charlesworth, the opinionated art critic of *Saturday Night*. Charlesworth fired the first round of grapeshot in an article on the National Gallery. After commenting favourably on the modern British collection there, Charlesworth turned avidly to the real purpose of his article: a resounding denunciation of the director's selection of Canadian art. "Canadian art," he wrote, "cannot be as laboured, dull and unimaginative as most of these pictures would have us think ... The average Canadian display is more vital and interesting than this ... The Canadian gallery is depressing and disappointing because of the carelessness revealed on all sides; – painters of an inferior quality over represented; painters of a high quality in some instances underrepresented or represented by their second best; a general absence of aesthetic sensibility."[15] Sir Edmund immediately replied and Charlesworth, in turn, published his remarks on the chairman's comments.[16] Jackson, with almost unpleasant relish, added his personal attack to Walker's more tempered criticism.[17] The atmosphere was warming up.

Charlesworth had chosen the Group of Seven as the example of gallery misjudgement and thus introduced the theory that the Group was the prime suspect in a gory case. Of the Group's art, Charlesworth contented himself with the assertion that it was "experimental," "of unproven quality," and "theatrical." Of the Seven's method of exposing their works, he was considerably less restrained: "'The Group of Seven' showed a good deal of canniness, by forming a powerful organized minority to compel the chartered organizations to recognize them and press their work on the official eye," a trap into which, according to the irate writer,

the gallery blindly fell.[18] In Charlesworth's mind, firm opposition would have to be mounted against the hoodwinked National Gallery and their audacious partners-in-crime, the Group of Seven.

Up to this point few other critics had seen the Group as a serious problem in the advancement of Canadian art. In fact, with two exceptions, the public had reacted with indifference or moderate approval to the Group's exhibited work. The first attack had already occurred in 1913 when F.H. Gadsby, in the Toronto *Star*, pinned the title of "Hot Mush School" on the embryonic Algonquin group.[19] Gadsby described the paintings he saw as "a Dutch head-cheese having a quarrel with a chunk of French nougat," "a plesiosaurus in a fit as depicted by industrious and misguided Japanese." The second incident occurred during the war. Again it was a writer in the *Star* who led the attack; Charlesworth followed,[20] singling out J.E.H. MacDonald's work for its "crudity of colour," and calling *The Elements* "Hungarian Goulash" and *Rock and Maple* "Drunkard's Stomach." Despite these two incidents, critics, including Charlesworth, had had relatively little to say against the future Group of Seven members.[21] Only when the National Gallery, partially through the Seven, began to threaten the power of the Royal Canadian Academy and its supporters, and to challenge their artistic control of Canada, did critics really attack the Seven [...]

With the news of the Wembley exhibit the academy spies quickly detected what they now felt to be the gallery's intrusion onto their territory: the organization and control of foreign exhibits. The RCA claimed that as it had "exercised this function for the last 40 years [a questionable statement at best] ... it [was] ... the proper body to organize, counsel and manage Dominion exhibitions of Canadian art outside of Canada as well as in Canada."[22] Countering the gallery's proposal, the academy requested hanging space in the National Gallery for its annual

exhibition of that year and announced that it, the RCA, would choose the Wembley representation from that show.[23] The gallery would have none of it. The academy then suggested they name the jury for the selection. Again the gallery refused. Walker pulled out of storage his most formal and definite rhetoric to reply that "The Board of the National Gallery regrets that the Royal Canadian Academy should now take the position of desiring to insist that the judging of works of art should be placed in the hands of a jury chosen by the Royal Academy alone ... The Board believes that the jury already selected is thoroughly representative of all shades of artistic opinion and could not be improved upon"[24] [...]

On the surface the Wembley controversy has the appearance of an understandable divergence of artistic taste. The traditional painters were fighting the advent of newer, more modern art forms. G. Horne Russell, E. Wyly Grier, Ernest Forsby, all conservative stalwarts, felt threatened and revolted by the unconventional Group of Seven canvases. At the same time, both sides were aware of the advantages of continuing the dispute: publicity. The more free press coverage they could muster, the more likely attendance and sales figures would rise.

A complementary reason for the dispute was the power-play between the academy and the gallery. In fact it may have been the main reason. Such fierce argument would never have occurred had the respective spheres of influence been clear. If parliament or the president of the RCA had established which body would organize foreign Canadian art exhibits, and if such a decision had been financially viable, the Wembley controversy would not have happened. This was not the case. As early as the official opening of the first academy exhibition in 1880 some division of power had been suggested: "These works [the academicians' deposited diploma pictures] will be at the disposal of one of the Minis-

ters who might be charged with this trust and it will be in his option to decide whether they shall be exhibited in other parts of the country or loaned for the purposes of art instruction for a time to local schools."[25] Unfortunately this proposal was left in this nebulous state. In 1913 some attempt was made to sort out the conflicting areas of responsibility. By-law no. B1 of that date stated that "The Trustees may lend the objects of art owned by the National Gallery to any duly accredited or authorized art or other public body for the purpose of public exhibition and instruction." This eliminated the two qualifiers that had been included in the 1880 clause: the limitation to academicians' works and the restriction to exhibitions held in Canada.[26] Still confusion reigned. Later H.O. McCurry, director of the gallery upon Brown's death, commented on the Wembley controversy: "The present riot has been staged with no other purpose than to gain control of the National institution by the Royal Canadian Academy such as was contemplated by the individual who inserted the objectionable clause referred to in the Bill introduced in 1913."[27] The Wembley dispute was therefore both a challenge of control and a clash of opinion. In the conflict as in the outcome the two were merged. The victors, the National Gallery and the Group of Seven, gained in strength and prominence to dominate the Canadian artistic scene; the vanquished, the Royal Canadian Academy and the traditionalists, fell in power and popularity to relative oblivion. The Wembley controversy marked a clear turning point in the history of Canadian art.

* * * * * * *
Reprinted from Ann Davis, "The Wembley Controversy in Canadian Art," *Canadian Historical Review* 54, no. 1 (March 1973): 48–9, 61–4, 66–7, 69–70, 73–4.

J.E.H. MacDonald, *The Elements*,
1916, oil on board, Art Gallery
of Ontario

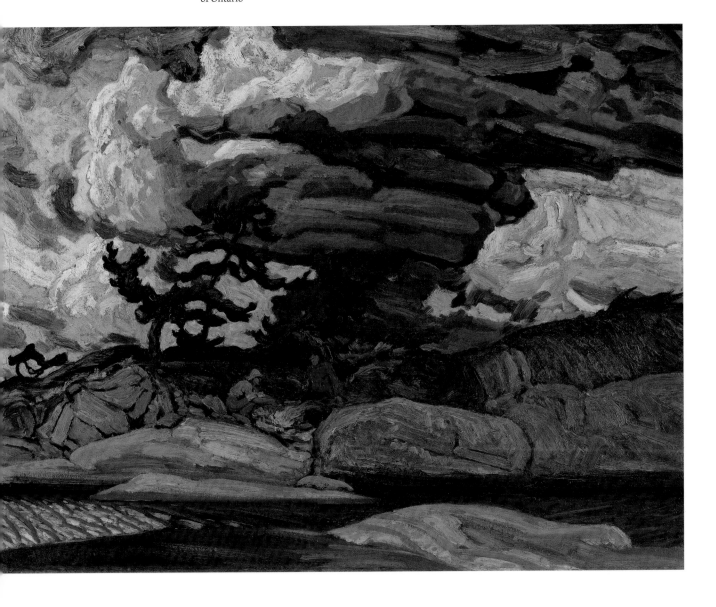

Grey Owl

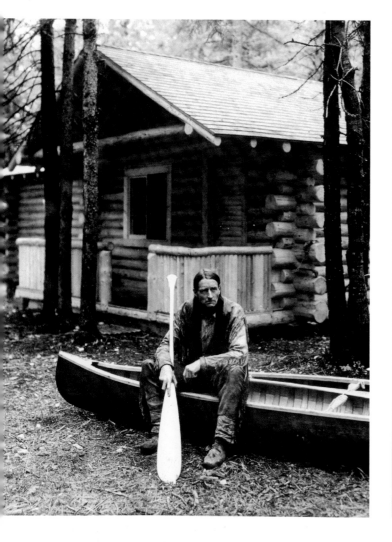

Tom Thomson

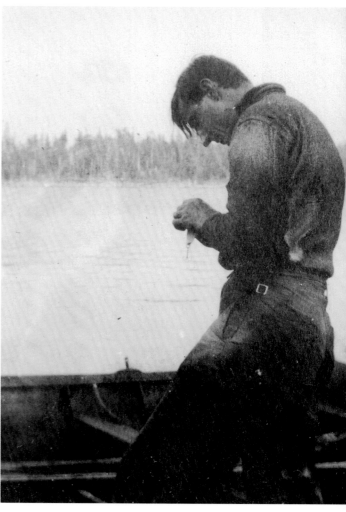

DOUGLAS COLE

# Artists, Patrons, and Public

## An Enquiry into the Success of the Group of Seven

**FOR THE VAST MAJORITY** of Canadians, it has been said, Picasso and the Group of Seven are probably the only modern artists remembered from school or general reading.[1] This remarkable fame enjoyed by a single Canadian artistic Group resulted from a number of factors, not least of which were nationalist aspirations, delightful controversy, influential friends, and vigorous self-promotion. One essential element in the Group's success was the commonality of experience established between artists and their patrons and public. A leader of the Group, J.E.H. MacDonald, once observed that "art requires associated ideas"; the observer "must have experiences generally similar to the artist" before he can appreciatively respond to the work before him.[2] The Group's success, first with a small number of important people and then rapidly with a larger public, was built upon a shared discovery of the northern wilderness as a central fact and symbol of Canadian life. This essay is an examination of some aspects of the common experiences of painter, patron and public which aided in the Group's unprecedented acceptance and fame.

From the last decade of the nineteenth century, one can observe a quickening response by Canadians to the wilderness landscape around them. Paralleling and often led by a similar movement in the United States,[3] Canadians developed what may be called a wilderness "ethos," a new appreciation of the physical, aesthetic and spiritual values of those areas where man's incursions upon nature were relatively absent.[4] Within the ethos, wilderness called man back to his primitive strength, refreshing him through strenuous living in a natural environment. There he found a spiritual regeneration from close contact with the vital forces of nature and he drew from it an appreciation of the beauty and grandeur of unspoilt nature.

The Canadian wilderness ethos expressed itself in a dozen ways – in the creation of wilderness parks like Algonquin and Garibaldi, in children's woodcraft camps, in Grey Owl, in the wild animal stories of Ernest Thompson Seton and Charles G.D. Roberts, in the summer cottaging movement, in the art of Emily Carr and the Group of Seven, even in the historical writing of Harold Innis and Arthur Lower. Its roots lay in the western tradition of ideas of Arcadia, primitivism and romanticism, but the reason for its rapid development between 1890 and 1930 lay in the growth of crowded industrial cities and the simultaneous development of easy means to escape them.

It was the urban condition which, more than anything else, caused Canadians to seek wild landscape. The period from 1891 to 1921 witnessed a phenomenal growth of Canadian cities. Montreal and Toronto almost tripled their populations, while the newer Winnipeg increased by seven times. Vancouver grew from 42,000 in 1901 to 179,000 in 1921.[5] For the first time, many Canadians found themselves living within an industrial and urban landscape, a landscape made all the more alien by its newness, its inadequate accommodation, sanitation and recreation facilities and by its noise, increasingly intensified by the motor car. Enthusiasm for city life was, as J.S. Woodsworth wrote, only for the visitor: "The novel sights and sounds soon become familiar. The higher the buildings, the less sunshine; the bigger the crowds, the less fresh air ... We become weary in the unceasing rush, and feel utterly lonely in the crowded streets. There comes a wistful longing for the happy life of "God's out-of-doors" with the perfume of the flowers and the singing of the birds. But our work now lies in the city and in the city we must stay.[6]

The reaction to urban conditions was, at least for many of the middle and upper classes, to escape them. The prosperous moved into outlying garden suburbs, commuting into the city's core only for work and urbanity. Not surprisingly, they sought recreation completely away from the city and all that it meant.

The harassed city-dweller could, of course, go back to the land, to a rural setting, and many did. Among the wealthy, a desire to live the quiet, English-style country life, amidst cultivated gardens and stables, remained a very pleasant attraction.[7] Increasingly, however, the push of the city and the pull of nature became an escape into a totally uncivilized, wholly uncultivated landscape, "to forests unmeasured and unblazed, and streams untraversed," to "a primitive kind of life, and therefore very simple."[8] Canada offered ample opportunity "to hie away from the roar of the great city and the inexcrable pressure of its life" to "some beautiful lake cradled among primitive hills."[9] As the editor of the *Canadian Magazine* boasted, Canada's "thousands of lakes and rivers afford plenty of sport for the seeker after pleasant excitement, her vast forest preserves are still well stocked with the finest game in the world, and the natural beauty of the many regions, which the prosaic hand of civilization has not yet touched, affords rest to the tired man or woman of the world."[10] These abundant recreational areas were, moreover, within close proximity to most urban Canadians. From Toronto, the heart of the Canadian wilderness ethos, Muskoka Wharf, was only a few hours by the Grand Trunk, Algonquin Park but a small distance farther. The Georgian Bay's thirty thousand islands were within a day's travel by train and steamer, while the hitherto remote Temagami area required after 1904 only an overnight journey on the *Cobalt Special*. Montreal, with the Laurentian Mountains so close, was hardly less blessed. Winnipeg was within easy reach of the Lake of the Woods. Vancouver had the wilderness within view of its city centre, easy of access by ferry to the north shore of Burrard Inlet or by boat to Squamish from where the Pacific Great Eastern made its way into the wilds of the mountainous interior. For many urban Canadians, the wilderness began almost where the city's pavement ended; for others, it was scarcely further than

the city's depot. Railway mileage doubled in the two decades before World War 1, much of it into Shield and mountains. Road-building in the inter-war period further increased the mobility of the urban middle class. The Laurier boom and that of the mid-twenties, particularly the rapid development of "New Ontario," helped create both the conditions of urban density and the means by which to escape them.

The rush to the wilderness encompassed many forms of recreational escape. The early 1870s had seen the beginning of resort recreation in Ontario, then a decided Muskoka boom in the 1880s. It was not until the last decade of the century, however, that all the factors – railway development, rapid urban growth and economic affluence – came together to bring about a large and intensive summering movement. Conspicuous was the growth of cottaging, supplanting to a large degree the resort hotel.[11] "In the neighbourhood of each city," reported J.A. Cooper in 1900, "there are one or more special districts where the summer cottage is in increasing evidence and where the formalism and restraint of the city can be laid aside for the benefit of mind and body."[12] Social groups were also evident, most notably the donish Madawaska Club of Go-Home Bay on the Georgian Bay and the more financially exclusive Seigniory Club on the Lucerne-in-Quebec estate at Montebello. The Madawaska Club was the idea of Professor W.J. Loudon. It was composed of University of Toronto alumni and faculty who, after securing a site at Go-Home, made their first season in 1898. For most of the lecturers and professors Go-Home was entirely novel. One recalled "the vivid impression made by the first glimpse of rocks and pine trees" interspersed with white tents and the University flag. It seemed, he remembered, "all very different from the landscape and life of older Ontario."[13] Life at Go-Home offered both an easy informality and a robust adventureness, an escape from the formal restraints of city and

professional clothing, manners and schedules and an opportunity for fishing and canoeing. [...]

Perhaps the best literary expression of the wilderness idea comes from a man who so absorbed the woods and their inhabitants that he became himself an Ojibwa. Grey Owl's career is a supreme manifestation of the lure of wilderness values, his writing a magnificent celebration of wilderness ways, and his popularity an expression of wilderness tastes. As a boy in Hastings, England, he invented the fantasy of Indian ancestry and played the role of Big Chief Thunderbinder.[14] Arriving in Canada in 1906, Archie Belaney travelled to the northern Ontario wilderness – Cobalt, Lake Temagami and Biscotasing – where he took up trapping, adopted the dress and ways of the Indians and learned Ojibwa lore and legends. Converted from a trapper to a protector of beaver, Belaney turned to writing initially under his own name and then as Grey Owl. His success in the 1930s was instant and overwhelming. He wrote simply and sincerely on the theme of "my beloved wilderness," of his "harsh, untamed, beloved North with its romance, its wild freedom," of his beaver who were "the Wilderness personified, the Wild articulate."[15] The most successful of all Canadian nature writers, Grey Owl was also the most perfect embodiment of wilderness values, much more so as a converted white man than as a half-Indian.

In the summer of 1915 Belaney met Tom Thomson. Nothing is known of what was said on the occasion. Grey Owl remembered Thomson as a ranger who gave him three oil sketches.[16] The similarity, remarkable in build and appearance, between the two men extends to the wilderness legend which each created.

At the time of this symbolic meeting between two of Canada's wilderness heroes, Thomson was summering for the third time in northern Ontario. His first journey to the north had been in 1912 when he went to Algonquin Park, then canoed from Biscotasing through the Mississaugi Forest Reserve. For these 1912 journeys into the wilderness there seems little precedent in Thomson's earlier 34 years. A farm boy in his youth, Thomson had adopted an urban vocation, commercial art, after dabbling in the equally urban professions of machinist and business college teacher. His moves – from Owen Sound to Chatham to Seattle to Toronto – were a progression from rural to urban. By the time of his first wilderness experience he had lived in Toronto for about seven years, a period longer than the Algonquin years, and his holiday trips, aside from a visit to Huntsville in 1910, seem to have taken him no further afield than the Humber Valley, Lake Skugog and home to his parents' Owen Sound farm. Until 1912 Thomson's life was typical of the urbanized farm boy.

But something captured him in 1912. After his northern trips of that year he was never again satisfied unless canoeing, fishing and sketching in the forests and lakes of Algonquin Park. He quit his Toronto office the following spring to establish what became a pattern of some four winter months in the city and the rest of the year in the wilderness. Thomson, who in 1912 had to be given a packsack by his Toronto friends, had suddenly become a convert to the wild. He increasingly divested himself of the "paraphernalia of city life"; his dress became "more and more like that of the backwoodsman."[17] Overcoming his ignorance of canoes – his father had never trusted the craft – Thomson acquired the reputation of an expert. Even in Toronto he sought to replicate the wilderness by moving to a rustic shack on the Rosedale ravine where he could snowshoe at night and be free from "all that otherwise made Toronto."[18] Thomson had become a wilderness freak, creating – like Grey Owl – a role as the wilderness man.[19]

The other artists who were to compose the Algonquin school and then the Group of Seven were similarly without wilderness experience. The early years of Arthur Lismer and F.H. Varley,

*Maclean's*, 1 July 1949, cover

natives of Sheffield who arrived in Canada only in 1911 and 1912, encompassed nothing more untamed than the Yorkshire moors. The early paintings of J.E.H. MacDonald, raised in Durham, England, Hamilton and Toronto, seldom ventured farther from the city than the domesticated landscape of High Park. MacDonald, though a keen naturalist, was never a robust figure; he remained "a quiet, unadventurous person, who could not swim, or paddle, or swing an axe, or find his way in the bush."[20] The wilderness experience of A.Y. Jackson, a man who later refused to sketch within sixty miles of Toronto, was, until 1910, restricted to a single canoe trip on the placid Rideau. When first exposed to the north country, it impressed him as a great holiday place, but "not quite paintable." Georgian Bay was "nothing but little islands covered with scrub and pine trees."[21] Only Lawren Harris, who spent boyhood summers with his wealthy parents in the Muskoka, experienced anything like a wilderness youth. That background was reinforced by a winter's trip to Minnesota lumber camps in 1908–09 and the possession of his own cottage on Lake Simcoe. Harris, not Thomson, was the only member of this

Group with a background touching upon the Shield country. [...]

The Group was fortunate, too, in having as friends writers and editors sympathetic to the landscape which dominated their paintings. Barker Fairley, Merrill Denison, Harold Mortimer Lamb and F.B. and Bess Housser were among those who wrote favourably about the new art of the northern wilderness. Fairley, a professor of German at the University of Toronto, had a deep familiarity with Go-Home Bay, producing there both poetry and light sketches in the Group's pictorial manner.[22] His essays for the *Rebel* and its successor, the *Canadian Forum*, were among the earliest favourable notices the artists received. Fairley was, as well, the moving force in the art committee of Hart House, whose collection, begun with Jackson's *Georgian Bay, November*, purchased in 1921–22, was followed by thirteen other Group pictures before 1930.

Another friend, playwright Merrill Denison, had virtually been raised at his mother's resort of Bon Echo, a rustic retreat on Lake Mazinaw in the Shield north of Kingston. At Hart House theatre, Denison wrote plays set in the northland, spoofing the casual hunters and cottagers who went there. The premier production of "From Their Own Place," set in a holiday cabin, included Arthur Lismer cast as a backwoodsman.[23] Both Lismer and Jackson were guests at Bon Echo, the former painting several canvases of the massive rock escarpment, the latter a poster advertising the resort. Meanwhile Denison wrote of the Group and its triumphs. Harold Mortimer Lamb, a mining expert, artistic photographer and connoisseur, was yet another early enthusiast. A Montreal friend of Jackson, who put him in touch with the Toronto movement, Lamb had an intimate familiarity with the north from his work with the Canadian Mining Institute. From 1913 Lamb was writing spirited articles praising landscapes which "potently express the spirit of the Canadian northland."[24] "To those, who

like myself, know the northland of these canvases of Thomson ... and Jackson, and often those of MacDonald are intensely expressive, intensely true, intensely vital and eminently sincere."[25]

None of these writers, however, matched the passion of F.B. Housser – either for the northern wilderness or for the Group's pictures. Housser was a financial writer for the Toronto *Star*, a Theosophist and an enthusiast for the northern wilderness. Although particularly well acquainted with Georgian Bay and Algonquin, to Housser the whole north was "a magnetic land, able to get hold of man and draw them as it draws the steel of a compass." Housser recognized that the northern wilderness was "the playground of hundreds of thousands of Canadian people" and felt that "the love of it is deep in our souls."[26] He linked this passion for wilderness landscape to a fervent partisanship for the paintings of Thomson and the Group in his *A Canadian Art Movement*, published by Macmillan in 1926. His first wife, Bess (later the second wife of Lawren Harris), was both an artist in the Group style and a writer on the artists' behalf in the *Canadian Bookman*.

These writers and patrons, members of the upper and middle income urban elite who formed the small cultural establishment of the time, responded to the Group's pictures in part because of the associations which they had with the portrayed landscape. Each had a long and usually intimate knowledge of the Canadian wilderness and a deep love for it. As David Milne remarked of Thomson's pictures, they were popular not for their aesthetic qualities, but because the subjects were recognizable and loaded with pleasant associations of holiday, rest and relaxation.[27] The northern wilderness of the Shield, especially Algonquin Park and Georgian Bay, which the Group's pictures presented, was the playground of an increasing number of Canadians and the temporary working place of more. The Group's pictures were, once the initial shock of a seemingly brazen style was overcome, recognizable portraits of familiar places or symbolic images of known objects which became more familiar the more often they were seen or experienced. Behind the Group and its pictures was that perpetual process of identification and association. The Group painted "the kind of scene which every Canadian likes in reality"; they "in common with every Canadian lad ... delighted to cut themselves adrift from civilization among the lonely Northern lakes."[28] The Group were well aware of the association and consciously promoted it. "These pictures," read their foreword to the second Group exhibition in 1921, "express Canadian experience, and appeal to that experience in the onlooker."[29] Harris understood the process: it functioned, he wrote, "as an interplay between the artists and the country. The way in which the artists explored, camped, and lived, were strictly in the spirit of the country and its peoples."[30] The Group was responding to the values and tastes of an urbanizing country which sought to re-establish its ties to nature by escaping into wilderness areas. The Group was part and parcel of the values which produced wilderness writers, wilderness parks, lakeside cottages and wilderness camps. By the time Thomson and the others were converted to the wilderness idea, there was a ready audience of affluent and influential patrons prepared by their own experiences to respond to the portrayal of wilderness subjects. As the recreational popularity of the northern landscape increased to national and mass proportion, so was the Group elevated to the status of Canadian cultural heroes and their work enshrined as national icons.

\* \* \* \* \* \* \*
Reprinted from Douglas Cole, "Artists, Patrons and Public: An Enquiry into the Success of the Group of Seven," *Journal of Canadian Studies* 13, no. 2 (summer 1978): 69–78.

# Northern Developme

# Chapter 4

# Northern Developm

THE CONCEPT OF NORTHERN DEVELOPMENT carries decidedly negative connotations today, conjuring up images of a natural environment bent if not broken by the excesses of industrialization and technology. In the early twentieth century this was not the case, and the resource-rich North was seen, in Paul Walton's phrase, as the "economic cornucopia" that would underwrite Canada as a modern nation-state. At the same time, northern lakes, forests, and rocks were capable of arousing deeply romantic and patriotic yearnings; such were the convolutions and outright contradictions of Canadian industrial modernism. Quoting an *Owen Sound Sun* article on Tom Thomson's 1912 visit to the area, Walton puts the matter bluntly: "Technology gave value to landscape." The picturesque and wild landscapes of the North came into focus largely because industrialization was radically modifying the land just outside the frame of the picture. As Mel Watkins notes, some of the most famous paintings of the North represent views from the porches of cottages built on recently cleared grounds.

Rosemary Donegan agrees that modernity in the Canadian experience was being played out in terms of landscape. But for her it is essential to add the term "democratization" to the mix. Whereas the success of the Group of Seven may be seen as a case of class aggrandizement, with the artists providing a cultural buttress to the interests of central Canada's economic elites, she looks at other locations within the economic spectrum, seeing not only exploitation and self-interest but also opportunity.

# Chapter 4

Numbers of artists, including members of the Group, consciously painted these industrial landscapes with a modern visual vocabulary they thought appropriate to the emergent modern nation. If some, like A.Y. Jackson, were flummoxed by the challenge, others produced some of their most aesthetically powerful works, not least because in these paintings they chose to confront rather than elide the dystopian complexity of the new economic realities. If that is the case, however, the question must then be asked why these works lack currency in the Group of Seven canon, which is overwhelmingly dominated by paintings bereft of the human presence in the landscape.

The Group's work rode the momentum of the early twentieth-century economic boom, but it was documentary photography that took up the nationalist cause during the economic upturn that followed the Second World War. In the work of the National Film Board of Canada's Still Photography Division in the 1950s and 1960s, Carol Payne argues, the land was "measured in economic terms." While economic activity was suppressed in most paintings produced by the Group, in the NFB's promotional, quasi-official images it was foregrounded, as were the cultural and racial hierarchies inscribed by it.

The idea that Ontario's Near North constituted a utopia, economic or otherwise, is treated with irony and humour by Watkins. When he was growing up on a part of Georgian Bay closely associated with the Group, his hardscrabble existence inspired not patriotic sentiments but a powerful desire to escape.

Watkins identifies strongly with the paintings of Eleanor Bond, which employ dizzying perspectives at odds with the traditional perspectives found in paintings by the Group. Her representations of the landscape are set in a near future of economic collapse, ecological degradation, and social isolation, and they comment on the restricted vision that brings about such dissolution. In a self-referential work that proved to be one of its last, the artist collective General Idea painted a capsule form associated with AZT on a cheap reprint of *Northern River*, Tom Thomson's widely reproduced and much loved painting. Thomson's melancholy work serves as a vehicle for General Idea to suggest, with bittersweet irony, that the myth of wilderness has been infected by a literal and figurative virus.

# General Idea

PHARM@COLOGY, 1994

A.P. 3/3          Pharmecology          G.l. 1994

From the 1915 oil painting **NORTHERN RIVER** *(114 x 102 cm.)* by **TOM THOMSON**, *(1877 - 1917) in the National Gallery of Canada,*
Ottawa. Copyright Pandora Publishing Ltd., Victoria, V8P 1B1. CANADART #3503
D'après la peinture à l'huile par **TOM THOMSON.**

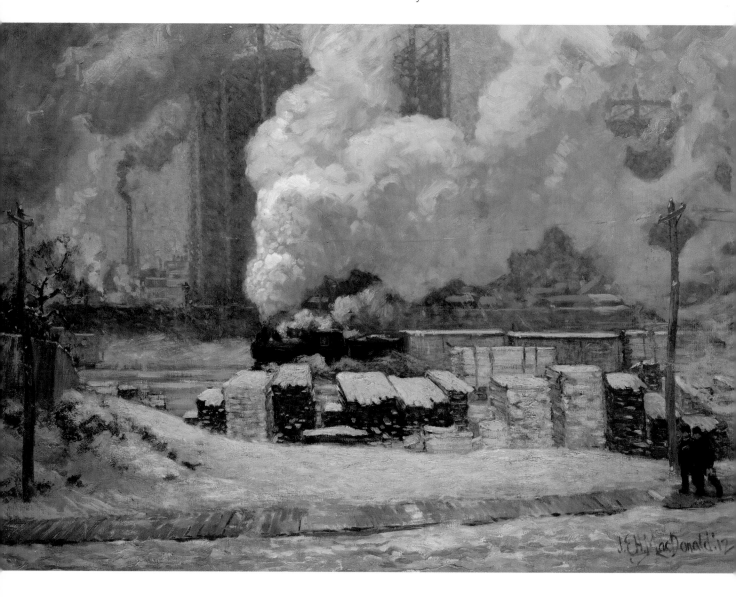

J.E.H. MacDonald, *Tracks and Traffic*, 1912, oil on canvas, Art Gallery of Ontario

# The Group of Seven and Northern Development

PAUL H. WALTON

THE DECADE OF THE 1920S was a period of unprecedented activity in all the arts in Canada[1] and the Group of Seven sensed the growing momentum as they prepared for their third exhibition in 1922. Encouraged by increased patronage and public approval, their brief preface for the catalogue sounded a new note of boldness and self-confidence, ending with the words, "In the midst of discovery and progress, of vast horizons and a beckoning future, Art must take to the road and risk all for the glory of a great adventure."[2] But this sentence was also a reflection of the current public mood about the economic prospects for Ontario and the nation, which could be characterized as one of defiant optimism that the opportunities offered by "the vast and wonderful physical assets of the country" would soon end the post-war recession and allow continuation of "two and a half decades of phenomenal progress."[3] Their buoyant frame of mind was soon justified by an acceleration of economic and cultural growth that reached a climax in 1929 and was celebrated with the publication of the *Yearbook of the Arts in Canada, 1928–1929*, which included a contribution by Lawren Harris rejoicing in the continuing success of the Group of Seven and predicting its continental, if not global, influence with the triumphant statement, "We live on the fringe of the great North across the whole continent and its spiritual flow, its clarity, its replenishing power passes through us to the teeming people south of us."[4]

A few years later the historian Frank Underhill, writing in the depths of the Depression, remembered the enthusiasm of Harris and other contributors to this volume and commented: "[As] we look back, we can see that it was not so much Canadian art, actual or potential, which excited [these writers] in that intoxicating year of 1929, it was the boom. They were mainly giving expression to what more vulgar fellow-Canadians were expressing in skyscrapers and railway extensions and International Nickel at 73."[5]

However, as we have seen, the excitement he noted was not simply the accompaniment of a single, frantic year of economic growth but the outcome of a prosperous decade that was itself the climax of years of prosperity beginning in the late 1890s. That was when Canada began to accelerate its changeover from an agricultural to an industrial nation as it embarked on what economic historians refer to as "The Great Transformation."[6]

This radical and profitable remodelling of economic life was expedited in Ontario by the acquisition in 1889 and 1912 of very large tracts of territory in the North that had formerly been claimed by the federal government, thereby creating a "New Ontario" extending far into the Precambrian Shield. Prized for its timber and promise of mineral wealth, the newly acquired territory was vigorously promoted by Ontario politicians and the financial community, but northern development also benefited from the "Laurier boom" affecting the whole country as settlement of the western plains began in earnest in the late 1890s and the long economic depression of the previous two decades came to an end. Also, tariffs had been put in place to protect Canadian industry so that soon after 1900 Ontario experienced a surge of economic growth and dramatic developments followed one after the other in rapid succession. Iron ore, copper, nickel, gold, and silver began to be mined on the Precambrian Shield in spectacular quantities and large industrial complexes were built at Sault Ste Marie, Sudbury, Cobalt, Timmins, and elsewhere. A new source of energy, hydro-electricity, made possible the explosive growth of the pulp and paper industry, which introduced an innovative use for the forest wealth of the North and, in addition, tourism began to develop into a significant northern enterprise.

These developments depended on new metallurgical processes for the extraction of gold and nickel from the hard rock of the Shield; the invention of methods for the large scale

Franklin Carmichael, *A Northern Silver Mine*, 1930, oil on canvas, McMichael Canadian Art Collection

manufacture of paper from wood; the perfection of the hydro-electric turbine and the improvement of transportation systems, all of which became available after 1880 as part of a world-wide, second industrial revolution based on modern science and technology. The excitement of this enterprise gripped the imagination of Ontarians to the extent that for decades they were caught up in a feverish mood of optimism about what seemed the prospect of almost unlimited growth and prosperity based on the natural resources of their province.

Toronto was the major beneficiary of renewed industrial progress that was further stimulated by World War I. It soon became the smoke-stack city we see in J.E.H. MacDonald's *Tracks and Traffic* from 1912 (Art Gallery of Ontario), the manufacturing hub of a railway network built to transport raw materials down from the North and carry manufactures up from the south and out west along routes like those depicted in 1913 by MacDonald in an illustration entitled *A Night Train in the Northland*. Thus energized, Toronto became a community consumed by commercial ambition to such an extent that in 1910 Sir Edmund Walker, President of the Bank of Commerce and patron of the arts, felt impelled to sound a warning in the Toronto *Globe* with an article entitled "Shall Canada Go Money-Mad? ...," which also enquired, "What ... must be the fate of a nation which does not give due place to the intellectual and the artistic in life?"[7]

At this moment a community of commercial artists in

Toronto was excited by a concern similar to Walker's. In their spare-time sketching activities, they had begun to work toward the formation of a distinctive school of Canadian painting featuring the Northland as subject matter, but their sense of a need to explore the aesthetic potential of the wilderness must have been linked, one feels, with an awareness they shared with so many others of its availability for pioneer endeavours of all kinds linked to the business life of Toronto.[8]

Ontarians had by then learned to see the North as a cornucopia overflowing with natural resources, no matter how forbidding its aspect might have been in the past. Suddenly, "technology gave value to the landscape,"[9] as one notes in the *Owen Sound Sun*'s description of Toronto artist Tom Thomson's visit in 1912 to the Mississauga Forest Reserve in "the wilds of New Ontario." The report commented on the scenic beauty of the land, but even more emphasis was placed on its rich resources of minerals, forests, water-power, and fish and game.[10]

Thomson's accidental death in 1917 conferred mythic stature on his memory as the guide and inspiration of the artists who formed the Group of Seven three years later. A number of them had explored the north in his company from 1914 to 1916 when their enthusiasm for its possibilities as an artistic resource was inevitably coloured by what may be called the "Grey Owl syndrome" as they revelled in "going native" for a few days or weeks so as to absorb the spirit of what they believed to be a pristine wilderness. This was particularly true of those with strong, "old-country" ties, Varley, MacDonald, and especially Lismer, who wrote eloquently about his first visit to Algonquin Park in 1914 when the North left an impression of "an atmosphere and a glamour all its own," and where spring is "one of the wonders of God's creation."[11] But their new sketching territory was also

remembered as "ruthless and savage," or "vast, drab and lonely,"[12] responses that can be verified with reference to the harsh reality depicted in Thomson's photographs,[13] where one often sees the Northland as the devastated site of the second great industry to be established, after the fur trade, in the North. The lumbermen, whose log-drives had been depicted in early paintings by J.E.H. MacDonald and Lawren Harris,[14] left behind them a land characterized by A.Y. Jackson as "slashed up, burnt over and flooded."[15] But it was this kind of country that Thomson made his own in Algonquin Park, which, as Jackson noted rather wonderingly, "Many people would consider monotonous, but to Thomson it was a treasure house of motifs, rivers, lakes, beaver swamps and abandoned lumber camps."[16]

In his sketches and finished paintings Thomson made some references to the fact that Algonquin Park had become a site for two industries, lumbering and tourism,[17] but in his most characteristic works he explored the new kind of landscape created by the clearing of white pine from the region.[18] He did not entirely ignore the damaging effect of logging on the environment ("drowned land," "burnt land," and shoreline debris are frequently depicted) but for the most part he concentrated on newly opened vistas of sky and water or on finding decorative patterns of colour, form, and texture in the tangle of underbrush, smaller trees, and bared rock, the "bush" that was often the remnant of the original forest.[19] In his best known show pieces like *The Jack Pine* he usually combined both "vista" and "bush."

Georgian Bay had been even more radically transformed by the lumber industry, which had cut down most of its high quality white pine by the beginning of this century. Lumbering continued, but after that the area became what was, in effect, a large, well-appointed holiday resort created by private enterprise.[20] As early as 1900 there were complaints that accommodation was overcrowded and the water-ways were encumbered with log-booms,[21] so it was hardly a wilderness area when Dr. MacCallum's cottage provided a comfortable base from which his artist friends could explore the region's picturesque possibilities. In fact, some of the best-known icons of the wilderness cult in Ontario could almost have been painted from its verandas – Jackson's *Terre Sauvage* (1913, National Gallery of Canada), Lismer's *A September Gale, Georgian Bay* (1921, National Gallery of Canada), and Varley's *Stormy Weather, Georgian Bay* (1920, National Gallery of Canada).[22]

The growth of tourism in the North was rapid and by 1907 Toronto regarded itself as "the gateway of the summer paradise of North America" in Muskoka, Georgian Bay, and Algonquin Park.[23] From the beginning the industry had to offer its customers a product that included not only fresh air, exercise, and scenery but as much as possible of the structure and predictability of urban life with regard to transportation, accommodation, planned social events, and so forth. Eventually, of course, the scenery came to be viewed with reference to an orderly set of expectations as visitors learned what to look for with the aid of the Group of Seven and their followers. Their works evoked romantic communion with the "wilderness" by means of a set of traditional conventions, sublime panoramas, beautiful valleys, and picturesque details, but they were cast in a modernist, "poster-esque" style that had evolved within the cultural processes of industrialized urban life. The combination and imposition of these patterns of form and feeling on the North Country had, therefore, the important function of creating a consoling myth about co-operative interdependence between cities and the health-preserving influence of nature,[24] but at the same time it augmented the process by which the tourist industry became a powerful mechanism for the absorption of the North into the metropolitan system[25] [...]

* * * * * * *
Reprinted from Paul H. Walton, "The Group of Seven and Northern Development," RACAR 17 (1990): 171–3, 178–9.

Arthur Lismer, *Copper Mining
Town, Ontario*, 1924, oil on canvas

ROSEMARY DONEGAN

# Modernism and the Industrial Imagination
## Copper Cliff and the Sudbury Basin

The grey lady of Coppercliff rose 574 feet above the smelter sheds, her face to the weather her hair blowing in the wind; I was impressed.

CHARLES COMFORT, 1935

**PRIOR TO THE FIRST WORLD WAR**, Canada was a colonial society thinly spread through a vast landscape, albeit one that was becoming increasingly autonomous from imperial control and sure of its own authority. It was "the war to end all wars"[1] that was the true beginning of the twentieth century, as Canada was rapidly launched into modernity. As with the United States and Europe, Canada quickly became a more industrialized and urbanized society, experiencing the economic ups and downs that mass capitalist modernization brought with it. The experience of modernity was a combination of intense economic growth, urbanization, and a dramatic rupture with the past, as Canadians sought to leave the past and its traditions behind, to live in the present, to be modern.

This focus on living a modern life would take many forms, but in many ways it was about the evolution of a country of immigrants into a more active and democratic culture, a more equal society. This sense of modernity found expression in the formation of artists' groupings, public art galleries, local arts clubs, the Little Theatre movement, graphic arts societies, emerging Canadian magazines, and, most importantly CBC radio. Politically, the basic democratic demand for the vote motivated women into creating feminist organizations, while there was a proliferation of social and political organizations, co-operative movements, and unionization, which through the 1930s and 1940s fought to obtain a living wage for many working people. It is within this context that the tension between the poles of capitalist expansion and cultural and political democracy proved fertile for the emergence of a distinctively Canadian version of modernism in the visual arts.[2]

It was the resource-extraction industries – mining and smelting, along with lumbering – that financed the growing cities of Toronto, Montreal, and Vancouver and the associated advertising and printing industries. Artists were acutely aware of these developments since most worked in the commercial arts, designing and producing imagery for the growing advertising and publishing industries. Painters such as Tom Thomson, J.E.H. MacDonald, Arthur Lismer, Franklin Carmichael, and Charles Comfort worked as commercial artists, many starting as apprentices when they were boys, sweeping the floors at Brigden's in Winnipeg or at Grip Engraving or Toronto Litho. As commercial artists, they were actively engaged in producing the images and ideas that represented Canada's growing modernization and national industrial aspirations. Their positions within major firms meant that they dealt with clients in the mining, financial, and manufacturing industries, such as Imperial Oil, Massey-Harris, Ford of Canada, Canadian Northern Steamships Ltd, and Inco Ltd. Although these artists were not personally wealthy, within the fluid and emerging cultures of Toronto and Montreal, they associated not only with other artists but also with various mining prospectors, university professors, industrialists, lawyers, and senior civil servants who shared their interests and who they hoped would buy their work! The boundaries between being an artist and having a commercial art practice often overlapped.[3]

In the 1930s there were arguments and discussions among visual artists about the Depression, the experience of modern life, the role of landscape painting, the threat of war in Europe, and the meaning of Canada's cultural and social democracy. These concerns can be seen in the feisty 1937 exchange in the pages of *Canadian Forum* and *New Frontier* between Toronto artists

Elizabeth Wyn Wood and Paraskeva Clark.[4] The debate is sharply drawn, with Wyn Wood representing those landscape artists who have, as she says, "leaned ... upon the wilderness for spiritual stimulation and nourishment,"[5] to which Clark replies (with the help of Graham McInnes) by exhorting the artist to "come out from behind your pre-Cambrian Shield and dirty your gown in the mud and sweat of conflict."[6] Within such arguments about landscape – in the taunts, the stridency, and the anti-communist rhetoric – there is an egalitarian aspiration and commitment to the experience of Canadian modernity. While Wyn Wood is generally seen as a traditionalist and a proponent of a romantic landscape tradition, nevertheless she defines Canada as "Six or seven cities and a row of slag heaps, from a bird's eye view, and enough inhibitions to make good Surrealists of us all,"[7] and goes on to discuss industrial architecture, grain elevators, public education, mass production, and government services. She also praises Canada's "measure of classlessness and of racial co-operation."[8] Wyn Wood concludes with a call for a new art, an art of modernity, one that includes culture and democracy, an art that "might function socially, as art for all ... not for the propagation of an ideology but itself a treasure, an enrichment of life."[9] Wyn Wood's and Clark's exchange is an example of some debates of the 1930s, as artists and writers were grappling with new artistic forms while attempting to create a space for an artistic practice within Canada, arguing about the social character of what Canada could and should be. These debates continued into the 1950s and beyond.

We can see this preoccupation with modernity in the range of visual responses to the northern Ontario industrial landscapes of Copper Cliff and the Sudbury Basin, one of the "row of slag heaps" that Wyn Wood referred to. The imagery of the mining and smelting industry both reflects and constructs the experience of industrial modernity. Considered as a group, the paintings of Copper Cliff and the Sudbury Basin illustrate the complex interrelationships between advertising, government and corporate promotion, mural commissions, and independent art work. In their individual images, the artists attempted through modernist forms to express a new, uncertain experience of the industrial landscape, both in their use of formal and stylistic elements and through the actual representations of industry in its broader social, cultural, and environmental contexts.

THE FIRST WORLD WAR and the high demand for metals led to the emergence of large Canadian and international capital investments in major resource-extraction industries, particularly mining and smelting.[10] This development was particularly dramatic in the Sudbury Basin, where the International Nickel Company of Canada Ltd (Inco) and Falconbridge Ltd were exploiting huge deposits of nickel and copper. The Sudbury Basin as a whole, but particularly the village of Copper Cliff, was the largest and most overt symbol of industrial modernity in Canada and occupied a singular place in the Canadian industrial imagination as part of a larger history of promotion, profit, conflict, and environmental devastation. The astounding scale of the physical site and its mythic role as a place of industrial alchemy, where rock was turned into metal, were symbols of the "New Ontario." Images of Inco's huge Copper Cliff operations, isolated mine shafts, Falconbridge's smelter and mills, and the pouring of hot slag were reproduced in school textbooks, trade promotions, advertisements, and government bulletins. The burnt landscape of the Sudbury Basin became a familiar sight to the thousands of drivers and passengers on the transcontinental CPR line. In particular, they saw the village of Copper Cliff, located at the Inco smelting site, where nightly slag dumping attracted

Charles Comfort, *Smelter Stacks, Copper Cliff*, 1936, oil on canvas, National Gallery of Canada

a large number of locals and visiting artists. Yet simultaneously, this economic transformation of the New Ontario was at odds with the cultural mythology of Canada as a pure wilderness, a vast empty landscape with pure blue skies.[11]

Several members of the Group of Seven visited Sudbury in the 1920s and 1930s, and its industrial scale and vista appear to have challenged them as landscape painters. Arthur Lismer's *Copper Mining Town, Ontario* (1924) depicts the community of Little Italy in Copper Cliff, with its higgledy-piggledy houses, as colourful, vital, and full of human activity, while the huge smelter stacks billow smoke in the distance. Unusual for a Lismer painting, this work focuses on the human scale of the village rather than the drama of the smelter and the ravaged local landscape. Franklin Carmichael's 1928 painting *In the Nickel Belt*, which on first perusal appears to be a geographically distant response formally aestheticizing the landscape, on closer observation presents a more subtle, yet powerful reading. The dramatic beauty of the burnt blue-green rolling hills, seen from a bird's-eye perspective, is subverted by the distant smoke plumes and smelter stacks, which raise questions about the effect of ore smelting on the local landscape. Similarly, A.Y. Jackson's 1932 painting of the Falconbridge smelter near Sudbury, *Smoke Fantasy*, is strikingly unusual in his larger body of work.[12] The smelter and mills are seen as a magical fantasy of billowing clouds of smoke, while a brilliant pointillist sunset of purples, pinks, blues, and greys dominates the painting. Unlike Carmichael and Lismer, Jackson appears to have been somewhat flummoxed by the industrial landscape of the Sudbury Basin. His response of a brilliant colour palette and abstract forms dematerializes the subject and drains the painting of power and meaning.

By far the largest body of imagery of the Sudbury Basin produced during the 1930s was by Charles Comfort. His depictions of Sudbury and nearby Copper Cliff, where Inco's smelters and the company town were located, provide a unique modernist perspective on the Sudbury Basin in the form of product and brand advertisements, sketches, photographs, and easel and mural paintings. Comfort first worked for Inco Ltd when he was commissioned by the company to produce a series of advertisements in an early version of corporate branding. The black and white scratchboard advertisements feature the industrial scale of modern life, the technology of the mines and smelters, at times focusing on striding male figures working – drilling, shifting levers, pouring molten metal – on futuristic cities and automobiles. The accompanying texts describe the new uses of nickel and copper while promoting Inco's brand Monel, a newly developed "rust-proof, corrosion-resistant" metal, which was to be used in many new electrical appliances and exemplified the modern, streamlined kitchen of the 1930s.

Comfort was clearly fascinated by the huge sheds and stacks and the voluminous exhaust of the Copper Cliff smelter. In 1935 he wrote, "The grey lady of Coppercliff rose 574 feet above the

smelter sheds, her face to the weather her hair blowing in the wind; I was impressed."[13] The photographs and oil sketches he produced for himself differ dramatically from the work commissioned by Inco. Comfort's independent work grapples both with the abstract beauty and drama of the industrial landscape and with its environmental effect. In his 1936 painting *Smelter Stacks, Copper Cliff,* the circling smoke pulses from the stacks, coalescing into a stylized dynamic abstract form, dramatized by the subtle use of whites and greys. Similarly, his small sketch *Chimneys* depicting the smelters and stacks huddled under the cliff in a cold grey-brown October twilight of rain and fog, conveys the physical experience of Copper Cliff. In his private writings he noted "the lunar character of the landscape ... the sulphurous stench of the atmosphere and the burning lava spills of slag."[14]

In the fall of 1936 Comfort was commissioned by Inco to paint a mural for a mining display in the Canadian Pavilion at the upcoming 1937 World's Fair in Paris.[15] The twenty-foot-long *Romance of Nickel* depicts the process of nickel and copper production, merging them into a seamless landscape of the New Ontario. The mural is dominated by the inverted Y form of a heroic hard-rock miner, whose aggressive stance emphasizes the power and thrust of machines and miners. A second figure, of an earnest scientist gazing into his microscope, is surrounded by the icons of modern life. The skyscrapers, bridges, crank shafts, streamlined trains and automobiles, radio towers, and airplanes represent technology and industry's rational objectives. The mural combines symbols of technology with French *moderne* design and elements of what one could call Stalinist heroic realism, industrial futurism, and corporate beneficence.[16] It speaks of progress, the future, and jobs at a time when Canada and the mining industry, which had been particularly hard hit by the crash of 1929, had just crawled out of the worst of the Depression.

By the late 1930s, the mining and smelting industry in the Sudbury Basin was in full production since nickel and its alloys were in high demand, as they continued to be during the Second World War. By the mid-1950s, Inco controlled over 90 per cent of nickel production in the world. During the war the International Union of Mine, Mill, and Smelter Workers organized Local 598 and signed up over 17,000 miners and smelter workers at Falconbridge and Inco, while also organizing café and hotel workers and the even the local taxi business. Mine Mill's commitment to social unionism, to a wide range of health and welfare programs, to family sports, and to such cultural activities as ballet and music lessons for children and, most importantly, a summer camp for working people and their families meant the membership had a strong identification with the union.[17]

By the late 1950s, Sudbury miners and smelter workers, like workers in many North American unions, were engaged in a number of acrimonious strikes over wages and working conditions. These strikes took place within the context of intense inter-union rivalry and McCarthyite red-baiting of the Mine Mill leadership because of its sympathy for the Communist Party.[18] Mine Mill saw itself as a democratic social organization, making Sudbury a better place to live by fighting for higher wages and better working conditions for its members. In 1956, in the midst of this bitterness, Henry Orenstein, who had studied at the Art Students League in New York on a veteran's grant and was active in Toronto left-wing cultural circles, was asked by Mine Mill Sudbury Local 598 to paint a mural for the downstairs beverage room of its new headquarters on Regent Street. Union leaders wanted a mural that would represent their ideas of democracy and strengthen the union as a progressive partner in the community, one that would show the intense bonds of militant social unionism while avoiding complex local union rivalries.

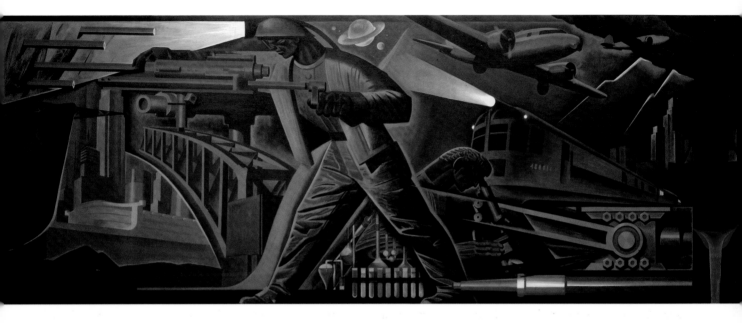

Charles Comfort, *The Romance of Nickel*, 1937, oil on canvas, National Gallery of Canada

Orenstein's Mine Mill mural is organized around the front door of the Regent Street union hall, showing it as the centre of the community, with members and their wives coming and going, talking and gesturing. This image is framed by an ambitious panoramic montage of the towns of Copper Cliff, Gatchell, Sudbury, and Richards Lake, as well as the Falconbridge smelter. Orenstein establishes the particularities of the local industrial landscape, such as the dumping of slag, the cars covered with grey ash, a woman gardening, families picnicking, and men talking and walking home from work, using multiple perspectives and depths of scale. The mural implicitly illustrates the modern tensions between jobs, the burnt and polluted landscape, and a humanistic view of daily life and the union in the community. Orenstein's industrial landscape is both critical of industry and yet celebratory of the democratic potential of modern industrial life. His painting style, reminiscent of Ben Shahn in its graphic linearity, exemplifies the role for murals and community arts within a larger political struggle. Paul Duval, a Toronto art

critic, stated in 1949 that "if we are to keep our people aware of their rights and their worth in the present ideological conflict for their allegiance … We must use every means to help them to a realization that freedom and democracy are not abstractions, but living, dynamic things which are capable of continued growth or devastating blight. And the mural can put these ideas right on democracy's doorstep in a visual form which is readily understood." [19]

Comfort's and Orenstein's murals, although commissioned for entirely different purposes and locations, elaborate certain aspects of modernism as both a stylistic form and a cultural concept. Both are celebratory and fit within the tradition of commemorative public art as didactic images expressing new forms of modern propaganda and advertising. Comfort draws on his background in advertising and illustration. While using the spatial continuum of Diego Rivera's murals, he produces a tightly constructed landscape of industrial wonder and scientific order, similar to Charles Sheeler's series of paintings and photo-

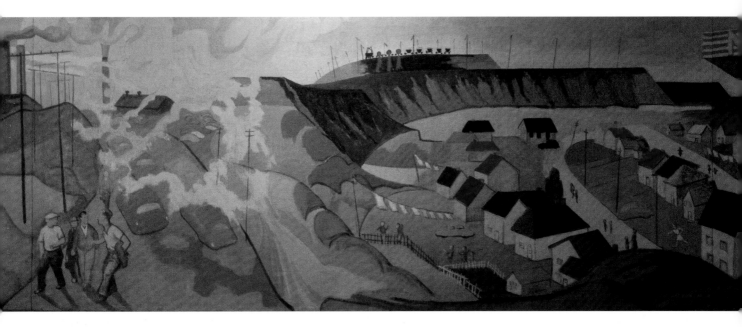

graphs of the River Rouge Ford plant. His figure of the hard-rock miner, although couched in stylized workerist imagery, is actually a corporate symbol and image of Inco. Orenstein's more stylistically naive, but nevertheless layered montage of Sudbury and environs is a visual document of work and community rarely explored in Canadian painting or public art. However, it is in the specificity of their original small sketches for the murals, such as Comfort's *Chimneys* and Orenstein's *Stacks, Copper Cliff*,[20] that these artists show their engagement with the industrial imagination, conjuring in loose abstract forms the ambiguous benefits, negative aspects, and at times exquisite beauty of the industrial landscape.

THE SMALL, BUT SIGNIFICANT body of industrial landscapes of Copper Cliff and the Sudbury Basin – independent artworks, mural commissions, and advertisements – established a vocabulary of images and symbols that are constitutive of Canadian modernism and its industrial imagination.[21] These images, which

acknowledge the conflicts within industry but show a belief in progress and hope in the future, reveal the impact of modernization on the wilderness. The imagery was often ambivalent – starkly beautiful and simultaneously dystopian. The artists sought to capture the new, uncertain experience of the industrial landscape, exposing the tensions and ambiguities of modernity, the industrial economy, and subsequently the environment.

It is worth noting that the industrial landscapes produced by many of these artists are unusual within the larger body of their landscape work. The intense experience of the industrial landscape challenged them as painters and led Carmichael, Comfort, and Lawren Harris[22] to produce some of their strongest mid-career paintings. The paintings focus not on the wilderness but on the double-edged beauty of smoke, chimneys, slag heaps, and the communities that symbolized mineral wealth, jobs, and the extractionist economy. Comfort's images of Sudbury are a remarkably coherent, modernist sequence of images. His vision both within the limitations imposed on the work commissioned

by Inco and beyond that in his independent work represents a new industrial experience.

If we look at the industrial landscapes of the Sudbury Basin as a whole, there are two interlaced visual thrusts or directions evident: the development of abstract forms as an aesthetic response to the realities of industrialization *and* a graphic stylization of forms, which the artists brought from their work as illustrators and designers. The ambiguity of many of the images is an interesting disjuncture between the representation of modern industry in advertising and the artist's independent response to the industrial experience. Shying away from the actual depiction of industry, many of the artists adopt a bird's-eye view of the landscape, a formal distancing, and yet give it a dystopian edge.

Using the critical premises of postcolonialism and poststructuralism, several critics and scholars have re-examined the representation and meaning of the landscape in Canadian visual culture, particularly in the work of the Group of Seven and their associates. What emerges from this analysis is a damning reassessment of the Group's landscape painting as anti-modernist, falsely inflated, and conformist.[23] Many of these critical interpretations, however, ignore the formal strength and complex content of the paintings, dismissing their visual power and ability to draw the viewer into the image;[24] even in reproduction this power is evident, as seen in the consistent popular appeal of the work up to the present time. To dismiss the artists of the Group of Seven as merely an institutional apparatus of the burgeoning national state is also to lose sight of the modernist thrust of their work and its social significance as part of the larger project of developing a modern, democratic Canadian culture. This narrow analysis, which locates the Group and their associates as anti-modernist, ignores their roles as participants in and creators of the modernity of their time. Their industrial images challenged historical notions of beauty and the landscape and still raise questions today about the meaning of modernism and the effects of industrialization on the environment. They explore the issue of how something so powerful and yet so destructive to the landscape as the mining and smelting of ore can still be dramatically beautiful in its abstract form. For these artists, the visual freedom to explore new forms and meanings opened up by modernism also provided the freedom to expand what art could do or be.

The intense sunlight sculpting the stacks and the sunset colours dancing on the smoke plumes of the Sudbury Basin are part of the conflicting visual realities of the industrial landscape. They speak to the often quoted hope of Sir Wilfrid Laurier that the twentieth century would belong to Canada, which may actually have been more insightful as a social, economic, and democratic aspiration than he has been given credit for. As Pearl McCarthy perceptively commented in 1935, Charles Comfort's work is "legitimate modernism, not the modernism which asks the spectator to choose between having naturalism or thought, or aesthetic principles, but one which amalgamates them."[25] These industrial landscapes remain part of Canada's industrial future, pointing to social and cultural problems that have yet to be resolved.

"How Shall We Use These Gifts?"
National Film Board of Canada
photo-story, Release no. 294, 19
September 1961, National Gallery
of Canada

National Film Board Mat Release No. 294.     For release on or after TUESDAY, September 19, 1961.

## Wise Men Scan the Land that has Everything

# How Shall We Use These Gifts?

*Once there was a country that had everything: vast reaches of tall forest, mile on mile of rich black prairie soil, sparkling lakes, broad rivers and fish-abundant seas. But as the years went by the people of this country, having so much, became careless with their riches. They misused the land and were prodigal with water and forest. The wise men of the country grew alarmed and one day they said to the people: "If this extravagance and waste continue, we shall soon no longer be a wealthy country but a poor one. Therefore, let us hold a great meeting and plan how we shall use our gifts that they may continue forever."*

The 11 governments of Canada gather in Montreal October 23-28, 1961, for the most important meeting of Canadian governments since the Fathers of Confederation sat down around a table in Quebec City 97 years before

and decided that millions of square miles of virgin land and lake were to become a nation called Canada. The first truly national conference on "Resources for Tomorrow" has been two years in preparation. Co-sponsored by all the provincial and the federal governments, its purpose is to discuss common problems, pool information about resources and determine "how we shall use them". Discussing the seven topics of agriculture, forests, wildlife, water, fisheries, recreation and regional development, the experts at Montreal will assess the kind and value of Canada's renewable resources, work out guidelines to action by governing bodies. In their hands, on their plans, depends the future of the country that "has everything".

*. . . and lo! the people prospered, because they worked together to make the land and the water work for them.*

It takes land and water and work to make grain. Diminish any one of them and a wheatland becomes a wasteland. Planned use of agricultural resources will keep Canada's wheat growing tall and golden under the sun.

This picture was taken in Canada, for Canada has deserts, and dustbowls, and burned-over forest land, and polluted waters rank with dead, floating fish. These other pictures were also taken in Canada: rolling fields of grain, clean unspoiled beaches, timid wildlife surprised in country so beautiful it makes you sad. Which is Canada's future?

The miles of cars heading north out of the cities on summer weekends indicate modern man's need for space to relax. Recreation is one of seven topics to be discussed at the forthcoming national resources conference. Over 80 background papers have been written for the Montreal conference by experts in various fields.

Country like this was Canada at the time of Confederation, nearly 100 years ago. And much of Canada remains as unspoiled as this Rocky Mountain scene. But now the population is eighteen millions, all needing land, goods, space and water. Resources are no longer limitless. Planning becomes imperative. The conference will promote the idea of planned *use* of resources. A tree not cut at maturity is wasted, just as is one cut before. Planned development can once again make Canada's renewable resources virtually limitless.                National Film Board of Canada Photos

CAROL PAYNE

# "How Shall We Use These Gifts?"

## Imaging the Land in the National Film Board of Canada's Still Photography Division

IN A 19 SEPTEMBER 1961 PHOTO-STORY, the National Film Board of Canada's Still Photography Division presented a series of supposedly emblematic photographs of the Canadian land. This pictorial features an idyllic nature scene complete with deer wading into pristine waters, a farmer surveying a wheat field, a young couple lounging on a beach, and a dramatic vista of the southern Alberta badlands. Accompanying text tells us, in the glowing language of a tourist brochure, that Canada is endowed as "the Land that has everything": "vast reaches of tall forest, mile on mile of rich black prairie soil, sparkling lakes, broad rivers, and fish-abundant seas." It goes on to ponder the question "How Shall We Use These Gifts?"

This photo-essay typifies key aspects of the NFB Still Photography Division's treatment of the land during the 1950s and 1960s. Here we are presented with a perception of the land not only as an emblem of the nation itself but also as a potential treasure trove of economically sustaining natural resources. In fact, this pictorial promoted "Resources for Tomorrow," a conference held in Montreal in October 1961 that addressed the management of natural resources. Photographic rhetoric effectively asserts that message of mastery over an abundant – if, at times, dormant and fragile – earth. Sweeping vistas lend the scenes grandeur, while the photographic gaze enacts a sense of authoritative visual control over all it surveys. But what of the text and particularly the title that frames this layout: "How Shall We Use These Gifts?" Who are these "we" granted such "gifts"? In photo-stories such as this example, of course, a Euro-Canadian audience was presumed; the land is offered as their – that is, our – right to enjoy, to protect, and from which to prosper.

Within the vast archive of images produced under the auspices of the NFB's Still Photography Division, representations of the Canadian land figure prominently. They served not only as markers of Canadian identity but as sites for promoting economic status and enacting cultural and racial hierarchies. This essay will examine official governmental imaging of the Canadian land by the Still Photography Division, with particular attention to photo-stories produced from 1955 to 1969, such as the example introduced above.[1] My treatment of these works is informed by W.J.T. Mitchell's assertion that "landscape *circulates* as a medium of exchange, a site of visual appropriation, a focus for the formation of identity."[2] I will argue that the Still Photography Division's extensive pictorial and textual treatments of the Canadian landscape are encoded in two distinct though complementary configurations. First and most prominently, pictorial conventions of landscape are adopted to promote natural resources and their exploitation by governmentally sanctioned industry. Here it is implied that the land's true value is measured in economic terms; it has been unleashed and protected only through the industry and ingenuity of Euro-Canadians. By extension, land as economic resource becomes a sign of national prosperity itself. Secondly, landscape devices appear often in relation to Aboriginal subjects. But in this second group, they contribute to the Division's consistently paternalistic representation of First Peoples.

Although lesser known than the National Film Board's much celebrated Motion Picture units, the Still Photography Division also achieved an ambitious and influential program over a history spanning 1941 to 1984. The Division commissioned, disseminated, and organized some 200,000 photographs as well as hundreds of "photo-stories." These often jingoistic images and pictorial essays were consumed regularly by millions of Canadians and international audiences in newspapers, magazines, NFB-sponsored picture books, and exhibitions. In effect, the Division served as the country's image bank, constructing a

governmentally endorsed portrait of nationhood within Canada and abroad.[3]

The Still Photography Division was founded in 1941 – two years after its parent agency – under John Grierson. A central figure in the history of non-fiction film, Grierson both authored the 1938 report prompting the Canadian government to found the NFB and served for six years as its first government film commissioner.[4] The Film Act charged the NFB with the task of "help[ing] Canadians in all parts of Canada to understand the ways of living and the problems of Canadians in other parts" – in effect, fostering a sense of national cohesion.[5]

Long after he departed the NFB in the mid-1940s,[6] Grierson's influence would loom large over the Still Photography Division, particularly his allegiance to and interpretation of "documentary."[7] For Grierson, documentary – in film, photographs, or other media – primarily served the state and managed citizenship.[8] Not only at the NFB but within a broader sphere, photographic and filmic documentary emerged during the 1930s and after, as John Tagg and Bill Nichols have demonstrated, as privileged forms in a pervasive discourse of social management.[9]

The authority of the documentary photograph stems from, first, a historic investment in the credibility of industrial machinery[10] and, secondly, the commonly held perception that the photograph is – in Peircian terms – an *indexical* sign.[11] It is the second of the two – the photograph's existence as a seemingly unmediated reflection of its referent – which is particularly relevant for this study. If the photograph in general can therefore be understood as an indexical sign, the loose category of documentary images magnifies that interpretation; they effectively resist all other potential readings by privileging the photograph's role as a conveyor of supposedly unimpeachable information.[12]

But, of course, a photograph is by no means a wholly neutral and objective trace of the visible. A belief in photography's factuality and authority is predicated on two highly debatable premises: the reductive equation between the concepts of "truth" with "objectivity" and the belief that empirical information provided by the human optical nerve is "objective" and universal. Even for those stubbornly clinging to the empiricist belief that optical experience is equivalent to factualness, the camera poses problems. Though possessing a seemingly indexical relationship to our perceptions of external appearance, a photograph, it is generally agreed, does not precisely replicate optical sensation and it *mediates* the visible world it represents. The camera frames subjects within arbitrary borders excluding peripheral and – usually – binocular vision; alters depth, colour, and tone; extracts one visual instance from a temporal continuum; translates optical experience into the form of a two-dimensional representation employing the conventions of Western Renaissance perspective; and recontextualizes through placement, accompanying language, and the vagaries of reception, among myriad other means.[13]

Documentary photographs, such as those produced by the NFB Still Photography Division, have long been recognized as effective tools of persuasion – or, more pointedly, as means of encoding ideology – specifically because the photograph is at once a malleable carrier of meaning and yet convincingly disguises subjective "opinion" as dispassionate fact. In short, documentary constitutes, in Foucauldian terms, a *regime of truth*.[14] John Grierson himself acknowledged the disguised subjectivity of the filmic and photographic image when he famously defined documentary as the "creative treatment of actuality."[15] Yet typically, Still Division images – like photography in general – have been presented as neutral, objective, and authoritative facts. It was this perception of the photographic image that

made it an ideal tool for Grierson's project of institutional social management.[16]

THE DIVISION'S CHIEF VEHICLE for disseminating photographic images throughout much of its history was the photo-story, such as the example discussed above.[17] These layouts featured between four and nine photographs accompanied by captions and a brief text. With their construction of a linear narrative, combination of text and image, and collaborative character, photo-stories reflect the ongoing influence of the film industry in Division work.[18] Although NFB film production divisions were moved to suburban Montreal in the mid-1950s and consequently there was little direct interaction between the Still Photographs Division and those units, the structure of the Division and its approach to photographs would continue to reflect filmic conventions.

Photo-stories were produced as often as weekly and distributed in both French and English to Canadian newspapers and magazines as well as to international publications. From the 1950s through the 1960s, placement of photo-stories ranged from the popular Canadian pictorials *Weekend Picture Magazine* and *Canadian Geographic* and various international newspapers through the Associated Press to more modest special interest publications such as the Hamilton, Ontario, religious publication the *Calvinist Contact*.[19] To their wide readership, photo-stories probably appeared indistinguishable from a publication's editorial content. The National Film Board was generally only noted in a tiny byline sometimes accompanied by the assignment photographer's name or not acknowledged at all. This presentation, of course, enhanced their semblance of neutral authority; but it also underscores the institutional character of their authorship.

Division photo-stories remained remarkably consistent in tone and style during the period discussed. Throughout, photo-graphs are given precedence over text; images are arranged to move the viewer's eye around smoothly, often with one visual "protagonist" appearing as a figure with whom the viewer identifies. In contrast, text is limited to less than two hundred words with additional, though brief, captions, all written in the imperative and jingoistic voice of national salesmanship. Although by the mid-1960s the Division, in exhibitions and book-length publications, was promoting a more personally expressive form of photography or the still photographic equivalent of what film theorists Bill Nichols and Julianne Burton term "observational documentary," photo-stories during the same years continued to rely on a presumption of anonymous neutrality and authority. Like the expository or "classic" documentary film work of Grierson himself during the 1930s and 1940s, they remained unflinchingly didactic and relied on the all-seeing eye of the camera as a sign of the omniscient authority of government.[20]

An irrepressibly optimistic picture of Canadian prosperity, progress, and harmonious diversity emerges from the photo-stories. In these pictorials, three general themes recur: the country's diverse geographic and multicultural makeup, achievements by individual Canadians (particularly in the sciences and arts), and the country's natural resources. Yet it is those addressing natural resources which mark the most frequently recurring subjects for NFB photo-stories. Of the five hundred photo-stories produced between 1955 and 1969, approximately ninety (or almost one-fifth) dealt with some aspect of Canada's natural resources.

Within this group, landscape imagery became a prominent and consistent feature. Eye-catching vistas and yet more dramatic aerial views of expansive terrains were highlighted in virtually all of these pictorials. While the Division also produced scenic views and scenes of outdoor leisure for pictorials devoted to tourism,

"Revolution on the Prairies,"
National Film Board of Canada
photo-story, Release no. 115, 22 July
1957, National Gallery of Canada

natural-resources photo-stories were the most frequent vehicle for the pictorial strategies of landscape. They are conspicuous in the Division's various treatments of the oil industry and other mineral resources, as well as in those dealing with agriculture. The last of these, for example, also often associated the fecundity of the earth with the female body. A recurring topic for photo-stories on Canada's natural resources and a key site for images of the Canadian land were those addressing the lumber industry. Approximately one-tenth of natural-resources photo-stories addressed some aspect of pulp and paper production or logging. Images of lumbering were also featured in the annual photo-stories that served as year-end reviews. Finally, photo-stories addressing fisheries, hydroelectricity, and water also exploited the potency of the landscape view.

Like photo-stories in general, the use of landscape in those devoted to Canada's natural resources follows a relatively uniform configuration. Typically, each pictorial features one large landscape view, whether an aerial depiction of crops or a distant vista of logging or another dramatic scene. This highlighted image is augmented by an array of three to eight other photographs depicting closer views of the area featured, scenes of labourers at work and at rest, and often a portrait of an individual who emerges as a protagonist in the narrative. In all of these pictorials, the large landscape view was crucial in arresting the reader's attention and contextualizing both text and other images.

Dominant landscape views in natural-resources photo-stories were used – ostensibly – to provide credible information about the industry featured. They offered geographical context and detailed visual data. But, of course, they were also effective promotional devices. The sheer scale of the sites depicted in virtually all natural-resources photo-stories, signalled a sense of natural plenitude. The grand vista, in particular, came to function as something of a pictorial analog to economic prosperity.

In addition, this emphasis on the image of the land met the Board's – and the Division's – overall mandate to construct a pictorial and textual rhetoric of national unity. These images achieve that lofty goal in several ways. Generally, they function as synecdoche. In short, specific terrains come to stand in for the *whole* – not only the whole of an industry, such as the lumber industry, or a particular region of the country but often for the entire country. Photo-stories regularly minimized specific references – to the site and date of the representations, for example; accordingly, they were granted a sense of universality. Similarly, when individuals were presented, they usually appeared as relatively interchangeable archetypes. This suppression of specifics and emphasis on typologies also had a more pragmatic function: images that were not exclusively associated with a specific series of current events could more readily be reused in a variety of different contexts. Division images, elaborately catalogued according to subject matter, were – and remain today – accessible to a variety of government agencies, organizations, and individuals for distinct ends.

Landscape photographs within Division photo-stories also buttressed calls for national unity simply by evoking the time-honoured equation between 'nature' and Canadian cultural identity. Numerous scholars, including many of the contributors to this volume, have noted that images of wilderness and notions of Canada as a (mythic) arcadia have long been part of the discourse on Canadian nationhood. Idealizing and seemingly eternal, landscape representations have long proved effective and unifying emblems of the state. Even in images devoted to the industrial exploitations of the land's bounty, such as the natural-resources photo-stories discussed here, "nature" as a signifier of "Canadian-ness" is central.

# Revolution on the Prairies

Mechanization of prairie farms began in the 20's, was rapidly accelerated during war years when farmers turned to machinery in lieu of man-power. Schiefner works his 1,440 acre farm with the help of one son.

Ed Schiefner has always been a man to keep abreast of the times. He brought the first combine into his area in 1926, has kept pace with the continuing search for more efficient methods of wheat farming.

New methods of harvesting grain have wrought a revolution on Canada's wheat farms. Fields dotted with golden stooks of wheat ripening in the sun—once the picturesque trademark of the prairies—are rarely seen. Today most farmers harvest their grain like Saskatchewan's

Ed Schiefner above. The wheat is cut and left lying in "swathes" to ripen on the ground where it is less affected by wind, rain and hail which can destroy a crop overnight. "Swathed" wheat ripens in about half the time it would require while standing.

Wheat farming has given the Schiefner family a good living. Their attractive home has every modern convenience; radio and television have broken the isolation of the early homesteaders.

Straight combining—cutting and threshing the grain in a single operation—is disappearing. Farmers prefer to reduce weather hazards by "swathing" their fields first, harvesting later when grain has ripened.

The grain is trucked to country elevators, later is hauled by box car to the lakehead elevators which have a storage capacity in excess of 90 million bushels. Three of the many elevators at Port Arthur, Ontario, are shown above.

Improved varieties and modern harvesting methods combine to keep Canada on top as the world's leading producer of high quality wheat.

National Film Board of Canada Photos by Richard Harrington.

While the landscape format in photo-stories devoted to the country's natural resources proved useful to the Division's promotion of a unified Canada, it was also the site for enacting a mastery over the land. Recent scholarship, particularly that informed by postcolonial discourse, has exposed the complex ways in which landscape as a category not only symbolizes but enacts colonialist desire.[21] As W.J.T. Mitchell argues, "the representation of landscape is not only a matter of internal politics and national or class ideology but also an international, global phenomenon, intimately bound up with the discourses of imperialism."[22] By invoking landscape's scopophilic possession of territory, Still Photography Division photo-stories "naturalize" governmental claims of Canadian prosperity and plenty.

A 22 July 1957 photo-story on farming, entitled "Revolution on the Prairies," for example, exploits the gaze to assert a sense of natural abundance and to endorse agricultural technology. This arrangement of six photographs with captions revolves around the figure of Saskatchewan wheat farmer Ed Schiefner. Presented as an archetypal prairie farmer, Schiefner is featured in a prominent and deferential portrait at upper right; but he is also seen in a supposedly typical day: cutting wheat, stacking bales, and eating with his family. Images devoted specifically to the Schiefner family are augmented with those of a larger-scale farming operation and an aerial view of grain elevators at

## _Age-Old Hunt For Fabled Fish of Canada's North_

# SAPOTIT - Where The Char Run Big

As the sky-circling sun of the arctic summer skims ever-lower during its midnight arc across the northern horizon, families of Canadian Eskimos head inland. With the sun's long, drawn out, day-by-day farewell giving warning of yet another far-off winter to be provided against, the hunters, living in the ways of their forefathers, make for the ice-cold rivers where the big fish gather. As glistening, sleek, fat-bellied arctic char leave ocean feeding grounds to shoal in the river waters, the Eskimos build stone walls in the icy current to trap the succulent fish. For days men toil waist deep in the frigid pools, piling rocks against the river's flow. When all is ready and the fish are trapped, hunters take their spears, wade among them in great excitement. Small fish and agile fish are lucky. Through holes in the weirs and by leaping the stones they break free to continue up-river. Numbed by the water's chill, the hunters drag their catch ashore for cleaning, set aside tasty fish bellies for future feasts, eat a few fish and as they work away. Later,

A dozen miles upstream from salt water, near Pelly Bay, 100 miles inside the Arctic Circle, Eskimos spear fish at a _Sapotit_—fishing site. Stone walls of trap must be rebuilt each year in icy water.

placed in piles and covered by rocks, the fabled fish of the north—a staple food in times of want—is cached for the winter sustenance of man and dog.

Eskimo hunter Iteemangnak, holding his fish spear constructed of musk-ox horn prongs bound onto a wooden handle with sealskin thongs, is delighted at his catch.

NATIONAL FILM BOARD
PHOTOSTORY

Iteemangnak, his wife Panneeak and their son pull catch to river bank for cleaning.

As char runs increase in size, catches of fish mount up in front of Eskimos' seal and caribou skin tents. Fish are cached under rock piles to await winter's need.

One of the women, with child on her back, at work spearing arctic char — a succulent fish of the salmon family that vies with its Atlantic cousin as a delicacy.

---

Port Arthur (now Thunder Bay), Ontario. Within this pictorial, we witness that complex intersection of gazes that Catherine Lutz and Jane Collins have discussed in their study of _National Geographic_ photography.[23] The photographic gaze prominently exploits sweeping vistas and aerial views. This characteristic is apparent particularly in the top left perspectival view of Shiefner cutting his crop on a seemingly endless plain and in the lower right vista of grain elevators on Lake Superior. These images signal not only enormous scale and wealth but also the sheer power of modern machinery. (Indeed, accompanying captions stress the "mechanization" and "modern conveniences" available to prairie farmers.) At the same time, the views also provide

a sense of scopic possession. The portrait of Ed Schiefner at the upper right compounds this. He is viewed from below, a photographic convention that enhances the subject's stature and implies respect. In turn, the layout has been designed so that Schiefner seems to gaze across his land with a look of satisfied pride. We join him in that gaze, for the image of Schiefner functions as a surrogate for the viewer. The pictorial message of economic prosperity – one that is utterly at odds with realities of prairie farming today – is further buttressed by accompanying text. The language emphasizes enormous scale through specific quantities and statistics. Here, for example, Schiefner's 1,440-acre farm is noted, as is the Port Arthur, Ontario, storage facility with

a "capacity in excess of 90 million bushels."

This example typifies natural-resources photo-stories in text and pictorial content. Together they extol the land's great abundance, while suggesting that those potential riches are unleashed only through technological expertise. At the same time, they imply that this expertise is the domain of Euro-Canadians, who were virtually the exclusive subjects of natural-resources photo-stories. Indeed, as well as other non-Europeans, it is notable that while aboriginal peoples were the frequent focus of Division photo-stories in general, they were almost entirely excluded from those depicting Canadian natural resources. Instead, aboriginal subjects – even those about harvesting foods – were segregated into ethnographically oriented narratives. Again, references to "nature" and the visual rhetoric of landscape were central to depictions of First Peoples in photo-stories, but now the meaning of the land shifted. In short, if landscape was a marker of national identity, it was also coded in terms of race.

A 1964 photo-story treating Arctic char fishing near Pelly Bay, just outside the Arctic Circle, provides an example of the racial coding of the land in Still Division photo-stories. This pictorial features five photographs under the title "Age-Old Hunt for Fabled Fish of Canada's North: SAPOTIT – Where the Char Run Big"; each portrays Inuit fishermen in their "sapotit" (a stone fishing weir or structure to confine fish) and with their catch. The contrast to "Revolution on the Prairies," the photo-story noted above, is striking. Here grand vistas of the open prairie give way to claustrophobic views, pictorial order to disarray, and the emphasis on the latest in technology to – as the text tells us – "age-old" procedures and tools. Indeed, images and accompanying text go to great lengths to emphasize the "primitive" character of the Inuit tools and methods. In the Pelly Bay photo-story we are once again introduced to a central protagonist:

the Inuit fisherman Iteemangnak. His portrait, too, is featured prominently as a means of personalizing what is posited as a broader phenomenon. Pictured at the upper left directly below the title, Iteemangnak is, however, shown at a less deferential angle than Ed Schiefner. Rather than contemplatively surveying the land and thereby signalling a sense of domain over it (as occurs in the prairie photo-story), Iteemangnak looks toward, though not directly at, the viewer. Schiefner's serious countenance is replaced with an awkward smile. Iteemangnak appears as the object of the intended viewer's gaze, not, like Shiefner, a surrogate for their presence. The other images included in the Pelly Bay pictorial view Iteemangak's fellow fishers from above and at somewhat of a distance. This was the Division's then standard vantage point of supposed objectivity, unobtrusiveness, and authority. The photographs diminish the apparent stature of the people portrayed while suggesting a superior, caretaking role for the implied, non-Native viewer.

In this, and other photo-stories addressing aboriginal subjects, Canada's First Peoples were often associated with the land pictorially and through text. However, rather than asserting domain over nature, they appear encompassed by it.[24] This approach is apparent not only in the visual representations but in accompanying text, which presents the fishermen as part of the rhythms of nature:

As the sky-circling sun of the arctic summer skims ever-lower during its midnight arc across the northern horizon, families of Canadian Eskimos head inland. With the sun's long, drawn out, day-by-day farewell giving warning of yet another far-off winter to be provided against, the hunters, living in the ways of their forefathers, make for the ice-cold rivers, where the big fish gather ... For days men toil waist deep in the frigid pools.

In short, the Inuit hunters and their families portrayed here have become the objects of a controlling colonial gaze, enacted literally in visual terms and more metaphorically by text, as surely as the land itself.

Division photo-stories addressing aboriginal subjects employed some of the key forms of colonial discourse that Homi K. Bhabha has outlined.[25] The photographic image emerges as an effective vehicle for the promulgation of the stereotype, which according to Bhabha constitutes colonialism's "major discursive strategy." The photographic gaze, then, is critical in the enactment of the colonial assertion of power, but it is also highly ambivalent, constructing the Other as at once "an object of desire and derision."

Images addressing the Inuit often depersonalize and infantilize their subjects. The Inuit are routinely described as "childlike" and shown just as often in apparent awe of southern (Euro-Canadian) technology.[26] An elevated vantage point – seen in the photo-story featuring Iteemangak and, indeed, in most photo-stories featuring the Inuit – effectively diminishes the subjects and implies an elevated guardian-like status for the viewer. In photo-stories featuring First Peoples, the image of the land is again central, but not as an extension of national domain so much as a means of containing the aboriginal Other.

As Robert Houle has observed, there is no word in any Native North American language still spoken for "landscape."[27] A Western (European) concept predicated upon a hierarchical Renaissance model for organizing space, landscape entails a perceived division between viewer and environment. At the same time, it also plays on the notion of scopic possession by the viewer. Within American aboriginal pre-contact societies, the idea of such distinctions was culturally antithetical. Instead, representations of the physical environment were integrated.[28]

In photo-stories produced by the National Film Board of Canada's Still Photography Division, such as the examples cited in this essay, representations of the Canadian land were tightly coded. As I have argued, landscape images appeared most frequently in photo-stories devoted to Canada's various natural-resources industries. Within that context, sweeping vistas of grand terrains were effective in promoting a sense of the country's natural plenitude and Euro-Canadian expertise in unleashing those riches. Such standardized or interchangeable views were employed as a means of promoting national unity, the NFB's chief mandate. The images were also coded in terms of race. If images of natural-resources industries celebrated mastery over nature, those depicting First Peoples deployed representations of the land to enact a cultural containment. For the NFB's Still Photography Division, the land was a potent marker of Canadian identity, one in which national attitudes toward the earth, economics, and race were deeply inscribed.

# Reflections on Being Born in a Group of Seven Canvas That Is Magically Transformed into a Sensuous Eleanor Bond Painting

MEL WATKINS

Eleanor Bond, *Converting the Powell River Mill to a Recreational and Retirement Home*, 1985, oil on canvas, Canada Council Art Bank

UNBEKNOWNST TO ME AS A CHILD, I was born in Group of Seven country. (Colleagues who know me as a political economist rather than as an art critic, please note that I am not talking about Canada's membership in the so-called Group of 7, a.k.a. the G-7 that is presently running the world if anyone is, where Canada is allowed in, the cynics say, to make sure that a U.S. motion always has a seconder.) At the time, growing up on a farm near Parry Sound on Georgian Bay, it simply seemed like a place where there was too much rock and too much wind.

Trees were nice to look at, and fun to climb when your parents weren't watching, but my father and his father before him made such living as they could by cutting them down. Rocks were for skinning your knees. Water was avoided, since few could swim. The only people who really seemed to get off on the scenery were the tourists, and their patronizing ways with the locals – sonny, are we on the right road to see those lovely quints?[1] – were, to say the least, off-putting. I grew up to appreciate the story about the anthropologist who, when asked how tourism could help the people who lived there, said "Send the money and stay at home." At the time, one could hardly help noting that the tourists were nowhere in sight when the air was bitterly cold, and the snow banks were above your head, and the hard part of living was happening.

I do not remember at what point in my schooling I first became aware of the Group of Seven, but it was not a minor moment. Last summer (1996) I went to Montreal to see the René Magritte exhibition with its magnificent skies of blue and billowing clouds, and ever since I have looked more longingly at the sky and have been conscious of how much we are cut off from it in cities bathed in electric light. Similarly, to see even a bad reproduction of the Group of Seven landscapes was to realize the beauty that abounded in scrabbly rock and scrub pine. The first time I saw the real thing (art that is), when I came to the University of Toronto as a student and whiled away the hours studying in Hart House with its well-hung walls, I was deeply impressed by the texture of the oils and the vividness of the colours, and I began to appreciate the beauty of the countryside which I had so gladly fled.

All of which fits with the central argument of Simon Schama's magnificent book *Landscape and Memory*: "Landscapes are culture before they are nature; constructs of the imagination projected onto wood and water and rock"[2] – the holy trinity for Schama and for the Group of Seven. (And I agree with Schama that any easy linking of democracy and the forest is problematic. The only time that Parry Sound kicked up its heels and went CCF/NDP was in the 1940s when war plant jobs had pulled people off the land. Paint the prairie wheat fields and the grain elevators if you want to celebrate the roots of deep democracy in this country.)

But I could never quite shake my sense of the absurd that seemed to inhere in the difference between the Group of Seven's take and mine. The locals, understandably, tire of stories about city slickers roughing it out in the bush when the locals did it to keep alive. Like others, I came to wonder why there were never any people in the Group's pictures. Vegetable and mineral, but no animal. Were there Indians hiding behind those trees whom, since they are such stealthy chaps, we understandably can't see? Where is the ubiquitous summer cottage, or is this the view out the frame of the big plate glass window? (There's a kind of postcardy you-could-build-a-cottage-here-if-you-could-find-a-place-for-the-septic-tank look.) As for those who tried to make a living out of this stony land, they're just irrelevant.

I frankly didn't feel part of the picture and still don't … nice place to visit but I wouldn't want to live there. I can understand why some Ottawa officials feared in its time that the Group of Seven paintings would discourage immigrants – who had not yet

thought their way through to becoming cottagers.

Professionally, I became an economic historian, powerfully under the influence of the great Harold Innis and his pioneering studies, in the 1920s and 1930s, of the staple trades. Innis's creative genius did for indigenous scholarship what the Group of Seven did for art. It is striking how both, at the same time, painted the same picture. Innis massively documented the myth of Canadians as "hewers of wood and drawers of water" – and blasters of rock – but his critics complained, then and now, that there were too few actual people populating his pages, that, in today's Gramscian discourse, there was too little by way of human agency.

Briefly, in the 1960s, when personal circumstances permitted it, I became a modest collector of art. I discovered that my tastes ran, with the times, towards the abstract. I have, still, hanging over my mantelpiece, an original watercolour by Gershon Iskowitz entitled *The Parry Sound Series 1965 #1*; to me, it is the gentle colours and deeper hues of a sunset filtered through dark and swirling leaves. It is like no sunset that I saw in Parry Sound, but Iskowitz had the advantage of not being born there and coming to it with fresh eyes.

Enter Eleanor Bond, whose work I discovered only yesterday and who has made me feel at home again. Consider the painting *Converting the Powell River Mill to a Recreation and Retirement Home* or *Development of a Fishing Village as a Honeymoon Resort*; contemplate that nonsensically no-nonsense title. It so happens that the farm I was born on has long since been sold. The hay fields where the scorching sun beat down and there were no trees for shade, the potato patch where, by the time you'd finished hoeing the weeds and killing the bugs, you had to start again, have become a trailer park. Not for the affluent, but for those who can't afford cottages.

I went there a year or so ago, drove around, got out of the car and stood and stared, and in my middle-class academic way I thought it was a bit tacky and I felt sad and lost and out of place. But then I thought, these people, some of whom have parked their trailer for good (let's hope they have another one in Florida), are letting the flowers grow the way my mother did, are enjoying this place. They've found a use for this God-forsaken land where, once the mighty pines had been felled, there was no excuse for staying around.

What's happened to the old farmstead is pretty absurd, if you think about it, but in a hopeful sort of way. It's right up there with John Steinbeck, who went back to Monterey, California, to the sardine factories on Cannery Row that he had written about, and they were all closed and the place was overrun with tourists. When someone asked what he thought about that, expecting perhaps that he would complain about the loss of the good old days, he said, Well, you can run out of fish but you can't run out of tourists.[3] Atlantic Canadians should take note; somewhere on the east coast, there's a place crying out for the Bond-like motto: From lobster trap to tourist trap. (Mind you, a line must be drawn on this touristy talk, like when Newt Gingrich gushes about tomorrow's "honeymoon in space" and adds – this man isn't just a political pervert – "Imagine weightlessness and its effects and you will understand some of its attractions.")[4]

Who needs nostalgia and sentimentality when you can experience the freedom of life, the amusement and the anxiety[5] in the land of the absurd? Eleanor Bond has put some sanity into that sanitized Group of Seven.

By the time I was a child the great stands of old pine were gone, but I remembered how my brothers and I reimagined them every time we heard our grandfather (whose farm it was) offer us one huge nickel for every knot we could find in a milk-house built of those ancient trees; we knew better than to waste our

time looking and sometimes he gave us a nickel anyway. (He was endlessly perplexed by stories of how the cottagers were actually paying more for knotty pine.)

I remembered that while we still lived there and pretended to farm (my father claimed that the rocks grew faster than the potatoes), they straightened the road that ran past our house. They blasted some rock – it was wondrous to watch – and the boulders strewn about were shortly adorned with wild roses. There one could sit, careful to avoid the thorns, and watch the occasional car go by and dream of the day when you'd be in it. That's progress.

Jumping jarringly to the present, go back to that quotation in endnote 5. Is Bond depicting fact or fiction? I think the former. She's certainly on top of what passes in my profession as economic conversion. When, a few years back, the armed forces base was closed in Summerside, PEI, the federal government located the processing centre for the dreaded GST there – replacing, admittedly, one undesirable activity with another. When the Pinetree Line radar system in Northern Canada was abandoned in the late 1980s as the Cold War thawed, DEW stations were converted into everything from a retirement village to a self-contained native community. Such serendipity is pure Bond.

Not to put too fine a point on it, what I like most about Bond is the playfulness of her paintings; at the end of this dreadful century, we're entitled to an occasional reminder of the joyful side of modernity. I have the utmost respect for John Bentley Mays who has brought depression (mine included) out of the closet,[6] but where he sees Bond as a critic of the chaos wrought by capitalist culture,[7] she makes me like life in the technological society.

My eldest son was, as a small child, utterly entranced when he saw a freight train carrying cars – literally technology piled on technology. Times Square (what a clever name for a space) did that for me as an adolescent – a memory I have to suppress whenever the issue arises of what hydro exports have done to the Cree. (In the higher stage to which electricity has since taken us, Times Square has become merely garish and tacky and dirty, but in its day, I can tell you, it was wondrous to behold.)[8]

For me, there's a lilt and a lightness to Bond, a dizziness, a dazzle, a riot of colour, the deadpan humour of the titles; there's more than that in her paintings, but what I see is there for the taking. There's also a sensualness, a sexiness, that spices up the experience – maybe Newt is on to something. To this aging male, there's a welcome feminine quality about her work – captured by the lusciously titled *The Centre for Fertility and Ecology Is Subsidized by Visitors to the Waterslide Area*, where even the market is being civilized – in contrast with the stern patriarchy of the Seven (who, incidentally, were not only all men, and all white, but all anglos; the Toronto-based Group of Seven speaks to national unity only in English).

Arthur Kroker makes the compelling argument that discourses on technology – from Harold Innis to Marshall McLuhan to George Grant to (I would add) Ursula Franklin – are central to the Canadian mind.[9] The technological environment is as real as any physical landscape; Innis's *Changing Concepts of Time* could have been titled, Schama-like, *Technology and Memory*. By rendering technology visible, by making us actually acknowledge its existence and contemplate its character, Bond seems to me to be as important today as the Seven were in their time.

In Kroker's terms, it's no accident that Bond is a Canadian. Place matters, even when it is not content for the painting, because it is context for the artist; if the real message is the medium, the real content is the context. Perceptive though she is, Naomi Klein is wrong when she writes, "We cannot update the Group of Seven because we have abandoned its premise: the belief

that place matters."[10] It's hard to square that with Eleanor Bond's most recent series of paintings, which are about Rotterdam, done in Rotterdam under local commission and titled *Cosmoville*, at the same time as she insists, convincingly, that she is grounded in Winnipeg.[11]

How does Winnipeg matter? When I was a graduate student in economics many years ago, in Cambridge, Massachusetts, the Sunday *New York Times* carried an ad inviting industry to locate in Manitoba because it was half way between the Atlantic and the Pacific. Given that transport by land was considerably more expensive than by water, economics said that was exactly where one shouldn't locate! So there's an ambiguity, an ambivalence, if not some confusion, about the place; is Winnipeg in the west or the east? Maybe it's best, in these post-everything times, to be grounded in a place that is itself not too grounded.

Though there's still that mystery of the missing persons that cannot be found. Whenever I go to Queen's Quay Terminal in Toronto's Harbourfront, I pause to re-enjoy Lupe Rodriguez's *Luncheon on the Grass: A Canadian Perspective* (1994) with its vivid colours and Latin feeling of, oddly, a picnic with no people. We seem in awe of what's outside us. Marshall McLuhan claimed that we Canadians are the only people who go outside to be alone. Apparently we wander right outside the frame.

It's true, I suppose, that a painting only exists when someone looks at it (we're back to context again), so in that sense people are always there. But I risk sounding as if I know what I'm talking about, whereas I actually only know what I like.

★ ★ ★ ★ ★ ★
Reprinted from Mel Watkins, "Reflections on Being Born in a Group of Seven Canvas That Is Magically Transformed into a Sensuous Eleanor Bond Painting," *University of Toronto Quarterly* 66, no. 2 (spring 1997): 411–16.

# Eleanor Bond

*LATER, SOME INDUSTRIAL REFUGEES FROM COMMUNAL SETTLEMENTS IN A LOGGED VALLEY IN B.C., 1987*

*THE WOMEN'S PARK AT FISH LAKE PROVIDES HOSTELS, HOTELS AND HOUSING, 1990*

# Contest and Controve

# Chapter 5

# Contest and Controve

THE LANDSCAPE PAINTINGS of the Group of Seven and their associates generated almost as much controversy at the end of the twentieth century as they did at the beginning of it. In the three case studies that follow – two involving major art institutions and the other concerned with the "institution" of Emily Carr – national identity and its representations are at the core of the disputes. All three case studies date from the period 1990–2000.

In the give-and-take of these acrimonious debates, three questions kept recurring. Who should have the authority to recount the narratives of Canadian art? What forms should those narratives take? And how should national identity figure in the construction of the narratives? "Culture has long been the pivotal point," Anne Whitelaw observes, "around which the contestation of national identity has occurred in Canada." Through institutions of culture, such as the Canada Council for the Arts, the CBC, the McMichael Canadian Art Collection, and the National Gallery of Canada, governments have subsidized domestic cultural production as a matter of policy. Among the stated reasons for subsidization have been the formation of national unity at home and the promotion of Canada's status abroad. For example, the circulation by the National Gallery of reproductions of paintings by Tom Thomson, the Group of Seven, and other contemporary artists, which is discussed by Joyce Zemans, had an important place in the definition of Canadian art from the 1920s onward.

There is a long and noisy history in the modern era of attacks against art and its interpretations both in North America and in

# Chapter 5

sy

Europe. Attacks have been mounted against the exhibition of art, the acquisition of art with public funds, the placement of art in public settings, and the right of certain kinds of art to exist at all. All four forms of attack save the last one come into play in the case studies, especially that involving the McMichael Canadian Art Collection. It is well documented that the visual side of the so-called culture wars of recent decades in the United States have revolved primarily around contemporary art. This has been the case in Canada too, except that historical art has played a substantially larger role in art controversies north of the border than it has to the south. In Canada there have been concerted attempts to reinscribe discredited narratives of historical art by situating it in a sanctified zone beyond debate. In "The Trouble with Emily," Robert Fulford dismisses the work of half a dozen West Coast critics and curators for presenting alternative – that is, alternative to the traditional – interpretations of Carr's work.

Robert McMichael, founder of the gallery that bears his name, took extreme measures to protect what he understood to be the traditional story of Canadian art against contrary interpretation. He tried to enforce a view of Canadian art that was purged of the present, especially what is diverse and polyglot about the present. Richard Hill argues that McMichael's model was the graveyard he installed on the gallery's grounds for members of the Group of Seven. McMichael preferred "art and ideas set forever in amber," Hill writes. "This necrophiliac vision of Canadian art and identity [proclaims] that the only good artist is a dead artist." McMichael's

boot-hill convictions about Canadian culture and identity were publicly condemned by the professional art community, at the same time that they were supported and subsidized by two Ontario governments. As Gu Xiong and Andrew Hunter suggest in their installation at the gallery, *Ding Ho/Group of 7*, liberatory cultural movements can also carry the seeds of repression.

National Gallery of Canada

Canada    Musée des beaux-arts du Canada

# The National Gallery of Canada

ANNE WHITELAW

# "Whiffs of Balsam, Pine, and Spruce"
## Art Museums and the Production of a Canadian Aesthetic

Not all the pioneering in Canada has been done in her forests and plains by any means. The growth of the fine arts from the days of the earliest topographical draughtsmen and water colourists ... to our own day, when a vigorous and national school of painting is springing up, has been no less heroic and deserving of epics and monuments than the work of other explorers and her statesmen.[1]

CULTURE HAS LONG BEEN the pivotal point around which the contestation of national identity has occurred in Canada. Poised between two major political and cultural powers, politicians and members of the cultural elite have attempted since Confederation to stem perceived encroachments on the nation's autonomy by controlling the import of cultural goods, and by subsidizing local production.[2] As the legislators see it, a strong centralized support of Canadian culture remains the foremost tool in the construction of a Canadian national identity: a tool which has proven useful historically in bringing together the remote regions of the Canadian political landscape, but which has also served as an important mechanism in "acculturating" immigrant cultures and assigning them a place within the Canadian mosaic. National institutions of culture – the National Film Board, the CBC, the National Museums – function in different ways to ascribe a coherence to, as well as to contain, a diverse set of practices and traditions that may be characterized as "Canadian," advancing a single unified national culture that would effect a (unified) national identity.

Although the repository of *high* culture, a realm traditionally associated with universal values that transcend national boundaries, the National Gallery of Canada also figures as an important marker of national culture. This importance goes beyond the gallery's legislated status as a national institution, with a mandate from the federal government to promote Canadian identity. The gallery's fostering of national culture is made visible in the exhibition of its permanent collection, and specifically through the display of the work of Canadian artists. It is through this display that a coherent narrative of Canadian art is constructed, a narrative organized around the contribution of Canadian artistic practice to the nation's growing realization of its status as an autonomous state. Inscribed in the display of Canadian art in the National Gallery's permanent collection, then, is Canada's emergent sense of itself as a nation.

Although the gallery's exhibition of Canadian art is organized as a chronicle of artistic development in Canada, it is motivated by a quest for a specifically Canadian aesthetic vocabulary: an artistic language that would reflect Canada's distinct identity and signal its separateness from the former colonial power.[3] For many historians, this distinct Canadian aesthetic took shape in the work of the Group of Seven, a collective of artists working out of Toronto who, from their first exhibition in 1920, foregrounded a new style in painting that broke with the European picturesque style of their predecessors and set the agenda for the development of Canadian art. The Group's almost exclusive use of the landscape as subject matter contributed to their status as Canada's "national school." This essay, however, is not concerned with the nationalism of individual works of art. Rather, it examines the exhibition of works in the permanent collection of the National Gallery, and the production through this display of narratives of nation-ness. As I will argue, the gallery has organized this artistic chronology around particular conceptions of "Canadian" art and "Canadian" identity, conceptions that are seen to be epitomized in the paintings of the Group of Seven (and Tom Thomson)[4] during their most cohesive years as a group.[5]

Lawren Harris, J.E.H. MacDonald, Arthur Lismer, A.Y. Jackson,

Fred Varley, Frank Carmichael, and Frank Johnston came together through a common dissatisfaction with the state of Canadian art and a desire to "paint Canada." On a formal level, these artists broke with the aesthetic conventions of their time, the European-derived romantic and picturesque landscape tradition found in the works of the preceding generation of Canadian painters, preferring the stylized lines of Art Nouveau design and the brilliant colour of the Fauves. As the artists matured, they developed an increasing interest in the use of broad, simplified forms and shapes to represent the massive wilderness of northern Ontario, perhaps most evident in the later work of Lawren Harris. In this, the artists have often been regarded as Canada's first modernists: for breaking with prior artistic conventions in Canada, and for introducing abstraction on a wide scale. The principal claim to artistic distinctness of the Group of Seven, however, is their treatment of the Canadian landscape, and the belief that their paintings alone captured the essence of the Canadian spirit. As J.E.H. MacDonald wrote in the *New Statesman* in 1919:

> The Canadian Spirit in art prefers the raw youthful homeli-
> ness of Canada to the overblown beauty of the recognized
> art countries. It aims to fill its landscape with the clear
> Canadian sunshine and the open air, following faithfully
> all seasons and aspects and it would make its treatment
> of them broad and rich attempting to convey the sense
> of rough dignity and generosity which the nature of the
> country suggests. Let the reader go if he will [to the exhibi-
> tion] and feel in the pictures the Canadian spirit in art,
> striving through sincere expression for a self-determina-
> tion which will enable our people to make their necessary
> and fitting contribution to the common art treasures of the
> world.[6]

It is this legacy of the Group of Seven, their preoccupation with

the landscape as artistic subject matter and as a philosophy of Canadian distinctness, that has provided coherent material around which a narrative of national identity has been articulated. The centrality of the land figures in other media such as film and literature,[7] but in the years following the First World War, it was the paintings of the Group that produced the visual vocabulary and conception of territory around which nationhood could be articulated. As British critics' favourable reaction to the work exhibited at the British Empire Exhibition in 1924 testifies, this portrayal of the landscape was seen not only as constitutive of Canada but as the first art form that celebrated Canada's emerging sense of nation-ness:

> Canada reveals herself in colours all her own, colours in
> which the environment of Nature plays no insignificant
> part. She has mixed her colours with her restless unre-
> strained energy, her uncontrolled forces. We feel as we
> look at these pictures, the rush of the mighty winds as
> they sweep the prairies, the swirl and roar of the swollen
> river torrents, and the awful silent majesty of her snows.
> And such is Canada's art – the "pourings out" of men and
> women whose souls reflect the expansiveness of their wide
> horizons, who dream their dreams, "and express them-
> selves in form and colour" upon the canvas.[8]

As the above passage suggests, the success of the Group's paintings in Britain was due in large part to the way in which the artists' choice and treatment of subject matter was seen to embody contemporary images of Canada's national character. This also accounts for their later popularity in Canada, and the relative ease with which such paintings of northern Ontario and Quebec functioned to represent the nation both in Canada and abroad. As Benedict Anderson has argued in *Imagined Communities*, the nation is produced less through the defining of territorial

boundaries than through the collective imaginings of its inhabitants. Anderson thereby moves the emphasis from an essentialist notion of national identity as something one is born into to a fluid conception of nationhood as a sense of belonging, organized around shifting signifiers that resonate in the experience of a nation's populace. As such, nations are to be distinguished not by their falsity or their genuineness but by the way in which they are imagined. Cultural artefacts, institutions, landmarks, and geographical elements play a central role in the representation of the nation and constitute some of the mechanisms through which an affective relationship between it and its inhabitants is produced. The museum is one such mechanism which makes the nation visible. Through the ascription of symbolic value on certain objects placed on public display, the museum produces a narrative of nationhood within which a national public can inscribe itself. There is thus in the museum's display an attempt to build on the affective relationship of the individual citizen with the nation, isolating those objects that resonate on a national level, obscuring elements that provide conflict. The museum produces a discourse of nation-ness that frames individual objects in terms of collective memory through appeals to a common heritage and shared national values.[9] Through their location in an overarching narrative of national artistic production, objects are mobilized to provide viewers with a sense that they are members of a national public, and that they are participating in a collective endeavour that has meaning beyond the individual experience.

In Canada, the recent construction of two major museum buildings in the capital – to house the Canadian Museum of Civilization and the National Gallery – testifies to the centrality of cultural institutions in the articulation of national identity. The National Gallery was established by the nation's first Governor General, the Marquis de Lorne, in 1880, little more than a decade after the founding of a Canadian state to unify Upper and Lower Canada. Both the National Gallery and the newly instituted Royal Canadian Academy of Arts[10] were seen by the Governor General and other members of Canada's cultural elite as essential tools in the encouragement of a distinctly Canadian cultural tradition. The promotion of a visual symbolic that was "native" to Canada was seen as a mechanism that would differentiate Canada as much from the United States as from Great Britain, as well as bring together under the aegis of a single institution the cultural products of Canada's disparate regions.[11]

Under the terms of the first National Gallery of Canada Act of 1913, the gallery's primary function was educational: its mandate was "the encouragement and cultivation of correct artistic taste and Canadian public interest in the fine arts, the promotion of the interests of art, in general, in Canada."[12] The belief in the civilizing powers of high art was central to the formation of many art museums in the New World at the turn of the century,[13] and over the years the National Gallery has actively sought to acquire important works from Europe and the United States in order to present a complete art historical survey.[14] Nevertheless, the work of Canadian artists remains a central component of the gallery's collection, and its quest for a truly Canadian high art tradition has resulted in its promotion of Canadian artists at home and abroad. This position was stated as far back as 1912 by director Eric Brown:

> There is no doubt that Canada has growing along with her material prosperity a strong and virile art which only needs to be fostered and encouraged in order to become a great factor in her growth as a nation. No country can be a great nation until it has a great art ... [H]owever, ... the encouragement of our national art in its broadest and best sense is not achieved by the exclusive purchase of Canadian works

of art. The purpose of our National Art Gallery is mainly educative, and as a knowledge and understanding of art is only to be gained by the comparison of one work of art with another, so for this comparison to lead always to higher ideals and understanding we must have in addition to our own Canadian pictures the best examples we can afford of the world's artistic achievements by which we may judge the merit and progress of our own efforts. It is on these lines that the purchase of works for the National Gallery is proceeding.[15]

As a national institution, in addition to acquisition policies the gallery has had (and continues to have) a commitment to making its works accessible to the entire population of Canada through a program of circulating exhibitions and educational material. There is then in the National Gallery's own policies and internal structure a continuing belief in the centrality of its role in building a national culture, through the presentation of a largely European cultural heritage and through the collection of works by living Canadian artists.

This commitment to a nationalist project, however, is not simply an internal motivation. As one of four national museums in Canada,[16] the National Gallery has a mandate from the federal government, outlined in the 1990 Museums Act, to "preserv[e] and promot[e] the heritage of Canada and all its peoples throughout Canada and abroad, and [to] contribut[e] to the collective memory and sense of identity of all Canadians."[17] In recent years, as was particularly apparent in evidence submitted to the Standing Committee on Communications and Culture of the Federal Government in 1991,[18] the National Gallery has stood by this belief in the importance of a national culture, and the centrality of its role in maintaining that culture. To quote from the gallery's submission to the committee: "As one of the govern-ment's national cultural agencies, we will strive as always to make visible to all Canadians the supremely important part artists play in creating our national identity, our 'Canadianness.'"[19]

The art museum's assigned role in the production of a national culture is not specific to Canada, despite our chronic nationalist malaise. Since its inception as a public institution at the end of the eighteenth century in France, the art museum has functioned as a monument to the nation. As Carol Duncan and Alan Wallach have described in "The Universal Survey Museum," it functions, both physically through its architecture and symbolically through the display of accumulated objects, as a marker of the state's power. Through the chronological exhibition of a representative selection of works from the history of art that culminates with the greatest achievements of the nation's artists, the art museum serves both as the storehouse of "official" western culture and as a monument to the artistic production of the nation itself. As Duncan and Wallach thus argue, it is through the orchestrated narrative[20] of displayed artifacts in the museum that the state can make visible its adherence to the highest values of western civilization, while simultaneously positioning itself as the rightful inheritor of those values through the works of the nation's greatest artists. In more general terms, the aesthetic ideology at work in the art museum is one that operates along a modernist notion of art as embodying universal, transcendental values, while at the same time highlighting the production of the nation's artists as emblematic of those universal values.[21]

The permanent display in the Canadian galleries of the National Gallery provides a linear chronology of Canadian artistic production from the late seventeenth century to the 1960s. Traditional in scope and intent, it provides a trajectory of great moments in Canadian art organized around a selection of major artistic movements – for example, the Group of Seven, Painters

Eleven, the Automatistes, and the Plasticiens. As in most "survey" museums throughout the western world, the traditional art historical view of the history of art as a linear stylistic trajectory is present in the gallery's display of the permanent collection.[22] This view of the history of art as a progressive artistic development culminating in abstraction is reinforced in the physical layout of the rooms that house the collection of Canadian artworks. The major moments or instances of works that do not fit into the larger teleological narrative of "Canadian art" are situated in the smaller theme rooms, adjacent to the main rooms, and therefore outside the main exhibition trajectory. One of the most important motivations in this stylistic progression is the development of abstraction, first seen in the styl-

ized landscapes of the Group of Seven, and reaching its apogee in the very disparate work of the Plasticiens and the Painters Eleven in the 1950s and '60s. The rise of artistic modernism, as it is traced through the trajectory of the permanent collection, signals the abandonment of European-derived realist art forms and Canada's move towards entry into a universal aesthetic avant-garde. This full participation in the international art world can perhaps best be seen in the shift in the gallery's organization of its permanent collection: from a strictly Canadian history of art up to the 1960s, to the integration of the work of Canadian and international artists in the contemporary galleries.

This stylistic separation of works into those that form the main history and those works that are outside this history must also, however, be seen as part of the larger project of both the National Gallery and the Canadian art historical establishment:

namely, the development of an authentically Canadian aesthetic. This quest for a distinctly Canadian artistic vocabulary was the original impetus behind the creation of both the Royal Canadian Academy and the National Gallery, under the assumption that the development of such an aesthetic – and the establishment of a wholly Canadian art movement – would translate into visual terms the affective experience of nationhood. This distinct Canadian aesthetic was seemingly only achieved with the Group of Seven, whose exploration of the Canadian landscape – though that landscape only reflected a small portion of Canadian territory – was seen by both the artists themselves and by posterity as "a direct and unaffected mode of painting derived from an experience of the Canadian land that all Canadians, if they would only look about themselves, would have to acknowledge as being true and worthwhile."[23]

\* \* \* \* \* \* \*

Reprinted from Anne Whitelaw, "Whiffs of Balsam, Pine, and Spruce": Art Museums and the Production of a Canadian Aesthetic," in *Capital Culture: A Reader on Modernist Legacies, State Institutions, and the Value(s) of Art*, ed. Jody Berland and Shelley Hornstein (Montreal: McGill-Queen's University Press, 2000), 122–8, 134–6.

Tom Thomson, *Spring Ice* (1916),
four-colour lithograph, c. 1930,
National Gallery of Canada

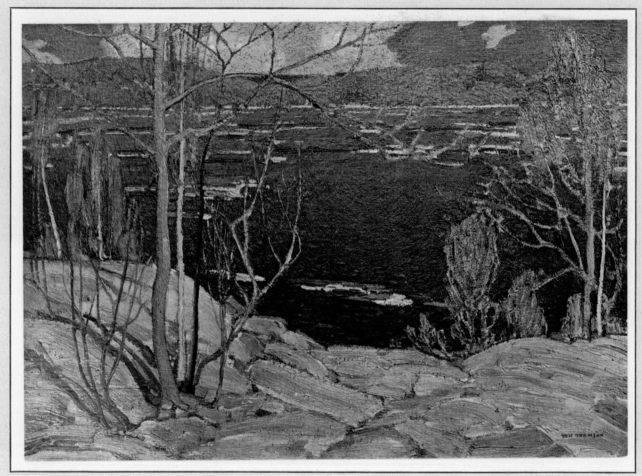

SPRING ICE

TOM THOMSON, 1877-1917

# Establishing the Canon

JOYCE ZEMANS

## Nationhood, Identity, and the National Gallery's First Reproduction Programme of Canadian Art

**IN MOST OF THE WRITING** which has dealt with the role that reproductions have played in the history of Canadian art, it has been assumed that the Sampson-Matthews Ltd. silkscreen project was largely responsible for shaping our notion of Canadian painting and establishing the Group of Seven and landscape painting as the *sine qua non* of Canadian art.[1] The silkscreen project was conceived by A.Y. Jackson and undertaken in co-operation with the National Gallery of Canada during the Second World War. Presented at a meeting of the Canadian Group of Painters, it was initially discussed as a project of the Group. However, given the scale and work involved in soliciting artists to contribute their work and finding corporate sponsors for that work, the administration was essentially left to Sampson-Matthews. The project received both the Department of National Defence's endorsement – the work was intended to raise the morale of Canadian troops – and that of the National Gallery of Canada. The Gallery's role was very carefully defined. It would provide some works in its collection for reproduction and would sponsor the adaptation of the works by living artists. The Gallery established a selection committee which, at least nominally, was responsible for approving submissions.[2]

In his work on the Group of Seven, Dennis Reid has drawn attention to the importance of reproductions of their work and especially the wartime silkscreen project: "A whole generation of Canadians who grew up following the Second World War learned of the Group almost entirely from reproductive silkscreen prints that seemed to hang in every school library, bank, and doctor's waiting room in the country."[3] In her history of the National Gallery, Jean Sutherland Boggs also acknowledges the Sampson-Matthews project, remarking on the large quantities of reproductions distributed to the armed services and "others overseas and throughout Canada." She describes, as well, the

Gallery's attempt to maintain a national presence during the Second World War through educational films on Canadian artists (with the National Film Board) and collaboration "on broadcasts on art to schools for which the Gallery printed and distributed over 120,000 small reproductions in 1944–45."[4] Neither she nor Reid, however, discusses the origins of these projects or the fact that the first programme of reproductions to create a nation-wide consciousness of Canadian art was initiated by the Gallery in the 1920s. By 1940 it had placed hundreds of thousands of images of Canadian art in classrooms, libraries and homes throughout the country and abroad.

This paper will examine the National Gallery's *original* Canadian reproduction programme and the largely unidentified cultural transactions in which surrogate images played a critical role in defining Canadian art. I will argue that the reproduction programme which was largely responsible for constructing our notion of Canadian art was conceived by the National Gallery almost two decades *earlier* than the Sampson-Matthews project. Complementing the thrust of the Gallery's programme of acquisitions, exhibitions, lectures and articles, it influenced the entire country's idea of what was Canadian about Canadian art.

To understand the importance of the first reproduction programme dedicated to Canadian art and the light it sheds on the Gallery's philosophy, I will look at a number of intertwined histories: the evolution of the programme; the selection of works that were reproduced; how those reproductions were marketed and an audience built; as well as the public response. Each represents an important element in the construction of a national Canadian art.

On December 14, 1913, before the second board meeting of the new National Gallery, Director Eric Brown wrote to Edmund Walker, Chairman of his Board:

I am hoping to lay before the forthcoming meeting of the Trustees an idea regarding the sale of reproductions of the National Gallery pictures which I believe will materially advance the value and importance of the National Gallery throughout the continent ... I believe there would be a ready sale in the book stores throughout Canada of both postcards and 5 x 7 reproductions in the Vandyck process and I suggest that with an expenditure of about $1000 over a term of 18 months we can not only have on sale here all the reproductions we require but we can also have them on sale in every important city in the Dominion and lastly make considerably more than the original outlay from their sale.[5]

Walker wrote the next day from his Toronto office at the Canadian Bank of Commerce to encourage Brown in the enterprise.[6] At the December 15th meeting, the Trustees approved the recommendation and the Director was instructed to obtain proofs.[7] On May 5, 1914, the proofs were shown to the Board, prices were approved and Brown was instructed to have them on the market as soon as possible. In 1915, the Gallery obtained "several thousand photogravure reproductions of [its] pictures" from the British firm of Vandyck Printers Ltd.[8] Twenty-four 5" x 7" plates were made; the first run was 1000 prints on 12" x 10" marked, medium cream stock. Another 5000 postcards of eighteen different subjects were printed. By September the prints were on sale individually and in portfolios of six.[9] We have, at present, little evidence of the range of paintings from the collection that were included in the 1914 reproduction programme but there does not appear to have been any particular focus on Canadian works. By September 1921, when the Gallery attempted to re-order, the company replied that they had discontinued printing on hand-presses and were devoting themselves entirely to the more rapid and very economical machine photogravure.[10]

The Gallery's commitment to the use of visual surrogates was not limited to making reproductions from its own collection. It also acquired the full set of 142 Medici Prints, representing masterpieces of European collections, which it advertised and circulated throughout the country for educational purposes. For libraries, galleries and schools which could not offer museum-standard security or display conditions, these prints provided an excellent way to familiarize Canadians with the masterpieces of European art.[11]

It is however the second phase of the National Gallery of Canada's reproduction programme, begun in 1927, and its focus on Canadian art that is the principal subject of this paper. As early as 1929, Arthur Lismer, writing in the *Yearbook of the Arts in Canada*, remarked on the "excellent reproductions in colour of well-known Canadian paintings, especially the Tom Thompson [*sic*] northern landscapes, which are available at a very low price to the public. These prints are to be seen nowadays on the walls of a great many public schools in Canada. The National Gallery, or any gallery, can be a source of educational enlightenment to thousands, old and young, who never get a chance to enter its doors."[12] Hansard records a 1930 discussion about the reproduction programme in the House of Commons, emphasizing the programme's enormous popularity with the general public and its effect in "making available to the people of Canada at very low cost, colour reproduction [*sic*] of Canadian pictures hitherto unattainable anywhere ..."[13]

Describing the important role which the Gallery had played through its extension work, the 1951 Royal Commission on National Development in the Arts, Letters, and Sciences reported retrospectively:

In 1922 [*sic*] the present Director [Eric Brown], on tour in Western Canada, discovered the need for reproductions of

Canadian pictures. A year or two later a series of reproductions in large and in postcard sizes was begun. These were sent out to the schools with lesson leaflets prepared by an expert in art education [Arthur Lismer]. This educational programme was carried further with the development of radio which made possible broadcasts from the Gallery over the national network. The National Gallery has also taken an active part in the production of films dealing with the work of Canadian artists ... The officials of the National Gallery consider that broadcasts and films on art undertaken at national expense are a legitimate and essential part of the Gallery's responsibilities.[14]

With the development of advanced techniques for mechanical reproduction, both the public and the private sector quickly recognized the opportunities that such images could provide.[15] Elected President of the American Association of Art Museum Directors in 1924, Eric Brown would have been familiar with the colour reproduction programmes upon which his American colleagues were embarking and the educational thrust of those projects, as well as the growing business in reproductions of Canadian art which was centred in Toronto. In 1926, Rous and Mann advertised the *Portfolio of Canadian Art*, with a text by Brown and Fred Jacobs, as "prints suitable for framing" with special terms for boards of education and teachers. That collection, described by a contemporary reviewer as works by "dead painters – exquisitely done," included Krieghoff, Jacobi, Kane, Fowler, Brymner, Peel, Blair Bruce, Morrice and Thomson.[16] There were as well, individual artists whose popularity had warranted the publication of reproductions. Colour lithographs of Cornelius Krieghoff's paintings were popular and Nelson's Ltd had published a large-size series of Canadian historical paintings by C.W. Jefferys. Dennis Reid has discussed the interest in original prints among

the Group of Seven in the 1910s and '20s, describing Lismer's war lithographs and Casson's silkscreen work. In 1925, Rous and Mann published a limited edition set of signed photolithographs of drawings by Group members. In 1931, A.Y. Jackson worked with William E. Courts Company on a silkscreen Christmas card project, entitled *Painters of Canada*, of forty-six different cards by twenty-six artists.

In 1930, Brigden's in Toronto described itself as an "art reproduction house," and not as "merely colour engravers or printers." Toronto-based Claudius Gregory Fine Arts Prints combined distribution of reproductions from the National Gallery's collection with the marketing of original prints and signed limited-edition photolithographic reproductions of works by Canadian artists. The British Empire Art Company, which advertised black-and-white etchings, exclusive colour prints and original colour woodcuts principally by non-Canadian artists, also included the work of Winnipegger W.J. Phillips who had established a significant reputation in the United States.

The development of techniques for the production of relatively inexpensive high-quality colour lithographs of art works coincided with the National Gallery's recognition that outreach would have to play an even greater role in the fulfillment of its national mandate to support Canadian art. Thus its 1927 reproduction programme focused on Canadian art and targeted the school population as its principal market.

To contextualize the focus of the reproduction programme, the shape it would take and the role it would play within the larger framework of Gallery activities, it is important to understand the philosophy of the Gallery and its directors. As the Gallery had defined its purpose in its 1921–22 *Annual Report*, it was first to build a "collection of the standards of all art, ancient and modern, by which contemporary standards might be judged and

sound artistic education obtained." Secondly, to fulfill its civic responsibility, it would "do everything possible for the art of its own country, by purchasing it, exhibiting it, and bringing its importance as a national asset and an influence for good before the people generally, and by creating and cultivating in them correct artistic taste."[17] The directors saw their task as establishing the country's patrimony by determining what was significant production in Canadian art and bestowing value upon it through acquisition and recognition. Nurturing and promoting that art, the Gallery could educate and elevate Canadians through Ottawa-based exhibitions and a national programme of loan exhibitions, lecture tours, prepared slide-lectures, and the dissemination of reproductions of works in its collection. The 1927 reproduction extension programme was constructed in such a way that, as well as providing information and education about the history of western art, it would validate Canadian art by locating it in its rightful context within that history.

Nationalism and identity would be related determining factors in shaping the Gallery's Canadian reproduction programme. Describing art as "closely interwoven with the history of nations and the geography of countries" and noting that "the story of its growth is the story of all that is intellectual and moral," the Gallery saw nation-building and the establishment of a common heritage for Canadians as key responsibilities.[18] As its 1925–26 *Annual Report* observed, "Canadian art is passing through a period of self-establishment as a national factor ... Nationalism in art is the result of climate, geography, religion and national character superimposed, however unconsciously, on the individual's desire to paint or to express himself in any one of the art's forms."[19]

National unity, the promotion of a common understanding of Canadian life, along with the expression of "national feeling" and vigorous Canadianism would be the motivating factors in the establishment of each new national institution in this period. The visual arts, and more specifically painting, like radio and, later, film, were believed to have the capacity to mold public taste, to create proper moral values and identify the basic truths required to establish a sense of nationhood. Classrooms across Canada offered an ideal means of reaching the new generation of Canadians, including those in remote areas. As Arthur Lismer stated, "Prints of Canadian pictures, wisely used, will go far in establishing a knowledge and love for the work of our own artists and our own country ... the art of our own country is no less important a medium of study, if our children are to be made conscious of the beauty and character of Canada"[20] [...]

Although circulating exhibitions were the most direct way in which the National Gallery's presence was manifested in communities across the country during the first decades of this century, such exhibitions depended on the existence of an adequate venue. The reproduction programme, however, required only a receptive ministry of education, school board, individual teacher or committed citizens to provide classrooms and individual students across the country with their own "collections" of Canadian art.

While works by artists from other parts of the country represented a significant part of the Sampson-Matthews silkscreen project of the 1940s, the selection of the images seems to have been motivated more by the policies of the art world, geographical requirements and sponsorship concerns than by aesthetic criteria. In contrast, the Gallery's reproductions which decorated classrooms and were integrated into curricula between 1929 and circa 1950 were almost exclusively central Canadian and landscape-based, representing paintings created before 1930.[21] Although the Sampson-Matthews project greatly increased the quantity, size and quality of reproductions available, its focus

on living artists and their work, however conservative, did not translate into a heavy demand for these prints. The real attraction was still Thomson, the Group of Seven and the Canadian wilderness aesthetic which had been consolidated by the earlier programme.

The impact of the early reproductions of Canadian art was heightened by the lack of other reference points. Those who frequented galleries in most major centres would have had the opportunity to see loan exhibitions of original works. But for most, the surrogate images, framed by text, classroom experience and the authority of the Gallery, came to represent Canadian art. Subject matter linked the works in a coherent narrative; meaning was conferred through the verbal descriptions."[22] Issues of scale, of texture, of painterly quality could only be imagined.

That more artists (or audiences) did not raise their voices at the narrowness of the reproduction programme and the lack of commitment to artists from across the country reflects the dominance of the central institutions. Saskatchewan's admonishments that the National Gallery had some responsibility to make known the work of that province's artists appear to have been unique. It was only in response to the *Young Canada Listens* series that questions were raised about the lack of representation of women artists in an aesthetic construct in which ruggedness, vigour and drama (terms regularly employed by Lismer in his description of works included in the National Gallery series) were considered the highest praise.

Today the validity of the meta-narrative has been rejected; but at the time, the creation of a linear history designed to position Thomson and the Group of Seven at the apex of Canadian artistic achievement and to establish the pivotal role of the National Gallery in the minds of Canadians was a central purpose of the programme. The Gallery aspired to provide an aesthetic education for the country's expanding population, "creating and cultivating ... correct artistic taste."[23] Through its education programme, it offered aesthetic sustenance to nourish the nation, providing the requisite "sense of beauty" and the "intellectual and moral" impetus that would create a great society. Nationalism and patriotism were key elements in the project, and Lismer's texts suggest that it was also intended to improve understanding between English and French Canadians.

Carol Duncan might well have been writing about the National Gallery of Canada and in particular its first Canadian art reproduction programme, when she described how art museums serve as repositories for the higher authoritative truths of our society and how they bind the community into a civic body. As such, Duncan argues the museum was seen to identify society's "highest values, its proudest memories and its truest truths."[24] The National Gallery of Canada's reproduction programme was a critical component in that institution's attempt to position itself and the conceit of a national art in the minds of Canadians. Establishing the basic truths essential to the ritual of nation-building, the Gallery established a Canadian art canon whose iconography would dominate the Canadian psyche for more than half a century.

\* \* \* \* \* \* \*

Reprinted from Joyce Zemans, "Establishing the Canon: Nationhood, Identity and the National Gallery's First Reproduction Programme of Canadian Art," *Journal of Canadian Art History* 16, no. 2 (1995): 7–11, 26–29, 35.

Exhibition banner, *The Group of Seven: Art for a Nation*, National Gallery of Canada, 1995

# Art for a Nation?

LYNDA JESSUP

**IT IS OFTEN SAID THAT HISTORY** is written by those in power, that the past belongs to the winners. The National Gallery of Canada's current Group of Seven exhibition is a good example. Produced in one of Canada's most authoritative cultural institutions – in the eyes of the public, its premier gallery – "The Group of Seven: Art for a Nation" was launched unabashedly in 1995 as a celebration, a major exhibition marking the seventy-fifth anniversary of the Group of Seven's first show in May 1920. Intended to tour triumphantly through 1996, it has been booked at the Art Gallery of Ontario (where it appeared until May 5 as part of the larger "OH! Canada Project"); by the Vancouver Art Gallery (where it is currently showing until September 2); and at the Montreal Museum of Fine Arts, where it opens in November.

"Art for a Nation" comprises almost 180 works, not all but most by Group members. These have been arranged in six galleries, five devoted to selected paintings from the 1920 show and from the seven subsequent "flagship" exhibitions at the Art Gallery of Toronto, in which the members showed together as the Group along with their invited guests (one room each for the 1920 and 1921 shows, followed by three rooms combining those of 1922 and 1925, 1926 and 1928, and 1930 and 1931). The remaining gallery is devoted to pieces by what are described as "Academicians," selected members of the Royal Canadian Academy whose works are serving double duty in the exhibition as representative of the "academic," a term defined in the late nineteenth century to characterize the position of such institutions as the French Academy and the Royal Academy in London in relation to what were then being advanced as new ideas in art. Now synonymous with conservatism, conventionalism, dullness and prejudice, the academic is used to give shape to the central thesis of the show: that the Group of Seven was an avant-garde who succeeded in the face of hostile critical reception, who championed innovation

and originality in art and, in doing so, challenged established conventions of taste and the authority of the official art institutions through which taste itself was defined.

I am not saying that this thesis is clearly stated as such in the exhibition or in the catalogue. Nor is it argued in either context from the historical distance created by seventy-five years of hindsight and the wealth of critical studies of the avant-garde that have been published in the last thirty years or so. If that were the case, then there would be some resonance of Renato Poggioli's 1962 observation that avant-garde art is a historical concept. Recognizing it as "a phenomenon belonging to the history of art," he pointed out, "... means treating it not so much as an aesthetic fact as a sociological one." Instead, the exhibition is resolutely presentist, historical analysis having been eschewed in favour of a moralizing tone that clearly distinguishes good guys and bad. Here it is, more than half a century after the Group trounced their opponents, and we are still being asked on the one hand to react indignantly to what is presented as the "virulent attack" of the conservatives, who valued "tradition over innovation and technique over content," and on the other to root for the apparent underdogs who, armed with "new material" and "new methods," we already know will win the day.

A staggering amount of wall text has been generated for just this purpose. It includes a substantial introductory panel, wall texts in every gallery, short quotations (or what curator Charles Hill refers to as "maxims") in enlarged vinyl letters on the walls above the works, and a whopping 109 extended labels beneath. Significant portions of the introduction and panels, and all the extended labels, consist of quotations from contemporary writings, whether newspaper or journal articles, public addresses or private letters, all of them intended to illustrate that, although the Group members were supported by articulate writers, "all the

way along they were confronted by vociferous opposition." The sheer volume of quotations unmediated by analysis or comment also suggests the curator felt this material "speaks for itself" in an objective presentation of historical reality. One of the chief problems with this notion, of course, is that historical material never speaks for itself; the curator always directs the course of the conversation through selection and arrangement.

In this case, he has so privileged the cacophony of contemporary opinions about the Group that what have since come to appear as central contradictions in the Group's rhetoric have become, through uncritical repetition, central contradictions in the exhibition. We are told in the introductory panel, for instance, that "they fought against a colonialist, academic mentality that slavishly accepted standards defined by the past and by the cultures of Britain and Europe and denigrated all Canadian creative ventures." Yet, in the panel accompanying a selection of works from the Group's 1921 exhibition in Toronto, it becomes apparent that meeting such "foreign" standards was regarded by the members as a validating exercise, one the gallery clearly feels is worth repeating today. This explains why the curator has stepped outside the defined parameters of the current exhibition to include a work that was not exhibited in the Group's Toronto shows, Lawren Harris's *A Side Street*. It was purchased from the Group's "U.S. Tour 1920–21" by the Detroit Institute of Arts, the panel tells us, making it a precursor to the 1924 purchase of A.Y. Jackson's *Entrance to Halifax Harbour* by London's Tate Gallery. "Foreign recognition," the panel explains, "would continue to be important in the Group's campaign to win support from Canadians and confirm that our artists had something unique to contribute to the world." As though to deepen the irony, the Tate purchase, which is also included in the show, is touted in the next panel as confirmation of the Group of Seven's greatest

critical success: "the almost unanimous" praise accorded by the British press to the artists' work in the Canadian art section of the 1924–25 British Empire Exhibition at Wembley.

And here is another irony: the response of the British press was, and is now again being celebrated by the National Gallery as vindication of its constant support of this avant-garde for more than a decade prior to the Wembley show. At the time, the most public evidence that this was the Gallery's perception of Wembley events was its publication of, not one, but two books containing reprints of the favourable reviews. In the current show, the fact that the National Gallery is still celebrating its own contribution to the Group's success is evident in the way in which the Gallery's support is profiled while that of other patrons is not. In fact, aside from the two art institutions mentioned above, the only purchaser of the artists' works identified by name in the exhibition panels is the National Gallery of Canada, which is presented, along with the unnamed, as having bought regularly from the Toronto shows. Of course, this representation of information has other effects as well, not least of which is the way the self-congratulatory credit given the National Gallery for its staunch support of the artists runs counter to the central idea of the Group as a beleaguered avant-garde. In other words, it is difficult to sustain the central argument that the Group struggled in the face of real opposition, when the National Gallery's current desire to celebrate itself as champion of the Group reveals once more that the opposition was a paper tiger.

In any case, it seems to me that it is less important to determine whether the artists were a legitimate avant-garde than it is to acknowledge the fact that they positioned themselves as such. Setting aside the argument that avant-gardism in any case is less a matter of reality than it is of attitude and consciousness, it is important to remember that, when all the formative influences

have been taken into account, both the Group's rhetoric and the members' work can be most closely aligned with what critic S. Morgan Powell described in 1918 as "the blustering spirit of Post-Impressionism," that vanguard movement originally centred in Paris at the end of the nineteenth century. The Group of Seven simply cast Post-Impressionism in stridently nationalistic terms. In keeping with the avant-garde theory inherited by the artists, for instance, originality was the defining quality of a work of art. It made itself felt through distinctive pictorial effects, which were seen as the product of the creative impulses of the original, or authentic, artist. In the years around the Seven's formation in 1920, the most prolific writers in the Group also argued that work such as theirs was authentically Canadian, and that this was evident, not only in the subject matter, but also in the technique, which in this case registered the creative impulses of the original, Canadian artist.

Circular as this thinking may seem today, at the time it effectively naturalized the artists and their work, and situated them in contrast to what J.E.H. MacDonald described as "painting with a Dutch name on it," that dark, moody, tonal, and now "inauthentic," painting practiced by Canadian followers of northern Europe's Hague school. Seen in art historical terms, they were giving local expression to international ideas in Western art and, in doing so, investing them with the immediate relevance they may have been lacking otherwise. Similarly, the almost unanimous praise British reviewers subsequently awarded the Group's work at Wembley should be read not only as the validating response of a sympathetic, yet knowing, audience but also as evidence of what was by then increasingly widespread acceptance of Post-Impressionism, or at least of the tempered version practiced by the Group members in 1924. To do otherwise is to evaluate both the artists' activities and their art in ahistorical terms, ignoring the larger international art scene – and the larger history of art – in favour of a parochial view of the history of art in Canada that substitutes careful examination of the modernist theory promulgated by the Group of Seven for the type of mystification evident in seventy-five-year-old assertions that "in their quest to discover and affirm a Canadian identity" the Group contributed to the development of "a Canadian art."

Boosterism of the latter sort might establish a celebratory tone for the exhibition, but it also means the National Gallery of Canada is blithely promoting the Group's narrowly defined, exclusive Canadian nationalism, a nationalism based on the notion that there is an essential Canadian identity. Keep in mind that we are a quarter of a century into state support, through government policy, of a Canadian nationality based on the notion of multiculturalism. In this sense alone, it is surprising that a state supported institution would unquestioningly thrust the Group of Seven's work at contemporary audiences as "Art for a Nation." Something is wrong here. The introductory panel to the exhibition clearly states, "The Group's goals were nationalist and their prime audience was English Canadian," and yet the show does not address the implications of this.

Instead, it presents the Group of Seven's work as the standard against which all cultural efforts should be evaluated, the Group's ideals as the defining framework within which all cultural activity should be understood. In a hierarchy with clear gender, ethnic and class dimensions, and with the Group of Seven securely at its top, the artists are praised in a quotation from a 1932 Blodwen Davies article, for instance, for having "gone out of their way to encourage women whose work indicated the same vigorous attitude, the same frank and unconditional conception of the mission of the painter." Evidently intended to counter what Robert Fulford has recently described as "the now common view of the

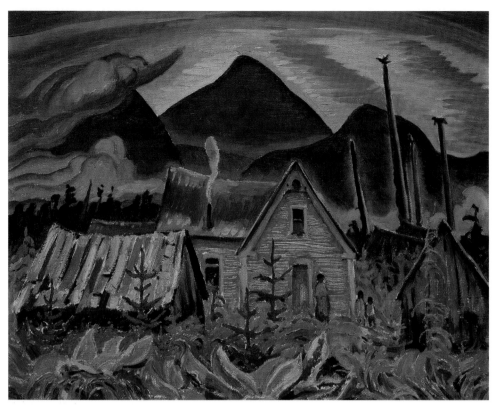

A.Y. Jackson, *Indian Home*, 1927,
oil on canvas, Robert McLaughlin
Gallery

Group as an exclusive boys' club," such a testimonial is only part of what appears to be a larger effort to celebrate the Group as both enlightened and inclusive. Also cited is the Group's collaboration with National Museum ethnologist Marius Barbeau "to preserve a heritage he perceived as menaced by change, indifference, and hostility from a colonialized elite." Vaguely identified in the show as "the traditional cultures of Quebec and the West Coast," the contemporary cultures of Aboriginal groups of the Pacific west coast and of the rural, French-speaking habitant population of Île d'Orléans and the north shore of the St Lawrence are delivered to us as evidence of the Group's generous spirit in "preserving" this newly acquired national heritage.

Why not set the latter activity in the larger historical context offered by the international art scene? Why not explain to contemporary audiences that this attempt to incorporate Native work and habitant culture into the canon of Canadian art was a nationalized manifestation of a broader effort, in modernist theory at least, to discredit the academic notion of fixed standards of artistic competence by extending the definition of art to include the work of children, of the untrained and the naive, and of what were seen at the time as the primitive and the folk? Not only would this be in keeping with the exhibition's thesis, but it

would also generate the historical distance needed to avoid the type of celebratory account currently proffered in the show. As it stands, the Gallery's insistence on a laudatory narrative brings the exhibition into direct conflict with the very thing the Gallery seems bent on avoiding: current thinking about issues of representation. In the light of such debates, it is no longer so praiseworthy for Barbeau and his friends to have represented other contemporary cultures in Canada as the ancestors of what they presented, contrastingly, as the "modern" Canadian culture to which they belonged. Representing some peoples as "of the past" – as existing in that indeterminate time we call "the traditional" – effectively denied their existence in contemporary time and, thus increasingly in the view of the Group's English-Canadian audience, from consideration as equal participants in modern life. Harnessed as part of a definition of Canadian identity in keeping with the culture of British-Canadians, they were used to give expression to the dominant ethnic nationalism of the time.

The Gallery may want to protect the Group from reconsideration in light of such thinking, but it is a difficult task. The historical record clearly shows that, despite the Gallery's efforts to resuscitate the Group as populist, most of the patrons serviced by the artists belonged to a small, Toronto-based Anglo-Canadian elite. (The National Gallery was most intimately connected through the chair of its Advisory Arts Council, Edmund Walker, who was a prominent member of this elite.) As far as support of female artists is concerned, the widely held notion that the Group

was an exclusive boys' club may have arisen from the well-known fact that the future Group members came together in the second decade of the century at Toronto's Arts and Letters Club, an exclusive men's you-know-what. Or perhaps the idea was simply generated by the fact that all the Group members were men. It is beside the point in any case. At this stage in the development of scholarship in the field, it would be critically naive to address the practice of women's history and feminist approaches by simply adding women artists to what is still the story of the Group of Seven.

Yet it appears the Gallery is attempting to do so. More than this, the evidence of the exhibition suggests that it sees recent scholarship and current debates in the field as a threat to its parade. This seems to be the reason it has refused to engage seriously with either. In fact, the massive, 350-page catalogue that accompanies the show summarily dismisses recent approaches to the Group in a scant two-paragraph discussion full of valued prose and questionable generalizations. First, it divides what is, for the field of Canadian art history a relatively large body of writings into two spurious categories, or "strains": one that is evidently good because it reflects "the powerful influence [the Group's] art and history have had on our perception of Canada" and one that is evidently bad, even irresponsible, because it is produced by scholars who "question the Group's ideology" and present material that casts the artists in a less than reverential light. One writer, who should apparently be damned for even inquiring, "has questioned whether their paintings of Algoma were not intended to assist Sir Edmund Walker and the Canadian Bank of Commerce, which had considerable investments in Algoma Central Railway."

Despite what the Gallery sees only as blasphemy, we already know, for instance, that the Group's oppositional stance was mitigated by the strong support of an emergent nationalist elite. As far as criticism of the Group's associates is concerned, the basis is well established; my own work in this area demonstrates that Group members themselves were intimately involved in appropriation, not only of aboriginal culture, but also of the habitant culture of rural Quebec. The point of such studies, however, is not to criticize the Group of Seven, or for that matter, the National Gallery of Canada, which was also actively involved in these activities. If they now reflect unfavourably on either party, it is in the light of contemporary values, which see the subordination of one culture to the viewpoint of another as a discriminatory act. As A.Y. Jackson put it in a letter from Baie St Paul, Quebec, in 1924, "The Hotel Victoria has not changed except Joe the proprietor's son has a baby, the first of twenty I expect. [T]he French idea is 'raise your own immigrants and save on the steamship fare.'"

Jackson's comment also brings us to the question of the artists' business interests, for when he made that now questionable statement, he was on one of his many sketching trips to rural Quebec in the 1920s, a substantial number of which he made with free passes on either the CNR or CPR. In fact, in the 1920s all the major sketching trips by Group members outside Ontario were made with free passes from one of the two major railway companies. And they weren't issued by the railways for altruistic reasons; sensitive to the tourist market, both companies knew there was good cultural advertising to be had from the situation, and so did the artists. They were astute businessmen, in the business of art to be sure, but in business nonetheless. That is why the real possibility exists that Walker and the Group members saw mutual benefits in the artists' plans to paint the landscape along the line of the Algoma Central. To pretend otherwise is to subordinate already ample evidence, both of the artists' business acumen and of their collective ability to cultivate various types of

patronage, to an image of the original and thus "authentic" artist as authentically uncommercial.

This image may fit in well with National Gallery's mistaken belief that the Group's rhetoric had to reflect the artists' lived experience to make them a legitimate avant-garde, but the Gallery's blind determination to advance it is no excuse for its dismissal of critical approaches to the period. In other words, I am not saying the problem here is between "old" and "new" art history, or between conservative and revisionary; I do not want to set up a false opposition that ultimately posits the Gallery as defender of tradition. Simply put, the Gallery is not practicing conservative art history, it is practicing poor art history. The National Gallery has simply dismissed what many see as the beginning of a long overdue critical evaluation to introduce its hope that by retelling the tale based on contemporary documents dealing with the Group it will "lay a new groundwork for debate." But that's not how it works. The Gallery cannot set the direction of critical discussion without engaging in it to begin with. That's the nature of debate. That's where the excitement is. That's what the Group of Seven deserves.

* * * * * * *

Reprinted from Lynda Jessup, "Art for a Nation?" *Fuse Magazine* 19, no. 4 (summer 1996): 11–14.

# The Britishness of Canadian Art

LESLIE DAWN

*Canadian Section of Fine Arts*, British Empire Exhibition, Wembley, 1924

**BETWEEN 1924 AND 1927** the National Gallery of Canada (NGC) staged a sequence of ambitious overseas exhibitions, two at the British Empire Exhibitions at Wembley and one at the Musée du Jeu de Paume, adjacent to the Louvre in Paris. Their collective purpose was to establish a unified national image and identity, different from the nascent nation's main colonial sources, a cultural claim parallelling the dominion's political aspirations to autonomous statehood. Each display accordingly produced a successively stronger focus on the landscapes of Tom Thomson and the Group of Seven.

The Wembley shows of 1924 and 1925 were triumphs. The British critics readily discerned and applauded the nationalist and modernist agendas within images of nature depicted as wilderness. The NGC collected the reviews and republished them in two anthologies for Canadian audiences as proof of the venture's success.[1] Both the reviews and the exhibitions figure prominently in the histories of Canada's arts as validation of an emerging national identity in the 1920s.

The Parisian exhibition, however, provoked a different reception. The reviews were again collected and then translated, anticipating a third vindication.[2] But problems arose. Bluntly put, the Paris exhibition failed. The responses were largely patronizing, if not negative. Confirmation of the works' "nationality" and "modernity" was withheld, while the emphasis on landscapes was disparaged. The reviews were never made public. Indeed, their existence was obscured, even suppressed.[3] And for good reason. The negative responses from the centre of modernism destabilized the foundational premise, handed down to the present, that the British reception constituted a universal recognition of the works' uniqueness, originality, and difference, that is, its essentialized "Canadianness."[4]

But the variations in national receptions raise other questions.

Why did the British respond positively and the French negatively? Could one infer from the British appreciation that they were already predisposed to the new Canadian painting based on their own traditions? Were, then, the Group works a recapitulation rather than a repudiation of British landscape conventions and consequently a continuity of colonial culture rather than a break with it?[5] Conversely, did these images and issues remain unreadable to French audiences, unfamiliar with the principles and codes of the picturesque and its implementation within colonial contexts? What are the consequences of such possibilities?

The Wembley exhibitions were placed under the direction of the NGC and its British-born director Eric Brown. Brown had little experience in art when he emigrated in 1909. What he had had been gained from sitting beside his brother, the landscapist Arnesby Brown, who worked at St Ives, where the direct experience of nature was favoured.[6] Brown's limited familiarity with British landscape painting was sufficient for Edmund Walker, chair of the board of the NGC and president of the Bank of Commerce, who hired Brown in 1911 as curator and a year later as director. Walker, the consummate Canadian capitalist, understood the links between economic, political, and cultural power and positioned himself accordingly. He was a staunch supporter of maintaining closer ties with the empire against those who wished to ally Canada with its southern neighbour.[7] At the same time, he promoted a distinct Canadian national identity as expressed in the visual arts. The Group of Seven was the perfect instrument to reconcile these two potentially conflicting positions. Under Walker's leadership, the NGC supported the Group from the start and continued to subsidize their practice and valorize their agenda into the 1920s.[8] The investment paid dividends in cultural capital. By the mid-1920s, their position as representatives of Canada's national identity and image was secured on

the home front. Wembley presented a golden opportunity to test these claims in the international arena. Britain was the colonial parent, the so-called mother country, from which Canada was perceived as cutting its apron strings. The ritualistic return to the colonial centre could establish recognition of the dominion's independence, yet also declare its solidarity with the empire at a time when both were undergoing fundamental shifts in identity.

The first Wembley exhibition was a large and mixed affair, with 270 works by 108 artists. Group members and Thomson were represented by 20 canvases and 12 prints. Twelve additional panels by Thomson were listed under one number.[9] Unlike any other "group," they were given their own salon, and Brown's foreword to the catalogue "took on the tone of a Group manifesto."[10] Moreover, the catalogue's cover, designed by J.E.H. Macdonald, featured a lake, a canoe, rocks, and a lone pine, all Group icons.[11] Anyone touring the exhibition with this guide was cued to pick out those works corresponding to its title: *Canadian Section of Fine Arts*. The critical responses indicate that this highlighting was successful.

The reviews in the 1924 anthology demonstrated the British appreciation.[12] "Canada is developing a school of landscape painters who are strongly racy of the soil." "The first impression of the Canadian Galleries is that there is emerging a native school of landscape, awaiting a wider recognition abroad." "Landscape is the strength of the collection, as is the case with Canada's, but the latter brings surprises, for there is evidence of an original school absorbing 'modern' tendencies in the representation of native scenery." "[T]hese Canadians are standing on their own feet, revealing their own country with gay virility." "With Canada ... [w]e can sincerely acclaim a vigorous and original art" that offers "genuine modes of national feeling." In contrast, the same critic noted, "The New Zealand painting is mostly cold and

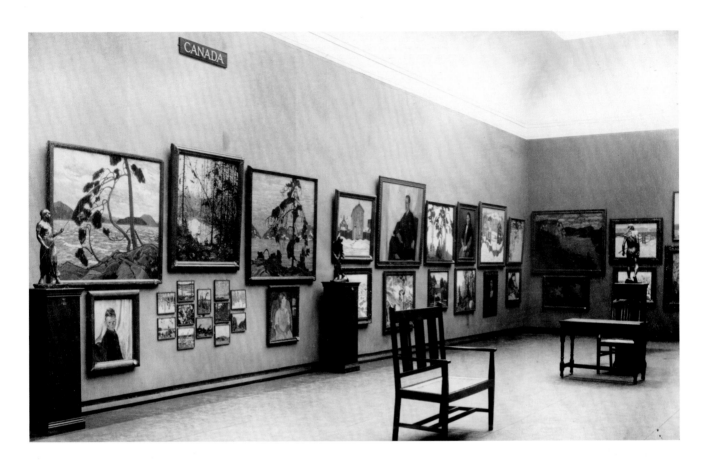

insipid ... In South Africa there is ... a rather tired vigour ... The pre-eminent quality of the Australian work is 'atmospheric,'" and so on. Canadian national identity, independence, modernism, and native, wilderness landscapes were all closely linked by the British critics.

In the revised 1925 installation the Group and Thomson had 23 oils and 12 drawings among the 198 works on display. The reviews were less numerous but still unstinting in their praise.[13] One critic noted that "the brilliant and original work of the Canadian painters stands out even more prominently than it did last year. The Empire will have to recognise now that Canada possesses a distinctive national school of landscape painters of the highest merit." Another claimed that "the exception to the general dullness of the galleries is that of the Canadian rooms, which show us incontrovertibly that Canada is well on the way to producing a school of painting entirely her own. And this because her painters show more audacity, and a greater thirst for experiment than those of any other colony."

Within this second wave of appreciation, one review took precedence. Paul G. Konody, a prominent critic, had already experienced Canadian art in its propagandistic function while acting as Lord Beaverbrook's adviser for the Canadian War Memorials Project. After the war, Konody was brought to Canada, where he became familiar with the new landscape image and its practitioners and promoters. His piece in the prestigious *London Observer* recapitulated the story of the Group as it has been narrated since.

Konody's response is dense, rich, and diplomatic. He identified the Group and Thomson with the conjoined myths of origin and "isolation," struggle and neglect, and the "ignorant public" opposition to their work. He outlined their successful forging of an independent "national school" of "Canadian landscape." By discounting "European influences," he implied that the work was without colonial precedent and was truly Canadian, autochthonic, and "native."

Konody's figuring of the Group as "bravely fighting" combatants both equated them with patriotic soldiers and positioned them within an avant-garde. Conflating militarism, colonialism, and artistic advancement, these artists were modern "pioneers," "daring" to chart new territory both pictorially and geographi-

J.E.H. MacDonald, *Willow Tree*,
1901, oil on wood, Art Gallery
of Nova Scotia

cally, literally "discovering" the land and their art with "progressive strides," while at the same time battling those who opposed their explorations to map out, define, and claim this new topography and artistic terrain for Canada. Tactfully unsaid, it was the very colonial parent, as represented by the RCA, that inhibited the young nation's aspirations to colonize its own territories and establish its own modern visual culture. By deploying the catchall term "decorative," Konody associated the Group with modernist European movements since Neoimpressionism. But again this linkage went unspoken, as it would have called into question the previous claim that the Group was without European influence.

In short, Konody was receptive to the complex cultural, aesthetic, and political messages invested in the landscapes and was able to read them and rearticulate their interlocking but sometimes conflicting claims with great proficiency. In turn, he expected his audience to understand and share these views. I would like to propose that this expectation of a broad British sympathetic response was not misplaced. Rather, it was based on the unspoken acknowledgment that these works would already be familiar to his readership, despite their ostensible difference and newness, precisely because they depended in many ways on particularly British principles for the representation of nature and echoed long-standing British claims for landscape.

Two foundational premises of the new Canadian landscape were its direct links to the soil and the correspondence between artistic pioneering and the task of taking possession of the land that was depicted in the name of the nation. The connections between possession and representation are, however, not uniquely Canadian but descended from British traditions. Landscape painting in Britain achieved recognition as a separate subject matter, equal to history painting, in the mid to late 1700s. Earlier English landscapes had originated as topographical portraits of the estates of the landed gentry. To survey, in both senses here, meant to declare ownership. Topographical landscape was, however, utilitarian and without independent artistic merit. Charles Harrison states: "Landscape achieves autonomy as an artistic genre in England only when ... the countryside comes to be distinguishable from the business of reinforcement of title."[14] He notes, however, that this other autonomous quality could coexist with that of affirming property, as in the work of Constable. More recent writing on the continuity of British landscape in colonial contexts has demonstrated how this fortuitous usage of landscape as an act of possession and reterritorialization has continued and expanded in colonial contexts.[15]

Next comes the claim that the work of the Group and Thomson achieved national difference and a unique identity, separate from its colonial parents, by being a non-mediated, non-academic response to nature uninfluenced by outside European sources. Again, this complex premise can be traced to the

William Gilpin, *Landscape with Ruined Castle*, c. 1790, drawing on paper, Fitzwilliam Museum

beginnings of landscape painting in Britain. Over one hundred years before the Group, Reynolds saw "Gainsborough's work as a direct response to nature" that was "not indebted to the Flemish School, nor indeed to any school, for his grace was not academical, or antique, but selected by himself from the great school of Nature."[16] Furthermore, "Writers on the picturesque derived Gainsborough's landscapes not from [European] schools of landscape painting but from the English countryside itself."[17] Indeed, the very claim that there was a relationship between landscape and national identity was British: "In painting as in poetry, the appeal to swelling nationalism was strong pressure behind the emergence of an English school of landscape."[18] These basic premises of the Group were, then, already embedded within the practice of British landscape painting by the late 1700s.

By the early 1800s, British landscape paintings had become absorbed by the aesthetic pictorial formulae known as the picturesque. Codified and popularized through the writings of the Reverend William Gilpin, they provided the means through which landscape was judged suitable to be made into a picture. Although challenged by Constable, Turner, and Ruskin, these codes persisted in landscape practice throughout the century. In particular, they played a major role in colonial expansion throughout the 1800s. W.J.T. Mitchell provides some insight into the reasons why the picturesque persisted in the colonies where land was being claimed as British, while being progressively seen as outmoded at home. He links the pre-eminence of landscape in Britain to the rise of imperialism and colonization and states that the "semiotic features of landscape, and the historical narratives they generate, are tailor-made for the discourse of imperialism, which conceives itself ... as an expansion of landscape understood as an inevitable, progressive development in history, an expansion of 'culture' and 'civilization' into a 'natural' space in a progress that is itself narrated as 'natural.'"[19] Certainly, something along these lines occurred in Canada.

The arrival of picturesque and topographical landscapes in Canada corresponded to British military conquest and colonization in the mid-1700s. Without retracing the complex history of the introduction of German, American, and French influences, it can be established that the convention of viewing the Canadian landscape for its picturesque possibilities persisted until the end of the following century. *Picturesque Canada*, published in the mid-1880s, with images selected by Lucius O'Brien, the first president of the Royal Canadian Academy, represented Canadian territory as a sequence of picturesque encounters through which an untamed and uninhabited wilderness became a productive nation. Until the turn of the century, then, Canada represented itself as proudly British in image and institution.

Not only were Canadian views of the landscape up to this time based on the British pictorial conventions and practices, but these landscapes transmitted more complex messages

WOLFE'S COVE.

Lucius O'Brien, *Wolfe's Cove*,
engraving, published in *Picturesque
Canada*, vol. 2 (1882)

concerning what Andrews has recognized as the "issues of property and territorial control," "the propagandistic transmission of national identity," and the ability to represent "pictorial colonization" and what Young calls "re-territorialization," all of which were part of the British imperial and colonial traditions.[20] As has been shown, it was precisely these messages that Konody saw in the work of the Group of Seven. All of them had their sources in British landscape. Indeed, in the late 1800s, Britain was attempting to establish its own essentialized national identity, represented visually in landscapes, especially those depicting the agrarian south, as opposed to the industrialized north. Arnesby Brown was part of this movement and was eventually knighted for his efforts. His brother, Eric, would then have had at least a rudimentary knowledge of how landscape could be configured as nationalist and British before he arrived in Canada.

The generally accepted narrative constructions, however, posit a rupture after the turn of the century in which all colonial and most direct foreign influences were suddenly and completely abandoned. As Dennis Reid put it, "The artists who exhibited together in Toronto as the Group of Seven in May 1920 had by that time developed a doctrine and a style of painting based on the idea that Canadian art could find sufficient sustenance in Canada alone."[21] Consequently, any connections between British landscape traditions both past and present, and the production of the Group of Seven and Tom Thomson have been ignored, denied or disguised in the recitations of the historical narratives that their work has generated.[22]

The issue was first made explicit by Northrop Frye in 1940. He declared that Thomson's work was not picturesque, a term he equated with the colonial, because Thomson drew his inspiration from a direct confrontation with the uninhabited land. In contrast, Horatio Walker's works were "picturesque clichés." Frye concluded that, "for all Canadians ... who wanted ... the predigested picturesque ... and who found in a queasy and maudlin nostalgia the deepest appeal of art, Horatio Walker was just the thing."[23] The opposition between impotent milquetoast timidity and virile manly heroism, as figured in the difference between the castrated colonial picturesque and a seminal Canadian national art, could not be more clearly delineated.

More recently, Anne Whitelaw has indicated that this denial of the picturesque continues in the current display of Canadian art at the National Gallery, which "is motivated by a quest for ... an artistic language that would reflect Canada's distinct identity and signal its separateness from the former colonial power. For many historians, this distinct Canadian aesthetic took shape in the work of the Group of Seven ... who foregrounded a new style in painting that broke with the European picturesque style of their

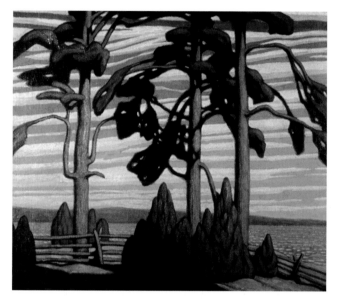

Lawren Harris, *Pines, Kempenfelt Bay*, n.d., oil on canvas, Art Gallery of Hamilton

predecessors and set the agenda for the development of Canadian art."[24] This view is rehearsed in the "art historical survey texts on Canadian art," confirming that the narrative of Canadian art and identity has been and still are written and displayed *against* the picturesque.[25]

Yet both Frye and Whitelaw seem at odds with how the Group and their works were perceived at the time of their production, when British connections were not so denigrated. During the 1920s, critics both at home and abroad noted their picturesque qualities. Even Fred Housser, in speaking of Thomson's discovery of the North, stated that "in Northern Ontario these painters found [a] new and picturesque landscape, typically expressive of the Canadian spirit. The discovery was to give direction to Canadian art."[26] Evidently, the opposition was not so clearly observed at the time.

Indeed, the first hanging of Wembley seems to have been designed to ease the transition between British traditions and the "new" Canadian painting. Four large pictures dominated the main wall: Thomson's *The Jack Pine*, *Northern River*, and *The North Wind* and Lawren Harris's *Pines, Kempenfelt Bay*. The last received the warmest critical response in the prominent English art journal *Studio*, one of the sites in which the promotion of landscape as essentially British was played out in the early twentieth century. In a review not included in the NGC anthologies, the critic opposed it to the obsessive detail of Millais's *Ophelia*.[27] But other recognitions may be at work here. The painting stands out from its companion pieces in that it is anything but a wilderness landscape. Rather, its cultivated domesticity arises from its depiction of the garden and vista from the Harris family's country property on Lake Simcoe. It thus fit into British topographical conventions of using landscapes to portray and proclaim entitlement to one's estate. Furthermore, its composition corresponds precisely to picturesque conventions. The shadowy, grassy foreground provides shelter for the viewer, the pines both screen and frame the view across the lake, the fence demarcates the borders of the property, and the midground water and distant irregular hills continue the tripartite spacial division. All of these elements had become the clichés of the picturesque after Gilpin formulated them in the late 1700s. Even pines were the trees of preference prescribed by the picturesque.

Harris's pivotal picture, then, worked as a transition in two ways. His "tamed" pines, part of his personal property, were easily transfigured into the wild and ragged ones in the paintings nearby. This correspondence allowed the latter to be seen as Canadian possessions, that is, as part of the national estate. At the same time, similar compositional formulae served as the scaffolding for all four works, uniting them both with each

other and with British traditions. Indeed, the entire vocabulary of the picturesque, including rocky, abbreviated foregrounds; trees arranged into screens, frames, shades, and refuges; watery, reflecting midgrounds; distant hills; tripartite spaces; and asymmetrical, irregular compositions; all featuring the unbeautiful and rough in nature, formed the foundation not only for Thomson's three works but also for countless Group compositions. This confirmed the premise of the larger exhibition of which the Canadian works were part. As the catalogue for the entire Palace of Arts show puts its goal, "Now first can be seen in one place how the Daughter Nations have developed their art from the English School."[28]

Other aspects of Group practice also derived from British precedents. Their ritualistic, redemptive treks into semi-wilderness areas of Algonquin Park and the Algoma region descended from the picturesque practice of taking walking tours and sketching in the Lake District of England. So too did their longer tours to the West. Harris's picturesque image of Maligne Lake was in fact part of the second Wembley exhibition. Thus the mythic claim that the Group's works came from an unmediated and uninfluenced response to a raw and untouched nature was modified by the mediation of colonial practices and the sites they actually chose, just as its "Canadianness" is modified by its dependence on British traditions.

All of this is not to say that the Group "style" was not cobbled together from other sources as well, including Art Nouveau and Scandinavian art. Recognition of their reliance on British landscape traditions, however, opens the possibility that their work is, if not autochthonic, at least highly innovative, and more so than previously thought. But the extent of the Group's invention and achievement, particularly their ability to negotiate a difficult terrain that placed them in the paradoxical position of at once confirming British solidarity and at the same time appearing to resist and reject it through Canadian independence, cannot be fully appreciated in all its nuances unless one also takes into account their grappling with the British traditions that became part of their hybrid art. Neglecting this history also does not account for the failure of the Jeu de Paume exhibition, leaving it as an embarrassing and consequently neglected moment in Canadian art. Like Wembley, however, it needs to be resurrected and re-examined.

The "Exposition d'art canadien" at the Musée de Jeu de Paume was primarily an extension of the second Wembley collection, but in the absence of the juries that chose the work for Britain, Brown had free reign to refine the selection and clarify its meaning. He did so by increasing the proportion of Group works and appending a retrospective of Tom Thomson.

The exhibition also included a retrospective of the recently deceased Canadian expatriate painter James Wilson Morrice, who had established substantial critical recognition for his works within the Parisian avant-garde. Morrice, represented by only two minor pieces at Wembley, was now given forty-eight oils and his own gallery space which allowed his works to be singled out as different from, and more "French" than, the other paintings.[29] Paradoxically, his paintings were adopted by the Parisian critics to confirm an essential French national identity invested in modernity. This did not, however, translate to the other works. Any corresponding claim to a distinct Canadian nationality and modernity for the wilderness landscapes of Thomson and the Group was, by and large denied, despite the fact that the critics had been cued to read them as such through both lead up articles and the exhibition's catalogue essays.[30]

Gustav Kahn elevated Morrice to "un maître incomparable" on the basis of his French refinement.[31] Conversely, he brushed

by Thomson and dismissed him as a lesser painter, "beaucoup moins fort," thus withholding both modernism and mastery. Nonetheless, Kahn did note that he was "the most autochthonic. His motifs are purely Canadian, sought out in the picturesque locales of the scenes and seasons." Here, however, Kahn's ironic oxymoron of an "autochthonic picturesque" destabilized the myth of a rupture with a colonial past and rendered any claim to a distinct national identity ambiguous.

The reviewer for *Action française* was less ambiguous. Citing the "failure" of the Canadian painters to "attain their end," his comments on Thomson took the form of a lament: "How can one not perceive in his oeuvre the magnificent but unequal struggle between the object of a superb newness and the means of interpretation which is insufficiently flexible for what it is supposed to render. His paintings turn easily into vignettes."

One critic who did manage to isolate the Group and begin to rearticulate their agenda was directly associated with the exhibition. Arsène Alexandre, listed on the Comité de Patronage, cited Brown's catalogue essay: "In Canada, he [Brown] says, we are isolated from outside stylistic influences; the seasons are extraordinary, splendid ... These circumstances have given birth to a school, more or less a particular manner of painting." Given this equivocation, Alexandre did not confirm a distinct and modern national image. Here the "rupture" with European sources, essential to the narration of the national style, played against the Canadian program. For Alexandre and other critics, to be isolated and without influence inferred that the Group were "primitives," that is unsophisticated, unschooled, and immature artists outside the modernist mainstream who grappled with, but did not master, their conventions; in short, rude naïfs.

The responses of the British and French critics could not have diverged further. While the British reception validated the complex premises of the Group's landscapes, the French critics remained insensitive to the claims to a distinct national style and identity residing in a presumed unmediated response to the wilderness. These variances, however, were not due to either the presence or the lack of any essential "national" qualities within the works themselves. Rather, the French audiences did not have access to either the complex codes of the picturesque or to the entire apparatus by which British landscape painting was associated with and constructed around both colonialism and nationalism. The expected Parisian validation did not arrive because the Group's works were inherently British and were directed at British audiences. They were, then, as much the last gasp of colonial culture as the first breath of national independence. This realization leads to the conclusion that the primary purpose of the shows, as initially conceived at Wembley, and even of the Group's works in general was to declare both solidarity with and difference from that particular parent at a very delicate period within both the development of the empire as it moved to a commonwealth and in Canada, as it negotiated the transition from colony to dominion to nation. Ironically, the negative Parisian responses, which would have alienated both the Canadian artists and their supporting institutions, would only have served to further this end by solidifying imperial allegiances.

Within a larger context, the variations in responses also lead to the conclusion that readings of representations of nature are anything but natural processes. By destabilizing the mythic origins of Canadian national culture as they were proposed at that time and as they have come to be constructed since, they confirm what Bhabha states: that the narratives and identities from which nations are constructed are extremely complex, fragile, and riven with contradictions, despite attempts to make them appear seamless and natural.[32]

# What Would the Group of Seven Say?

## The McMichael Canadian Art Collection

JOYCE ZEMANS

Kathleen Munn, *Untitled I*, 1926–28, oil on canvas, National Gallery of Canada

**THE ONTARIO GOVERNMENT** has been convinced that the McMichael Collection of Canadian Art in Kleinburg has gone astray in its operations and collecting policy, thereby violating the terms of an agreement its founders, Robert and Signe McMichael, signed with the province 35 years ago.

To address this concern, the government has tabled Bill 112 to, in effect, restore control of the McMichael Canadian Art Collection to its founders, Robert and Signe McMichael. The bill, which passed second reading in the Ontario legislature last week, raises the spectre of thousands of works – ones deemed "inappropriate" by the McMichaels themselves – being offloaded or deaccessioned to other institutions or galleries or individuals. The government has been unclear on this.

But has the McMichael really been violating the terms of the 1965 agreement? And should the McMichaels now be regarded as the final arbiters as to what should today be purchased and displayed? In reply to the first question, I would argue that this is not the case. With respect to the second question, I say "definitely not."

Ask members of the public about the McMichael Gallery and they will tell you that the McMichael, about 30 kilometres northwest of Toronto, is devoted to the Group of Seven specifically and to Canadian art more generally. Tourists go to see the landscape images of the Group, the works of present-day Canadian artists who have been inspired by their work, as well as work by Canada's indigenous artists.

Under the direction of the McMichaels, the gallery acquired a range of works by approximately 270 artists, which represented not only the importance of the Group of Seven in Canadian art but also the diversity of contemporary Canadian practice. As director of the gallery, Robert McMichael observed in 1977 that the institution had responded to "increased enthusiasm" for Canadian works through exhibitions of contemporary art.

Clearly then, the issue is not a case of returning to an original narrow mandate. In fact, the language of the 1965 agreement, far from supporting the argument of the McMichaels and the Harris government of an institution gone astray, actually buttresses the actions and acquisitions that successive directors and boards of trustees have taken since it was signed. The wording of Section 13 states: "The said collection shall be known as the 'McMichael Conservation Collection of Art' and shall be comprised of paintings by Tom Thompson [sic], Emily Carr, David Milne, A.Y. Jackson, Lawren Harris, A.J. Casson, Frederick Varley, Arthur Lismer, J.E.H. MacDonald, Franklin Carmichael and other artists as designated by the Advisory Committee who have made contributions to the development of Canadian art."

The point of contention in the current dispute is, simply, that Robert and Signe McMichael do not like some of the more recently acquired works, many of which raise contemporary issues about the relationship between nature and culture and challenge the wilderness ideology espoused by the Group.

These works respond to the images of the Group, challenging us today as the work of the Group challenged viewers three quarters of a century ago. Likewise, some of the First Nations and Inuit art works in the collection deal with political and social issues, making reference to contemporary life and experience.

What Bill 112, in fact, will accomplish, if passed, is to legislate the overturning of a well-developed, coherent collections policy created within the framework of the original mandate and the work of duly appointed boards working within that mandate to fulfill the public trust.

From time to time in this dispute, which has been going on for years, the McMichaels have presumed to "speak for" what the Group and its colleagues would have wanted. Four years ago, when it was enmeshed in a court case, the McMichael board issued a statement addressing, through a review of history, why the Group would not have approved of the McMichaels' narrow selection of representative artists. However, Robert McMichael, responding to a letter of support for the McMichael board from Charles Hill, curator of Canadian art at the National Gallery, said these ideas were second-hand. He personally had known six of the Group members and he knew they would have agreed with him.

Now in this particular realm of retrospection, there are several choices. You could rely on the actions and words of Group members during the period in which they came to prominence and later to dominate the Canadian art world. You could speak to those individuals who knew them well and ask them to extrapolate, from their own knowledge of the artist, his or her (though Emily Carr is the only woman artist included in the McMichaels' shortlist) feelings on the subject. Or you could rely, as Robert McMichael has, on personal conversations with some of the artists, albeit at a moment in time long after any spirit of the Group as such had hardened, in some cases, into stereotype and occasionally self-interest.

What if the artists named in the legislation and central to the collection were asked to determine the future of the gallery? How would they have interpreted the original mandate and how would they respond to the subtle changes inherent in the current legislation?

As an art historian focusing on Canadian art, I would like to hypothesize what some of these artists might have said about the thrust of the new legislation. Though they were individuals (even the Group of Seven did not really speak in a single voice), it might be worth having the artists speak through evidence of their collective actions. (Tom Thomson isn't included here since he died before the Group was actually formed.)

In 1924, for instance, when the members of the Royal Canadian

Academy protested the fact that the National Gallery had selected members of the Group to represent Canada at the British Empire Exhibition of Canadian art in Wembley, Group members argued that there should be no single way of looking at Canadian art and were adamant in soliciting support for their opinion. In the year 2000, they would have a hard time with a public gallery, ostensibly dedicated to their ideals, deaccessioning art which did not look like theirs.

Today we think of Group of Seven exhibitions as being dedicated to the Canadian landscape. In fact, their exhibitions always included portraiture, urban scenes, figure studies and even abstract art. They did not want to create a new academy, and in their exhibitions included experimental works by such contemporaries as Bertram Brooker, Lowrie Warrener and Kathleen Munn – works that, in their day, were as controversial as those to which the McMichaels object today. Doubtless an explanatory note in the proposed new legislation – calling for the McMichael to focus on "the beauty of Ontario" as depicted in the first half of the 20th century – would certainly have troubled the Group. Its members painted throughout the country and saw their role as national rather than provincial. A.Y. Jackson was from Quebec and returned to paint there every year. The Group regularly invited Quebec artists, as well as Emily Carr (from British Columbia) and L.L. FitzGerald (from Manitoba), to exhibit with them.

Furthermore, when the Group perceived, in 1932, that, in spite of themselves, they had become locked into public perception as a narrowly defined landscape school, they disbanded formally and reformed as the Canadian Group of Painters which was broadly based and not at all directive in terms of style or subject.

Moving from the collective perspective, what would individual members of the Group have thought of the Mike Harris legislation? Franz Johnston, for one, would no doubt be somewhat conflicted. It is possible that he might have agreed with the legislation tabled last month. After all, in 1927, after seeing a Cubist exhibition, he wrote: "Braque's still life is sickening even to one with a good stomach." But Johnston, who left Toronto for Winnipeg shortly after the Group was formed, is named in neither the original nor the new legislation – a fact which, had he been aware of it, might have soured him on the project.

Lawren Harris, arguably the Group's philosophical heart, was eloquent about the role of art in society and wrote and spoke frequently on the topic. In 1927 he lobbied for a Toronto showing of the International Exhibition of Modern Art, which included the abstract works of artists such as Wassily Kandinsky and Piet Mondrian. True, it was Harris who, in the Group's catalogues and in his 1926 article "Revelation of Art in Canada," tried to articulate the relationship between landscape and national identity, but he would have protested the narrow nationalism implied in the new legislation. Representational and abstract art, he argued, were part of the same continuous creative practice. Discussing the same exhibition as Johnston in 1927, he wrote, "… complacency plays no part in the life of creative individuals: The urge of spirit is too active in them."

While Harris clearly would have rejected Bill 112, J.E.H. MacDonald might have agreed with the restrictive definition of the Group contained in the legislation. A mature artist when the Group came to prominence, he dedicated himself to the landscape in the 1920s and was fulfilled by his role in the Group.

Fred Varley, by contrast, would have aligned himself with Lawren Harris. Though he painted landscapes throughout his career, Varley wrote to his sister in England that the empty landscapes of the Group of Seven held little interest for him. He was one of the few members of the Group who included figures in his landscapes, often equating the figure with the landscape

rather than dwarfing the human presence by the grandeur of the mountains or forest scenery. In the 1930s, living in British Columbia, Varley returned to the landscape for inspiration but he was influenced less by his Ontario colleagues than by Sung dynasty landscape painting and Buddhist philosophy. Varley also was primarily known as a portraitist – perhaps Canada's greatest – though this body of work is not central to the philosophy espoused in Bill 112.

Franklin Carmichael's last major work was an abstract composition titled *Gambit #1*, now housed in Kleinburg. It appears the artist was embarking on a new direction; however, the fact it was painted in the year he died (1945) makes it difficult to say what his take would be on the actions of the McMichaels.

Clearly A.Y. Jackson, were he alive today, would object to the restrictive tone of the legislation. In 1966, he wrote Robert McMichael, suggesting that "it would be a good investment if you acquired current examples of 'objective' work with the intention of exhibiting it later on. Such artists as Ogilvie, York Wilson, Alan Collier, Colville, Forestall, Comfort, Lemieux and others." Though he appears to have disliked the work of some of the "moderns" such as Paul-Émile Borduas, Jackson actively supported the development of younger Canadian artists from all parts of the country.

Arthur Lismer became a pre-eminent art educator in Canadian art. Though continuing to be engaged with the landscape, his later painting was often as much about the interior movement of the landscape and its rhythmic expression as the place portrayed. As an accomplished teacher, he remained open to all forms of artistic expression and would inspire several generations of modern artists. In short, he would have opposed Bill 112.

In fact, of the artists mentioned in the original 1965 legislation, only A.J. Casson, who came to the Group of Seven toward the end of its collective life, would likely unreservedly espouse the vision of Canadian art propounded by the McMichaels. Emily Carr was a champion of the right of artists to explore new ways of creation and wrote eloquently about the importance of recognizing contemporary expression. Another McMichael favourite, David Milne, never agreed with the nationalist approach to the landscape that the Group of Seven espoused and he had a hard time with the dominance of the Group during his lifetime. More influenced by French and English aesthetic theory and modernism than his Group contemporaries, he would have vigorously decried the McMichaels' current narrow definition and focus.

It is, of course, impossible, finally, to say today what the artists themselves might think about this current situation. It seems equally evident that they would not have agreed among themselves. Most, however, would agree that the issues of the public good, public trust and public responsibility have been cast into doubt by the legislation currently being debated. As a whole, the Group abhorred the notion of a static definition of art and, were it alive and well today, would reject a narrow definition of their art or their project. As artists who believed strongly in the importance of the public museum, they would find that the line between public and private institutions has been blurred.

In 1927, Lawren Harris wrote: "The truth is that works of art test the spectator much more than the spectator tests them. Great art is never kept alive by the masses of men, but by the perceiving. … It is in the vanguard of life not in the main body." He believed that Canada's public galleries had a responsibility to contemporary artists and might have once believed that Robert and Signe McMichael were among the perceiving. Today, he would protest the narrow definition of art which the McMichaels and the government wish to impose.

* * * * * * *

Reprinted from Joyce Zemans, "What Would the Group of Seven Say?" *Globe and Mail*, 9 October 2000.

# Letter to the Editor

CHRISTOPHER VARLEY

**JOYCE ZEMANS IS RIGHT, OF COURSE** (What Would the Group of Seven Say? – Oct. 9). The Group of Seven was an incubator of new talent, not a closed shop of arch-conservative wood-chopping rustics. By 1928, the group's exhibitions included more works by "invited contributors" than by the members themselves. In 1933, the group expanded into the much larger, more inclusive, and geographically diverse Canadian Group of Painters. According to Paul Duval's count, more than 200 Canadian artists exhibited with the CGP over the next four decades. Ironically, Robert McMichael now wants to banish many of them from "his" gallery. Mike Harris should have taken the time to examine the historical record before jumping into bed with Mr McMichael.

* * * * * * *
Reprinted from Christopher Varley, "Letter to the Editor," *Globe and Mail*, 10 October 2000.

Gu Xiong and
Andrew Hunter

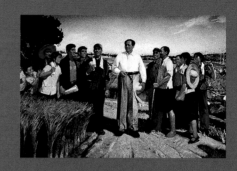

Lawren S. Harris (1885-1970)
Snow, c. 1917

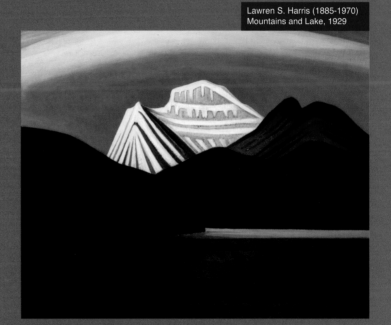

Lawren S. Harris (1885-1970)
Mountains and Lake, 1929

Lawren and Bess Harris grave,
McMichael Canadian Art
Collection

# Graveyard and Giftshop

RICHARD WILLIAM HILL

## Fighting over the McMichael Canadian Art Collection

The graveyard, McMichael
Canadian Art Collection

**IT'S PROBABLY BEST TO START IN THE GRAVEYARD.** The gift shop would do – and we'll get to that – but the graveyard is better. Surely this is the heart of the McMichael Canadian Art Collection. As conservative as the gallery's programming has often been, it must certainly be founder Robert McMichael's greatest innovation, for the McMichael has unquestionably pioneered the artists' graveyard.

Yes, tucked away on the grounds of the McMichael is a cozy, exclusive little boneyard wherein lie the bodies of six members of the Group of Seven and Robert McMichael himself. Like all brilliant innovations, it seems obvious once it has been proposed. One is staggered by the elegant simplicity of the idea. How better to ensure that your collection is complete than to collect the bodies of your favourite artists? True, collection-building then makes it necessary to disinter and move a few corpses, but so be it. You are a resourceful entrepreneur. And as you go down your wish list checking off the boxes, you aren't too disappointed to

miss out on the really big fish – Thomson – because those you do have are genuine one-of-a-kind items on which you have cornered the market. And once safely replanted, they are awfully tough to deaccession.

If, as some people insist, the museum is at its heart a collection of dead things, then surely this little plot of land is the purest expression of the museum, a kind of ur-gallery of dirt, mouldering bones, and headstones.[1] After all, headstones are simply labels by another name (in museums, basic labels are called "tombstone labels"), and in the McMichael's graveyard the headstones are literally that: stones. As we all know, untouched stones are the purest form of Canadian sculpture, metonymic stand-ins for the landscape itself.[2] Any attempt to actually sculpt or otherwise manipulate them can only be seen as a defilement of their natural purity. And natural purity is what the McMichael Canadian Art Collection is all about.

In November 2003 the collector himself, Robert McMichael, pure Canadian, was added to his own collection. It was a brilliant (but no doubt entirely unconscious, or should I say post-conscious?) act of posthumous performance art in which he transgressed every boundary in the art museum triad, becoming simultaneously artist, collector, and object in his own collection.

Few museums receive the controversy and public scrutiny that they deserve. Robert McMichael's pugnacious megalomania ensured that his eponymous gallery received plenty as it tried to change and grow. When the Harris Tories returned control of the institution to McMichael in 2000, it was only another stage in an ongoing struggle for control of the institution. It was obvious that in McMichael's mind this was an art museum with the ambition to be a graveyard. By original design it prefers art and ideas set forever in amber. This necrophiliac vision of Canadian art and identity has been universally reviled by the art community, but,

damn it, McMichael and his friend Mike Harris were convinced that the only good artist is a dead artist. Together they look like protagonists in a George A. Romero zombie film, struggling with increasing perplexity and asking themselves, "Why won't these damn artists stay dead?"

What was perhaps missing in the public thrashing of McMichael and Harris was a more fundamental question. Is the McMichael capable of ever being wrested free of its flawed founding premises, regardless of who is at the helm? Is McMichael's icky blood-and-soil nationalist sentimentality too profoundly wired into the whole project, or is there hope?

Robert McMichael had the idea of creating a museum based on his collection back in the 1960s. He had made a small fortune selling bridal products and brought his nose for cheese to the arts, zooming in unerringly on the Group of Seven as his main target for acquisition. But what to do with this great collection? In retrospect it is clear that his real desire was for a private foundation that he could continue to control, but why go to the trouble when the friendly Tory government of Bill Davis was willing to make him a sweet deal? In 1965 he gave his 3,500-square-foot log house and 194 works of art, valued at $815,515.00, to the province, which passed a law six years later making the entity a crown corporation. In exchange, McMichael received a very generous cultural property tax receipt based on the value of the $815,515.00 donation. He and his wife were allowed to continue to live free of charge on the property for approximately sixteen years, with a car and housekeeper paid for by the government. Robert McMichael maintained control of the gallery in a salaried position. If the potential for conflict of interest hasn't already passed through your mind, then perhaps you are still doing the math. Did members of the Davis government realize they had made a deal with the devil, or were they, like their contemporary Tory

Front entrance, McMichael
Canadian Art Collection

counterparts, so sympathetic to the sensitivities of millionaire entrepreneurs that their nostrils had, from daily exposure, lost sensitivity to the smell of brimstone?

In 1982, amid many rumours of impropriety, including the accusation that the line between McMichael's private and public collecting activities tended to be rather blurry, the province convinced him to accept a legislative agreement that placed management and control in the hands of the Board of Trustees. A further $298,544.00 from the public purse went into McMichael's pocket, and he got a new home elsewhere as well. Since then the collection has grown to some 6,000 works and the institution itself to some 85,000 square feet. More importantly, the collection has expanded in scope to include contemporary art (with some special focuses, such as art by aboriginal and Inuit artists). It was this direction that drove McMichael into a fury. In his mind there are seventeen artists worthy of collection by the gallery and they are all safely dead. In 1996 he sued to regain control of the gallery but lost on appeal. The issue seemed settled at last. Then Mike Harris was elected and gave McMichael by executive fiat what he couldn't achieve through the courts. According to the legislation Mr and Mrs McMichael became lifetime members of the acquisition committee, which was autonomous from the board and would expand its powers to include selling work and mounting exhibitions. The deal was universally reviled in the art community, with even the likes of Christopher Hume of the *Toronto Star* calling McMichael the "Slobodan Milosevic of Canadian art"[3] for his desire to cleanse his collection of degenerate art.

If nothing else, this is a cautionary tale about the dangers of shackling public institutions to private interests, particularly a single, powerful private interest.[4] When these deals go wrong (in this case, the deal was wrong from the beginning), the public loses control of the direction of the institution. Public-private partnerships are justified as a means to save public money, but as the McMichael case demonstrates, the public can easily end up paying for everything anyway through tax breaks, direct investment, or subsequent court costs. Stripped of all the rhetorical nonsense about donor "generosity," these partnerships turn out primarily to subsidize the self-aggrandizement of rich folks, while sacrificing the ability to create the sort of institutions that we want. In the case of the McMichael collection, it would have been cheaper and much less painful to cut out the middleman and start a new art museum from scratch. But of course, conventional wisdom, public policy, and tax law are all designed precisely to ensure that we can't cut the rich folks out of the decision-making process. This is "new left" thinking, but we used to simply call it plutocracy. And Kleinburg – would we have located a new museum in far-flung Kleinburg if we'd had a choice?

IF THE MUMMIFIED HEART of the McMichael is to be found in the graveyard, the content and sensibility of the institution are best looked for in the gift shop. Think late sixties–early seventies kitsch Canadiana. Think an airport gift shop view of Canadian identity: majestic empty landscapes and Indian curios. Visiting the place has always given me the creeps. The exterior, main entrance, and lobby suggest that you might be visiting a ski chalet rather than a gallery. Each exposed log oozes with an immediately recognizable brand of sentimental, rustic nationalism that smacks of desperation. This is the national image of a country with low self-esteem, busy reconceptualizing itself through the sensibility of Walt Disney circa 1970. It's hard to believe they didn't put in a man-made lake nearby just so Pierre Trudeau could paddle up in a canoe in his fringed buckskin coat. What completes it all for me is that they collect and display Aboriginal art as though it somehow has an obvious ancillary

The gift shop, McMichael
Canadian Art Collection

role in this tourist caricature of Canada. We have been the victims not the beneficiaries of this national myth, but by all means feel free to sell our images to the tourists, as long as you give them only exactly what they expect.

This struggle for control of the McMichael was an unholy alliance of a dangerously simplistic national mythology and an equally bankrupt Tory "common sense" revolution. Here are a few simple reasons why we ought to be suspicious about the whole situation. First, never trust a group of urban intellectuals – modernist painters to boot – when they tell you they are getting back to nature and the spirit of their country. Urban intellectuals have been claiming to do this as long as cities have existed, and they have all been guilty of bad faith. All they find out in the woods are the ideas they brought with them. Second, never, ever, trust millionaires who build rustic log palaces for themselves. Ask them who they're trying to fool. Probably themselves. They don't want to take responsibility for the world they've created – the one we still have to live in. Any recent visitor knows that the McMichael itself is increasingly an island of faux nature in a sea of subdivisions built by Harris's developer buddies. If there is a core paradox in this version of Canadian national identity, it is that we somehow want the world to see us (and even to imagine ourselves) as inhabitants of a natural wonderland, at the same time as we are replete with natural resources that are up for grabs. Of course, the resource-extraction industries that are our true history inevitably tend to gobble up the scenery. This is why my favourite part of the McMichael grounds is the self-decon-structing parking lot, which is bisected by rows of high-tension wires that thrum with a maddeningly industrial intensity. Third, never, ever, ever, trust a provincial government that hides behind a corny, nostalgic view of nationalism while its policies actually destroy everything decent this country has developed

over the past century. If we could stand the Group's nation-alism being harnessed to create Trudeau's "just society" or Joyce Wieland's anti-Americanism, how does it feel to use it to screen out the sprawling subdivisions and SUVs of the common-sense revolution?

The problems built into the institution's original concep-tion have meant that the curators have had their work cut out for them. At their best, they've tried to bring new, critically engaged perspectives to bear on the collection. These have been particularly effective when they have run against the grain of the institution, such as Gu Xiong and Andrew Hunter's *Ding Ho/Group of 7*, which used contemporary art to play the Group's nationalism off against popular Canadian images of Chinese culture and the ethos of the Cultural Revolution. What McMichael failed to realize was that, even if he kept contemporary artists out forever, he couldn't stop the new scholarship that has challenged the cozy mythology around the artists he loves. The question is whether these sorts of challenging exhibitions will inevitably look like "interventions" in the McMichael environment. As one-offs, they might work,

but in the long term they merely reiterate the centrality of the dominant narrative.

The implicit racism of McMichael's desire to cling to a view of Canadian culture purged of the influence of non-white immigrants was the most insidious aspect of his conservatism. Not only did it misrepresent the historical presence of non-white immigrants at the time of the Group, but it suggested that a contemporary institution calling itself the McMichael Canadian Art Collection can retain the fiction that "Canadian" means white Canadians. I saw this kind of thinking in action when I visited the McMichael on Canada Day a few years ago. The gallery had hired a group of Chinese lion dancers to perform. My friends and I overheard the following gems from the crowd: "What do lion dances have to do with Canada Day?" And from some confused woman who has taken the Bering Straight theory (the hypothesis that Aboriginals of the Americas migrated across the Bering Straight from Asia during the last ice age) too far: "Why are those *Natives* always so loud?" McMichael wanted to collect art "in the Canadian spirit," but judging from his statements that spirit is vapid – devoid of both criticality and cultural diversity.

The status of the Aboriginal art is especially bizarre. On one hand, we tend to be famously absent from the Group's landscapes. I keep trying to imagine these territories as wildernesses and I can't. To produce this new *tabula rasa*, not only have Aboriginal peoples been erased but so has an entire perspective on the land. There are no Thunderbirds in the skies. No powerful spirits of the underworld down in the depths of the lakes. No fragile human beings in the middle, tending their relationships with these great forces. How quiet this wilderness must be. I find the silence deafening.

It is true that Indians are somehow part of Canadian national mythology, but we must be kept categorically separate from it as well. I'm sure McMichael was happy to keep his Norval Morrisseau paintings, which I understand he saw as innocuous enough (proving yet again that he wasn't so clever about art), but he definitely didn't want other, more explicitly contemporary works by Aboriginal artists around. I remember seeing a criticism that someone had written in a comment book during a show of Aboriginal artist Jim Logan. As I recall, it denigrated Jim's work and urged the gallery to return to showing only Group of Seven and "Indian art." Obviously this genius wanted Jim to paint like Morrisseau before he'd recognize him as an Indian. But nobody painted like Morrisseau until Morrisseau invented the so-called Woodlands School in the 1960s. So why does he get to be an Indian (i.e., representative of an exotic, safely historical culture), while Jim doesn't? The answer is simple: a racist attitude that only recognizes Aboriginal cultures as quaint vestiges of the past. We must be vanished Indians, additional denizens of the graveyard.

The result of this nonsense was one less publicly funded institution regularly showing the work of living artists (not to mention the resurrection of increasingly outdated perspectives on dead ones). The McMichael was turned into a joke among Canadian art institutions, and the only people who didn't get it were McMichael and Harris. But perhaps it's not too late for the Province of Ontario, which now owns the McMichael, to give the Group of Seven art and the ski chalet to a private foundation and invite it to operate the facility. Then we could take the contemporary collection that he didn't want anyway and start an exciting new contemporary art gallery. It will be in a relentlessly contemporary building located somewhere that you don't need a car to get to. All visitors will be forbidden to wear plaid shirts, eat doughnuts, or say the words "canoe," "beaver," or "maple leaf." And the artists won't need to be dead to get a meeting with the curators. Enough of this zombie nationalism.

Emily Carr, *Above the Gravel Pit*, 1936, oil on paper, Art Gallery of Greater Victoria

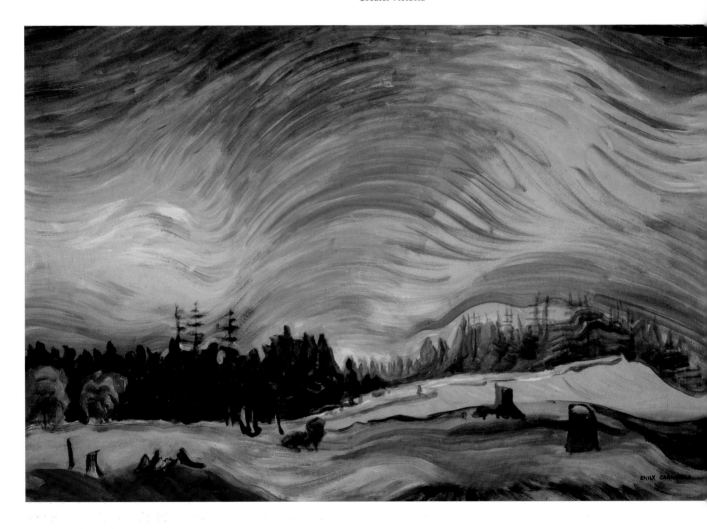

# Emily Carr

SCOTT WATSON

# Disfigured Nature

## The Origins of the Modern Canadian Landscape

[...] **EMILY CARR PRODUCED, LATE IN HER LIFE**, a body of work that was stimulated and encouraged by the Group, particularly by Lawren Harris. Her paintings remain among the most sexualized of any Group or Group-influenced artist. She never tired, in work after work, of paying homage to the vitalism she not only believed she perceived in nature but which she also thought was appropriate to a modern idiom. Her spiritual guide to nature was also the gay bard, Walt Whitman. In her paintings, nature is rendered symbolic: trees are giant male organs and forest byways are orifices for penetration, the sky and sea tingle with the universal vibration. Her landscapes are also haunted, not with the war dead, but with ruins of other civilizations. In her paintings, the fecundity of nature overwhelms old totem poles and renews itself amidst the slash of logged culls. One would not claim that Carr consciously sought to define the terms of this conflict in her work, nor can we count her as an environmental activist in the contemporary sense. She created an imaginary nature, thinking she was disclosing its source of truth. While she eventually abandoned the patriarchal vocabulary of the Group, her life's work involved the presentation of the ruins rather than the living fabric of First Nations people. The rapport she sought with the ruins and the allegorical narrative of "nature-conquers-all" eclipsed the possibility of any understanding of the social, political and cultural struggles that are involved in the territories she depicted. Thus while her work rebelled against the conventions of painting and in her life she rebelled against the conventions of a patriarchal society, her work insisted that nature was an expression of God. She seemed to have little knowledge of the real legislative oppressions of her First Nations friends and encouraged the view that they were part of natural, rather than human, history.

The view of nature that emerges from the aesthetic program of the Group is a stage set for the patriarchal ghost. Carr's nature was the result of a projection of poetic vitalism on forests, skies and growing things. She liked instability, hated civilization and saw in the forces of natural regeneration a kind of utopian nihilism and the potential end of what men had made. Carr's ruins are carcass-like; there's a sense of something violated, a body disinterred, of something brought wrongly into the corrosive light and air. This morbidity in her was stimulated and fueled by the idea of cultural extinction and annihilation and she sought the evidence among old abandoned village sites and falling totems, using them as an allegory for the vanity of all male construction.

The middle-class cult of Emily Carr tends to obscure the challenging negation her paintings often imply. Her biographers, perhaps like Carr herself, have declined to deal with her sexuality. There are no records of her sexual or erotic attachments; she may have had none. The idea of sex seemed to disgust her. The view that Carr was lonely and sexually frustrated (incomplete) has been voiced by her biographers and friends. Some attribute this to an early affair gone wrong, family trauma (we'd say abuse these days), others to Carr's own sense that, as a woman, she could never marry and remain independent enough to realize her art (yet she put art on the back burner for fifteen years). Her work and her personality have been appropriated by the very normative culture she rebelled against. Speculation about her sexuality revolves around the terms of lack, repression and unfulfillment. It is always a heterosexual lack, however, that is under scrutiny. None discuss Carr's unrealized potential for lesbian relationships. Thus sexism and homophobia still circumscribe an understanding of her work, and thus an understanding of her vitalist readings of nature. For example, when she dropped the hard

phallicism Lawren Harris had encouraged for her late manner of rhythmic vibrations, was she attempting to define her motif as an expression of a feminine sensibility? Her choice to abandon form and mass for a vision of continuous movement was an attempt to discover transcendent unities. Nevertheless, this decision also meant an end to her readings of nature as a phallic, heterosexual allegory of thrall and penetration in favour of a reading of unfettered movement and corresponding vibrations [...]

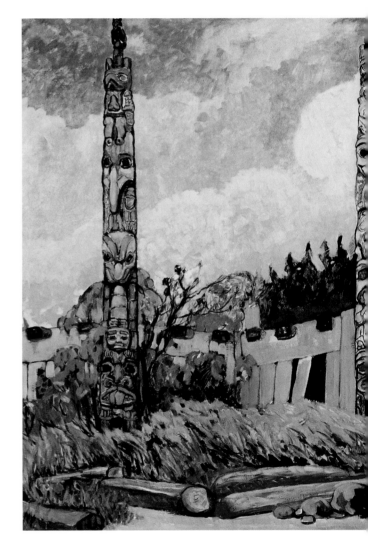

* * * * * * *

Reprinted from Scott Watson, "Disfigured Nature: The Origins of the Modern Canadian Landscape," in *Eye of Nature*, ed. Daina Augaitis and Helga Pakasaar (Banff: Walter Phillips Gallery, 1991), 109–10.

# Construction of the Imaginary Indian

MARCIA CROSBY

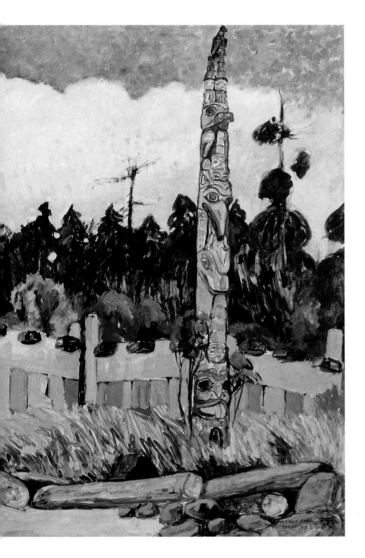

Emily Carr, *Tanoo, Queen Charlotte Islands*, 1913, oil on canvas, British Columbia Archives and Records Services

**I AM GOING TO SPEAK ABOUT** what seems to be a recent phenomenon in the arts and social sciences – the embracing of "difference." As a component of postmodernism, difference may take the form of the many voices that struggle against the hegemony of the European "master narrative." In the face of popular culture and an ever-shrinking globe, it is also a saleable commodity.[1] Increasingly, we as First Nations people assert our national and cultural differences against the homogenizing effects of academic discourse, mass culture and government legislation.[2] However, interest in First Nations people by Western civilization is not such a recent phenomenon; it dates back hundreds of years, and has been manifest in many ways: collecting and displaying "Indian" objects and collecting and displaying "Indians" as objects or human specimens,[3] constructing pseudo-Indians in literature and the visual arts. This interest extended to dominating or colonizing First Nations people, our cultural images and our land, as well as salvaging, preserving and reinterpreting material fragments of a supposedly dying native culture for Western "art and culture" collections. Historically, Western interest in aboriginal peoples has really been self-interest, and this Eurocentric approach to natives – in all its forms – takes up a considerable amount of space within academic discourse. The purpose of this paper is to refuse the prescribed space set aside for the Imaginary Indian. Despite the West's recent self-critique of its historical depiction of "the other," I am not entirely convinced that this is not just another form of the West's curious interest in its other; or more specifically, the ultimate colonization of "the Indian" into the spaces of the West's postmodern centre/margin cartography. Exposing the self-serving purposes, and the limitations that such cultural maps impose on all First Nations people, is an act of confrontation and resistance. I also consider it an act of affirmation to speak in the first-person singular, refusing

an imposed and imaginary difference in order to assert my voice [...]

An interesting aspect of the salvage paradigm is that it may occur at many historical points. James Clifford describes the conditions under which "saving" an "othered" culture takes place: "a relatively recent period of authenticity is repeatedly followed by a deluge of corruption, transformation, modernization ... but not so distant or eroded so as to make collection or salvage impossible."[4] Some sixty years after Paul Kane had recorded the remaining images of so-called authentic Indian life, Emily Carr made up her mind to record for posterity the totem poles of the Northwest Coast in "their own original" village settings[5] before they became a thing of the past.[6] Like Paul Kane, Carr claimed her paintings were "authentic."[7] There is a double edge to her serious endeavour to record for posterity the remnants of a dying people: Carr paid a tribute to the Indians she "loved," but who were they? Were they the real or authentic Indians who only existed in the past, or the Indians in the nostalgic, textual remembrances she created in her later years? They were not the native people who took her to the abandoned villages on "a gas boat" rather than a canoe. My point is that the "produced authenticity" or stereotype that Clifford refers to is invisible in Carr's work, and therein lies the danger. It could be argued that her paintings were authentic or real in the sense that they were ethnographic depictions of actual abandoned villages and rotting poles.[8] However, her paintings of the last poles intimate that the authentic Indians who made them existed only in the past, and that all the changes that occurred afterwards provide evidence of racial contamination, and cultural and moral deterioration. These works also imply that native culture is a quantifiable thing, which may be measured in degrees of "Indianness" against defined forms of authenticity, only located in the past. Emily Carr loved the same Indians Victorian society rejected, and whether they were embraced or rejected does not change the fact that they were Imaginary Indians.

Images of abandoned villages, such as *Tanoo*, with the remaining poles leaning over, rotting in neglect and deterioration, call up images of a not-too-distant culture removed from the present. The remaining fragments of Northwest Coast native culture are to be recorded for the historical interests of British Columbia and Canada.[9] In her biography of Carr, Doris Shadbolt introduces the following excerpt from one of Carr's talks on totem poles as "a statement of high moral purpose: 'I glory in our wonderful west and hope to leave behind me some of the relics of its primitive greatness. These things should be to us Canadians what the ancient Briton's relics are to the English.'"[10]

Obviously, material culture does not grow or exist in a forest by itself. The poles Carr painted were created by and belong to the First Nations peoples of the Northwest Coast. Carr's literary description, in her mission statement, of the poles as relics to record (to "save" as traces of "the West's primitive greatness") locates her work within the salvage paradigm. She describes the poles as belonging to a geographical space, a landscape devoid of its original owners. Her association of the material culture of the Northwest Coast native people with the "primitive greatness of the West" was naturally facilitated by the already entrenched construction of the Indian as nature. Carr invests the "relics" of her country, Canada, with a meaning that has to do with her national identity, not the national identity of the people who own the poles. The issue here is that the induction of First Nations peoples' history and heritage into institutions as a lost Canadian heritage should be considered within the context of the colonization of aboriginal land. At this time, when the struggles of First Nations people for aboriginal rights and self-identity are being

Jack Shadbolt, *Coast Indian Suite* (detail), 1976, charcoal and acrylic on board

widely publicized, it is inappropriate, I think, for an art historian to describe Carr's remarks as a "statement of high moral purpose." However, commonly held notions not only of Imaginary Indians, but of Canada's mythical icons – or sacred cows – die hard.

In the summer of 1990, the National Gallery of Canada presented a retrospective of Emily Carr's work. In the foyer to the exhibit, the text on the wall introduced Carr as: "A child of British Columbia, [who] forged a deep bond with the native heritage and natural environment of that province and [who] against many odds, fought her way through to her subjects, responding intensely and openly to their message. Her profound understanding of the meaning of that heritage and her intense search for a religious meaning in her life, resulted in the final and most important statements of her life, the vital expression of the spiritual forces of Nature."

I do not believe that Carr could have possibly had "a profound understanding" of the many nations of native people who inhabited the Northwest Coast during her time. They were, and still are: Nisga'a, Gitksan, Tsimpsian, Haisia, Haida, Nuu'chah'nulth, Kwagiulth, Heiltsuk, Nuxalk, Songish, Cowichan, Nanaimo/ Chemainus, Comox, Sechelt, Squamish and Sto:lo. (This list does not include the southern-, central- or northern-interior nations.) If she did forge a deep bond with an imaginary, homogeneous heritage, it was with something that acted as a container for her Eurocentric beliefs, her search for a Canadian identity and her artistic intentions. To accept the myths created about Carr and her relationship with "the Indians" is to accept and perpetuate the myths out of which her work arose. The academic community today has access to primary source material of First Nations people and postcolonial discourses, and should have a broad enough perspective to consider what Carr did not and perhaps could not see.

However, many artists who were inspired by Carr's work continue the colonial process of re-presenting native imagery as a means of formulating a regional art. An entry in Jack Shadbolt's journal, 24 February 1985, says: "First off – and this is easiest to say in a broad generalization – the Coast Indian is the nearest symbolic mythology to hand. Originally fired I suppose, in my formative early years, by contact with Emily Carr, my interest was fanned by her powerful and brooding evocations of tragedy in the dying culture of the abandoned Indian villages with the romantic grandeur of their remnant standing against the overwhelming wilderness, an image that appealed to my youthful temperament."[11]

In his book on the work of Jack Shadbolt, Scott Watson concedes that perhaps Shadbolt's use of native imagery is an attempt to establish "roots," but further states that "while this project may be appropriative and colonizing, it is an attempt to be inclusive. It proposes that the Indian cultural heritage is 'our' heritage," a proposal enabled, Watson asserts, by Shadbolt's "rejection of social realism for a biological model of culture and an atavistic model of consciousness."[12] Although Watson critiques the notion of "a dying people" as "patronizing at best, and racist at worst," he mentions the Canadian modernists' "appropriation" of Indian heritage only in relation to their use of it within modernist theory.[13] Yet the myths of an "empty land," a "dying people" contaminated by European culture and the Indian as Nature (and all its corollaries) reflect and shape present-day attitudes towards First Nations people. These notions are not just abstract theories within literary and visual-art circles, but a dynamic in the courts of this country. In 1989, government lawyers, in disputing Gitksan-Wet'suwet'en land claims, attempted to establish that Indians who eat pizza, drive cars and watch television – that is, who no longer live as "traditional" Indians residing in some timeless place – did not meet Eurocentrically established criteria for authenticity under which, the courts assert, Indian "rights" were established.[14]

The colonization of the native cultural heritage reflects the political attitude of the Canadian government towards First Nations people and our land, and ultimately affects our basic human rights. Talk about the "inclusion" of a native heritage implies identification with the dominant culture, and some benefit to who or what is being included. Yet this "inclusion" denies the existence of systems of signs encoded in visual images, dress, language, ritual, that have specific sociopolitical and religious meanings for specific nations of people.[15] The colonization of images in order to create a new Canadian mythology is parasitic, requiring that the first-order meanings within native communities be drained. This is not an inclusive act, but an act predicated on our exclusion, or "otherness" [...]

* * * * * * *
Reprinted from Marcia Crosby, "Construction of the Imaginary Indian," in *Vancouver Anthology: The Institutional Politics of Art*, ed. Stan Douglas (Vancouver: Talonbooks, 1991), 267–8, 275–9, 287–90.

# The Trouble with Emily

ROBERT FULFORD

How Canada's greatest woman painter ended up on
**the wrong side**
of the political correctness debate

From *Canadian Art*, winter 1993

IN THE SUMMER OF 1990, a wall text accompanying an Emily Carr exhibition at the National Gallery declared that Carr "forged a deep bond with the native heritage" of British Columbia, and developed a "profound understanding of the meaning of that heritage." That's not a new notion: it's a point often made about Carr by those who write earnest schoolbooks, and anyone who has read even a little about Canadian art will be familiar with it. But what does it mean? The answer involves a controversy that has been gathering around Carr in recent years, nibbling at the pedestal on which she has stood for two generations, drawing her into the midst of racial politics and postmodern theory, and challenging her place of high honour in Canadian art and women's history.

How profound, exactly, was the understanding to which the wall text pays tribute? Did Emily Carr understand native culture in the way she understood, say, the British-colonial Victoria in which she grew up? Or did she understand it in the way a diligent scholar may come to know a single foreign culture after years of study? Could she have explained the subtleties of belief by which coastal natives lived their lives and made their art? Or could she have described the differences between the Haida she encountered at Skidegate and the Tsimshian she met on the Skeena River in a way that either the Haida or the Tsimshian would recognize? Or does the word "profound," which springs so easily to our lips, mean something vaguer in this case, something like a mystical leap of imagination and empathy by which Carr miraculously found her way, through otherwise impenetrable forests of exotic belief and custom, into the very heart of native life?

Perhaps the wall text was no more than a pious tribute to one of the saints of Canadian culture, a saint whose story has nourished nationalists, feminists, British Columbians, and many other admirers of her work. Judith Mastai, who runs public

programs at the Vancouver Art Gallery, has noticed how Carr enthusiasts love to burnish this story and "stand in its warmth," a beautiful phrase for one of the familiar uses of the cultural past. By now just about everyone knows the two dramas that make up Carr's myth. One is the standard modernist saga of the solitary artist whose talent and courage triumph over obscurity, neglect, poverty, and depression, making each painting into a personal victory that later generations adopt as part of their national heritage. In this case the sex of the protagonist heightens the narrative and places it firmly in women's history as well as in the history of Canadian painting. The other drama, equally powerful, involves her encounter with the great wooden sculpture of the coastal villages of British Columbia, sculpture which was largely created in the nineteenth century and allowed to rot through much of the twentieth, neglected both by the descendants of those who made it and by the white authorities who were governing the province and making every effort to obliterate the native cultures.

Carr began visiting those villages in 1907, fell in love with them, and soon (to use a phrase that seemed quite innocent only a few years ago) "made them her own." She found them dying and determined to give them life in her paintings, a project that involved much arduous travel; it turned her into one of those artist-adventurers whose work involves going long distances to find their subjects.

She succeeded so well that even today many of us, when we think of those villages, think first of Carr's paintings. We understand that her work was stylized, sometimes caricatured, that she added her own distortions to the native art that she saw. We know that sometimes it's impossible to say for certain which distortions are Carr's own and which belonged to the objects she sketched, sometimes in haste. She was, after all, an artist, not a reporter. We have far more precise visual accounts from photog-

raphers and filmmakers who have made their way up and down the BC coast. And yet it is Carr's version that first springs to mind, partly because of her undoubted talent and partly because she was seeing it freshly, discovering for herself a miracle of cultural history in her own part of the world. She was far from the first outsider to see the poles of the coastal and river villages, but she was the first to focus on them with the eye of an outstanding artist in the European tradition. She was equipped to do for them what Picasso did for the African sculpture he encountered around the same time, and what Gauguin earlier did for Tahitian art: she could take them imaginatively out of their own milieu and exhibit their virtues within another culture, a service that artists have been performing for other art at least since the time when ancient Romans copied Greek sculpture and thereby spread Hellenic influence through the empire. The idea that her eloquent tributes to native BC carving would one day be resented, and even perhaps labelled "appropriation," could not have occurred to her, any more than it could have occurred to Picasso or Gauguin or the Romans.

Carr was also something of an amateur anthropologist, which has lately turned out to be another source of trouble. In 1935 aged sixty-four with her travels to the coastal villages and her paintings of native art now well in the past, she discussed the life of the natives with great confidence as well as obvious affection. Lecturing in Victoria, she implied that native BC art could be ranked along side the greatest known, an idea that must have seemed radical at the time and is by no means universally acknowledged even today. She discussed, as equivalents, the "old masters of Europe, the Chinese and Japanese, the Greeks, the Byzantines, the Assyrians, the African negroes, the Indians of America ..." She argued that the source of the greatness of the coastal art could he found in the natives' relationship with

nature, a relationship she believed she understood. She focused on the simplicity of native life, which in her view made their art possible. The natives were obliged to work directly from nature: "They saw, heard, smelled, felt, tasted her," drawing knowledge from intimate contact rather than theory. "They looked upon animals (through which they mostly expressed their art) as their own kindred. Certain of the animals were more than that: they were their totems and were regarded by them with superstitious reverence and awe." She described the use of animal symbols by the chiefs, and the pride a carver took in representing these creatures: "His heart and soul were in his work; he desired not only to uphold the greatness of his people but to propitiate the totem creature. The Indian's art became great because it was produced with intensity. He believed in what he was expressing and he believed in himself."

When she described this accomplishment, every verb she used was in the past tense. Finally she mentioned the artists of the present, 1935. She acknowledged that some still carved well, "but the objective and desire has gone out of their work." They no longer believed in the power of the totem. "The greatness of their art has died with their belief in these things." Reading, writing, and "modern ways" had irreparably broken their concentration on art. By the end of her talk it was clear that she was speaking a lament for a dead culture, one which she had been fortunate enough to glimpse and portray in its dying moments before the last great poles collapsed of their own weight and were reclaimed by the rain forests.

For much of her life, Carr was personally isolated, but she nevertheless painted, thought, and wrote from inside the heart of an empire of taste that ruled the world by what it regarded as natural right. She proceeded from the European tradition (somewhat, but not radically, modified by Canadian experience), and

looked at the world, including the coastal natives, as a European. For that reason, her reputation is now under attack. Her legacy has become a battlefield in the culture wars, the subject of postmodern revisionism combined with retroactive racial justice. Just as she used native culture as a way of expressing herself, now natives (and others sympathetic to the present situation of natives) are using her as a way of exhibiting and analyzing the imperialism of white Canadian culture, in her time and ours.

To understand what has happened we need to understand that postmodernism represents the triumph of context over art. This kind of criticism began as a way of demonstrating the importance of the environment in which art is produced and used. It arose specifically to deny the work of the New Critics of the 1940s and 1950s whose "close reading" of poetry excluded biography and history and searched for meaning within the poem itself. It also opposed formalist art criticism, which depicted the development of art as proceeding from an inner logic rather than as a part of its society. Twenty or thirty years ago, enemies of the New Critics and the formalists believed they were righting the balance, introducing realism into a too-rarefied criticism by insisting on the importance of social and political influences. But since then, postmodern thought has reversed the old emphasis rather than adjusting it; in fact, criticism now habitually uses art as an illustration of its context rather than using the context to illuminate the art. Art has become criticism's tool. In many a literature class across western Europe and North America, theory has superseded poetry itself, reducing Wallace Stevens or Sylvia Plath or Shakespeare to the level of "examples," evidence to prove academic theories about race, sex, and imperialism.

Within this world, it seems natural to focus on what we can now properly say on the subject of Emily Carr, and what that in turn says about her time, our time, and the relationship of culture

to social justice. Marcia Crosby, a Haida/Tsimshian student of art and history, has a firm response to that National Gallery wall text's assertion about Carr's "profound understanding." She states it in her essay, "Construction of the Imaginary Indian," published in 1991 in *Vancouver Anthology: The Institutional Politics of Art*, edited by Stan Douglas. Put plainly, she doesn't believe a word of it. In her view Carr could not possibly have had a profound understanding of the many nations inhabiting British Columbia. Crosby names sixteen distinct nations, from Nisga'a to Sto:lo, and that's the short list – she doesn't mention any of the nations of the interior. It would be impossible for anyone to develop, as a part-time interest over a couple of decades, a deep understanding of so endlessly complicated a world. What Carr did was form an emotional bond with it: it deeply touched her imagination, and she felt for it. But even that bond (Crosby argues persuasively) was not with the nations themselves but with something that never existed: a homogeneous civilization, Carr's own mental construct, a kind of generic native civilization, what Crosby calls "the Imaginary Indian."

This was a fantasy vessel that Carr, like other whites, created. Into it she poured her longing for a Canadian culture and her ideals about nature. Believing she understood this "Indianness," she naturally felt qualified to judge it, and even to write its obituary. Like the European writers who enjoyed their own melancholy feelings about the dead cities of the Middle East (the theme of Rose Macaulay's *The Pleasure of Ruins*), Carr saw the sweet poetry of death in the fallen totems of the Northwest. As Crosby says, her paintings of the last poles "intimate that the authentic Indians who made them existed only in the past, and that all the changes that occurred afterwards provide evidence of racial contamination, and cultural and moral deterioration. These works also imply that native culture … may be measured in degrees of 'Indianness' against defined forms of authenticity," which were also located in the past. "Emily Carr loved the same Indians Victorian society rejected, and whether they were embraced or rejected does not change the fact that they were Imaginary Indians."

This is why (as Judith Mastai wrote in a paper given in November 1992 at the University of Essex) "Today Carr's images are perceived as part of the problem" rather than as the act of tribute that Carr believed they were. Mastai argued that "paternalistic, white artists" romanticized the idea of dying races and claimed to salvage the remains of these doomed civilizations while at the same time, "consciously or unconsciously" supporting the federal government's development of a nation that ignored aboriginal rights. These artists also, and Carr in particular, "appropriated the imagery of the First Nations' peoples."

The word "appropriation," bearing the implication that people of one culture do not have the moral right to depict other cultures in fiction or painting, has lately become a rhetorical weapon in the hands of intellectuals claiming to speak for minority rights. Its power derives, oddly, from its very irrationality. In my experience, people hearing of it for the first time cannot believe that anyone could put forward so ludicrous an idea: even the most modest education in cultural history teaches us that art of all kinds has always depended on the mixing of cultures. But just because the concept of "appropriation" stands so far outside the realm of common sense, it has acquired the charm of the exotically radical and attracted an exceptional amount of attention. It depends heavily on another idea, which has no name but has nevertheless become widely popular: I call it "ethnic possession." According to this doctrine, I hold a form of ownership in the culture produced by members of my race, even if I myself actively produced none of that culture. More than

that, I am, by virtue of my race, inherently more knowledgeable about "my" heritage than people of other races can ever be.

"Ethnic possession" applies, so far, only to races and cultures oppressed by the majority. If someone of English background said "I automatically understand Chaucer better than any Pakistani who has studied him daily for ten years and those who argue otherwise are both insensitive and insulting," that statement would be seen as almost insanely racist. But if an intellectual speaking for a minority sets forth precisely the same formulation, it is not only given a fair hearing but may sometimes be applauded and even taken seriously by institutions such as the Canada Council. The burden of historic guilt created by racism has so distorted the perceptions of western intellectuals that frequently we cannot see support for this notion as the act of condescension that it surely is.

Robert Linsley carries the critique of Carr to another level: he attacks her not only for what she did but also for what she failed, in his view, to do. In *Vancouver Anthology* he writes: "Carr's empathy with the natives partly depends on her distance from them. The glamour of the noble savage that surrounds the Haida and other northern tribes in her work could not belong to the natives of the Songhees reserve in Victoria." He goes on to note the absence of figures in her mature work: "People are replaced entirely by their artefacts." Linsley implies that it was Carr's duty to paint the living Songhees rather than the villages left by dead Haida. Apparently Carr should have looked ahead to the 1990s, when she would be judged by Linsley and similar critics; then she might have made some small contribution to the understanding of the situation of natives in the twentieth century. True, she could still have been accused of appropriation, but she could have consoled herself with the thought that it was done in a good cause. Instead, poor fool she acted like an artist: she saw a magnificent subject, unknown to the world but within her reach, and hardly able to believe her luck, joyfully painted it.

Scott Watson has convicted Emily Carr of another sin: she didn't keep up with public affairs. "She seemed to have little knowledge of the real legislative oppressions of her First Nations friends," he announces in an essay that appeared in *Eye of Nature*, published by the Walter Phillips Gallery at Banff in 1991. Watson can't forgive Carr for painting what she saw, in this case, magnificent villages that were on the point of disappearing: "Carr's ruins are carcass-like; there's a sense of something violated, a body disinterred, of something brought wrongly into the corrosive light and air. This morbidity in her was stimulated and fueled by the idea of cultural extinction and annihilation ..." Watson seems to be saying that there was something unhealthy ("morbidity") in Carr's fascination with the dying villages. Unlike her critics of the 1990s, she lacked the power of positive thinking. She should have turned away from this amazing spectacle and focused her attention instead on the problems of native rights and the difficulty of maintaining native cultures in the twentieth century. If she had been truly healthy she might have avoided art altogether, and perhaps have found work as a social worker, a politician, or even a professor. Postmodern criticism could have saved her from herself.

A far more thoughtful and sympathetic account of Carr's relationship with the natives can he found in "Northwest Coast Native Culture and the Early Indian Paintings of Emily Carr, 1899–1913," a recently completed doctoral thesis by Gerta Moray of the University of Guelph. Unlike Carr's other contemporary critics, Moray has gone far beyond the usual sources: her research encompasses the written record, contemporary newspaper coverage of Carr's activities, oral-history material, and, most important, the many paintings and sketches that Carr made in the years she spent

studying native art. Moray understands the postmodern critique of Carr, and has read these arguments with care. Yet her thesis is an eloquent defence of Carr, her work, and her motives. In the end she persuasively refutes just about every point made by Carr's critics.

For Moray the notion that Carr appropriated Indian art for the use of whites, and ignored the native culture of her own time, entirely misses the point. As Moray shows, she was not an artist seizing on Indian art for purely formalist reasons; all to the contrary, her art was a public, political act, owing as much to her civic conscience as to her artistic sensibility. She specifically opposed the white authorities, whether missionaries or government employees, who were urging natives to change their way of life, and she saw the totem poles as part of "an integrated and complex native culture ..." In writing about her travels to native villages "she took pains to acknowledge that these places belonged to her guides and it was they, not she, who understood them."

Carr's goal was to vindicate the natives against the negative views of whites, "asserting their honour, dignity, and the coherence of their traditional way of life and beliefs." Far from ignoring contemporary natives, she took care to show them her work, and took pride in the fact that they accepted it. Moray quotes Georges Clutesi, an Indian artist who knew Carr and visited her studio: "She made it so very simple for me to see how important it was to remain myself, and to not change my style ... It was largely because of her counselling that I kept the style I began with." Carr understood that some natives, in their desire to assimilate, were ignoring or destroying the evidence of their cultural past, and she wanted to persuade them that this art was worth saving.

Unfortunately, she didn't have the effect on the white community that she hoped to have. In her dealings with provincial museums and in her Vancouver exhibition of 1913, she discovered that few of her fellow whites could be persuaded to share her esteem for native art. As Moray says, "Carr's espousal of native art forms was not acceptable for her own local audience until ... the message of her art's significance came from Ottawa." But that doesn't reduce the fact that her documentary project was what she called it: an "homage" to the art of the coastal Indians.

The past can be a great burden for the living, if one's present life is seen as no more that a melancholy epilogue to vanished greatness. But this is not a unique problem for natives, and should not be discussed in isolation. Egyptians, Greeks, and Italians have known about it for millennia; the English are beginning to understand it, and the Americans think they can see it just ahead. Its implications for those who live with it are far more complicated that the formulations of postmodern criticism might suggest. It is a gross insult to any group of people to say that they have no future. But avoiding that insult should not involve distorting the past.

Marcia Crosby, in dealing with another work of art, George Bowering's novel, *Burning Water*, objects to the depiction of bad-smelling, drunken, promiscuous Indians, even though she acknowledges that Bowering's intention is to criticize white, Western ideology. Good authorial intentions aren't enough, she says: "There is a difference between using a theoretical critique and being used by it." Emily Carr, if she could speak from the grave, might well make precisely the same point.

\* \* \* \* \* \* \*
Reprinted from Robert Fulford, "The Trouble with Emily," *Canadian Art*, winter 1993, 33–9.

# Emily Carr and the Traffic in Native Images

GERTA MORAY

Emily Carr, *Skidegate*, 1912, oil on card, Vancouver Art Gallery

**IN THESE POSTCOLONIAL TIMES** the ideological and political dimensions of artistic practice are more than ever under scrutiny. How do we read the work of an artist whose career and reputation were built on traffic in the Native image? This was literally the case with Emily Carr (1871–1945), a founding figure of modern art in Canada and a colleague of the legendary Group of Seven, who grounded an imagined modern-Canadian national identity in images of the landscape as a vast, alluring, and threatening wilderness. Carr herself contributed a further element to this foundational Canadian imagery: her paintings of the British Columbia landscape incorporated traces of what her white Canadian contemporaries saw as the ancient and exotic culture of the Northwest Coast Native peoples – what we see now as a colourful, local, and completely "Canadian" heritage. In the years between 1907 and 1913 Carr made 200 paintings documenting the villages, the carvings, and the peoples of the Northwest Coast First Nations. In 1927, when she was in her mid-fifties, a large group of these paintings were shown in Ottawa at the National Gallery of Canada; the "Exhibition of Canadian West Coast Art, Native and Modern" brought her into the national art scene. In 1941, her first published book, *Klee Wyck*, a collection of tales of her encounters with Native peoples, won the Governor General's Award and became a best-seller.[1] Carr's success as an artist was founded on the appeal of her Native images within a colonial context, the problematic history of which must be taken into account.

The Canadian settler community's enthusiastic adoption of Northwest Coast Native traditional artefacts as works of art (and, through the 1927 exhibition, as part of a national artistic heritage) becomes scandalous when we realize that Canadian government policy was at the same time intent on the forcible assimilation of Native peoples, on the eradication of their languages, beliefs, and traditions through compulsory residential schooling, and on the

suppression of First Nations' political protest by making illegal any fundraising for the costs of pursuing land claims.[2] This was the culmination of a process that had begun during the seventeenth century on the east coast of what would become Canada and finally reached the west coast in the second half of the nineteenth century, a process through which aboriginal peoples were dispossessed of their lands and traditional livelihoods by an inexorable tide of settlers in an invasion that was if relatively bloodless, nonetheless ruthless.

Developments in Canada were part of broader currents in a world increasingly interlinked by the domination of Western imperialism. The artefacts of non-European cultures became objects of European study and classification both in the *métropole* and in the colony. They were first collected as scientific specimens or ethnographic exotica for imperial museums. Later, through primitivism (an artistic current central to modernism), they were seen as the aesthetically superior creations of more "authentically" artistic but "uncivilised" non-European cultures that were doomed to extinction.[3] In the late nineteenth century, as urban industrial Europe reaped the wealth of global imperialism, the material products of other races became a consumer spectacle in the great world fairs and in department stores on both sides of the Atlantic.[4] In predominantly white settler colonies and in former colonies (such as the United States), as aboriginal peoples were subjugated and their land rights and traditional cultures eroded, they were classified as "vanishing races." This classification was accompanied by the construction of romanticized images of what was seen as their spirituality and rootedness in the land. Emily Carr's career unfolded within these international and colonial currents of response to non-European cultures, with their conflicting strands of romantic projection and exploitative plunder.

Drawing on recent critiques of the Eurocentric imperialist treatment and representation of non-European peoples, Marcia Crosby, an art historian of Haida-Tsimshian descent, has initiated a debate about Carr's images of Northwest Coast Native culture. She writes:

> There is a double edge to [Carr's] serious endeavour to record for posterity the remnants of a dying people: Carr paid tribute to the Indians she 'loved,' but who were they? Were they the real or authentic Indians who only existed in the past, or the Indians in the nostalgic, textual remembrances she created in her later years? They were not the native people who took her to the abandoned villages on "a gas boat" rather than a canoe ... [H]er paintings of the last poles intimate that the authentic Indians who made them existed only in the past, and that all the changes that occurred afterwards provide evidence of racial contamination and cultural and moral deterioration ... The issue here is that the induction of First Nations peoples' history and heritage into institutions as a lost Canadian heritage should be considered within the context of the colonization of aboriginal land.[5]

Crosby's call for cultural processes to be seen in a political context is timely. Her verdict on Carr's paintings, however, rests on the picture of the artist that is current in narratives of Canadian art history and in popular culture, a picture that has constructed Carr as a mediator of Native traditions for Canada's white settlers. Carr has become a Canadian cultural icon and her work and persona have taken on an altogether autonomous and mythical life.[6] We must remember, however, that Carr produced her nearly 500 "Indian" paintings during a life and career that spanned a long period of change and development, and that her output went through distinct stages in both conception and reception.

To illuminate the part played by her images of Northwest Coast culture in Canadian historical processes and the specific position Carr herself took up within them, each stage of her career needs to be considered in its geographic, social, and political framework.[7] As Molly H. Mullin has written, "Concern with *otherness* and its metonymic objects occurs in specific historical contexts, contexts that may be obscured by analyses of a more global nature and by such broad terms as *Primitivism* and *Orientalism*."[8]

In this paper I shall argue for a methodologically complex approach to interpreting postcolonial situations. Carr offers a case study that calls for attention to issues of gender, of colonial identity and nation building, of regionalism, and of the crossing of cultural boundaries during periods of historical change. I shall engage these issues through an examination of Carr's image-making as it unfolded in three intersecting contexts: first, in her involvement with the international current of primitivism; second, in the position she staked out for her work amid the regional politics of settler-Native relations in British Columbia; and last, in the reception of her work and its evolution within the arena of the Canadian national art scene. My goal is not to contribute to Carr's legend as a heroic individual, but rather to recognize the complexities and contradictions of her involvement in various cultural currents, and the shifting meanings of her work in changing contexts. While Carr contributed to the traffic in Native images that accompanied the dynamics of colonial exploitation, I shall argue that her work was also a site of resistance to both predominant regional settler attitudes and the attitudes of nation-building elites in central Canada. Carr, as an agent, held a thoroughly ambivalent position in the traffic in Native images, and the situation is complicated by the fact that she herself has become an object in this traffic. I shall suggest that her treatment of the Native image has fresh relevance in light

of the situation of First Nations communities and First Nations artists today.

Emily Carr's paintings of Northwest Coast Native villages were transformed when she came in direct contact with the French current of artistic primitivism during her studies in Paris in 1910–11. Before this, her first Native images, made in the Nuu-chah-nulth villages around Ucluelet in 1899, had been finished mostly in pen and ink, the preferred medium of commercial illustration. Her studies in England during 1899–1903 enabled her to record the Northwest Coast landscape and local features of interest more ambitiously in large-scale naturalist watercolours. In 1907 she had the idea of creating a complete pictorial record of Native villages, a venture that shows the professional acumen and ambition of this young woman artist competing in the newly fledged Vancouver art scene. Sensing that her techniques were still not adequate to her task, she travelled to France in 1910 and studied in Paris with a number of teachers associated with post-impressionism and fauvism. The most important was the English painter Henry Phelan Gibb, a friend of Henri Matisse and Pablo Picasso, who, like them, was indebted both to Gauguin's eclectic formal borrowings from Japanese prints, archaic Greek and Egyptian art, and Javanese and Maori sources, and to Gauguin's assumption that the revitalization of European art could be effected through direct contact with art forms and lifestyles of what were seen as "primitive" cultures.[9] For Emily Carr, initiation into Parisian primitivism meant that Northwest Coast totem poles, which had fascinated her since she began the project to document them in 1907, were securely ratified as works of artistic merit.

Carr returned from Paris a modernist with a conscious regard for the formal qualities of non-European art. As she wrote in a letter to the Vancouver newspaper, *The Province*, "Art is art,

nature is nature ... The Greeks and Egyptians did not copy nature in their works of art. The Japanese use nature, they do not copy it, and our native Indians do not copy nature, yet their carvings inspired by nature are wonderful."[10] A comparison of two works by Carr shows the difference that the experience in France made to her mode of representing Native villages. *Potlatch at Alert Bay* (c. 1909), is a watercolour painted in a late nineteenth-century naturalist style with an ethnographic interest in the appearance, clothing, and activities of people in the scene. In her auto-biographical notes, Carr mentions that she took some of these watercolours with her to France and, after discussing them with her teacher, "re-painted them cooprating [*sic*] the bigger methods I had absorbed over here with the bigger material of the west."[11] A small oil panel, *Totem Pole, Alert Bay* is probably one of the works repainted in oils in France from her early watercolours. Carr has extracted the housefront and totem from a larger composition, placing them in a shallow plane parallel to the surface of the canvas, and enlarging them to fill the frame. The emphasis now is on the decorative forms of the pole and on the intense colour, which gives the image a fairy-tale quality. But Carr's interest in the poles as art did not lead her to elide the figures in the scene: the village is shown as peopled.

Something different was at stake for the colonial, Carr, than Gauguin's exploitation of an exotic Other as a means for the artist to escape his own stifling and bloodless European urban civilization and to purvey fantasies of such escape.[12] Both Carr and contemporary artists in the United States were appropriating the cultural production of aboriginal populations residing within the borders of their modern nation states. These white settler nations had, by 1900, developed imagery and founding myths that gave a special role to the aboriginal peoples within their boundaries, making them emblematic both of the new land, and of a prehistory now superseded by the European introduction of progress and modernity.[13]

In the case of Carr, caught between European primitivist taste and the needs of her colonial homeland, we have a distinctive outcome. When Carr equated the aboriginals' use of abstracted and geometrically decorative form with a more primal creativity – an assumption at the root of the primitivist transvaluation of so-called tribal arts – she did not do so in order to appropriate the forms for exercises in autonomous formal experiment, like those of Gauguin and Picasso. She had other priorities, the most urgent of which was the need to experience, record, and learn to understand as well as possible the context and meanings of Native cultural traditions that were rapidly being modified by the introduction of Euro-Canadian industrial goods and political pressures. Having conceived the project of documenting "totem poles in their own village settings,"[14] she committed herself to observing standards of accuracy that would satisfy current anthropological criteria. She developed a serious interest in Northwest Coast Native cultures (fed by reading ethnographic publications available in the Vancouver Public Library and Museum) and set out to represent the poles in each village with all their forms precisely rendered. Contrary to received art-historical wisdom, this did not present a conflict for Carr's painting after her French training.[15] The forms on the poles and the brightly coloured paint applied to them by Kwakwaka'wakw carvers were visually fascinating to her and they fitted the stylistic preferences she had learned from her teachers. In Post-Impressionist studio lore, which taught the exploitation of complementary and saturated colours and boldly generalized shapes, Carr found methods that enabled her at last to render both the intense colour and the vast scale of the coastal landscape. While making studies of the totem poles at Skidegate, Haida Gwaii, Carr learned to draw the

characteristic form language of Northwest Coast carving and to integrate that language with the landscape background through the use of arabesque lines. This led her to the idea that Native art was informed by close attention to the coastal environment. Carr thus took what suited her interests from the broader current of primitivism and applied it to distinctly local concerns. She created an artistic mode through which she could encounter and translate local realities, both geographic and ethnographic. For Carr, this process was at once subjective (in the choices of motif and emphasis that occur) and systematic (in her submission to the discipline of accurately recording Native designs). It was an outgoing process of exploration and learning that folded back upon itself as it offered Carr images through which she could express personal themes of local allegiance and sense of place […]

* * * * * * *

Reprinted from Gerta Moray, "Emily Carr and the Traffic in Native Images," in *Antimodernism and Artistic Experience: Policing the Boundaries of Modernity*, ed. by Lynda Jessup (Toronto: University of Toronto Press, 2001), 71–5, 87–8.

# What Is Canadian in Ca

# Chapter 6

# adian Landscape?

# What Is Canadian in C

ENVIRONMENTAL EXPLANATIONS of national character are the product of nineteenth-century European nationalism, imperialism, and often racist, quasi-scientific theories. However spurious, they retained their currency well into the twentieth century. As late as the 1960s in Canada, Prime Minister John Diefenbaker, in an anti-American fit of economic wish-fulfillment, revived an appeal to the country's northern destiny. By that time, though, self-righteous nationalism grounded in geographic northernness was beginning to undergo criticism and debate. In his contribution to *Nationalism in Canada* (1966), a book edited by Peter Russell that played an important role in the debate, Cole Harris argues that a Canadian identity based on contact with a Precambrian Shield that few Canadians had experienced made little sense, particularly when the vast majority of the population lived and farmed in pockets between the non-agricultural North and the United States.

The phenomenon of nationalism and the rise of nation-states has been investigated and theorized by Benedict Anderson. "The internal logic of a world of nations," Anderson writes, requires expressions of particularity and authenticity. In Canada's case, the threshold of nationhood was reached through new realities and international responsibilities arising from the First World War. Along with it came the need to produce signs and symbols representative of national distinctiveness, as well as a conception of the Canadian character. In this context, the emergence of a national art movement was an inevitability, though the signs and symbols of distinctiveness produced by the Group of Seven in their work were frequently contradictory. The presence of a vast "wilderness" landscape may have marked off Canada from Britain and the Old World, but the process of mapping, naming, and representing it meant that the landscape could no longer be referred to as pristine and untouched.

The question of authentic Canadianness grounded in a wilderness North has been probed by any number of writers and artists. While Roald Nasgaard describes how the formative influence of a comparable school of Scandinavian landscape painting was suppressed in Canada in the name of national originality, despite its acknowledgment by members of the Group themselves, Robert Stacey argues that one of the primary effects of the nationalist myth surrounding the Group has been to obscure the actual originality of their work. In a fascinating case study, Grant Arnold discusses the paradox faced in the 1920s by the Vancouver photographer John Vanderpant, whose move from a traditional to a modernist practice was deeply affected by the new national school of landscape representation. In a series of woodblock prints produced in the 1980s, Robert Fones considers the cartographic implications of the myth of Canadian wilderness. As his map of the natural range of the Canada plum and those of other plants demonstrates, nature does not respect national borders. Liz Magor and Peter Doig have both addressed iconic signs of Canadianness in their work. Magor's *Cabin in the Snow* represents a quintessential Canadian scene, except that it is an illusion, a

# Chapter 6

# ...adian Landscape?

charming but nonetheless ersatz landscape created from cotton batten and dramatic lighting. The Group of Seven is cited in many of Doig's paintings, but they are pervaded by a shadowy, brooding atmosphere that invokes the past as a spectre, be it the ghostly image of Group member Franklin Carmichael painting in the landscape or an image of a lone canoe floating on a lake, bringing to mind Tom Thomson's drowning on Canoe Lake in Algonquin Park.

Canada's aboriginal peoples haunt visions of a national landscape. Commenting on F.B. Housser's hagiographic tract *A Canadian Art Movement: The Story of the Group of Seven* (1926), Scott Watson writes, "Whiteness represented the northern expanses, but it had racial connotations." For thousand of years before Thomson or the Group set their sights on Algonquin Park or Algoma, these regions had been home to nations of indigenous peoples who, though they might provide a model for the self-sufficient woodsman-artist, were victims of colonial dispossession. That dispossession is the subject of works by Stan Douglas and Robert Houle. Douglas's video installation *Nu·tka·* is based on a conflict during the colonial era between the English and the Spanish over trade rights in the territory of the Nuu-chah-nulth people of coastal British Columbia. As the Europeans erase each other through the superimposition of competing images and sound, it is the natural environment in all its glorious magnificence that emerges intact. The paradoxes of dispossession, which are intimately linked to distinctions between legal and cultural

relationships to the land, are at the heart of Robert Houle's series *Premises for Self Rule*. Citing historic treaties with the Crown that enshrine the right of Native peoples to reserve lands, the work comments on the peoples' shrinking connection to the land that is at the heart of aboriginal history, spiritual meaning, and identity.

In her deconstruction of the national flag, which invokes nationhood through the image of landscape, and her critique of the critique of the National Gallery of Canada building's failure as a symbol of national unity, Reesa Greenberg asks what relevance tropes such as these can have at a time when Quebec threatens to separate, Canada's indigenous peoples are asserting their land claims, and the population is becoming increasingly diversified. The work of Michel Saulnier, whose *Le Groupe des Sept* is a series of images that merge Group motifs and the straightforward design of rural Quebec domestic architecture, and of Jin-me Yoon, whose *Group of Sixty-Seven* invokes citizenship, community, and the act of looking backward as well as forward, registers that it is time for new sets of representations and understandings.

David Milne, *Barns*, 1931, colour
drypoint etching, National Gallery
of Canada

David B Milne /25

# The Myth of the Land in Canadian Nationalism

COLE HARRIS

**WHEN PEOPLE WEIGH THE NATURE** and basis of their nationalism they usually dwell on aspects of their culture, history, or race; but English-speaking Canadians tend to explain themselves in terms of land and location. Some Canadians, as Mr Berger points out,[1] considered their countrymen to have been shaped and strengthened by a hard northern realm, while others have envisaged a Canadian nation forged by the development of northern resources. An appeal to our northern destiny was one of the responsive notes struck by Diefenbaker in 1957 and 1958, and that appeal was probably strengthened by the Canadian apprehension that geographically we are North American, a fringe of regions on top of the United States. These two conflicting geographical propositions are central to many discussions about the nature of Canada: Canada exists because it is a distinctive northern land; Canada is North American, its southern boundary is geographically illogical and therefore fragile and probably temporary.

In print these geographical poles are clearest in the historical literature, for Canadian historians, along with some Canadian novelists,[2] have most frequently turned to the land to explain the character of Canada. The Laurentian theme running through the writings of Harold Innis, Donald Creighton, William Morton, and other Canadian historians, is the theme of the fur trade – the transcontinental enterprise based on the resources of the north and anchored to the towns which provided manpower, capital, and skills for northern development. In extreme form the theme becomes an incantation to the north:

> Canadian history began when the Vikings carried the
> frontier of fish, fur, and farm across the North Atlantic
> to Iceland and Greenland ... From that obscure beginning
> Canada had a distinct, a unique, a northern destiny. Its
> modern beginnings are not Columbian but Cabotan. And
> when the French followed Cartier up the St. Lawrence, they

were at once committed by the development of the fur trade to the exploitations of the Canadian Shield ... The Canadian or Precambrian Shield is as central in Canadian history as it is to Canadian geography, and to all understanding of Canada ... And this alternate penetration of the wilderness and return to civilization is the basic rhythm of Canadian life, and forms the basic elements of Canadian character.[3]

At the other pole are the continentalists; A.S. Morton, Fred Landon and, to a degree, A.R.M. Lower, Frank Underhill and A.L. Burt. Their studies have tended to emphasize "the mingling of the Canadian and American People,"[4] and have agreed with J.B. Brebner who opened his history of Canada with the sentence, "Perhaps the most striking thing about Canada is that it is not part of the United States"[5] [...]

The concept of the northern character and destiny of Canada has usually been bound up with the Precambrian Shield. Its landscape of rock, water, and stunted spruce, its thin, acidic podzols and glacially disrupted drainage form an environment with which few Americans have had to contend. As the boundary of this environment is close to the southern boundary of eastern Canada, it is not surprising that the resources of the Shield, furs, timber and minerals, the centres which provided the capital and some of the skills for the development of the Shield, as well as the enterprises which emerged in the Shield, have been considered to be the mainspring of Canada. Nor, in view of the size of the Shield and its proximity to settled Canada, is it surprising that the Shield has been part of the Canadian consciousness. No one objected that the Group of Seven should be considered the most Canadian of our painters because they painted a part of the country with which few Canadians were familiar. Harold Innis probably argued correctly that the boundaries of the Canadian state were laid in the fur trade;[6] and today, if railways, radio and

television networks could be considered to have inherited the route of the fur trade, then the Shield is also indirectly responsible for any sense of territoriality "from sea to sea" that has emerged in Canada.

And yet, however important the Shield has been in the development of Canada, only a handful of Canadians have lived there, or anywhere in our non-agricultural north. A relatively small percentage of Montrealers or Torontonians have been the employees of firms developing the resources of the north. Rather, Canadians have been a people living in pockets between the non-agricultural north and the United States. From the early years of Canada until well into the present century, farming was the principal Canadian occupation, and thus the character of French- or English-speaking Canadians has been drawn more from this agricultural background than from contacts with the Shield.

* * * * * * *

Reprinted from Cole Harris, "The Myth of the Land in Canadian Nationalism," in *Nationalism in Canada*, ed. Peter Russell (Toronto: McGraw-Hill, 1966), 27–9.

# Robert Fones

*NATURAL RANGE OF BUR OAK, 1984*

*NATURAL RANGE OF CANADA PLUM, 1984*

*NATURAL RANGE OF SHAGBARK HICKORY, 1983*

*NATURAL RANGE OF WHITE OAK, 1984*

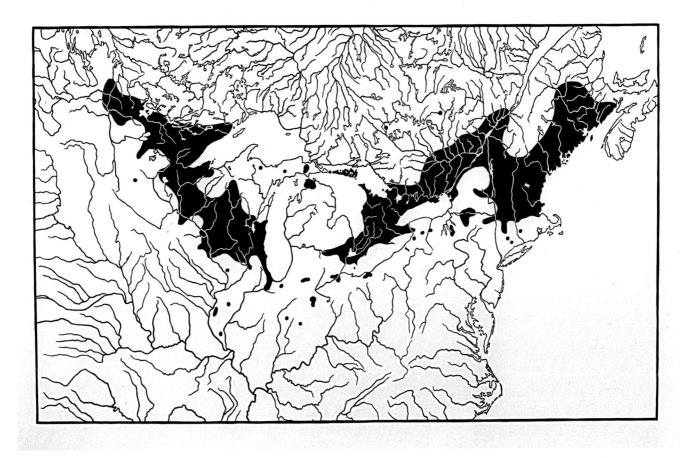

F.H. Varley, *For What?*, 1918, oil on
canvas, Canadian War Museum

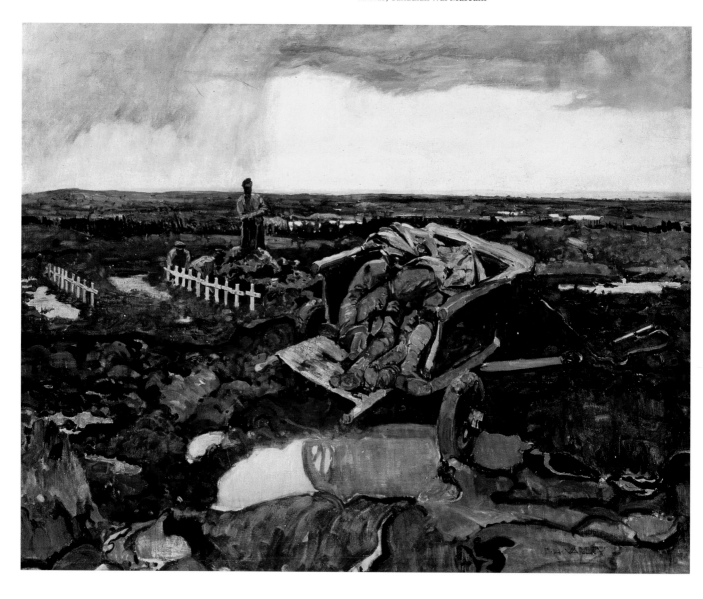

BENEDICT ANDERSON

# Staging Antimodernism in the Age of High Capitalist Nationalism

**IT IS PERHAPS EASY TO FORGET** that in the first quarter of the twentieth century the entire population of Canada, geographically the second largest country in the world, was roughly the same as that of Greater London, the imperial capital. It is only a little harder to remember that until the Great War industrialism was something still largely foreign. Small wonder therefore that a Department of External Affairs was only created in 1909, a bare decade before the Group of Seven made their initial splash.

But in that decade, "everything changed." When the Empire went to war in August 1914, Canada automatically followed suit. Eventually, over 600,000 Canadians were either enrolled in Canada's own army and mini-navy or fought with the United Kingdom's air force. Two-thirds of these people served outside Canada, 60,000 were killed (more than all the Americans who died in Indochina) and 173,000 were wounded. In 1917 a conscription law was imposed for the first time, over the vehement opposition of many Québécois, following the extraordinary disfranchisement of all Canadians originating from 'enemy alien' countries who became naturalized citizens after 1902. The war also brought about a huge state-led change in the economy: between 1914 and 1918, industrial employment increased by more than a third, and between 1913 and 1920 the value of exports more than tripled. Meanwhile, a federal government facing large war-related debts, for the first time imposed both a personal income and a corporate profits tax. And by 1918, women could vote in federal elections.

Along with nationalization of violent death, nationalization of the economy, and nationalization of the voting-age citizenry, nationalization of culture too was inevitably under way, given the huge new demands made upon the subjects of the state. If the entire country counted only six museums in 1867 at the time of Confederation, this nullity would not do in the era of the tank, radio, cinema and the aeroplane. By the eve of the Second World

War one hundred and fifty new museums had been created. Seen from this angle, the début of the Group of Seven in 1920 and its rapid ascension in Ontarian public esteem is not really surprising.

After its initial half-millenarian late-eighteenth-century stage, nationalism everywhere was expressed through a paradoxical binary that can be read, if one wishes, as what Ian McKay calls anti-modern modernism. On one side, the hunt was on for "authenticity," "roots," "originality," and "history," as nationalism's historically new consciousness created a radical break with the past. On the other side, nations were everywhere understood as "gliding into a limitless future," developing in perfect synchrony with the breakneck speed of Progress. Nineteenth-century Greek nationalists struggled both to revive the long-gone spirit of classical antiquity and at the same time to catch up with "modern Europe," and in this they were absolutely not unique.

In the nineteenth century, however, only a minority of existing states were nation states; most nationalist movements were directed against existing monarchical-imperial states, and drew their strength "from below." But there were deep trans-national tendencies at work throughout the century that would end this obsolete world-system and would create in 1920 – just months before the appearance of the Group of Seven – the unprecedented League of Nations as custodian of a new world order. Increasingly from that moment on, since all League members had to present themselves to each other as national, the state arrived to play a leading role in developing anti-modern modernism. The state was to be at once the rational planner and guardian of the nation's progress and at the same time the best guarantor of its originality – however this was conceived. What is most striking in retrospect is how unparadoxically these dual tasks were conceived. The term "heritage industry" did not sound oxymoronic in people's ears.

The internal logic of a world of nations, understood at one level as a world of fundamentally similar, co-operating and rivalrous entities, also meant that nation states were required to display, for one another, their parallel differences. One almost always had to have, until very recently, rectangular flags; one had to have national anthems which were recognizable as such in their basic form (no triple-time waltzes). One had to provide, on a massive scale, national histories for young nationals in schools, and these histories had to be written in such a way as to show instantaneously their nature. One needed to foster national sports to make satisfactory showings at Olympic Games. And, of course, one had to have national handicrafts, literatures, arts, dances, etc. for display – in international competitions, Nobel Prize sweepstakes, exhibitions, trade fairs, and the rapidly ballooning struggle for advantage in the world-market of tourism. Seen this way, it is perfectly clear why the twentieth-century nation state has had so huge an interest in sponsoring, financing, steering, vending, stimulating, planning, and authenticating universally grounded particularity and originality.

Twentieth-century nation states came to face these paradoxically universal tasks with vastly different resources, histories, and difficulties. Among these states, the twentieth-century Dominions formed a very special minority. Spain had long since lost its Creolized colonies of settlement in South and Central America. In 1900, France's empire was overwhelmingly 'colonial' in the modern sense and was restricted to Asia and Africa; the only substantial overseas settlement of 'French' people was in parts of eastern Canada, and for well over a century this population had been firmly subordinated to London. The outcome of the Boer War finally put the main overseas area of Dutch settlement in the same position. Thanks to its historic naval supremacy and later industrial primacy, the United Kingdom was the only European imperial power that managed to create, and to maintain into near-contemporary times, racially based, politically dependent settler states: Australia, Canada, New Zealand, and, up to a point, South Africa.

If one asks the question of where, in these special states, national originality was to be looked for, one can see at once that in the first half of this century the choices were rather limited. As described with elegant asperity by Lynda Jessup, the mythology of the Group of Seven, strenuously proclaiming the grandeur of the untamed wilderness of Canada, illustrates one possibility, which has its parallels in the nationalizing cultures of the other Dominions. The "untouchedness" of the landscapes appeared to guarantee their aboriginal eternity, while their strangeness and scale marked them off decisively from anything British. (This perhaps mattered most to those of the Group of Seven who were first-generation immigrants from the United Kingdom.) In this light, one can see the Group's (modernist) antimodernism and anti-industrialism as a symbolic way of separating itself decisively from what, even as late as 1920, was one of the world metropolises of industrial modernity.

To be sure there was, so to speak, a catch. Truly "untouched wildernesses" cannot, by definition, be national. Such wildernesses predate the human species, let alone nationalism, by eons. Their nationalization requires their human naming and their mapped location within a web of political territorialities (the Laurentians, not the Green Mountains of Vermont), and their representational subjection by nationalized artists, nationalized railway companies, and nationalized tourist agencies, who tend to think along the same lines [...]

* * * * * * *
Reprinted from Benedict Anderson, "Staging Antimodernism in the Age of High Capitalist Nationalism," in *Antimodernism and Artistic Experience: Policing the Boundaries of Modernity*, ed. Lynda Jessup (Toronto: University of Toronto Press, 2001), 97–103.

# Peter Doig

*CANOE-LAKE, 1997–98*

*FIGURE IN A MOUNTAIN LANDSCAPE*

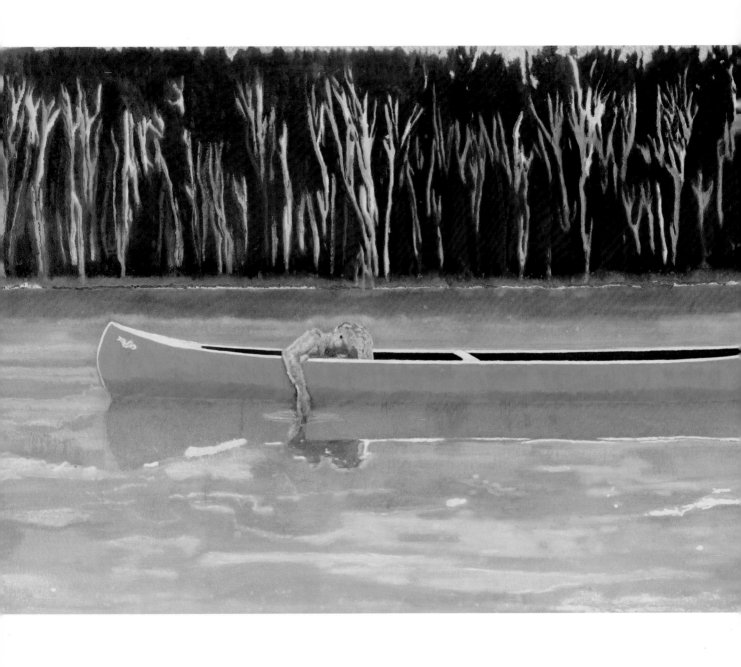

Gustaf Fjaestad, *Winter Moonlight*,
1895, oil on canvas, Nationalmu-
seum, Stockholm

# The Mystic North

ROALD NASGAARD

It is not so important that all small nations make imme-
diate and astonishing contributions to the great culture ...
It is, on the contrary, of major importance that they develop
independently and logically from their own roots, working
with subjects which especially suit them – in order little
by little, and in an original way, to grow part of the larger
organism, and address its variety from an original and vital
perspective.

RICHARD BERGH[1]

One of the reasons that landscape painting is the typical
expression of new movements in new lands is in the fact
that the artist is, intuitively, the medium through which
this knowledge (so essential to growth) of environment
must flow into consciousness ... Today ... wilderness is
understood as a source of power.

ARTHUR LISMER[2]

IN THE MYTHOLOGY OF CANADIAN art the Group of Seven is
acknowledged to have formed the first genuine school of Cana-
dian art and to have been the first to paint the Canadian north.
However many earlier artists devoted themselves to the Cana-
dian landscape, the Group of Seven not only identified its wild
and rugged character as uniquely Canadian, but also recast it in
a stylistic form that would determine, for this century at least,
how Canadians perceived their landscape. Out of trees, rocks,
and lakes the members of the Group also established the basic
symbols of national identity, however romantic and unrelated
to the realities of contemporary life these may have been. In this
they did for Canada what Nordström and the national Romantic
movement had done for Sweden two decades earlier, with sunsets
and midsummer twilight [...]

In *A Canadian Art Movement* (1926), the first comprehensive
history of the development of the Group of Seven, F.B. Housser
remarks somewhat strangely: "The story of the rise of the Scandi-
navian native school of painting sounds like an echo of the story
of our own."[3] We may assume that the chronological inversion of
his simile, whereby a later source produces an earlier echo, was
not entirely innocent, but something of a deliberate obfuscation
designed to acknowledge certain similarities between Scandina-
vian painting and the Group of Seven without having to concede
any essential dependence of the Canadians on their Scandinavian
predecessors, which might cast into doubt the formers' origi-
nality. It was, of course, a prevailing myth concerning the Group
that its work came about because its members divested them-
selves of "foreign-begotten techniques" and turned freely and
receptively to the native landscape itself for direction. Housser
said as much in an article in *Yearbook of the Arts 1928-29*: "The
essential difference between the Canadian movement and art
movements in other lands was that its inspiration was one of the
*country* ... [and] drew its life from certain elements belonging
especially to Canada, primarily to the North, with all its peculiar
influence of sky, water and land." The Canadians had created a
peculiarly native expression because "there were spiritual moods
and physical effects in Canadian landscape for which no aesthetic
equivalent existed in the art of Europe, because European painters
had never been called upon to find such equivalents." It is true,
he admits in this later context, that Scandinavians have similarly
drawn their inspiration from the North, but, even so, scarcely
any Scandinavian works had been seen by the Canadians.[4]

Housser was not incorrect in maintaining that the artists
who would unite to form the Group of Seven in 1920, as well
as Tom Thomson, had seen very little Scandinavian art. Only
Lawren Harris and J.E.H. MacDonald had, and on only one

occasion when they saw the exhibition of contemporary Scandinavian art that visited the Albright Art Gallery in Buffalo in January 1913. For both Canadian artists, however, the experience of that exhibition was seminal and long-lasting and celebrated in reminiscences long after the fact. That their confrères, who knew about Scandinavian art only at second hand, should be less enthusiastic is understandable; the presumption of a European source interfered with the most fundamental conception of the new painting, namely that it grew out of an unprecedented, original, and immediate response to the uniqueness of the Canadian landscape.

But even A.Y. Jackson, who consistently maintained that the Group had learned everything from the land itself, in 1919 could speak of a similarity of approach to that of the Scandinavians. He indicated that the Group "frankly abandoned any attempt after literal painting and treated our subjects with the freedom of the decorative designer, just as the Swedes had done, living in a land where the topography and climate are similar to our own."[5] Later in life he acknowledged that the Buffalo show was much discussed when he arrived in Toronto in May 1913 to meet MacDonald, Lismer, and Varley, as well as Harris, with whom he began to share a studio in 1914.[6] But as Robert Stacey has described it, it is with "an almost grudging, offhand tone" that, at age eighty-two, Jackson accounts for the genesis of the Group: "What had started all this [i.e., the interest in Canadian subject-matter] was that MacDonald and Harris had become excited about a show of Scandinavian paintings they had seen. Now, the north of that country is much like Canada, and these fellows from over there were painting their north country the way that MacDonald and Harris thought we should paint ours. I guess if there was a starting point for the Group of Seven, that would be it."[7]

Both MacDonald's and Harris's accounts of the meaning and significance of the 1913 trip to Buffalo have been widely reproduced. They are examined here in conjunction with precisely the kind of Scandinavian painting that had impressed them. MacDonald's account was presented in a lecture devoted to a general survey of modern Scandinavian art, delivered at the Art Gallery of Toronto (now the Art Gallery of Ontario) on 17 April 1931.[8] But it grew directly out of his experiences from eighteen years earlier when he had seen the Buffalo exhibition. In his recollections he wanted to recreate the exhibition for his audience and give them a sense of the "affinity of inspiration" that the Canadians had discovered to exist between Scandinavian and Canadian artists. He and Harris were already prepared to respond sympathetically to contemporary Scandinavian art: they "were full of associated ideas," based not on any direct experience of Scandinavia, but on "feelings" about their own country, "of height and breadth and depth and colour and sunshine and solemnity and new wonder," for which there were correspondences in the Scandinavian pictures. The natural aspects of both parts of the world were similar, and also the "general attitude" of the Scandinavian artists paralleled their own. The resemblances were so strong that, "except in minor points, the pictures might all have been Canadian." But paintings such as these had not yet been produced at home, and thus, as MacDonald and Harris concluded, "we felt, 'This is what we want to do with Canada.'"

What pleased the Canadians were the virtues that had become international commonplaces for Symbolist landscape painters in the North. Scandinavian art had about it "a sort of rustic simplicity ... It seemed an art of the soil and woods and waters and rocks and sky ... with its foundations broadly planted in the good red earth." MacDonald's own work, as he moved tentatively toward a Canadian expression, had been described in similar terms by the painter and critic C.W. Jefferys in 1911: "native – as native as the rocks, or the snow, or pine trees or lumber drives that are so largely his themes."[9]

The Scandinavian work in the exhibition was "not at all Parisian or fashionable." On the contrary, it was "indigenous ... an art of the north, rising out of different conditions from that of Greece or Rome" (MacDonald uses the example of the Neo-Classical sculpture of Thorvaldsen as a foil to the general rule that Scandinavian art is indigenous). "It is the difference between olives and vineyards and heather uplands and the cliffs of fjords, the Isles of Greece and the rocks and birch groves of the Baltic."

MacDonald's praise of Scandinavian art for not being fashionable must be read in the context of his 1931 antipathy to more recent manifestations of modern art and "the frosty condescensions of super critics on *volumes* or *dimensions* and other art paraphernalia." Scandinavian art, presumably like that of the Group of Seven, could be "understood and enjoyed without metaphysics." It was, and this is the essential point, the work of "a lot of men not trying to *express themselves* so much as trying to express something that took hold of *themselves*. The painters began with *nature* rather than with *art*." Therefore "its notes have been Night, Winter, Spring, Wild Life, The Home, Our Own People, and in general it has run the elemental rhythms of sky, waves, land and trees." In the same way as the Scandinavians, concludes MacDonald, he and his associates "have our feet on Canadian earth and live in the Canadian sun," and correspondingly their art should begin at home and join Scandinavian work in being "true souvenirs of that mystic north round which we all revolve."

Harris's summation of the significance of the Buffalo visit took a more succinct form in a lecture on the genesis of and the ideas surrounding the Group of Seven, delivered at the Vancouver Art Gallery in 1954:

> MacDonald and I had discussed the possibility of an
> art expression which would embody the varied moods,
> character and spirit of this country. We heard there was

an exhibition of modern Scandinavian paintings at the Albright Gallery in Buffalo – and took the train to Buffalo to see it. This turned out to be one of the most exciting and rewarding experiences either of us had. Here was a large number of paintings which corroborated our ideas. Here were paintings of northern lands created in the spirit of those lands and through the hearts and minds of those who knew and loved them. Here was an art bold, vigorous and uncompromising, embodying direct first hand experience of the great North. As a result of that experience our enthusiasm increased, and our conviction was reinforced.

> From that time on we knew we were at the beginning of an all-engrossing adventure. That adventure, as it turned out, was to include the exploration of the whole country for its creative and expressive possibilities in painting.[10]

Though put down on paper many years after the fact, both accounts coincide on all essential points. The Scandinavian pictures spoke to what MacDonald called their own "associated ideas" and arose out of a sense of an "affinity of inspiration" between the two groups of northern artists. They helped focus nascent ideas about painting the Canadian landscape and gave moral support to the validity of the enterprise by providing convincing and impressive models of how it could be done. The Scandinavians seemed to reinforce the belief that a native art in the North could arise only out of a close affinity with and love for the essential characteristics of one's country. For both the Scandinavians and the Canadians these characteristics constituted the natural elemental forces to be discovered only in the northern wilderness, which, as MacDonald also understood, was a landscape distinct from the cultivated south and therefore requiring different means to represent it [...]

* * * * * * *

Reprinted from Roald Nasgaard, *The Mystic North: Symbolist Landscape Painting in Northern Europe and North America 1890–1940* (Toronto: Art Gallery of Ontario and University of Toronto Press, 1984), 158–60, 244.

# Liz Magor

*CABIN IN THE SNOW, 1989*

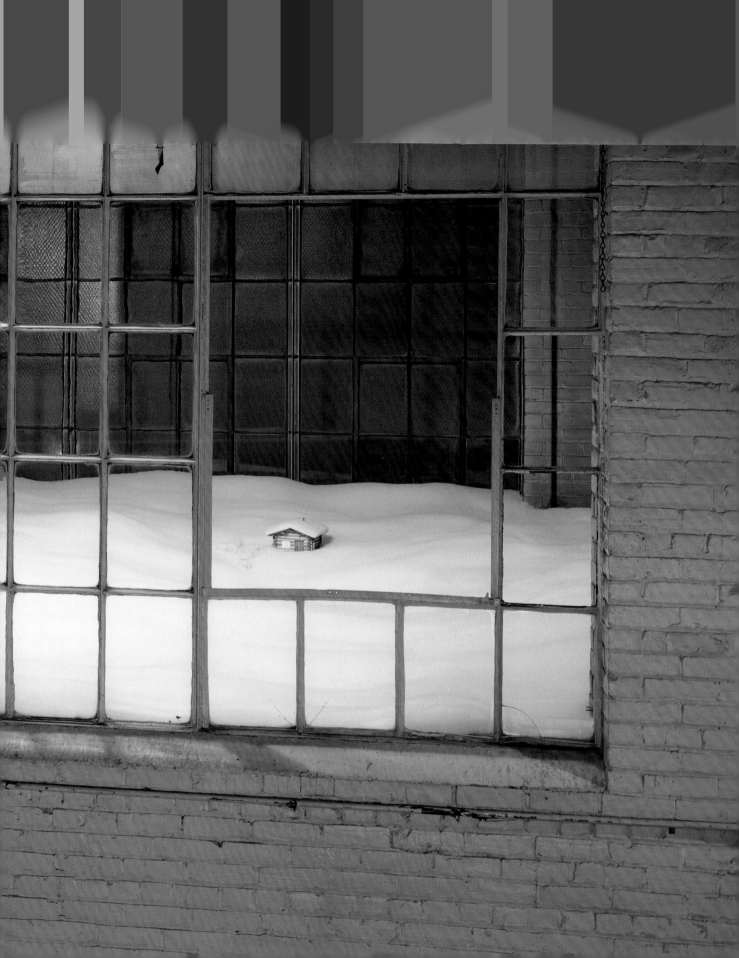

# The Myth – and Truth – of the True North    ROBERT STACEY

Cover of F.B. Housser, *A Canadian Art Movement: The Story of the Group of Seven* (1926)

**THE MORE ART CHANGES**, the more it stays the same. Art-facts become art-folklore within living memory; art history is a kind of scar-tissue of conflicting "evidence." Every culture, whether provincial or cosmopolitan, is a product of this process of transformation and accretion. In their haste to become old, young nations tell lies to themselves that turn into necessary truths.

Canada's puritanical founders, unfortunately, thought "myth" and "lie" were synonyms, and so proscribed the former while living the latter – thereby inventing an ironic national mythology of their own. But did not Ambrose Bierce, in his *Devil's Dictionary*, define "Mythology" as "The body of a primitive people's beliefs concerning its origin, early history, heroes, deities and so forth, as distinguished from the true accounts which it invents later"? Joseph Campbell called myths "life-supporting illusions." The American writer Paul Metcalf interpreted *myth* … not as something different from truth, but as *essential* truth.

There is no myth (or truth?) more essential to Canada's shaky sense of identity than the conviction that it represents, as the national anthem contends, "the True North." (The "strong and free" boast, on the other hand, is the subject of considerable debate.)

Another operative myth of Canada is that it is, as the poet Douglas LePan suggested, "A Country Without a Mythology." Self-evidently false as this fantasy in mythlessness might be, it has required endless correctives, the citation and disregarding of which are as ritual as the repetitions of the fable itself. Protestations become self-fulfilling prophecies; denial breeds confirmation.

A third and related national myth was posited by the poet Earle Birney in the concluding couplet of his notorious lampoon, "Can. Lit.," written in 1962: "no wounded lying about, no Whitman wanted, It's only by our lack of ghosts we're haunted." To which

dismissal the novelist Robertson Davies somewhat plaintively replied in 1964: "No ghosts in Canada?" In his attempted reversal of the no-ghosts, no-mythology myth, Davies made claims for the unheralded "Canadian writers of the past" which are equally applicable to the painters of roughly the same period: "In the land which pretends to have no ghosts, they have seen ghosts; in the country without a mythology, they have heard the ground bass of myth: in a country born not of love and struggle but of politics, they have fought battles; and, with reserve and irony, they have offered their country love."[1]

A hint of the sway that the idea of Canada projected by the twentieth-century artists who most publicly "offered their country love," the Group of Seven, continues to exercise over the English-speaking Canadian imagination is suggested in a recent Margaret Atwood short story. It describes a modish Toronto apartment's display of

> blocks of ... paintings, or sketches and drawings, by artists who were not nearly as well known when Lois began to buy them as they are now. Their work later turned up on stamps, or as silk-screen reproductions hung in the principals' offices of high schools, or as jigsaw puzzles, or on beautifully printed calendars sent out by corporations as Christmas gifts to their less important clients. These artists painted after the first war, and in the Thirties and Forties; they painted landscapes. Lois has two Tom Thompsons [*sic*], three A.Y. Jacksons, a Lawren Harris. She has an Arthur Lismer, she has a J.E.H. MacDonald. She has a David Milne. They are pictures of convoluted tree trunks on an island of pink wave-smoothed stone, with more islands behind; of a lake with rough, bright, sparsely wooded cliffs; of a vivid river shore with a tangle of bush and two beached canoes, one red, one gray; of a yellow autumn woods with

the ice-blue gleam of a pond half-seen through the interlaced branches.[2]

The implication here is that all upper-middle-class, middle-Canadian urban households are furnished with such instantly recognizable and self-affirming possessions, decades after the original buyers had acquired these once-controversial, now blue-chip tokens of wise investment. For a British equivalent of this assumption, the Glasgow School, the New English Art Club or the Camden Town Group would have to be posited as the "national" art movement, not only for its own time but for perpetuity.

If the Group of Seven's *oeuvre* has long since become domesticated and commodified, it should be remembered that, in their heyday, these artists sought to shed the complacency and timidity that had shackled their counterparts of the two generations before their own. Before their enshrinement as institutions, these latter-day *fauves* were viewed by conservatives as dangerous lunatics, and by liberals as needed rebels who alone could salvage the reputation of the chronologically young but culturally sclerotic Dominion. Their red-maple badge of courage was awarded them by posterity for daring to praise the North when it was still perceived as a barren, inhospitable void: "*Aca-nada*," the Portuguese fishermen's "nothing here," the no-man's-land the explorer Cartier believed "God gave to Cain," the "God-forsaken country called Canaday-i-o" of the lumberjacks' folk song.

Even to their friends these men (several of them recent immigrants from Britain) were strangers in an estranged land, "Going among this savage people" unguided by "monuments or landmarks." To their enemies they must have seemed like that "lust-red Manitou" who, "clumsily contrived, daubed/with war-paint," teeters through the forest of LePan's above-mentioned poem. Both extremes are mocked by the auction-room records Group of Seven canvases continue to set, and by their ubiquity in

259

the boardrooms of the corporations whose wealth derives from stripping the natural assets from the "Great Canadian Outback" that was the inspiration and occasion of those very pictures.

In the face of such contradictions, the legends thrive, divide and multiply. The axiom that, just as truth can be stranger than fiction, myth is stronger than history – rather, is history – needs constant reiteration. For the Group of Seven, the mythification began early, with the appearance in 1926 of F.B. Housser's *A Canadian Art Movement: The Story of the Group of Seven*, a scant six years after the confederacy's first joint exhibition in 1920. In a letter to Housser which he elected not to send, J.E.H. MacDonald, the senior member of the Group, commented that the book made him realize the cynical truth of Napoleon's saying that "all history is a lie agreed upon": "It seems impossible to state things exactly as they were ... The historian has to deal with documents and memories. The documents are the best material if written at the time. Memories put a haze around things which falsify them, or at all events poeticize them ... Things should be reflected as they were and not as they appear in the light of Cézanne or Roger Fry." MacDonald's chief criticism was that Housser had treated the Group as *sui generis*, rather than striving to "give things their proper order and sequence. It seems to me that the stage is not properly set in the beginning."[3]

The desire to dispel the mist of untruths, half-truths and truisms that enshrouds the actual achievement of the Group of Seven should not be construed as yet another act of post-modernist revisionism. In the present context, the project of deconstructive analysis of a national cultural myth is surely a self-defeating one, considering the obscurity of the artists in question outside of Canada. My interest in a more balanced and objective account stems, rather, from a conviction that the Group's best work is even more remarkable than the most generous of the British Empire Exhibition critics ventured on their first cognizance of these artists in 1924. Perhaps *The True North* will do something to support that view, and even go so far as to validate C. Lewis Hind's startling statement that "These Canadian landscapes ... are the most vital group of paintings produced since the war – indeed, this century."[4]

Unfortunately, the difficulty of setting the record straight is compounded by the fact that the basic story itself has only partially been told, and then only for domestic consumption. Of late, much of the most salutary work in this field of investigation has been undertaken by social historians, literary critics and cultural geographers. These non-art-experts have come to realize that no understanding of the intellectual makeup of Canada can be achieved without an assessment of the pictorial record, its economic and ideological sources, its distribution, its marketing, and its reception. As MacDonald hinted, one of the first quandaries that confronts the sincere de-mythifier is the lack of consensus about the chronology of the movement and its antecedents. Although the Group of Seven's champions made much capital of the alleged "radicality" of its programme, the same aesthetic and geographical imperative had been advocated for nearly half a century before. One could cite any number of pantheistic wolf-howls responding to the "call of the wild" at the height of the very era against which the Group and its followers professed to be in rebellion: the era personified by Queen Victoria's *locum tenens*, the Marquis of Lorne. Yet it was this poetical and artistically talented Governor General who had proclaimed, before the gathered throng at the opening of the Art Institute of Montreal in 1879, his conviction that:

> If legendary and sacred Art be not attempted, what a
> wealth of subjects is still left you, – and if you leave the
> realm of imagination and go to that of Nature which you

see living and moving around you, what a choice is still presented ... [I]n the scenery of your country, the magnificent wealth of water of its great streams; in the foaming rush of their cascades, overhung by the mighty pines or branching maples, and skirted with the scented cedar copses; ... in the sterile and savage rock scenery of the Saguenay – in such subjects there is ample material, and I doubt not that our artists will in due time benefit this country by making her natural resources and the beauty of her landscapes as well known as are the picturesque districts of Europe, and that we shall have a school here worthy of our dearly beloved Dominion.[5]

Nearly five decades after this prophecy of the rise of a national landscape school, Lawren Harris could pretend there was still something revelatory, if not revolutionary, in his pronouncement that the "North" instilled itself in the Canadian artist's "outlook" through "the bodily effect of the very coolness and clarity of the air, the feel of soil and rocks, the rhythms of its hills and the roll of its valleys, from its clear skies, great waters, endless little lakes, streams and forests, from snows and horizons of swift silver."[6] As the Canadian geographer Brian S. Osborne has noted:

These were the defining themes of the Group of Seven: rock, rolling topography, expansive skies, water in all its forms, trees and forests, and the symbolic white snow and ice of the "strong North."

Whatever its lineage, the work of the Group of Seven came to dominate Canadians' self-images, or at least, the images of their country. An ideology of Northern distinctiveness became central to the iconography of Canadian landscape.[7]

This ideology, however delusive, became central to the "self-images" of Canadians long before the Group made its iconography truly iconic. The Group's ability to position itself strategically as the exemplars of "Northern distinctiveness" owed as much to the growth of nationally comprehensive media – including radio and documentary films – as to the determinism implicit in Harris's philosophy of Canadian-ness as a function of nordicity, and of the "Virgin north" as a source of spiritual "replenishment." The mechanical reproduction and broadcast of pictures by (and of) these heroic figures served to impose their vision on the nation no less than did the North, according to Harris's theory, impose its values (both painterly and "eternal") on the artist.

In 1933, the year the Group disbanded, a University of Toronto professor of philosophy, Reid MacCallum, published one of the first attempts to place this exhibiting collective in context, and to winnow meaningful myth from mere wishful thinking. "The artists themselves," he noted,

probably rightly, have largely refrained from explaining what they are doing, being too busy doing it. At most, in the heat of controversy, one finds politico-geographical terms such as "Canadian Art," "Canadianism," "The Canadian North," or Lawren Harris's "The North" bandied back and forth, denied, or asserted to characterize the new movement in its essence. In the heat of controversy the use of terms intelligible to the public precisely because they are not art terms served a useful purpose in drawing attention to the fact that Canada now harboured eminent painters of her own doing excitingly original work; but the fact remains that the language of politics or geography is as unsuited as that of arithmetic to formulate the essence of an art.

MacCallum acknowledged, however, that

like most well-meant propaganda in a good cause, this talk of Canadianism has created myths which stand in the

Frank Johnston, *Fire Swept, Algoma*,
1920, oil on canvas, National
Gallery of Canada

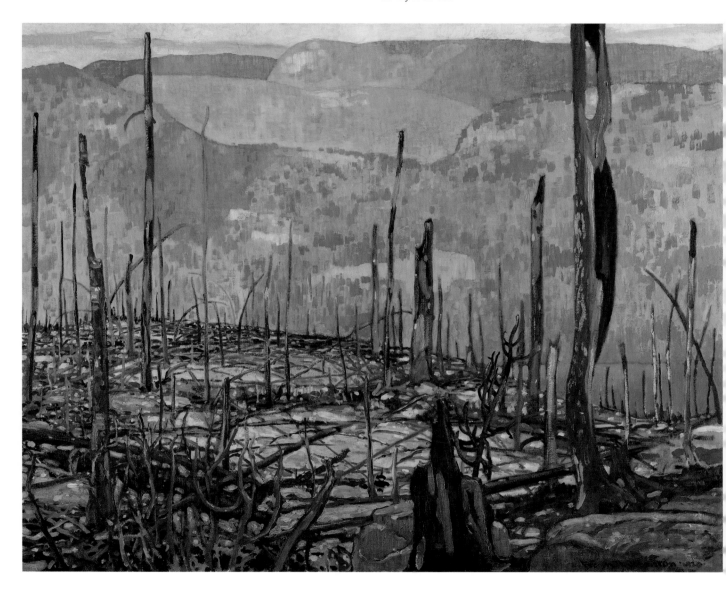

way of a proper appreciation of the movement. Take the case of that great, and in some ways solitary genius, Tom Thomson. The public has eagerly seized him and built up a myth about him. He has become a national, even a political, symbol of our recent emergence from political tutelage. For here, against a general background of effete academies, especially the Royal [Canadian] Academy, arises a true earth-born artist, untouched by the past, untutored and unspoiled, who depicts Canada in an idiom which is genuinely Canadian, who brings the fire down from heaven in a new land and founds a flourishing national school. It is a curious revenge of facts upon this quasi-political legend that its originators ingenuously take the universal success of the Canadian pictures at Wembley [in 1924] as the climax of their little drama.[8]

Among the more obstinate of the standard myths is the dictum that, as P.G. Konody had asserted in 1925, the Group's "lost leader," Tom Thomson, was "the artistic 'discoverer' of Canadian landscapes,"[9] in particular that of the Northern Ontario "bush." An artistic discoverer Thomson truly was, but neither he nor the Group could be said to have "discovered" the North, at least in the sense of exploring and appreciating it first, even among the pale-faced late-comers who usurped the homelands of the original Canadians.

One of the key perpetrators of the "discovery" half-truth/half-myth was the aforementioned Toronto lawyer, journalist and Theosophist, F.B. Housser. Housser is correct in stating that, with the Group's exposure to the spectacular "Algoma country" after the First World War, "began a procession of exhibitions across the continent in which thousands of Canadians saw for the first time on a large scale a 'Canadian statement in art.'"[10] But his hagiography errs in its rejection of all earlier recognitions that "The North, like the West ... is 'an indication of ourselves,'" and that its true expression in paint "demands the adapting of new materials to new methods"[11] [...]

\* \* \* \* \* \* \*

Reprinted from Robert Stacey, "The Myth – and Truth – of the True North," in *The True North: Canadian Landscape Painting 1896–1939*, ed. Michael Tooby (London: Lund Humphries and Barbican Art Gallery, 1991), 37–44, 62.

# Michel Saulnier

*LE GROUPE DES SEPT (1–7), 1983*

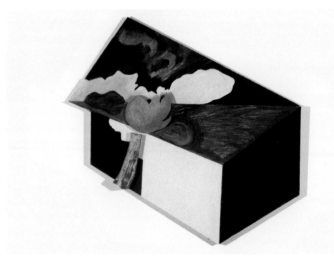

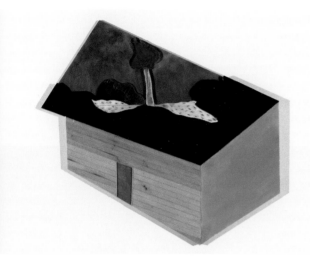

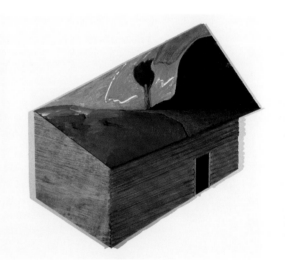

John Vanderpant, *In the Wake of the Forest Fire*, 1926, silver bromide print, Vancouver Art Gallery

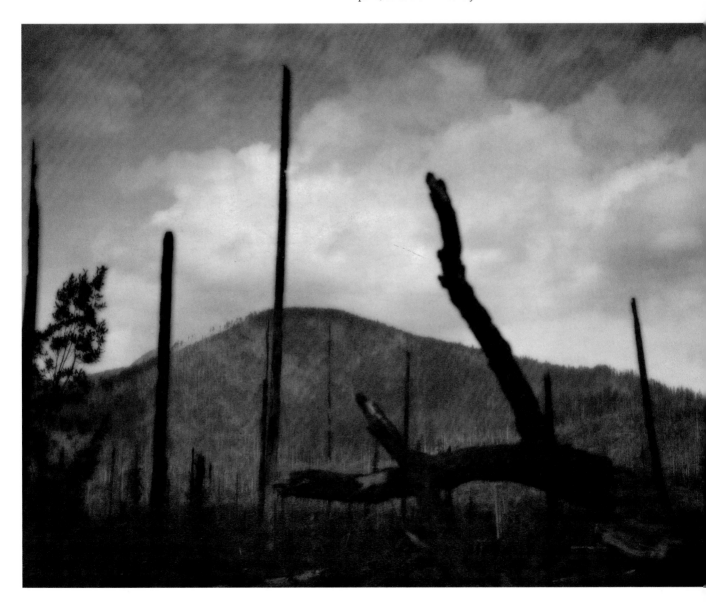

# The Terminal City and the Rhetoric of Utopia

GRANT ARNOLD

… pictorial photography… is a way behind in photographically giving what other arts are doing in their medium. It still dwells in the fairyland of romanticism … it is travelling by a horsecart midst the progress of motor power on wheel and wing.[1]

**THIS PROVOCATION APPEARED** in the November 1928 issue of *The Photographic Journal*. The London-based journal, published by the Royal Photographic Society had championed Pictorialist photography during the late 19th and early 20th centuries, so these remarks were clearly a challenge to a premise held dear by the journal's editors – the understanding that "the principles of art are permanent and no [Pictorialist photography] that is not based on them can be worth anything."[2] The surprise registered by *The Photographic Journal*'s readers in response to these comments would have been compounded when their unlikely source was considered – John Vanderpant, a successful commercial photographer based in Vancouver, Canada. Vanderpant was well known to *The Photographic Journal*'s readership. He had acquired an international reputation as a Pictorialist photographer within the network of camera club salons that flourished in Europe, the United States and anglophone Canada after the turn of the century. During the early 1920s, Vanderpant had participated in up to forty salons per year. The Royal Photographic Society mounted a solo exhibition of his work in 1925, which subsequently travelled to the Netherlands, Belgium and Germany. Articles on his work regularly appeared in publications such as *American Photographer*, *The Photographic Journal*, and *Focus*. In 1926, in recognition of his accomplishments, he was elected a Fellow of the Royal Photographic Society.[3]

By the mid-1920s, Vanderpant's practice was comfortably situated within a discourse that positioned photography as high art through the adoption of a codified formal vocabulary emphasizing qualities such as soft focus, atmospheric effect, and carefully balanced composition to emulate 19th-century European painting. He was not a figure *The Photographic Journal*'s audience would have expected to challenge Pictorialism's legitimacy.

Vanderpant's break with a milieu in which he had achieved such success points to a moment of crisis in his artistic practice. From his assertion that Pictorialist photography was outdated and lagging behind achievements realized in other media, we can infer that this crisis was related to the ability (or inability) of his practice to address conditions of life in a modern industrialized society. However, as subsequent passages from Vanderpant's text demonstrate, this crisis was also related to the difficulty of linking the vocabulary of Pictorialism to the nationalist discourse that gained prominence in the visual arts in Canada during the early 1920s […]

While Pictorialism was ascendant in Canada during the early 1920s, it was not a discourse free of tension. The proliferation of salons during the 1920s set up a competitive context in which photographers vied to be accepted into as many salons possible. The salons, in turn, often competed to gain prestige by including the largest possible number of international entries. As Pictorialism became increasingly popularized, questions were raised as to whether "artistic standards" were being denigrated, and to what extent "progress" was being made.[4] Vanderpant, for example, wondered whether the growth in the number of salons was "a sign of progress in pictorial photography, whether it tends to elevate the quality of work in general, or whether … it tends to make pictorial photography a mere artistic sport." He went on to note, "Many a print nowadays is made for the Salon instead of being an essential expression of the pictorialist."[5]

Further tensions were evident in relation to the incompatibility of Pictorialism's tenets and the sense of nationalism that was emerging within Canadian painting. The adherence to

visual formulas derived from European academic painting and the highly generalized character of Pictorialist imagery worked against the expression of a regional identity or specific sense of place. As early as 1913 Harold Mortimer-Lamb complained that Canadian pictorial photography had no national character and "might have been done anywhere."[6] In 1920, Arthur Goss optimistically predicted that Canadian art photographers would follow the lead of the newly-formed Group of Seven, "I believe it will be along the lines adopted by a group of Canadian painters to paint our scenery in a Canadian way that photographers must progress ... [to produce] something worthwhile and characteristic of our climate and our country."[7] However, five years later the biologist and amateur photographer A. Brooker Klugh lamented the difficulty of adapting Pictorialist aesthetics to the Canadian landscape in his monthly column in the British journal *Amateur Photographer and Photography*:

> ... scenery [in Canada] is by the mile, whereas in England it is by the foot. This very fact makes all the difference, because in England there is a great wealth of what one might term "pretty bits"; just, in fact, the circumscribed and complete bits of landscape which make most satisfactory compositions. In Canada, on the other hand, there is a great lack of the "pretty bits"; there are grandeur, vastness, and expansive views, which are entrancing to the eye, but which do not make effective compositions when reduced to the confines of a print of any reasonable size.[8]

As these remarks indicate, Pictorialism was seen to be incapable of conveying the aesthetic qualities that were central to the nationalist movement being consolidated around the figures of the Group of Seven, which was bolstered by the patronage of the National Gallery of Canada – the kind of institution to which Pictorialists had so ardently, but unsuccessfully, sought admission.[9] [...]

For an artist in Vanderpant's circumstances, to be positioned outside of the national movement around the Group of Seven was to be denied access to "the great adventure ... in the midst of discovery and progress"[10] on which they claimed to have embarked. In effect, it was to be denied participation in the modern age. In his 1928 article "Tradition in Art" – cited at the beginning of this essay – Vanderpant drew parallels between progress in transportation and progress in art, and asked his readers whether it would "be right to suggest that air traffic cannot get anywhere because it is not built on tradition ... [W]ould it be possible to satisfy men by merely improving and building railway coaches better than ever before?"[11] He argued that the "essential principle" of transportation remained the same, "the desire to move from one place to another," however "the medium by which it is achieved progresses with the growth of technical knowledge."[12] Similarly, he argued, art was founded on unchanging principles but had to break with tradition and assume new forms in order to address its time. Pictorialism's anachronistic reliance on "strict representation of traditionally conceived beautiful subjects"[13] rendered it inadequate to address the conditions of modern life. From this position Vanderpant could assert that Pictorialism was "travelling by a horsecart midst the progress of motor power on wheel and wing." Further, as long as Pictorialist photography held "to the pretty rendering of lens selected facts" it was "without [a] future except as an agreeable or pleasure giving pastime."[14]

At the time of his first solo exhibition in Europe, Vanderpant's practice was located at an intersection of conflicting discourses, linked to emerging manifestations of national identity and shifting responses to the processes of industrialization. Bound to a mode of photography which had already come under pressure, and which occupied institutional spaces that did not carry the prestige associated with the art museum, Vanderpant could

not sustain his practice in the face of these conflicts. Positioned outside the ascendant version of modernism advocated by the National Gallery of Canada, he was unable to ignore the contradictions that had characterized Pictorialism since its inception. The conceptual underpinnings of his work collapsed, and its lack of a viable future was revealed at the very moment his work was expected to attain its greatest success.

As an artist working in Vancouver in the mid-1920s – who wished to assert a measure of institutionally-sanctioned cultural sophistication while attempting to address the specifics of his locale – his practice could be revitalized only by claiming a position within the same nationalist visual culture whose success had thrown the viability of his Pictorialist work into question. Within a process of revitalization, three related issues had to be addressed. The first was the adoption of an identifiably modern approach to photography that could parallel the methods of the modern painter, as defined within the visual culture of the Group of Seven. The second was the linkage of his photographs to issues of national identity by visually articulating the "essentially" Canadian features of his environment. The third was an approach that would allow him to position himself as an avant-garde figure, breaking with Pictorialism's tired traditions in order to adequately engage with the modern era; an approach that would distinguish his work from the glut of banal, formulaic imagery that filled the salons. This break with Pictorialism, however, could not be too extreme. During the 1920s, the photographic salon was the only public forum open to Vanderpant's work, and he was not in a position to entirely alienate himself from that network and the audience it engaged.[15]

Central to the modernism of the Group of Seven was a separation of the formal values of an image from mimetic activity; "modern" art was seen to possess a level of autonomy that distinguished it from earlier models in which representation operated through imitation. For contemporary commentators, such as F.B. Housser, the modern character of the Group of Seven's painting lay in its directness and elimination of unnecessary detail, which permitted the artist to "emphasize only form which was significant to mood, composition, design and rhythm ..."[16] This directness – it was claimed – was dictated not by artistic convention but by the Canadian landscape itself, the crucial feature of which was an underlying sense of rhythm that imposed itself on the artist's sensibilities: "Perhaps that which most differentiates Canadian landscape, from that of the older art countries is this curious thing, rhythm. It exists here in its elemental form, Nature and the elements being the sole designer ... Surrender yourself to the rhythm of the north shore of Lake Superior, the prairies and the Rockies and it will set within you the tempo of the mood Canadian."[17] In the year following his Royal Photographic Society exhibition, Vanderpant began to adopt a simplified graphic economy in his work, deepening the shadows and increasing the contrast of his prints in order to emphasize rhythmic pattern in images such as *Circus* (c. 1926), and *In the Wake of the Forest Fire* (1926). Echoing the claims made for the Group's painting, Vanderpant held that his new emphasis on rhythmic form and simplicity marked a necessary break with Pictorialism's "methods of pretty representation" – a break which permitted him to respond directly to the "spirit of Canada" [...]

* * * * * * *

Reprinted from Grant Arnold, "The Terminal City and the Rhetoric of Utopia," *Collapse* 5 (2000): 31–2, 34–6, 39–42.

# Stan Douglas

*NU·TKA·*, 1996

**NU·TKA· IS A VIDEO INSTALLATION** in which two distinct images are interlaced on the same screen – weaving one image track, visible on the "even" raster lines of a video projection with another, presented on "odd" raster lines. These video tracks are played from disc, continually looping, with a quadraphonic soundtrack: two disembodied voices that drift around the exhibition space as they recount distinct narratives which, like the images, are woven into one another, sometimes speaking simultaneously and sometimes in exact synchronization. The work is set in the late 18th century at Nootka Sound, with conflicting tales told by the Commandant of Yuquot's first Spanish occupation, José Estéban Martínez, and by his captor, the English captain James Colnett – each of whom believed he had the right to claim land already occupied by a peculiarly "absent" third party, Chief Maquinna and the people of the Mowachaht Confederacy. In monologues derived from historical documents and their personal journals, the delirious Englishman alternates between recollection of his capture and the fantasy of escape, while the Spanish commander betrays signs of paranoia as he becomes increasingly uncertain of his ability to dominate the region.

The two image tracks were shot on 35mm film in two continuous takes from a vantage point on San Miguel Island, the original Spanish defensive site at Yuquot. The interlaced images are mostly in continual motion, panning and tilting, presenting various features of Nootka Sound – but they briefly come to rest, and into exact registration, on six occasions. At these moments, the uncanny apparition of a landscape subject to conflicting winds and opposing tides is seen. Concurrently, one hears Colnett and Martínez describing their respective delusions in exact synchronization with exactly the same words (excerpts from the Gothic and colonial literatures of Edgar Allan Poe, Cervantes, Jonathan Swift, Captain James Cook and the Marquis de Sade). As the narrators go their separate ways – recounting their contempt for one another and inability to endure the situation in which they find themselves – the interlaced image pulls apart also. Outside of the six synchronous moments the narratives, like images, are blurred and doubled, at a limit of legibility, sublime.

Lawren Harris, *Isolation Peak, c.*
1930, oil on canvas, Hart House Art
Collection, University of Toronto

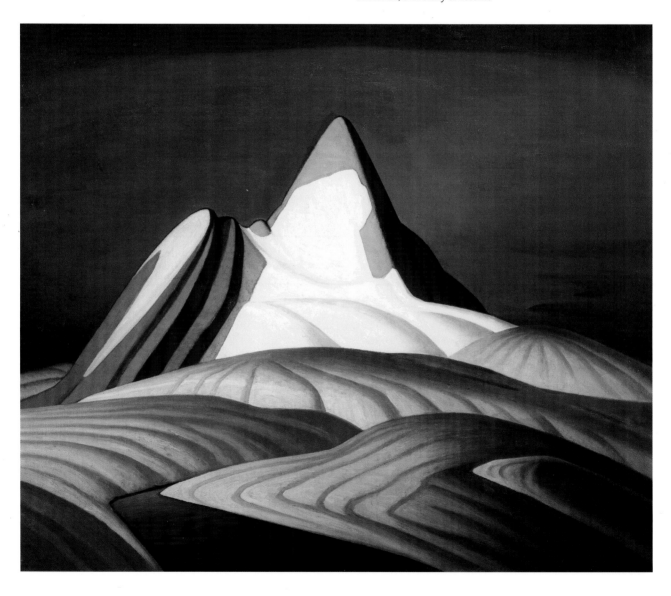

SCOTT WATSON

# Race, Wilderness, Territory, and the Origins of Modern Candian Landscape Painting

[...] **IN HIS ANALYSIS OF** the essentially Canadian in Canadian literature and art, Northrop Frye emphasized the unvisualized territory, as if picture-making, in poems or oil paintings, could enact a conquest for the imagination what was already conquered by commerce and the state. The "poets" of this territory were the painters known as the Group of Seven, who, in the early years of this century established a national school of modernist landscape painting. The painters who would become involved with the Group were all children of British immigrants or immigrants themselves. Their nationalism was enfolded in the colonial project. They did not imagine an independent country, but pride of place within the Empire, a bastion of whiteness in a polycoloured world. The Group liked to think of itself as springing from a natural necessity. But the national school of painting was really commissioned into being by interests who also worked under the banner of a nationalist agenda. Chief among these was Sir Edmund Walker, President of the Canadian Bank of Commerce. In 1913, Sir Edmund became President of the Art Gallery of Toronto, which he had helped found, and a trustee of the National Gallery of Canada (NGC). It was Walker and NGC Director Eric Brown who encouraged the group of young commercial artists by purchasing their work. Walker also knew the painter, Lawren Harris, through business and political connections. Walker had a large investment in the Harris family firm, Massey-Harris, and in 1911, joined Lloyd Harris, MP for Brantford and Lawren's cousin, in the "Toronto 18" – eighteen prominent Liberals who defected to the Conservatives in order to bring down the pro-free trade Laurier government. In short, political and financial connections bound Harris and Walker to common interests, interests that shaped their view of the national landscape school they helped to establish.

As legend has it, and this legend is available as history at any major Canadian art museum, the Group created a uniquely Canadian art. That they did so using European methods – that is, oil paintings of landscapes – and European models – the modernism of the Post-Impressionists and Art Nouveau, but specifically Scandinavian landscape painting – is well known but has not undermined the Group's claim to have made authentic Canadian images. Fred Housser, a close friend of the Group and financial editor for *The Toronto Star*, published his account of the painters in 1926. The book spread the ideas and legends of the Group across the country and established the painters as the fathers of Canadian art. Like Harris, Housser was a theosophist and devotee of Walt Whitman. The language of *A Canadian Art Movement: The Story of the Group of Seven* is flowery and hyperbolic. Generations of Canadians appear to have read it oblivious to its not-so-hidden character as a white supremacist tract.

Housser's intention, as he stated it, was not to write "so much the story of an art movement as of the dawn of a consciousness of a national environment which, today, is taking a most definite form in the life of the nation."[1] He proposed that a distinct Canadian race was emerging and that this race found in the wilderness its spiritual home and succour. "For Canada to find true racial expression of herself through art," he wrote, "a complete break with European traditions was necessary; a new type of artist was required."

Identifying the Canadian race with the wilderness and the north, Housser evoked a mystique of snow and "whiteness". Whiteness represented the northern expanses, but it also had racial connotations. For Lawren Harris the north was a metaphysical environment. "We," he wrote of Canadians, "are in the fringe of the great North and its living whiteness, its loneliness and its replenishment, its resignations and release, its call and answer, its cleansing rhythms. It seems that the top of the continent is a source of spiritual flow that will ever shed clarity on the

growing American race, and we Canadians being closest to this source seem destined to produce an art somewhat different from our Southern fellows."[2] He didn't have to spell it out: Canada was to be the white head on America's mixed race body.

The paintings that celebrated the north or the wilderness were intended for the middle-class of Toronto. The paintings would be touchstones of the spiritual experience not just of place, but of race. The specific region the first painters depicted was the "near north" of Ontario. The area between Georgian Bay and the Ottawa Valley was summer vacation territory, and the painters often stayed in the summer homes of their wealthy friends to paint the landscapes of the Pre-Cambrian Shield. For Housser this was "the race's inescapable environment. It is the playground of hundreds of thousands of Canadian people." The Group's painting campaigns were rarely in summer, however. Perhaps they wished to avoid other campers. But by painting from late fall to early spring they also wished to extract something quintessential from their landscape subjects. They thought of winter as Canada's season, as if the cold and the snow were metaphors of the nation's whiteness.

Housser imagined the Group's pictures as myth or a proto-literature. Referring to Homer and Hesiod, he claimed that, "The group's Northern Ontario canvases are doing for Canadian painting what the epic poets do for their races." But the transformation into epic or myth depended on the eventual disappearance of the wilderness and its eventual conquest by civilization. Housser noted the threat with little regret, writing, "The wilderness is being reclaimed and the forest is making its last stand. No first class literature has been created to preserve its mood." The forests might disappear, but they were not as important as the paintings of them, for the paintings, not the actual territory, mediated race consciousness. Housser predicted the appearance of "a spirit which as time advances will be capitalized in literature and more recognized in the race than it is at present. While these pictures live we can never forget our cradle environment. The work of the pioneer and explorer and the tenacious love of the red Indian for the land of his ancestors will be understood and the spirit of still unwritten epics will be preserved for us on canvas."

Indians in Housser's book were the dead Indians that Canadians love to lament. They inhabit the wilderness as ghosts. The wilderness itself exists in a permanent past tense, always at the origin of things. As Housser himself wrote, "... this Canadian group drew its inspiration from the past of this country, the wilderness." The wilderness managed to produce an artist who represented the new Canadian type from the concoction of Indian, explorer, and pioneer who called the wilderness home. In Tom Thomson, the Group found a type and martyr.

Thomson was said to have been shaped by the north itself and was therefore a transparent medium for its spirit. Unschooled, virile, a woodsman, "a sort of modern *coureur-de-bois,*" he was the perfect foil to the reviled European type: the artist as dandy or decadent. He was white and there was nothing queer about him. The maintenance of Thomson in type took extreme form. A replica of a northern trapper's shack was built for him in Toronto, so he could stay in role even in the metropolis. His characteristics, but most notably a certain reticence, if not muteness, included a kind of magical absorption of Indianness. "He knew the woods as the red Indian knew them before him," extolled Housser, claiming: "the cries of the wild were in every stroke of his brush." It was his special knowledge of the wilderness that made Thomson's canvases "unique in the annals of all art." For "never before had such knowledge and the feeling for such things been given expression in paint." It was "as though northern

nature itself were speaking to you through a perfectly attuned and seasoned medium."

Yet Thomson's experiences and pictures required considerable analogical explanation to approach what Housser called their pure "being." They could be comprehended by imagining that what European painters "felt for their Madonnas, Thomson re-experienced in his contact with northern nature." Or that a single tree in one of his pictures was "to the nature-worshipper Thomson what the symbol of the cross was to a medieval mystic." The single trees came to represent the singularity of Thomson as a type, and through them one can experience "that sweet loneliness which is exaltation." As was suitable to this high spiritual calling, Thomson was imagined as chaste, married to a wilderness which eventually consumed him.

Thomson died in a canoe accident in Algonquin Park in 1917, and the painters who survived him consecrated the park to him by never painting there again. His Algonquin Park pictures would be increasingly described as somber, moody, haunted, as if they themselves contained a premonition of their author's death, as if that death were destined. Northrop Frye described the pictures as disquieting and sinister. Claiming that Thomson's pictures evoke the feeling of something not quite emerging, Frye saw the incubus in their "twisted stumps," "strident colouring," and "scarecrow evergreens." The appearance of the incubus was, according to Frye, the result of an incomplete absorption or possession of the land.

Algonquin Park, now kind of a national shrine to Thomson (and his whiteness), was made a park in 1893, not so many years before Thomson painted there. Many of Thomson's pictures of the "wilderness" show the evidence of logging past and present. The park had been created as a forest reserve in response to an 1892 Royal Commission that had found the region in serious danger

of being over-logged. This park, in which Housser and Frye like to hear the tread of the dead red man, was part of a large territory claimed by Algonquin speaking peoples living in the region. They were not dead at all. In fact they have been in court every few years since the end of the eighteenth century protesting and petitioning the loss of their territory and infringements on their rights. The Group's imagination of the park obliterates all this contentiousness and is itself, as Frye points out, a kind of territorial claim in itself.

When Tom Thomson painted Algonquin Park it was part of a territory that was not just contested by the Algonquin. The Group of Seven's pictures look the way they do, extolling a "wilderness" vision, because they are implicated in the politics and finances of land use and exploitation. The area of Ontario that was chosen as the mould for the Canadian racial stamp had a long history before it was discovered as the home of the Canadian soul. It is part of what was once the nation called Huronia and had been inhabited by Algonquin speaking peoples for many thousands of years before conquest. Treaties and court cases in the nineteenth century defined much of what is now northern Ontario's present system of governance and administration. Eighty percent of Ontario is crown land, and from the early nineteenth century on the near north was subject to a conflict between the industrial uses envisioned by people living in the south, between resource extraction and an agrarian dream. Before the Group of Seven cast the near north as wilderness, many Ontarians imagined the territory in the future tense, not the past, as farmland. A plan to colonize the north with farmer-settlers, most of them immigrants, was Ontario policy, implemented with varying degrees of conviction until it was officially abandoned in 1935. The vision of Housser, that the wilderness was disappearing, was that of a succession of governments for whom, in the words of historian

Joseph Schull, "the lands of the nearer north with their great forests and infinite maze of waterways would someday yield to the plough."[3]

But the Group was not allied to the vision of the north as farmland. The wilderness they were interested in was more allied to industrial and extractive uses of the territory of the near north. The era in which they painted and developed their myth spans the years from 1912 – the year in which Ontario acquired part of Keewatin Territory, nearly doubling its size with, to paraphrase Frye, more unvisualized territory – to 1919, the year the Group officially declared itself and the Farmer's Union Party won an election and formed a new government in Ontario. The First World War brought a renewed effort to pastoralize or colonize the north when plans were made to replace immigrants with returning soldiers as pioneering farmers. These plans resulted in failure. The period of the war also saw increasing conflict between settler-farmers, First Nations communities, and communities of industrial proletariat who worked the mines, mills, and railways that criss-crossed the industrial north, which was becoming dotted with towns named after Ontario industrialists and politicians. During the years the Group of Seven first painted the north, the management of the resources of northern Ontario had become so corrupt, part of the orgy of profiteering that characterized the war years, that it was described as "the rottenest system of forest pilfering that ever existed on the continent." At the end of the war the north was in chaos and unrest. But it was the industrial and rural crisis of southern Ontario that lead to the dramatic election of the Farmer's Union Party as the government in 1919. Mobilized by their protest against conscription in 1918, and aggravated by the precipitous decline in the stability of rural southern Ontario where the population had declined by over 100,000 since the 1880s, the farmers allied with disenchanted urban voters and wrested power from a government that had been dominated by men who had interests in the north. Priorities shifted from funnelling money into pockets of northern developers to reconstruction of the war-battered southern economy. It was around this time that the painters who had survived Tom Thomson and the Great War began to paint the north again.

The Farmer's Union Party was pro-free-trade and it may be more than coincidence that the painters that anti-free-trade Sir Edmund Walker promoted as the national school by and large eschewed southern rural Ontario as subject matter. Housser explained this choice in typically racial terms: "Our Canadian pasture lands have not yet the racial stamp given by generations of war and peasantry such as the rural landscape of Europe has." This offered Housser the trope to explain how it was that the wilderness had become the past: "Just as European artists have long gone to Europe's past for inspiration, so this Canadian group drew its inspiration from the past of this country, the wilderness."

The interest in the north as rugged, resource-extraction territory was reinforced by the Group's postwar painting campaigns. Having left Algonquin Park as a shrine to Thomson, the painters looked next to the Algoma district for images of the national landscape. Housser reported that the war was itself a stimulus for the new painting school. Harris in particular hoped that the "swells of national feeling" induced by "the long list of casualties" could be redirected to "a more creative and magnificent communion than the communion of war" through wilderness images. Thus there was a patriotic, memorializing impulse in the search for red maple leaves in the autumnal Algoma region, a search for what one painter called "the desirable spot of red."

The Algoma district was painted between 1918 and 1922, by which time it was already industrialized, although at the time

the group painted it, its industries were in financial crisis. Some have advanced the thesis that the group's excursions into Algoma, in a boxcar especially outfitted for them which travelled on the Algoma Central and Eastern Railways, both insolvent since 1916, were underwritten to create new investment interest in the region.[4] Determined to give a picture of the wilderness as a territory that was just opening up, there were to be no pictures of mines, railways, or even the boxcar they rode in. With Algoma, the painters who formed the core of the Group of Seven set out to define a quintessential wilderness imagery that could be deployed to galvanize the national psyche. The somberness and disquiet of Thomson's pictures were discarded for a new set of values based on terms that emphasized dynamism. Roaring cataracts and vertiginous vistas replaced the relative serenity of Thomson's Algonquin Park scenes. Thomson's pictures had been painted when pastoralization of the north might have appeared inevitable and they partly served, as Housser thought all the Group's paintings did, as a preface to the civilization of the north. After the war, the Group's major patrons found themselves at loggerheads with a populist agrarian government that threatened to dry up the flow of public money into the pockets of northern developers. It is with these later interests that the Group's paintings conspire in presenting a new vision of the north, creating images of landscape fit for industrialization, canyons ideal for hydro-electric dams, navigable waterways, huge tracts of forest and Pre-Cambrian hills waiting for open pit mines. To this new industry-ready wilderness they attached the swells of national feeling. Housser exhorted his readers to "surrender to the rhythm of the North shore of Lake Superior" and to "the tempo of the mood Canadian."

A great deal of the effectiveness of the Algoma paintings appeared to depend on a sense of first-time discovery. Housser claimed, rather rashly, that with the Group the Algoma wilderness had been painted by artists for the first time. Frye argued that Lawren Harris's Algoma paintings were "as much of an exploration as the literal or physical explorations of La Vérendrye or Mackenzie." It would be straining credibility to imagine that the construction of the Tom Thomson type out of Indians and *coureur-de-bois* was some sort of meaningful recognition of First Nations' history, polity, and presence in the north. The construction of Thomson involved forgetfulness. However, the post-war painters, perhaps acting as operatives for industrial interests, by investing so much in their myth of discovery, utterly erased any sign of the long-term inhabitation of the region along with its prior industrial uses and instead showed us tracts of territory cleared of liens and bankruptcies, waiting to be claimed and exploited anew.

The history of Algoma includes the ceding of the territory to the British Crown by the Salteaux people of the Ojibwa nation in 1873. In the 1880s a struggle between the governments of Ontario and Canada broke out over timber rights in West Algoma. Ontario's ownership of the timber and its right to issue licences to cut it were challenged by the Federal Government on the basis that the Salteaux retained rights over the resources and that as the Salteaux, like all First Nations people, were wards of the Federal Government, those rights accrued to Canada, not Ontario. Ontario won the case in 1889. Not uncoincidentally, this case was regarded by Judge Allan McEachern as of "fundamental importance. It is one of the few Canadian appellate cases which makes any comment on the nature of aboriginal rights." In Canada, the case serves as "authority against aboriginal ownership and jurisdiction."[5]

The namelessness of the Canadian landscape is still an instrument to be used in court. Schedule Five of Allan McEachern's

judgement against the Gitskan and Wet'suwet'en prints lists of rivers, creeks, lakes, and mountains in the disputed territories. In one column is listed the Gitskan or Wet'suwet'en name, in another the "white" name, but as often as not, "un-named on government maps." Naming is part of possession. Namelessness is a preface to, if not quite permission for, conquest. The assertion of wilderness is also an assertion of namelessness and ownerlessness. It was on this basis that the Group could be said to extend a psychic or spiritual ownership to unvisualized and unnamed regions they depicted in the name of the Canadian race.

Northrop Frye wrote that "Canada with its empty spaces, its largely unknown lakes, rivers, islands – has had this particular problem of an obliterated environment throughout most of its history." I would like to restate this problematic by reversing the terms: The Canadian problem is an obliterated history throughout most of its environment.

\* \* \* \* \* \* \*

Reprinted from Scott Watson, "Race, Wilderness, Territory and the Origins of Modern Canadian Landscape Painting," *Semiotext(e)* 17 (1994): 96–104.

# Robert Houle

*PREMISES FOR SELF-RULE*, 1994

The Royal Proclamation, 1763

British North America Act, 1867

Treaty No. 1, 1871

Indian Act, 1876

Constitution Act, 1982

THE ROYAL PROCLAMATION October 7, 1763 BY THE
KING. A PROCLAMATION GEORGE R. Whereas We have
taken into Our Royal Consideration the extensive and
valuable Acquisitions in America, secured to our Crown
by the late Definitive Treaty of Peace, concluded at Paris,
the 10th Day of February last; ....And whereas it is just
and re........................ to our Interest, and the
Securit...................... the several Nations or
Tribes .............  ....We are connected, and who
live u.................... hould not be molested or
disturb...................... of such Parts of Our
Domin....................... not having been ceded to or
purchased by Us, are reserved to them, or any of them, as
their Hunting Grounds. – We do therefore, with the
Advice of our Privy Council, declare it to be our Royal
Will and Pleasure, that no Governor or Commander in
Chief in any of our Colonies of Quebec, East Florida, or
West Florida, do presume, upon any Pretence whatever,
to grant Warrants of Survey.....or upon any Lands
whatever, which, not having been ceded to or purchased
by Us as aforesaid, are reserved to the said Indians, or
any of them. And We do further declare it to be Our
Royal Will and Pleasure, for the present as aforesaid, to
reserve under our Sovereignty, Protection, and Dominion,

An Act for the Union of Canada, Nova Scotia, and New
Brunswick, and the Government thereof; and for Purposes
connected therewith. [29th March 1867.]....WHEREAS the
Provinces of Canada, Nova Scotia, and New Brunswick
have expressed their Desire to be federally united into
One Dominion under the Crown of the United Kingdom of
Great ..................... a Constitution similar in
Princi  Kingdom:....1. This Act may
be cite ....................... America Act, 1867. 2. The
Provisi ...................... to Her Majesty the Queen
extend ...................... ccessors of Her Majesty.
Kings ...................... l Kingdom of Great Britain
and Ireland....Powers of the Parliament...91. It shall be
lawful for the Queen, by and with the Advice and Consent
of the Senate and House of Commons, to make Laws for
the Peace, Order, and good Government of Canada, in
relation to all Matters not coming within the Classes of
Subjects by this Act assigned exclusively to the
Legislatures of the Provinces; and for greater Certainty,
but not so as to restrict the Generality of the Foregoing
Terms of This Section, it is hereby declared that
(notwithstanding anything in this Act) the exclusive
Legislative Authority of the Parliament of Canada extends
to....24. Indians, and Lands reserved for the Indians.... And

**Treaty No. 1**.... ARTICLES OF A TREATY made and concluded this third day of August in the year of Our Lord one thousand eight hundred and seventy-one, between Her Most Gracious Majesty the Queen of Great Britain and Ireland by Her Commissioner, Wemyss M. Simpson. Esquire, of the one part, and the Chippewa and Swampy ............ians, inhabitants of the country........ hereinafter defined and describ............ chosen and named as herein............ther part....Whereas all the Indian............untry....have been notified and in............ said Commissioner that it is the desire of Her Majesty to open up to settlement and immigration a tract of country bounded and described as hereinafter mentioned, and to obtain the consent thereto of Her Indian subjects inhabiting the said tract, and to make a treaty and arrangements with them so that there may be peace and good will between them and Her Majesty....The Chippewa and Swampy Cree Tribes of Indians and all other the Indians inhabiting the district hereinafter described and defined do hereby cede, release, surrender and yield up to Her Majesty the Queen and Successors forever all the lands included within the following limits, that is to say:-Beginning at the internatio

An Act to amend and consolidate the laws respecting Indians....[*Assented to 12th April, 1876*]....WHEREAS it is expedient to amend and consolidate the laws respecting Indians: Therefore Her Majesty, by and with the advice and consent of the Senate and House of Commons of Canada, enacts as follows:- 1. This Act shall be known and may b............ Act, 1876;" and shall apply to all............he North West Territories, includ............eewatin.... 3. The following terms............shall be held to have the meani............l to them, unless such meani............ubject or inconsistent with the context:-1. The term "band" means any tribe, band or body of Indians who own or are interested in a reserve or in Indian lands in common, of which the legal title is vested in the Crown, or who share alike in the distribution of any annuities or interest moneys for which the Government of Canada is responsible; the term "the band" means the band to which the context relates; and the term "band" when action is being taken by the band as such, means the band in council...6. The term "reserve" means any tract or tracts of land set apart by treaty or otherwise for the use or benefit of or granted to a particular band of Indians, of which the legal title is in ...

An Act to give effect to a request by the Senate and House of Commons of Canada....WHEREAS CANADA has requested and consented to the enactment of an Act of the Parliament of the United Kingdom to give effect to the provision hereinafter set forth and the Senate and the House of Commons of Canada in Parliament assembled have s............ Her Majesty requesting that H............sly be pleased to cause a Bill to............Parliament of the United Kingdo............The *Constitution Act, 1982* set out............t is hereby enacted for and shall h............nada and shall come into force as provided in that Act.....2. No Act of the Parliament of the United Kingdom passed after the *Constitution Act, 1982* comes into force shall extend to Canada as part of its law.... This Act may be cited as the *Canada Act 1982....* PART I. CANADIAN CHARTER OF RIGHTS AND FREEDOMS....25. The guarantee in this Charter of certain rights and freedoms shall not be construed so as to abrogate or derogate from any aboriginal, treaty or other rights or freedoms that pertain to the aboriginal peoples of Canada including (a) any rights or freedoms that have been recognized by the Royal Proclamation of October 7, 1763; and (b) any rights or freedoms that may be acquire

# Defining Canada

REESA GREENBERG

The Red Ensign

### DEFINING CANADA I

When I first visited England in the 60s there was a choice of three immigration wickets through which one could pass: British subject; Commonwealth; and Others. In the early 80s, these designations were changed to British, EEC, and Others. I remember my indignation at this first change in designation, my realization that the definition of a nation is never completely closed. I remember my fascination when trying to comprehend how the evaluation of a nation, if not its very destination, can always be imposed. The implication of such rumination is that, despite any fight for self-determination, whatever the nation, its definition is not necessarily what it chose. Between this external creation and one which seemingly emerges solely from self-generation, an explanation based on co-ordination, if not some multiplication of the issues under consideration, can be proposed.

### DEFINING CANADA II

In 1965, two years before its Centennial, Canada officially adopted its own flag. Prior to this date either the Union Jack or the Red Ensign had been flown. Debate about the design of the new flag centred on whether the Canadian flag should visually reference either of the mother countries (especially Britain) or be the symbol of an independent nation.

The final design differed radically from the Union Jack, the Red Ensign, the Tricolore, or the Stars and Stripes. Unlike the flags of past or would be colonizers, Canada's flag was not three colours (red, white and blue) but two. A centrally placed, stylized, red maple leaf on a white ground was framed on each side by a wide red border. The red borders were meant to symbolize Canada's *a mare usque ad mare* motto. The design of the flag represented a shift from national icons such as the railway, the CBC, the Union Jack or the Red Ensign where imagery was based on

span or surface to images which specify edge or borders. A maple leaf edged or hedged on two sides became the articulation of a connection between borders and nationhood.

This parenthetical framing can be seen as a reference to self containment or independence – what lies inside. The red edges also indicate a larger, related structure referring to what lies outside. The new Canadian flag defined the country internally and externally, its thick, red band/borders symbolising the desired inviolability of nationhood from internal or external threats.

In the Sixties and Seventies, Canada's economic and cultural policy was based on recognising the existence of borders, especially the border that exists between Canada and its only land neighbour, the United States ... In an attempt to ensure Canadian content or identity, legislation such as the Auto Pact, 1964, The Bank Act, 1967, and the Broadcasting Act, 1967, was designed to limit American intervention, as were Canadian efforts in the International Joint Commission to make the U.S. aware of the environmental implications of American activity in jointly owned waters. By asserting control of her borders, Canada believed she could control content.

That there [was] a difference, a divide, a border, however nebulous, between Canada and the United States became an accepted premise. Without it, Greg Curnoe's xenophobic slogan of that period, *Close the 49th Parallel*, and the name chosen for the Canadian government sponsored gallery opening in 1981 in Soho, The 49th Parallel, are meaningless as symbols.[1]

Ironically, neither the 49th parallel southern border nor a northern border was included in the design of the Canadian flag. It is almost as if the choice of design prefigured what Canada was to become. Canada, seemingly, has erased its southern border by entering into a Free Trade Agreement with the United States,

an agreement that many Canadians believe signals the demise of Canada as an independent nation. Canada in the Nineties is a country whose northern border is increasingly questioned internally by land claims made by Canada's indigenous peoples and externally by an ever-expanding U.S. military presence.

The choice of a red maple leaf as the central motif of Canada's flag also references a Canadian past and a Canadian future. Without the Group of Seven's vision of Canada and the Canadian government's subsequent championing of the Group's vision as a national visual image it is doubtful that a single tree-related motif would have been accepted as *the* signifying element of the Canadian flag. In "English" Canada, a single tree, silhouetted against the sky, heroically withstanding the forces of nature, as imaged by the Group, came to symbolize the country, "the true north strong and free." The image was and is well known. It was and is distributed widely through posters which hang in Canadian classrooms, book jackets and stamps. It is the image on the Barbican *True North* exhibition brochure, press release and private viewing invitation. The reduction of the single tree motif to a single leaf on the flag conjoined a popular visual symbol with

one that is audial – Canada's runner-up for a national anthem, *The Maple Leaf Forever.*

As with the choice of only lateral borders for the flag, the choice of the maple leaf has become increasingly problematic. With logging and acid rain decimating many of Canada's forests, Canada's indigenous peoples laying claim to vast treed lands, new immigrants preferring an urban Canada rather than a rustic one and Quebec preferring the *fleur de lys* as the flag for its would be country, it is doubtful that the maple leaf on the Canadian flag is, in fact, a symbol of forever. More and more, it seems the centre will not hold.

## DEFINING CANADA III

In the spring of 1988, the long-awaited new building of the National Gallery of Canada was opened. It is located in downtown Ottawa, near the Parliament Buildings and directly above the Ottawa River. Seen from the river, the building is poised on a rocky cliff. The choice of this natural-looking site recalls the vision of Canada as a rugged land portrayed by the Group of Seven. The connection between the Gallery and the Group is one of long standing and is explained in detail in Charles C. Hill 's catalogue essay, "The National Gallery, A National Art, Critical Judgement and the State" in *The True North: Canadian Landscape Painting 1896–1939*. Eric Brown, the first director of the National Gallery, played an instrumental role in promoting, both in Canada and in England, the work of the Group and its vision of the rugged north as typically Canadian. Early on the Group's work was bought by the National Gallery where it has always been prominently displayed. The very identity of the National Gallery is inextricably bound up with that of the Group and its image of Canada and this is made concrete in the choice of location for the first building to be constructed as Canada's National Gallery.

Seen from the city, the exterior looks like a mutant Gothic crystal palace, a self-described treasure of stone and light (Canada Museums brochure). It is especially so when seen at night. Moshe Safdie, the Gallery's architect, links the focal point of the building's facade, the octagonal Great Hall, to the nearby and visible "profile and build-up" of the neo-Gothic Library of the Houses of Parliament. In so doing, Safdie establishes a genealogical link between the first museum, a museum cum library, in ancient Alexandria, and, simultaneously, a generic link between the Gallery and government. Inside the Great Hall, inescapable views of the Parliament Buildings confirm the connection with government, making Canada's National Gallery a most transparent building statement on the relationship of art and national politics. Safdie has been criticized, particularly by Stephanie White, for missing an opportunity to, in her words, " consolidate a national identity, a national cultural stance, and to advance museum design." She speaks of the Gallery's outward appearance as "geared to vast crowds, flooding attendance, great amounts of glass and gigantic views of the local city – all things not to do, except by circumstantial location, with art, Canadian art, or Canada." She goes on to identify a "schizophrenia" in "the form of the National Gallery which will effectively prevent it from becoming [a] strong architectural symbol to the [Canadian] imagination ..."[2]

Safdie's Gallery is indeed schizophrenic but schizophrenia defined as "a mental disease marked by disconnection between thoughts, feelings and actions" (Oxford English Dictionary) is an appropriate term to use when characterizing Canada's recent attempts to define itself as a nation; especially when it is remembered that disease signifies dis-ease. White's unspoken concept of national identity is predicated on the utopic, and now recognized as unattainable, desire for a unified subject as the national psyche. It is a notion entertainable perhaps in Canada and

elsewhere in an earlier time but not in an era of mass international migration, realigned and shifting multinational, political and economic alliances and assertions of divergent ethnic minorities within larger nation states. White's concept of a unified national style does not recognize that today architects like Safdie are born in one country, are citizens of another and work in yet another. Their lived experience of national identity is not White's.

Given Canada's recent political history with the ever-present possibility of Quebec separating, the negative economic repercussions of the free-trade agreement with the United States, the assertion of land and other rights by Canada's indigenous peoples, an increasingly diversified racial citizenry and many more overt instances of racism and sexism, the dream of Canada as a unified nation is precisely that. No political party has formulated a convincing narrative of unity to which the various constituencies are willing to be bound. Safdie's split personality National Gallery clearly articulates the national psyche of Canada in the eighties.

Fittingly it is a two-faced National Gallery that is seen from the Quebec side of the Ottawa River. From this vantage point, only the right or east side of the National Gallery building is open, transparent. To the left or west of the Great Hall, the building is solid, closed, impenetrable. This double or two-sided discourse, welcoming and ungiving, is that of the government of Canada to attempts to alter the national status quo by its various minorities. The building of a separate museum, directly across the river, to house the cultural production of Canada's indigenous and immigrant peoples suggests just how divided the country's definition of itself is.

Douglas Cardinal's Museum of Civilization posits an image of the land that is the opposite of Safdie's Group of Seven related vision. The curves of Cardinal's pale pink buildings follow the shoreline, suggesting shelter, their massing and rough stone work echoes the cliffs opposite, the low horizontality of the complex invokes Canada's breadth. Cardinal's concept of architecture's almost symbiotic relationship to nature is derived from the Indian component of his Métis heritage. His Canadian Museum of Civilization is designed not to triumph over the land but to co-exist in harmony with it. Cardinal's buildings can be read as a metaphor for what Canada once was and once again might be [...]

* * * * * * *
Reprinted from Reesa Greenberg, "Defining Canada," *Collapse* 3 (1997): 95–102.

# Jin-me Yoon

FROM *A GROUP OF SIXTY-SEVEN*, 1996

The Expression of a D

# Chapter 7

ference

# The Expression of a D

THE IDENTIFICATION OF CANADA with wilderness landscape may have been faithful to the outlook and interests of a segment of Ontario's English-speaking population, but as a national myth it has always had grave shortcomings. It has made little accommodation for the values and particularities of Quebec and other regions of the country; it has mocked the values and ways of life of Canada's indigenous peoples; and it has also refused, as Shawna Dempsey and Lorri Millan's Lesbian Park Rangers performances demonstrate, differences of sexuality and gender.

In the essay that provides the title for this chapter, Esther Trépanier notes that there are critically distinct understandings of landscape in the English and French versions of the Canadian national anthem. While the English version emphasizes what is primal and wild, the French focuses on what is civil and tamed, a cultivated land imbued with local culture and history. Given this social understanding of landscape in Quebec, it is little wonder that the Group of Seven were met with a lukewarm response in the province. Indeed, many artists in Quebec considered the patriotic nationalism epitomized by the Group and their wilderness paintings an impediment to freedom of expression and formal experimentation. Modernity in Quebec, Johanne Lamoureux observes, has been only peripherally associated with the genre of landscape; it has been much more closely related to the cosmopolitan experience, with the metropolitan centre. In the absence of a nationalist master narrative of landscape in Quebec,

# ...ference

the genre has not had the kind of resonance it has elsewhere in Canada.

Robert Linsley sees economic rather than cultural difference as the basis for imbalanced relations between central Canada and other regions of the country. The centre has controlled the economic levers of power, he argues, but the discontents and strong local identifications produced by the imbalance, while understandable, have been misplaced. Given the movement of international capital today, which does not recognize boundaries, tensions between margins and centres make both more vulnerable to the larger global reality. The basis of a viable culture, Linsley argues, is secure land tenure, but it cannot be achieved without recognition of these developments. This issue has also been addressed by David Thauberger and Marlene Creates, two artists closely identified with specific parts of the country. Thauberger imagines western Canada not in isolation from the wider culture but as inseparable from it. His painting *Slough*, in which water lilies spread in patches across the surface of the canvas, represents a common feature of the prairie landscape that is not typically identified with the region. At the same time, water lilies carry a strong association with the artistic modernism of Monet's canonical paintings of his gardens at Giverny. *Lake Reflecting Mountains*, by contrast, recalls famous views of Lake Louise. However, the image was lifted from a photograph taken in New Zealand and used for a liquor advertisement. As for the red canoe

in the painting, it is a tourist accoutrement that belongs more in Algonquin Park than in the glacial waters of Lake Louise. For Newfoundlanders, the paired images of Marlene Creates's *Entering and Leaving St. John's, Newfoundland* (entering on the left, leaving on the right) mediate an urban-rural transition that is readily identifiable as a fixture of the local landscape. This type of sign-laden vista has become so widespread in contemporary life that its repetition seems to render this landscape almost placeless.

The disconnect between the concept of wilderness landscape and Canada's indigenous people in the paintings of the Group of Seven has been the subject of extensive critique in recent years. The problem, however, did not originate with the Group. In his case study of a sequence of landscape representations that began in the nineteenth century, Jonathan Bordo documents the process by which the presence of Native peoples was progressively erased from the landscape. The practice of erasure has not been confined to what is visual. In a series of photo-based works dating from the early 1990s, Christos Dikeakos considers the issue of naming, restoring to a number of familiar Vancouver sites their original Musqueam or Salish place names. He subsequently shot a related series of works at Wanuskewin Heritage Park near Saskatoon that broadened the terms of reference, demonstrating that suppression of the indigenous presence has been part of a larger habitual pattern denying overlapping histories of human interaction. It is history of this kind that animates *Offensive/Defensive* by Edward

Poitras, an artist of Métis heritage. The simple exchange of strips of sod from Gordon Indian Reserve (his familial reserve near Fort Qu'Appelle, Saskatchewan), on the one hand, and the lawn of the Mendel Art Gallery in Saskatoon, on the other, sets up a series of oppositional reverberations that reflect on the mutability of identity, culture, and place.

Poitras's piece is emblematic of an intimacy and connection with the land that is at odds with the European tradition of landscape. In many respects, the latter demonstrates a profound alienation from the natural world. Nowhere has this been more evident than in the representation of the Arctic, which has been pictured historically by outsiders as a blank, foreboding space. The biases of this attitude are evident in the videos and films of Zacharias Kunuk, which depict the Arctic landscape as a place where the Inuit have sustained life and a rich culture through harmonious adjustment to the given natural environment. The inextricable link between people and the land in First Nations' cosmology is given poetic and palpable force in *Ayum-ee-aawach Oomamamowan: Speaking to their Mother*, a work Rebecca Belmore performed with other participants across Canada in the wake of the 1990 confrontation at Oka. In it, the earth was addressed directly through a massive megaphone in support of political struggle to protect and defend the land. As Dot Tuer writes, "With the earth returning words scattered in the wind back to the speaker, stories were now imbedded in the landscape."

In her essay on Lawrence Paul Yuxweluptun, Loretta Todd quotes the elders: "The land is the culture." In his paintings, Yuxweluptun invests European devices for representing landscape with aboriginal attitudes and concerns, creating what she characterizes as highly charged spaces that resonate with the tragic consequences of colonization. The consequences of which she speaks refer particularly to the ecological ruin of the resources that sustain life on earth. One hardly knows whether to laugh or cry at Yuxweluptun's surreal scenarios, but in either case the viewer is left in no doubt as to which culture the artist considers best positioned to diagnose and remedy the situation. Calling attention to environmental and social issues was also the motivation for a series of butterfly gardens in urban settings and on-line created by Mike MacDonald. An artist of Mi'kmaq, Boethuk, Irish, Portuguese, and Scottish ancestry whose heritage was an integral part of his work, MacDonald in his gardens drew inspiration from aboriginal medicine, ethno-botany, and the science of plant-insect interdependence. Signifying both fragility and resilience, his gardens are astute political parables in natural form.

# Edward Poitras

*OFFENSIVE/DEFENSIVE, 1988*

The process of assimilation and genocide in nature, displacement and survival. The juxtaposition of urban and rural material. Symbolic of myself. The rural location of this project is on a reserve and alongside the summer trail to Batoche. My mother's people in defense of my father's people. A lead cache of words for bullets.

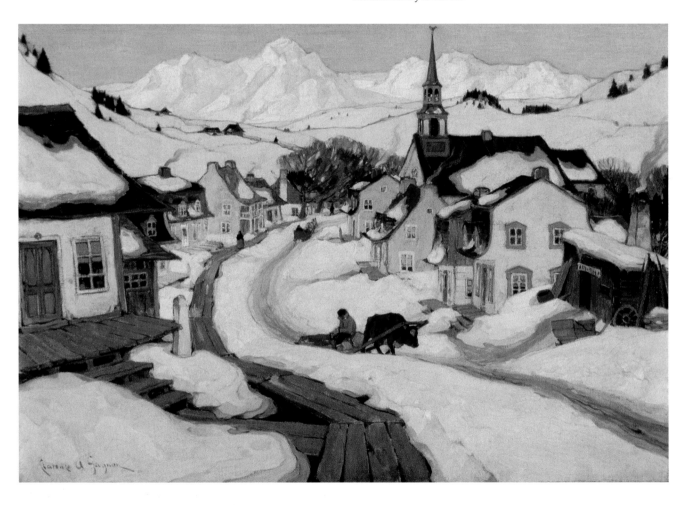

Clarence Gagnon, *Village in the Laurentians*, 1924, oil on canvas, National Gallery of Canada

# The Expression of a Difference

## The Milieu of Quebec Art and the Group of Seven

**ESTHER TRÉPANIER**

O Canada, terre des nos *aïeux*
Ton front est ceint de *fleurons glorieux*
Car ton bras sait porter *l'épée*, il sait porter la *croix*
Ton histoire est une *épopée* des plus brillants exploits
Et ta valeur, de *foi trempée*
Protégera nos *foyers* et nos *droits*

[O Canada, land of our *forefathers*
Your brow is crowned with *fleurons of glory*
As your arm can carry the *sword*, it can carry the *cross*
Your history is an *epic* of the most brilliant feats
And your valour, soaked in *faith*
Will protect our homes and our *rights*]

**THE CONSIDERABLE DIFFERENCE** which exists between the French and English versions of the national anthem, this ideological song *par excellence*, stresses the co-existence of two distinct perceptions of the territory, which in turn support their different pictorial approaches to the Canadian landscape.

The English version insists on the "true patriot love" which the Canadian brings to the "true north strong and free," emphasizing a vision of Canada as a virgin region untamed, still to be conquered. As François-Marc Gagnon[1] pointed out, the space to which they refer is uncultivated land, which was one of the favourite themes of the Toronto painters of the Group of Seven and their innumerable imitators.

On the other hand, the French version of "O Canada" values the "fleurons of glory," and the "feats" of those who sometimes used the "sword" to defend the "cross," the "faith," the "land of our forefathers," "the homes and their rights," and returns us to a way of life which existed prior to the English conquest. The geographical space which is referred to in this context is

that of this cultivated land which is divided up and organized into parishes, villages and even towns. Here the countryside is perceived more like a humanized setting, never very far away from that traditional rural life which the clergy and certain elite of French Canadians believed, until the Second World War, to be the best way to guarantee maintaining the Catholic faith and the French language in North America. This vision of the territory was considerably different to that of the English-speaking people and its specific character formed the basis of the regionalist tradition in Quebec. Compared to its "Canadian" counterpart, it had two peculiarities. Not only was the type of landscape reproduced very different from that of the northern regions, which were so dear to the painters of the Group of Seven, but, whereas the latter almost never portrayed man in their work, the Quebec artists also devoted an important part of their production to illustrating customs and traditional crafts. One can find numerous examples in the rather conventional illustrations of Edmond-J. Massicotte, but also in the work of those artists who, while having adopted more innovative techniques following their trips to Europe, were still no less instrumental in reinforcing this regionalist trend. Take, for example, the case of Clarence Gagnon and Suzor-Coté who continued to depict the Quebec landscape and many aspects of rural life (although it was coming to an end), while putting the bias on a formal, more modern and more subjective approach.

However, this interest in the Quebec landscape, indeed even in local mores, can also be found in the work of certain English-speaking painters. One can think of, among others, Horatio Walker, Maurice Cullen and James Wilson Morrice. However, I believe that the choice of these themes by English-speaking artists did not stem from the same ideological basis, and did not reinforce this traditional social plan, which was characteristic of the French-Canadian elite at that time. While the work of Walker

was sold particularly on the American market, which was so fond of anything which reminded them of the Barbizon School, the work of Cullen and Morrice rather fostered a certain openness to modernity.

## THE TWENTIES: The Question of Regionalism and the Reception of the Group of Seven on the Quebec Scene

This very conservative character which was generally present in French Canadian nationalism no doubt enables us to understand why the struggle against regionalism in art started in Quebec at the very moment when artistic nationalism in English Canada was gathering under the banner of "modernity." In fact it was in 1918, when the Group of Seven had not yet been officially created under this name, that an avant-garde Montreal review, *Le Nigog,*[2] started to denounce regionalism which obscured the artist's and writer's freedom of expression and formal experimentation and restricted them in the name of fallacious national imperatives, which glorified patriotic virtues. "A picture ... depicting a corner of the country which is dear to us will always evoke feelings in us which are unrelated to art ...," wrote Fernand Préfontaine,[3] the architect and art critic of *Le Nigog*. Nevertheless, it must be noted that this criticism of regionalism was only made by a minority of the avant-garde and it was not really taken up again until the thirties. The art critics of *La Revue nationale*, organ of the Société Saint-Jean-Baptiste showed that French-speaking clerical nationalism was an important ideological support for artistic regionalism. However, one must not forget that a good number of painters, both French- and English-speaking, developed a more modern approach to these regionalist themes or depictions of the Quebec landscape. This often enabled them to ingratiate themselves both to the defenders of nationalism and to the critics who were more open to thinking about artistic modernity. What

is more, this even allowed certain critics to consider regionalism in painting as a positive element. So the works of Edwin Holgate, Marc-Aurèle Fortin and many others led Jean Chauvin, director of *La Revue populaire* and author of *Ateliers*, a work about Canadian artists, published in 1928, to declare: "... like almost all Canadian artists, English and French, Holgate is clearly a regionalist. Yet, the manner in which all these artists express themselves reveals the effects of the education which they received abroad, particularly the influence of the School of Paris. Here one must beware of drawing parallels between regionalism in art and in literature. The former does not have any of the narrowness and the Jansenism of the latter."[4]

Thus, at least until the end of the twenties, Chauvin declared himself open to regionalism in art as long as it did not mean the loss of original pictorial research and did not exclude openness to international trends. It is to this extent that he was interested in the Group of Seven, comparing their work to that of Marc-Aurèle Fortin. The latter's canvases, he wrote in 1927, "are charming and have real decorative value. He paints like certain members of the Group of Seven, in the same spirit. They are more knowledgeable but definitely not more pungent."[5] For Chauvin, the painters of the Group of Seven, or others like Clarence Gagnon, should be counted among the founders of "our modern school of landscape."[6]

Along similar lines, a few years earlier, the critic from *La Presse*, Albert Laberge, having dealt with an exhibition of Lawren Harris at the Arts Club stressed that "M. Harris belongs to a group of avant-garde artists ... who are all endeavouring to portray as faithfully as possible the rough, wild and fierce sides of the Canadian land." Harris, he said, "enables one to see the very soul of this land."[7]

But, despite these examples of a favourable reception, the Group of Seven was not unanimously accepted in Quebec.

Marc-Aurèle de Foy Suzor-Coté, *Settlement on the Hillside*, 1909, oil on canvas, National Gallery of Canada

Although at the beginning of the twenties some saw the Group's innovative pictorial enquiry as interesting, it still stirred up many negative reactions. Some were, in fact, reported by Chauvin in his work *Ateliers*. Several of the painters he interviewed denounced the Toronto artists. Horatio Walker thought that they were "gloomy and that they falsified the image of Canada";[8] Frederick S. Coburn stated that they mixed up "eccentricity and originality" and that their painting was violent and brutal, like post-war literature";[9] for his part Hal Ross Perrigard thought that the decorative element in their work was too important and that they did not "represent all Canadian art."[10] In the end these criticisms were so numerous that Chauvin felt he had to look at this group again so that his book would not appear "through no fault of our own, [as a] catalogue of the complaints which were usually made by our painters against their friends in Ontario."[11]

In fact the criticisms which Chauvin reported were those which were usually made in connection with the Group of Seven, and which have often been quoted by historians. Let us simply add that they were also echoed by the French-speaking defenders of the region and landscape of Quebec, who were devoted to defending their own culture. For them, the landscapes of the Group of Seven represented a different vision of Canada; they provoked ambiguous comments. Let us quote, for example, this article by Pierre Bourcier published in 1921 in *La Revue nationale*. The author is commenting on two canvases by A.Y. Jackson which were presented at the Royal Canadian Academy's Salon d'Automne: "Let us turn to the landscapes which illustrate the rough, harsh and worn nature of Canada. Let us look at the canvases by Alex Jackson, the most wild and violent of the realists ... Mr Jackson, who fought for civilization for four years in France, appears to want to distance himself as far as possible from civilization in his painting, and shows nature in its most wild and savage state."[12]

In Quebec, the reactions to the Group of Seven in the twenties were not uniform. It would appear that they were conditioned by each individual's aesthetic and ideological approach.

## THE THIRTIES: Artistic Modernity and
## Criticism of Nationalist Landscape Painting

Though the defenders of modern Canadian art in the twenties proved themselves to be more in favour of all the new tendencies in landscape painting, their positions were however to change at the end of the decade. So, by 1929, Jean Chauvin denounced the reigning art of landscape painting, which only yesterday had been, according to him, an innovative element in Canadian art.

> Our painters' inspiration appears to be short-lived. Each one has found his little formula for depicting the Quebec landscape, and does not want to move away from it any more … Maurice Cullen resists, as do Clarence Gagnon and Suzor-Coté because they are beautiful, conscientious painters. But what will happen soon to all those who have tacked onto the Group of Seven? Because we now have to admit that, with the most outrageous ease the painters of Ontario have created a cliché. The masters of this movement remain great, but the painters who imitate them are merely making imitations, or forgeries or simply plagiarisms.[13]

So, at the dawn of the thirties, landscape painting was on the way to becoming, in modern eyes, a stereotyped pictorial formula lacking in authentic and original vision.

It must be said that the thirties was a decade of extremely rich and complex transition as far as the development of the art world in Quebec was concerned. Parallel to the traditional, conservative and regionalist approaches which were maintained, other artists and art critics established a trend in favour of modernity and internationalism.

This trend was timidly expressed again by French-speaking painters like Adrien Hébert or Paul-Émile Borduas, and more openly by the young generation of English-speaking painters such as Philip Surrey, Goodridge Roberts and Marian Scott, as well as by artists who had recently immigrated to Canada like Fritz Brandtner, Alexander Bercovitch, Louis Muhlstock and Jack Beder. This movement was supported by a growing number of well-informed art critics, both French- and English-speaking, whose articles could be regularly read in *La Revue populaire*, *La Revue moderne*, *Le Canada* (by Henri Girard), *La Presse* ("Reynald"), *Le Jour*, *Le Standard* (Robert Ayre) and *The Montrealer* (John Lyman).[14]

Beyond the individual differences, the notion of modernity which took shape in the thirties on the Quebec scene, and more precisely in Montreal, could be characterized as follows. In the first place, a denunciation of all notions about art which placed the value of the work on the subject-matter painted. The subject-matter was seen as being secondary to the originality of the artist's subjective expression, which could be seen in the quality of the formal work. Consequently, maintaining that the subject-matter was not important implied a radical criticism of the trends which persisted in wanting to create a national art based on one theme, the landscape or soil.

Nevertheless, one must stress the fact that the opening up to international pictorial movements, such as Fauvism, Cubism and Expressionism, examples of which could be seen in Montreal in the thirties, did not go as far as abstraction, apart from the odd exception. During this decade modernity was still expressed essentially within figurative art. Yet the accent was now placed on the more subjective and more formal elements of the artistic work. Within this context, the attitudes adopted towards the Group of Seven and landscape painting in Canadian art changed appreciably [...]

* * * * * * *

Reprinted from Esther Trépanier, "The Expression of a Difference: The Milieu of Quebec Art and the Group of Seven," in *The True North: Canadian Landscape Painting 1896-1939*, ed. Michael Tooby (London: Lund Humphries and Barbican Art Gallery, 1991), 99–107, 116.

# Johanne Lamoureux

## Interview with John O'Brian & Peter White

Adrien Hébert, *Le port de Montréal*, 1924, oil on canvas, Musée national des beaux-arts du Québec

**JO'B**  If it can be said that landscape was a contagious iconography for twentieth-century Canadian art – I've borrowed the term "contagious iconography" from you – then why does it seem to have been less contagious in Quebec than elsewhere in Canada?

**JL**  There are many aspects to your question. To address the issue of "contagion," without entering into statistics, I would first have to stress that landscape was indeed a well-spread practice in Quebec. But what you are asking, I think, concerns less the statistical presence of landscape in Quebec art than its impact, its resonance, and its shaping role of cultural identity within a national agenda – well, seen as such, landscape was probably a practice less significant in Quebec than in Canada. Yet that can be said only if we insist on defining landscape within the confines of iconography. Landscape, considered as a genre, was always more than iconography: it refers to the relation of a subject matter to form and composition; it has a formulaic dimension. And if we redefine the notion of landscape, as younger scholars like Johanne Sloan or Louise Vigneault have in recent years, to explore a broader cultural relation to any representation or intervention on territory and site (that could well include installations and promenades), then we may get a different picture of how the landscape issue is deployed in Quebec.

As for the first half of the twentieth century, it may now be said that the encounter between modernity and landscape exists in Montreal in the 1920s and 1930s, but it does not centre on the depiction of the wild nature of the Group of Seven and it also moves away from the earlier representation of rural landscapes in Quebec: the traditional scenes of small villages and communities closely knitted around the vertical line of a church that tells of the enduring presence of Catholicism and French culture. These traditional and regionalist pictures had invited a previous generation of scholars to tie landscape in Quebec to the

representation of a need for roots, a vertical anchoring in site rather than a celebration of wide expanses of untamed Nature. But Esther Trépanier, in the last decades, has convincingly shown that modernity in Quebec has been articulated through urbanity, the pictorial representations of urban life in Montreal in the 1920s and in the 1930s.

**JO'B** What sort of urbanity and modernity are you referring to?

**JL** Trépanier argues, against the mainstream view, that modernity in Quebec does not start with *Refus Global* (1948) and abstraction. She points to an earlier, figurative link to urban landscape as the first unfolding of modern concerns in painting. Urban landscape is not, and will probably never be, as resonant for the narrative(s) of Quebec art and the reshaping of collective identity as the artists of *Refus Global* were made to be from the 1960s or as the Group of Seven has been for Canada from the 1920s on. So the representation of modern life cannot embody the foundational moment the latter manifesto has come to emblematize. Yet this does not hinder the fact that the artists Trépanier talks about are indeed indicative of a blossoming sense of modernity in Quebec art, and one that deals with landscape. Now, what is interesting in this view is that the metropolis is by definition a modern motif, but it is also a theme antagonistic to the shaping of a nationalist agenda in painting. And if we have there – in this pictorial rendition of urban life – an archaeology of Quebec modernity before its full-fledged and abstract manifestation of the late 1940s, it is interesting to note that this forerunner practice was also, like *Refus Global*, not inclined to cater to any sense of national identity. (The recuperation of *Refus Global* as an emblem of Quebec modernity and the foundation of modern identity formation for a Quebec nation is a later – and quite paradoxical – construction that only evolved through the sixties and coalesced around the twentieth anniversary of the manifesto's publication.)

And it is also worth pointing out that to root modernity in the representation of modern life, with the Baudelairian ring it entails, echoes, if around a contrary theme (the urban street against the lonely pine), the conception of modernity as grounded in subject matter as much, if not more, than in form. The artists of the Group of Seven tied their status as modern painters to the depiction of the specificity of Canadian nature; the referent was an integral part of their project. That can also be said about the urban landscapes of Montreal, but the national agenda is replaced with a hybrid feel of the local and the cosmopolitan.

**PW** Which urban landscape artists do you have in mind? And what about the ambiguous position of the Anglo artist at the time?

**JL** I am not sure that the position of the Anglo was that ambiguous at the time. Montreal was an English-speaking metropolis. In the forties, before the dissociation between Lyman and Borduas, the Contemporary Art Society favoured relations between the two communities of artists. Esther Trépanier has studied the circle of Jewish painters working in Montreal during that time, but Adrien Hébert is the most emblematic painter to support her hypothesis. One can link Hébert to contemporary American painters like Charles Sheeler and Charles Demuth, to the Cubist derivation of the Precisionist trend. The painters of urban landscapes, it should be said, are not preoccupied with denying exterior influences; there is, for example, no rejection of European modernism, perhaps because the "metropolitan" agenda trumps any national one at this point.

**JO'B** Notwithstanding the escape from colonialism, the Group of Seven might seem to represent a kind of endgame of twentieth-century heroic landscape painting. Is there any sort of equivalent in Quebec to the heroic landscape paradigm established by the Group of Seven?

Jeff Wall, *The Pine on the Corner*,
1990, transparency in lightbox

**JL**  I find it strange that living in Vancouver, you would say something like that. Jeff Wall's or even Ian Wallace's photographic work are not without a heroic relation to the modern landscape. As for the second part of your question, I would say no, except perhaps for the industrial motifs in some pictures from Hébert (the grain elevators, the architectural scenes from Montreal harbour), wherein there is a concern for the monumental, if not for the heroic per se. More generally, the urban scenes of the metropolis stressed the pulse, the trepidations of the city: they celebrate the contingencies of modern life, and there again, this is not propitious to the formulation of an heroic stance. As for the regionalist landscapes of Clarence Gagnon and Marc-Aurèle Fortin, they represented rural life in a picturesque mode that was never grand. In both types of landscapes, one finds an insistence on markers of human activities. There is no fantasy, like one might find in the pictures of the Group of Seven, that nature is wild, rough, uninhabited, and uncorrupted by the process of industrialization.

**PW**  Do you think another aspect of this relationship to the land, which is distinctive from the Group of Seven, is the representation of the colonialist situation. While you were talking, I was thinking of the 1971 film *Mon Oncle Antoine* by Claude Jutra, the Christmas scene with the Anglo owners of the mine going around and giving out gifts. In terms of the ownership of land and the relationship to land and the wealth of the resources themselves, it's very different from the rest of Canada.

**JL**  Differences can lead to similar places. A common denominator between the sublimity of the Group of Seven and the picturesque of the traditionalist current in Quebec is that they both deny traces of industrialization and *economic* colonization. For the traditionalists, the land is inhabited; it is toiled and owned, but its resources, other than agricultural, are not, because wealth

was suspicious and tainted in Catholic Quebec.

**JO'B**  Is there any suggestion in what you are saying that at the moment the rest of Canada was beginning to rethink landscape in the 1960s and 1970s by moving in new directions, as exemplified in Michael Snow's *La Région Centrale* from 1969, that traditionalist practices were being reaffirmed in Quebec?

**JL**  Well, not reaffirmed, no. Reconsidered and rewritten perhaps. Jutra's film acknowledged the tensions between the social classes of a village, whereas that was generally lacking in the more homogeneous representations of the traditionalist painters. If you are looking for a contemporary parallel to the work of Michael Snow and Joyce Wieland's generation for artists from Quebec whose practice addresses a sense of site, I would suggest Melvin Charney. Of course, geography and landscape do not much inform his work, but he undoubtedly deals with space in new ways. He works between sculpture and architecture, but always through the constructed city, the urban realm, once more. His *Dictionary* or the *Trésor de Trois-Rivières* look, with a slightly ironic but somehow tender eye, towards the heroic elements embedded in vernacular and domestic architecture: pediments, cornices, columns, archetypal remnants of the temple structure. The Pop Art element that runs through Wieland's early work would find more echo in Quebec than what Snow was doing in *La Région Centrale*. If we exclude the abstract art of the sixties, one would perhaps find more affinities between the Ti-Pop movement in Montreal and the London School.

**JO'B**  Which artists do you have in mind?

**JL**  Pierre Ayotte, Serge LeMoine, artists who engaged with a popular, often local imagery: the crate of beer from a local brand, the colours of the hockey team.

**JO'B**  Some of Greg Curnoe's work was landscape based. He sometimes represented the vernacular landscape, as seen in some of

Maurice Perron (photographer) and Françoise Sullivan (choreographer), *Danse dans la neige*, 1948

his small watercolours or his big text paintings. Does the vernacular landscape figure in Ti-Pop?

**JL**   Only retrospectively, you could say. Since their practice, considered within the frame of genre, is undeniably closer to still life than to landscape: unless you think of the current Logoland of suburban and urban areas. But, on the other hand, Ti-Pop was concerned to provide viewers with a sense of the local through the imagery. Now, by bringing Ti-Pop or Charney into a discussion of landscape, I seem to prolong a modern tradition of urban representations as more central to the discussion of Quebec art. (The sixties were in fact dominated by the affirmation of abstract art: abstraction, through the role it had taken for the Automatistes, was beginning to gain momentum in the sixties as a strong collective metaphor of emancipation: it had a paradoxical mirror-function since it had a role, despite being non-figurative, in shaping a collective identity opened onto the "international" language of abstraction.)

But there are other types of relation to landscape and site in

Quebec visual arts. Louise Vigneault has proposed in *Identité et modernité au Québec* an anthropological reading of the important role of certain figures like the coureur de bois, the hunter, the Native, for the Automatistes (she explores a Tom Thomson side of Jean-Paul Riopelle). We knew the importance of these types in the Quebec literature of the first half of the twentieth century. But Vigneault's perspective is an important contribution because it highlights a significant streak of nomadism in the *visual arts* of Quebec, rather than insisting, as had been done for decades, on the craving for roots of the traditionalist rural landscapes or on the contingent sense of site in the urban landscapes of modernity. Of course, Automatism defended abstraction, but through its affinities with Surrealism it was a movement informed by discussions on primitivism. After all, amongst the most reproduced images associated with *Refus Global* in the last two decades, we would have to consider the photographs of Maurice Perron showing Françoise Sullivan as she is dancing against the white background of a winter landscape.

**JO'B**   Would it be accurate to say that feminism helped to reveal unacknowledged landscape concerns among the members of Borduas's circle?

**JL**   It is not only accurate but important to say it. But there are other factors to consider in this shift of vision. The demise of a certain pictocentrism has expanded our perception of what the Automatiste group was about, and we now acknowledge their work as representing a more interdisciplinary range of practices: dance, poetry, drama, design, photography. That is not to

say that one cannot address landscape issues from their pictorial practice. Vigneault notes that many titles for Borduas's pictures refer to the notion of insularity: she sees this proliferation of islands – *Sous le vent de l'île* and *L'île fortifiée*, etc. – as indicating a penchant for exoticism, an insistence on the voyage, the journey, the exile. But we could read this insistence on the island at other levels as well. Certainly, it has a socio-political ring that conveys isolation: the island, like the boat, is what Michel Foucault called a heterotopia, a world unto itself, different from its immediate surroundings. It has psychoanalytic resonance: the "landscapes" of Automatism allude to the psychic site of the unconscious; they unfold what we could call the landscape within. And finally, on the level of aesthetics, the island is the perfect metaphor for the emancipatory self-referentiality of abstract modern painting; it emblematizes perfectly the fantasy of formal modernism, that of an autarchic picture, breaking ties with all external interferences.

**JO'B** If I follow your argument correctly, Borduas and his circle expressed modernity through abstraction, while the Group of Seven expressed modernity by choosing to rough up the picturesque. I'm wondering about the Group of Seven being promoted as a national voice, rather than as an Ontario voice, which is what it was.

**JL** I don't know that the promotion ever fooled anyone, though. When you read the correspondence between Marius Barbeau and Eric Brown at the time when they were organizing their 1927 show, *Exhibition of Canadian West Coast Art: Native and Modern*, they already know they have to counter the perception of the Group as a phenomenon limited to Ontario. Brown wanted the artists of the Group to travel from coast to coast, as if the best way to ascertain "Canadianity" was to cover the total expanse of Canadian geography.

**JO'B** Brown succeeded. Working together, Brown and the National Gallery mythologized the Group of Seven and its claim to a national voice so well that the institution still adheres to the myth. *The Group of Seven: Art for a Nation* was the title of its large 1995 exhibition. The meaning is in the subtitle. That is one reason why regions in the rest of the country have tried to inoculate themselves against the centre's desire to speak for the whole.

**JL** But the "centre" also caters to regionalism as an accommodating narrative that allows the centre a self-effacing stance without truly depleting its power and control. Let us remember that the current director of the National Gallery, Pierre Théberge, was once a champion of Canadian regionalism. Surveys of Canadian art tell a story of the capital of art shifting cities from one decade to the next. Diana Nemiroff constructed the only biennale that took place in the new building of the National Gallery as an heterogeneous mosaic of lively centres (during the very same decade – the 1980s – that saw the emergence on the international art scene of a rather homogeneous image of Canadian art). So I am not certain that regionalism is a resistance to the centre: as often than not, it seems to me to be a discursive production of the centre.

**PW** We should talk more about the institutional impact on history and identity of the National Gallery. Our book was conceived as a response to the *Art for a Nation* exhibition. It was the largest show of Canadian historical art the National Gallery had mounted in a number of years and chronologically occurred between solo exhibitions of Emily Carr in 1990 and Tom Thomson in 2002. These exhibitions underscore the incredible pervasiveness of the Group of Seven, if we include Carr as a participant in the mythology. The Group has the stature of the Impressionists for Canadian museum-goers and the Canadian public. It's extraordinary. Part of our interest is to account for that staying power.

Paul-Émile Borduas, *L'île fortifiée*, 1941, oil on canvas, Musée d'art contemporain de Montréal

**JL** That should tell us that we are dealing with a compelling – albeit not necessarily true – narrative. I will not attempt to explain it in aesthetic or political terms: what phenomenon of collective recognition is successfully at work in that storyline? The rhetorical strength of such a foundational tale is certainly enhanced by a peculiar mirror-effect: the similarity between what the story is about and the procedures chosen to relate it. In Canada the historiography of art is as much about geography as the pictorial tradition it exalts is about landscape: a good Canadian art historian has to prove his or her Canadian competence by reviewing each region from coast to coast. "Ton histoire est une épopée," says the Canadian anthem. But seen from Canadian art history surveys, that history often runs like a marathon.

During the Révolution tranquille, art institutions in Quebec also came up with a foundational narrative of identity and modernity, and despite many attempts to deconstruct it, it too has had a kind of staying power, although probably not so much with a large public. Now, while we are discussing institutions and narratives, one surprising fact about Quebec art history is that there is still no survey of it, not even a survey of twentieth century art in Quebec. There is no equivalent to Russell Harper's 1966 *Painting in Canada: A History*, or Dennis Reid's 1973 *A Concise History of Canadian Painting*, or Barry Lord's 1974 *The History of Painting in Canada: Toward a People's Art*. Given this situation, the only way to obtain a sense of a general picture is to read different authors, different voices, competing and complementary hypotheses.

**JO'B** Does this relate to your earlier point that modernity is urban in Quebec? If you have an urban modernity, particularly one that owes a good deal to French continental thought, is it more inclined to refuse totalizations?

**JL** It is a complex and interesting question. I do not know for sure that urban modernity plays a role in the situation, but certainly cultural values and institutional traditions are at stake: traditionally, textbooks, manuals, surveys, anthologies are not as systematically produced in the world of French publishing (if we compare it with the Anglo-American taste for such publications), despite what we might perceive as a pedagogical need. There is even a tradition of intellectual contempt towards these formats, although I perceive a change on that front, in France at least. Whatever the reason (a predilection for study cases, a preference for analysis against synthesis, a lack of institutional will, an indifference for the visual arts in the world of publishing), when the time comes to produce an unfolding of the visual arts in Quebec, one is still left piecing monographs together. It complicates the narrative performance, but it also allows for challenging and stimulating discussions.

# David Thauberger

*SLOUGH, 1979*

*LAKE REFLECTING MOUNTAINS, 1982*

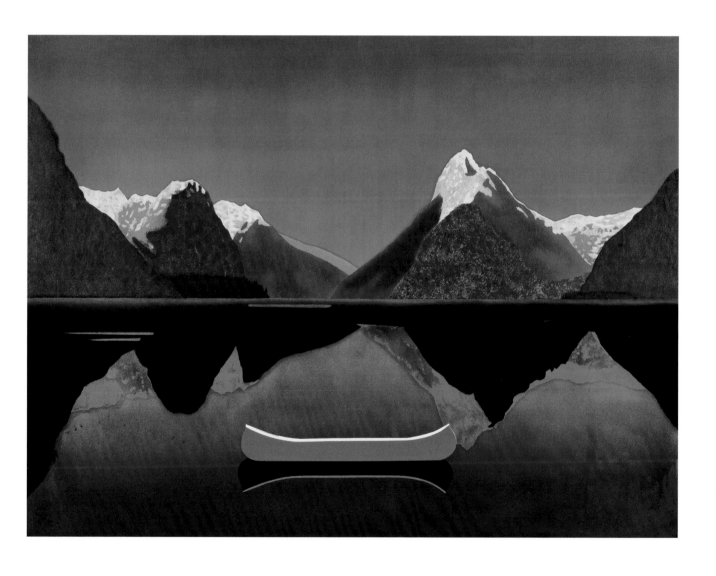

F.H. Varley, *Night Ferry, Vancouver*,
1937, oil on canvas, McMichael
Canadian Art Collection

ROBERT LINSLEY

# Painting and the Social History of British Columbia

**I'D LIKE TO START WITH FREDERICK VARLEY**'s *Night Ferry, Vancouver*, of 1937, not to interpret the work as much as to use it as a catalyst for my discussion. The drama of loneliness and obsession acted out by the figures of Night Ferry places it in the expressionist tradition of Munch, and sets it apart from the more typical expressionism found in British Columbia landscape painting – nature deformed by emotion, without narrative and generally without figures. I will discuss this later, but the central topic of my paper is what landscape painting tells us about the social realities of BC, and of course what it doesn't tell us. Among other things, the Varley speaks about the persistence and long-term continuity of certain fundamental social patterns. Varley painted this work while living in Ottawa; this is Vancouver in memory. However, though we can perhaps identify the Marine Building, there were no towers like this in Vancouver in the 1930s. In fact we know from Varley's own comments that this is an imaginary skyline of New York.[1]

The collapsing together of the metropolitan centre of North America and the continental margin, which cancels out of existence the Canadian centre, tells us a lot about the centrifugal forces acting historically on the country's regions, now becoming more visible in the era of free trade. The most persuasive theory of the Canadian economy is the staples theory, first proposed by Harold Innis in 1930. In this theory, resource-producing regions fall into a dependent relationship with the industrialized metropolitan centre that produces the machinery and other manufactures the resource region needs. The growth of a self-sufficient diversified economy can occur when the surplus generated by resource extraction is reinvested in the region. When the staples-producing industries are owned by foreign capital, there is little incentive for this to happen.[2] However, the relationship between resource region and centre is not summed up by the formal trade agreements between them. They are organically bonded together, forming two parts of a whole; but not equal parts, for the centre is the centre of control, and power rests there.

Notice that the mast and guy wires that divide *Night Ferry* into uncommunicating sections at the same time recall the telephone and other electronic links that tie all parts of the continent together. They remind us that what divides also joins, and vice versa. What distinguishes BC as a unique region, namely its political institutions, actually work through investment and resource policies to bond it closer to financial capitals worldwide. Conversely, what links BC most significantly to the outside world, that is, corporate directives and the flow of information and capital, serve to hold it at a safely subservient distance. Here, nationality or specific regional identities appear as convenient fictions that serve to mask the true internationalism of business. For business, all the world is one, and nation-states are annoying inconveniences where local political life interferes with the pursuit of profits. On the other hand, sometimes local governments preserve advantageous disparities. An example close at hand is land-tenure policy. Most of BC belongs to the Crown, hence, by a legal fiction, to the people, but in reality it is exploited and managed by large foreign-owned corporations. As expressed in the 1976 Pearse Commission on the forest industry: "From the industry's point of view, Crown ownership and sale of timber as it is harvested means that the public bears the enormous cost of carrying the forest inventory, so that the capital required to enter and operate in the industry is substantially reduced, as are the financial risks involved."[3] From the point of view of the investors, the disadvantage of public ownership is insecurity of tenure, but successive BC governments have done their best to allay industry anxiety by granting long-term leases.

As the native peoples have long recognized, secure land tenure

Maxwell Bates, *Beautiful B.C.*, 1996, oil on canvas, Vancouver Art Gallery

is the basis of a viable culture. The historical irony of British Columbia is that the colonists and immigrants who displaced the indigenes from their land are themselves the dispossessed, and dispossessed by the very institutions that supposedly guarantee their collective ownership. These ambiguities of ownership are exactly the subject of Maxwell Bates' 1966 painting, *Beautiful BC*. The title of this brilliantly satirical piece belonged to a glossy promotional magazine published by the tourism ministry. Anyone who can say "British Columbia is my home" without anger is unintentionally ironic.

Given this economic situation, the distinctiveness of BC as a region takes on an illusory quality. There is a continuity of culture rooted in the specific experience of this place, but it faces, as a permanent condition, an antagonistic socioeconomic reality. I'm not interested in reiterating tired complaints about lack of support for local art, or in reviving historical debates between regionalism and internationalism, between the provincial and the up to date. These banal discussions, which form the stuff of much writing on culture in Canada, are clearly beside the point because they are symptomatic rather than critical. Official neocolonial culture, nationalistic and patriotic of necessity, is haunted

by the question of its own validity, even its own existence. The probing of such anxieties by official culture becomes one of its most important functions, but can only work to block the clear perception of an uncomfortable reality (namely, the paradoxical status of the nation itself) by freezing the fluidity of the real into polarized and bureaucratic categories. Since the region (and the nation) is constituted in relation to another, and one of the functions of culture is to mediate this relationship, it should come as no surprise to find that the local consumer, from the moviegoer in the street to the wealthy art collector, has metropolitan tastes, or, conversely, to find that the consumer of local culture is elsewhere. The trade in culture opens up a special role for regional motifs as signs of difference which testify to the integrity of the region, but since the same conditions that enable this trade erode the distinctiveness of the region, these motifs take on the flat and stereotyped quality of a postcard Mountie. While the sophisticated local consumer instinctively demands that culture incorporate knowledge of these dynamics into itself, that art seem up to date, that films and TV programs be "competitive," a clear and conscious awareness of them is an absolute prerequisite for the artist who wants to avoid a naive regionalism on the one

hand or a generalized derivative modernism on the other. Here Varley's painting is remarkable and prescient, and an important document of art in BC; it is perhaps sadly appropriate that it is not in a local collection.

It is important to note that the relationship between Vancouver and its hinterland reduplicates the same centre-margin pattern on a smaller scale, except that here the dialectic of separation and unity is reversed. Where the region dreams a unique identity and in fact can only claim a specific, though not unique, role in a global economy, the city proclaims its harmony with nature when in truth it is divided from its hinterland by its role as the controlling centre of exploitation. For the urban dweller, whose very existence depends directly or indirectly on the resource hinterland from which all wealth comes, images of nature are a necessity, yet socioeconomic realities demand that these images hide rather than reveal the nature of the divided relationship between city and region. The more art concerns itself exclusively with raw nature, with the wilderness, the less it really tells us about the landscape. Distance is a fundamental constituent of landscape painting in the modern world, for landscape painting is a product of the modern city, painted by and for urban dwellers; it presents a particularly urban experience of nature as spectacle. The task is to determine the specifics of how that distance is articulated in BC painting.

We can start in the colonial period, when the English picturesque watercolour tradition and the topographical tradition of the military surveyor come together to objectify the landscape in complex ways. Edward Roper's *San Juan Island and Mount Baker from Vancouver Island, British Columbia* (1887) contains more than appears at first glance. The island in the gulf is American, hence a strategic point in any future conflict.[4] The grandeur and serenity of the scene characterize advertisements later used to attract settlers, especially as it is apparently empty of people and available for the taking. Here is nature as seen by the tourist, imperial strategist and developer.

In the mythology of BC modernism, the colonial vision is shattered by Emily Carr, who, particularly in her later period, penetrates appearances and for the first time feels the landscape. However, I suggest that this is not exactly the case. To the extent that we assume that the expressive dimension in Carr's work – the expansion and contraction of form, the flow of paint in parallel swirls as if through the magnetic field of her feelings – is a response to the landscape in front of her, we can read these pictures as evidence of an achieved unity of subject and object, other emotions and the world around her. But such a union of subject and nature is impossible in principle, and doubly so for Carr, rooted as she is in a society founded on alienation from nature as the precondition for its exploitation. At best, such works can only be fantasies of such a union, and as such they acquire their character as protests against an increasingly cold and denatured world. But at the same time, the cognitive dimension of art – its potential to teach us something about the world – is diminished, for it demands that a certain distance be kept. The degree to which Carr's work claims to actually embody a unity of nature and subject is in fact the degree to which one of these terms threatens to overwhelm the other; feeling lords it over representation and works to hide the distance fundamental to the very existence of the pictures themselves as protests.

On the other hand, in the more complex of Varley's pictures, such as *Mirror of Thought* (1935–36) or even *Night Ferry*, the figures are distinguished from "nature." The Varleys also contain different spaces and times. Pictures like these allow plenty of room for subjectivity, as well as the possibility that we might learn something about the world around us and our position

within it. Alienation from nature is at the core of Carr's works, yet this distance is hidden by their claim that they merge subject and nature, a claim reiterated uncritically by art historians.[5] Varley's work incorporates that distance into its structure.

Though Carr's expressionism can be criticized on philosophical-aesthetic grounds, I feel it can be redeemed as social protest. However, such a reading is complicated by the eroticism of the work. Though some of her landscapes have clearly vaginal or phallic imagery, these are not typical. Like many other modernists, Carr is an artist for whom painting itself is an erotic activity. The generalized nature of this eroticism, expressed in the later works by her obvious pleasure in the sensuous plasticity of paint, was noted by Doris Shadbolt: "There is much sublimated eros in her work, and some imagery of strong sexual connotation was frequent in the formal painting period ... Such content does not disappear in her later work, but is translated into a powerful and more generalized sexual energy."[6]

Seen within a broader modernist perspective, the eroticism of Carr's work is unremarkable, but in BC it is still a controversial topic. Deeply conflicted social attitudes towards sex, which still pervade the culture, ensure that discussion of eroticism in Carr's work is often received as an attack on her iconic status as a cultural heroine and BC's first modernist, a situation not in the least improved by recent feminist criticisms of gender stereotyping, which keep the discussion of these matters on a level of generality that inhibits a critical reading of specific practices. All this raises the possibility that Carr's work could still have an emancipatory shock value. Her sexualized landscapes could be read as a literal loving of nature, and as such an expression of an antitechnocratic, life-affirming critical position that still has the capacity to offend bourgeois proprieties. Yet social developments such as the repressive desublimation of sexuality in advertising and pornography make dreams of the revolutionary release of libidinal energies seem quaintly nostalgic. Those who would attach a positive value to the eroticism of Carr's work are just as out of touch with present realities as those who find such a reading offensive. The political meaning of Carr's eroticized landscapes remains a muffled controversy, yet one that perhaps could be opened up by placing her work in a broader local tradition. The gendering and sexualization of landscape is a long-standing theme in BC art, and, in the case of Carr, the Maxwell Bates painting already cited, and many works of Claude Breeze, to mention only a few examples, it is often entangled with environmental politics. A full treatment of this would merit another study. Meanwhile, episodes of genuine tenderness towards nature are present in some of Carr's paintings of clearcuts with young second growth. This observation supports my criticisms of her expressionism, and of expressionism in general, for the most meaningful element is not the immediacy of paint handling, but the subject represented [...]

* * * * * * *

Reprinted from Robert Linsley, "Painting and the Social History of British Columbia," in *Vancouver Anthology: The Institutional Politics of Art*, ed. Stan Douglas (Vancouver: Or Gallery and Talonbooks, 1991), 225–31, 244.

# Marlene Creates

# Shawna Dempsey & Lorri Millan

LESBIAN NATIONAL PARKS AND SERVICES, 1997 TO THE PRESENT

LESBIAN NATIONAL PARKS AND SERVICES

FIELD GUIDE
to
NORTH AMERICA

FLORA, FAUNA & SURVIVAL SKILLS

FIELD GUIDE to NORTH AMERICA

PEDLAR
PRESS

by RANGER SHAWNA DEMPSEY & RANGER LORRI MILLAN

### The Beaver
*(Castor canadensis)*

The Beaver lives in extended-family dwellings which block watercourses and form ponds. Called "lodges", these split-level habitations are made from logs and sticks, gnawed into desired lengths by the rodent's razor-sharp *dentata* and packed with mud. A lodge is so well-constructed that not even a bear can penetrate the Beaver's private realm! Constant renovation is necessary and keeps the Beaver active long into the night. The industry of these dam homeowners, though detrimental to woodlands, raises water levels and improves the neighbourhood for amphibians and waterfowl. The Beaver also provides warning against intruders by deftly slapping its paddle-shaped tail upon the water. Whenever you hear a "slap, slap" in the wetlands, a frisky Beaver will be close by!

This clever and mischievous animal is not only "busy", but also "eager". The fun-loving and frolicsome Beaver revels in watersports. She will swim to great depths of depravity to get her needs met. However, she is also highly selective. This, the largest of rodents, is monogamous.

Happily, Beavers abound; you need only look. Although once threatened with extinction by trappers, this wily creature modified its behaviour from

diurnal to nocturnal and, as a result, populations have swelled. Those of us who hail from the great northern land of Canada are proud to be represented by this furry beast and all that she signifies.

LENGTH INCLUDING TAIL 85–100 cm
WEIGHT 13–25 kg
COLOUR brown with black tail

MAMMALS AND YOU

120

121

# Christos Dikeakos

*CH'E CHÉE LMUN, 1992*

*WANUSKEWIN PARK, MIKE VITKOWSKI'S FARM,*
*SASKATOON, SASKATCHEWAN, 1993*

ch'e chée lmun

killer whale

seal

herring

octopus

junipers

cattails

balsam poplars

rose

mint

ducks

mall delicate ferns

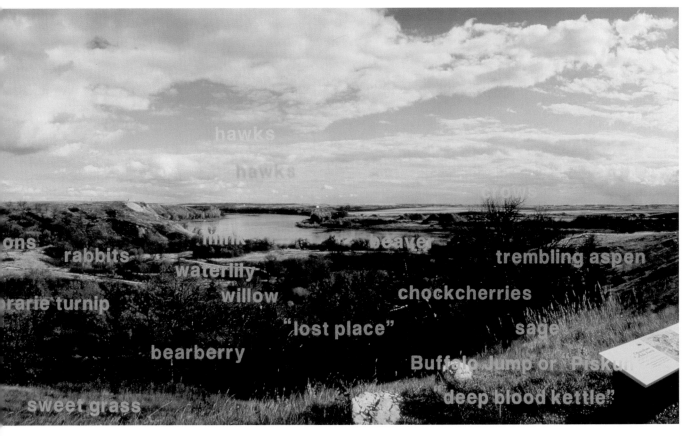

hawks

hawks

ons

rabbits

waterlily

rarie turnip

willow

bearberry

sweet grass

mink

beaver

"lost place"

chockcherries

trembling aspen

sage

Buffalo Jump or "Piskun"

deep blood kettle"

"Making a Portage"

Humphrey Lloyd Hime,
*Voyageurs and Canoemen of the
Assiniboine and Saskatchewan
Exploring Expedition*, 1858,
albumen silver print, Library
and Archives Canada

PORTAGING A CANOE AND BAGGAGE.

After Humphrey Lloyd
Hime, *Portaging a Canoe and
Baggage*, 1858, engraving
from *Illustrated London News*,
Library and Archives Canada

# Jack Pine

JONATHAN BORDO

## Wilderness Sublime or the Erasure of the Aboriginal Presence from the Landscape

## I. ERASURE

[The first image] is a photograph entitled *Voyageurs and Canoemen of the Assiniboine and Saskatchewan Exploring Expedition*.[1] It is a group portrait of men, ostensibly at the outset of a portage, dated June 2, 1858. The figures in the picture are posing with packs, paddles and a birchbark canoe, held aloft by its carriers; a cursory survey suggests that all the figures making up the group portrait are non-European. The title of the picture indicates a third party who are neither voyageurs nor canoemen. According to the title, the voyageurs and canoemen are part of an expedition exploring the Assiniboine and Saskatchewan Rivers. The third party are the organizers and leaders of the expedition – the explorers. It is they who have given purpose and meaning to the photograph because it has been taken as part of an "exploring expedition." The explorers, however, are not in the picture, only the bearers of the expedition. The explorers are on the other side of an invisible line marked by the viewing range of the camera. Thus *Voyageurs and Canoemen* is a group portrait of the indigenous bearers of the exploring expedition, not its white European agents.[2]

[The second image], an engraving entitled *Portaging a Canoe and Baggage*, is a group portrait as well. It appears, moreover, in significant compositional respects to be a replica of *Voyageurs and Canoemen*.[3] This is dated October 16, 1858, and appeared in the *Illustrated London News*.

Even if the engraving is a tracing of the photograph, it is not a faithful replica. Initial, slight, surprising differences between *Voyageurs and Canoemen* and *Portaging a Canoe* are to be noted. The figures are no longer dark and "Indianish." They all appear to be white and distinctly European – their caps, jackets and somewhat leisurely demeanour and attire suggest a recreational outing. Consider, for example, the figures with the tumped backpacks. In the engraving, one of the retouched figures is jacketed and holds a walking stick in his left hand. In the photograph there is no such stick. The means of conveyance for the trip is also significant. The birchbark canoe in the photograph has been replaced by a stolid, dorey-like boat of great weight and solidity, born aloft by a small platoon of carriers, whose apparel is reminiscent of a press gang of able-bodied seamen of Her Majesty's Royal Navy.

As a result of these substitutions, the retouched image has lost its specificity of place. That this is not some recreational outing in the Lake District, but possesses a new-world and imaginary "wilderness" setting, is indiscernible from the picture itself. Indeed, given the adjustments, it might just as well have been the Lake District. That its setting might be European North America is indicated by the verb in the title assigning meaning to the action. They are portaging what they call a canoe. "Portage" obviously has a French derivation from "porter." Part of the entry from *Le Petit Robert* reads: "... action de porter. Transport à dos d'homme. Partie d'un fleuve où on ne peut plus naviguer (qui oblige à porter les embarcations)."[4] According to the *Oxford Universal Dictionary* it means "a. The carrying or transporting of boats and goods from one navigable water to another, as between two lakes or rivers 1698. b. A place at or over which such portage is necessary 1698."[5]

The Oxford assignation of a North American provenance to portage as designating a place is linked to seventeenth-century exploration and competition with the French over the fur trade. The engraving clearly confirms that the figures are at a portage and are in the process of setting out with their equipment across it. My point here is that the locale has become indefinite. While *Voyageurs and Canoemen* is at a portage somewhere on the Assiniboine or Saskatchewan Rivers, *Portaging a Canoe* is at the portage. The portage has become a topos. The only thing that indicates that it might have a Euro–North American location is

the language of the title, the word portage itself. The image belies such a spatial ascription. In short, *Portaging a Canoe* is physically placeless. Portage is the name for an imaginary space, a topos. To draw out the deeper suggestions in this notion of portage as a non-place, we must return once more to the bearer figures.

When it concerns the social character of the figures, the engraving articulates a social division of class between the boat carriers and the pack carriers. The division is internal. Unlike the photograph where one party, the organizers of the expedition, are unpictured, the tracing seems to represent all those engaged in the activity. Everyone is to some degree a participant in the activity, even when the burdens are unequally distributed. The activity they are engaged in lacks an explicit purpose just as it takes place in an indefinable space. What assigns the meaning to the picture is precisely what the image had to erase, namely the aboriginal presence, both directly and indirectly. Hence, the significance of retouching a birchbark canoe as a dorey erases the material interface of the history of indigenous-white contact. The replica taken by itself is vague. We don't know where they are and why they are doing what they are doing. The contact itself, the fact that it ever happened, is put in jeopardy.

The images form an interpretive unit. The engraving owes its existence to the photograph upon which it feeds parasitically for its existence and its meaning. It is dependent causally and semantically upon the original photograph as much as a photocopy is dependent upon an original. From the point of view of this dependence and, unlike the photocopy, the engraving deliberately fakes originality by faking the original. The fraud creates a new subject which is an imposter ranging over an unnamed space. The imposter is among other things a white male European who appropriates the place occupied by the aboriginal and transforms it into a vague space. The occupation, in so much as it receives representation, requires an erasure of the aboriginal presence from the image. The replica is also a palimpsest. It is indeed a tracing of one image on top of another so that the imposter and the space occupied by the imposter rest on top of and cover over another space which it covers. Scratching the surface reveals the layer concealed beneath. The two taken together open up the way to a subliminal history of the Euro-Canadian wilderness sublime. Euro-Canadian wilderness as a system of representation – an ethos – will be marked by this absence. The erasure of aboriginal presence creates, as it were, a

F.H. Varley, *Indians Crossing Georgian Bay*, 1922, oil on panel, McMichael Canadian Art Collection

space that is indeed a gap. It is also a territory to be occupied and possessed, and a symbolic space, a topos being named. All three taken together begin to organize the meanings of wilderness, in the sense that Euro-Canadians might understand it.[6]

When John Wadland convincingly refers to the wilderness as "an ambiguous, detached and ultimately romantic space,"[7] he might well add the word "haunted," because it owes a part of its ambiguity, detachment and symbolic meaning to that aboriginality which is there but absent, not from the land upon which aboriginal peoples have continued their painful, marginal dwelling, but from the system of representation that we call "wilderness." The purpose of this study is thus to explore the Euro-Canadian view of wilderness not as an "idea" but as a cultural project that articulated itself as a system of representation, intimately and inextricably linked to what the photograph ignored – namely aboriginal presence.[8]

## II. A CURIOUS REPETITION

Two Frederick Varleys hang side-by-side at the McMichael Gallery as if they bear a special relationship to each other. The first painting, entitled *Stormy Weather, Georgian Bay* dated 1920, is a small version of the signature piece *Stormy Weather, Georgian Bay* that has so prominent a place in the Canadian section of the National Gallery. The second is called *Indians Crossing Georgian Bay*, 1922, the only work by the members of the Group of Seven I have seen that depicts indigenous people as an explicit and named subject of a landscape.[9] *Indians Crossing Georgian Bay* is a curious painting because the figures, descending a rocky ground, almost appear as if they were themselves part of the shield's carapace. It is difficult initially to discern them as human figures. That there are human figures at all, and that the human figures are named, is exceptional for the Group of Seven. This is not to say that Tom Thomson and the Group didn't or couldn't paint human and living figures. It was just not part of their wilderness landscape style, as will be demonstrated shortly. The two works contain a stark and surprising assertion because aboriginal presence does appear in the image side-by-side with an image, the characteristic landscape image of the Group, namely a landscape devoid of human presence, organized compositionally and symbolically by the figure of a foregrounded Northern tree, the Jack Pine.[10]

In order to appreciate the significance of the aboriginal figuration in the Varley image, one must keep in mind the temporal order of the images. *Stormy Weather* precedes *Indians Crossing*. The image of a landscape void of human presence precedes the apparition of specially designated human figures prominently occupying that picture space. The order at least provides a clue and point of entry into the significance of the aboriginal apparition, or, what is more to the point, the significance of the absence. Can anything more than temporal succession be drawn from the fact that *Stormy Weather* precedes *Indians Crossing*?

To tease this out, experimentally reverse the order and assume that *Indians Crossing* preceded *Stormy Weather*. One result of this reversal would be a repetition of the relation that *Voyageurs* has to *Portaging*. While the causality of the relation between the two images would be lacking, the ordering would bear an unmistakable resemblance to *Voyageurs* and *Portaging* in one significant respect, namely that aboriginal presence in the first image, *Indians Crossing*, would have been erased in order to establish a second image, *Stormy Weather*. In other words, in a significant way the Varleys could be said to repeat the visual crime of denial and appropriation of the photographic pair. And that would be too good to be true, too simple and far too correct.

When we change the order so that *Stormy Weather* precedes *Indians Crossing*, a visual "wrong" seems to have been righted.

Indeed, the aboriginal presence would appear to emerge from the absence – reapparition! But how to interpret this? I repeat my assumption that the thematizing of the aboriginal in the art of the Group of Seven is isolated and exceptional. What, however, does this isolated and momentary appearance signify?

It should be recalled that aboriginal presence was not only a common but an exalted thematic in nineteenth-century North American art, be it as picturesque idealization and/or ethnographic documentation. One need only cite as a paradigm the inseparability of wilderness and aboriginality in Lucius O'Brien's *Lords of the Forest*, a painting that follows in the path of his Hudson River predecessors and contemporaries; for example, Thomas Cole's *Falls of Kaaterskill* (1826), Sanford Gifford's *The Wilderness* (1860), and Albert Bierstadt's *The Rock Mountains, Lander's Peak* (1863).[11] *Voyageurs/Portaging* is interesting because it runs against the grain of the nineteenth-century picturesque image, which not only included Indians but exalted them.

The problematics of twentieth-century, northern – or even more specifically Euro-Canadian – wilderness sit somewhere nebulously and unnamed in the gap between the vague space that opens up between *Voyageurs/Portaging a Canoe*, on the one hand, where aboriginal presence disappears to be replaced by an exclusive white presence and, on the other, the sudden and unexpected surfacing of aboriginal presence in *Indians Crossing* out of the humanly voided space of the solitary tree of *Stormy Weather*. To focus on the problem once again, consider the juxtaposition of *Voyageurs/Portaging* and *Stormy Weather/Indians Crossing* in terms of a play of analogies using the values of absence and presence. The play of analogies is as follows:

| Voyageurs | Portaging | Stormy | Crossing |
| --- | --- | --- | --- |
| presence | absence | absence | presence |

The aboriginal presence in *Voyageurs* counterposes its absence in *Portaging*, while the absence of human presence in *Stormy Weather* is in counterposition to a specific and named human presence, the aboriginal in *Indians Crossing*. *Portaging* substitutes Europeans for indigenes. There is the absence of a specific presence, the aboriginal. With the Varley, *Stormy Weather, Georgian Bay* is devoid of all human presence. In the previous section the notion of a vague space as occupied by the whites was first broached. The disappearance of the aboriginal and its replacement by the whites opened up a vague space. *Portaging a Canoe* occurs in that vague and unnamed space. Indeed, *Portaging* is placeless – utopic. It is the imaginary. White presence appears in the utopic space where the aboriginals are not. Consider *Stormy Weather* and *Indians Crossing*. A specific human presence appears in the space established by the general absence of human presence. The vague space has come to have a sort of negative definition, since it is articulated in part, at least in so much as it is an image, a picture space devoid of human presence. That vague landscape space, articulating itself systematically in terms of the absence, is the modern Euro-Canadian wilderness that emerges at the beginning of the twentieth century and continues to this day to shape both our imaginative and our most mundane attitudes about human dwelling and the environment [...]

\* \* \* \* \* \* \*

Reprinted from Jonathan Bordo, "Jack Pine – Wilderness Sublime or the Erasure of the Aboriginal Presence from the Landscape," *Journal of Canadian Studies/ Revue d'études canadiennes* 27, no. 4 (hiver/winter 1992–93): 98–108, 125–6.

# Zacharias Kunuk

VIDEO AND LOCATION STILLS, IGLOOLIK ISUMA
PRODUCTIONS, 1990S

# Performing Memory

## The Art of Storytelling in the Work of Rebecca Belmore

DOT TUER

REBECCA BELMORE IS a sculptor and performer, a creator of installations and actions. She is an Anishinabe artist, an interpreter of history. Above all she is a storyteller. In the early 1990s there was a moment when, as a storyteller, Belmore felt she was being asked to tell all: to spill forth words that tore open the wounds of colonial oppression and racism. In being asked to tell all she wondered if she was telling too much, and decided to gather stories around her through gestures and objects rather than through words. In her performances her body became a cipher for the way in which the scars of history are embodied; in her installations her objects became offerings to a landscape that harbours the residue of ancestral memory. Through her gestures and objects Belmore has produced over the last ten years a powerful testimony to art as a process of concretizing acts of remembering and resistance, dreaming and mourning. After the exhibition closes or the performance ends, the material traces of her artistic process live on through their continual retelling. What follows here is my retelling of an exhibition held at the Blackwood Gallery in Mississauga in February of 2001, and of the insights Belmore has shared with me about her artmaking.

On a bitter cold winter day, with brilliant sunshine a fool's gold in a harsh north wind, I drive out to the Blackwood Gallery to meet Rebecca Belmore. Her exhibition, a performative work in progress, is almost complete. Belmore has spent a month as an artist in residence, creating a series of individual works that will form the component whole at the closing of the show rather than at its beginning. When I arrive on the grounds of Erindale College, University of Toronto, where the gallery is located, Belmore has just returned from lighting a fire and charring a log, ducking behind trees when the security car drives around. The log, which she will subsequently pound with nails and suspend above a bed of salt, is resonant with stories that reach back from the visceral moment of the work's creation to the ephemeral recesses of the artist's memory. Embedded in this work in progress are many allusions: to drums beating in the pounding of nails; to salt as an instrument of colonial trade and a simile for snow; to trees as natural monuments in a culture of spiritual clear-cutting; to shorn limbs as metaphors for our bodily existence. Like all the pieces in the exhibition the log is alive with stories woven into its making, stories that fill the gallery with murmurs of poetry and affirmation, past injustices and present struggles for self-determination.

During our meeting we sit at a country kitchen table in one corner of the exhibition space, where tea can be sipped and recorded tapes of several of Belmore's performances watched. On the wall behind us Belmore has placed a single rose and a picture of her mother standing in front of a log cabin; on a small shelf on an adjacent wall, a teacup service sits on a tray bearing the Queen's portrait. Beside us, subtly embedded in drywall, a pair of glass eyes watches us. The picture of the artist's mother and the tea service form a collective memorial to the meeting of indigenous and imperial histories. The glass eyes are uncanny reminders that objects can see you as well as you see them, that landscape is not inert but acts upon one. Belmore tells me that her mother, whose name was Rose, used to stay alone in the trapper's cabin shown in the picture. Isolated deep in the Ontario woods, Rose kept company with a transistor radio. One day, as night descended, the batteries in the radio began to die, and the crackling noises of other people's words slowly faded away into an eerie silence. Belmore tells me that when she was a child her mother took her by canoe to the island where she was born. Years later, after her mother died, she decided to canoe back to the island, but although she recognized the shoreline and the landmarks she couldn't find it. Silence, Belmore seems to be telling me, can be more powerful than words; the land harbours memories that we cannot always locate.

In 1991, Belmore travelled to Cuba to perform during the Havana Biennale. She chose as her site a historic colonial building, Castillo de la Fuerza (Castle of Strength), in which a staircase wound up the sides of an internal courtyard. Using a long red rope to tie her ankles and wrists together and gag her mouth, she struggled up the staircase, scooping up and sweeping away sand that lay across each worn step. The viewers gathered in the courtyard and at the top of the stairs could hear her exertion and panting, see the strain of her movements. Occasionally, she let a scream escape from her mouth. In this primal action, stripped of words and props, she conjured the ghosts of slavery, the silenced looks of oppression, the sweat of Cuba's sugar fields. In 2000, Belmore travelled to Montana to perform *Bury My Heart*, a work whose title honours the dead of Wounded Knee. A violinist played at the perimeter of a plot of land transformed into a field of mud by a water sprinkler, while Belmore dug in the wet earth with her bare hands to uncover a hole filled with blood. In the hole she placed a pioneer chair that she was staining, as well as a bouquet of carnations, which she then pulled out, bloodied and bedraggled. As her feet sunk into the oozing earth, her hands awash in blood and her white dress splattered with mud, her body and the remembering of history became intertwined. Through sparse and silent gestures Belmore had excavated the spirits of the dead.

In Canada, the dominant culture of English colonialism has denuded the landscape of its sacred elements, repressed the spirits of the dead. The Group of Seven's paintings, as symbols of a nationalist heritage, empty the northern woods of human traces. Nature and culture, land and body, indigenous and imperial histories are not conjoined but severed, a severing that finds its discursive echoes in the narratives of thinkers who have shaped our social imagination. Northrop Frye, an esteemed literary critic who searched for an answer to the question "where is here," constructed an embattled vision of Canadian civilization as a bulwark against a hostile wilderness. Frye's writing on the Canadian landscape was doubly negative: negative for the overwhelming emptiness of an untamed nature and for the way in which technology has obliterated the landscape. For Frye, "Canada is a country in which nature makes a direct impression on the artist's mind, an impression of its primeval lawlessness and moral nihilism, its indifference to the supreme value placed on life within human society. Its faceless, mindless unconsciousness fosters life without benevolence and destroys it without malice."[1]

In Frye's fixation on nature as a cultural void, the Canadian landscape (whether the craggy rocks and lonely pines portrayed by the Group of Seven or the inhospitable regions of the imagination mapped by Margaret Atwood in her book on Canadian literature, *Survival*) serves as the backdrop for Canada's historical narrative of an orderly progression from settler colony to modern nation. Memories of conquest and resistance are vanquished from a representational field, their absence papered over by mythologies of pristine wilderness or technological progress. Yet, although they are excised and disavowed, these memories still linger, still trouble, still disturb, whether in the collective uprising of the Mohawk Nation to protect their burial grounds at Oka, or in a quiet moment walking in the northern bush when suddenly the trees begin to whisper and stare. The condition of historical amnesia in which landscape has been depeopled is a traumatic one. It is this condition, this trauma, that Belmore addresses in her performances and installations.

As we sit talking in the gallery this winter afternoon, Belmore tells me that she has transformed the gallery into a landscape, one in which the objects speak to memories of historical conflict. Across the room from where we sit a pile of wood shavings forms beneath a pencil sharpener; near it lies a shredded paper figure curled up into a fetal position on the floor. In the corner hang rags dipped in plaster and beside them a white stiffened

shirt. Between the rags and shirt, stencilled into a patch of white plaster relief, are the names of confrontations between First Nations and government authorities: Oka, Burnt Church, Ipperwash and Saskatoon. On the far wall tiny souvenir Canadian flags are arranged to resemble the profile of the American Indian from the United States nickel. Fluttering in a fan-propelled wind, the diminutive flags shed their nationalist identity. They look more like dancing feathers, their shadows like clouds passing overhead, their profile like a mountain. Together, these pieces form the backbone of Belmore's narrative, retelling stories that we may have heard before in another guise through the mass media or through history books. Each piece also references a material element used by Belmore in a previous performance, linking questions of who tells stories to a conjoining of land and body, indigenous memory and imperial conquest.

In her use of pencil and paper Belmore takes European instruments for recording history and transforms them. Through the stories that are told about her objects the past is preserved as oral culture. The pencil sharpener and shredded paper figure are the material traces of a performance work by Belmore, in which she sat in a storefront window and wrote by hand in pencil from sunrise to sunset. As she wrote she spoke the words, which viewers heard broadcast through loudspeakers on the street. During the performance time was marked by the movement of the sun and the repetitive action of sharpening the pencil as it wore down. The significance of the manuscript Belmore produced through this day-long action was not in its written form, but in the labour embodied in the reams of paper and in the disembodiment of language that viewers witnessed as they watched her silent, glassed-in body mouth the words. By tearing up the manuscript and shaping from its remnants a bodily presence in the gallery, Belmore creates a memorial to the lived experiences that the written documents of history excise or misrepresent.

The shredded paper figure also has an immediate historical resonance to the stiff white shirt that hangs on the wall. Both these objects render visible the legacies of a racist history, alluding to the frozen bodies of First Nations men in Saskatoon, who in the dead of winter in 2000 were taken by police to the outskirts of the city and abandoned to die in the snow, without shoes or coats. The plaster rags, in turn, are echoes of the stiffened white shirt, embodying the repetitive actions of washing, scrubbing and cleaning away negative stereotypes. As part of a landscape in which the spirits of the dead are remembered and mourned, the rags become the guardians of memory: clouds, dreams and ghosts.

In 1991, as the mass-media coverage of the 1990 Oka confrontation began to solidify into a historical narrative that silenced First Nations voices and their stories of the uprising, Belmore created an enormous megaphone that she used in a series of performance actions titled *Ayumee-aawach Oomama-mowan: Speaking to Their Mother*. The megaphone served as a flash point of protest and storytelling in different locations across Canada, from Banff National Park, to the Prime Minister's Sussex Drive residence, to a northern Saskatchewan logging blockade. On each occasion Belmore would approach the megaphone and speak first, addressing her words to the earth. Then, others who were gathered around would take their turn. As they spoke into the megaphone an echo could be heard. With the earth returning words scattered in the wind back to the speaker, stories were now embedded in the landscape. Ten years later, as we sit and talk within another kind of landscape, one filled with the material traces of Belmore's performative actions, she tells me that she does not have beginnings in her work but only endings. Yet, through her artistic process of fusing body and earth, her endings are always the beginnings of other stories, her stories are gifts of memory, her memory becomes a repository of history.

* * * * * * *

Reprinted from Dot Tuer, "Performing Memory: The Art of Storytelling in the Work of Rebecca Belmore," in *Rebecca Belmore: 33 Pieces* (Mississauga: Blackwood Gallery, 2001), 32–6.

# Rebecca Belmore

*AYUMEE-AAWACH OOMAMA-MOWAN:*
*SPEAKING TO THEIR MOTHER,*
*PERFORMANCE, 1991–92*

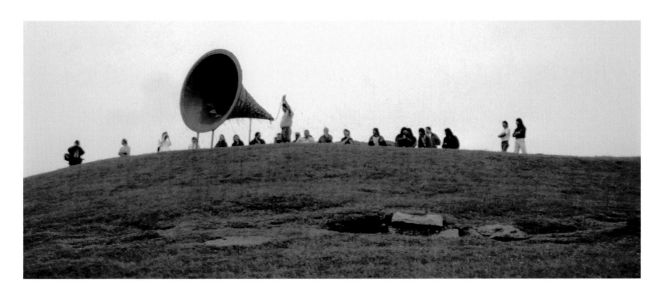

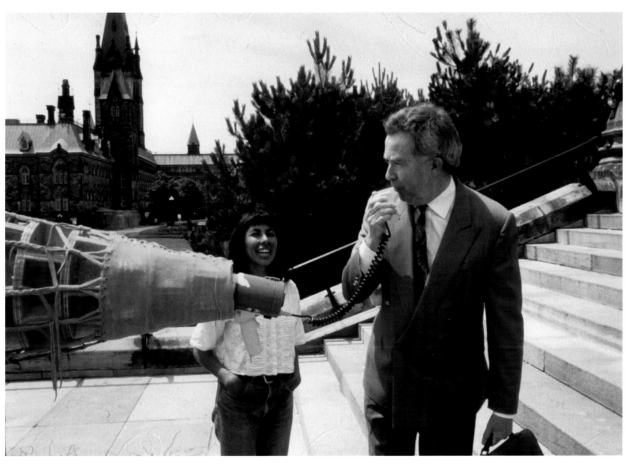

# Yuxweluptun:
# A Philosophy of History LORETTA TODD

**IT IS NOT EASY FOR ME** to write about Lawrence and his work. If I had known him as a child I could tell you about Larry, the little boy who followed his father to political meetings. I can't even offer a history of his art.

Instead I've known Lawrence since he went to art school, when I told friends that they should make a point of going to see his canvases. But we were only acquaintances, so I can offer no history of his work.

Then there is the increasing difficulty I find writing about the art that Aboriginal artists make. I worry about codifying a Native aesthetic and Native art. I worry about what you say, or don't say, being used against the freedom of the artist's imagination, or for betraying protocols or denigrating the sacred. It's not that I feel my words are so influential, it's just that words have power.

As Duane Niatum, a Klallum poet, said when asked to write about writing: My tribal elders encouraged me as a youth to scrupulously avoid making too many public claims that I knew more about a subject than anyone else in the community ... they would especially caution against one defining artistic goals and standards.

I too have had similar cautions and I've been taught not to assume I know what someone else has to say. Chekhov said the artist must lose himself in obscurity, which I believe can also apply to those who write about art.

There is also the risk of promoting the self as a display-case, both for the artist and the critic. Aboriginal artists are especially vulnerable to the display-case syndrome. It is there that Native has been literally and metaphorically placed, silent and easier to control, or so it was thought. For the artist it can also seem to be a safe place, looked at but not touched.

Still, I must say something because from the first time I saw *I had a Dream that Some Day All Indigenous People will have Freedom and Self-Government*, I thought the artist had a strong way of thinking.

I thought that this strong way of thinking was about history and about politics, about being an Aboriginal man, about Yuxweluptun's relationship to the earth.

It affirmed that as an Aboriginal person his way of thinking was strong. Not simply confrontational, or political, or adamant – although that isn't uncommon – but strong: strong enough to resist, but resilient enough to adapt. A strong way of thinking that is the result of centuries of intellectual and poetic enquiry into the way in which we should conduct ourselves.

In that first painting I was startled. I marvelled at the scale, the humour, the use of colour in relationship to traditional use of colour. These were all proud but not arrogant innovations. This was boldness without vanity, expansion without destruction; this was risk with responsibility.

Perhaps in Lawrence's own life at that time this strong way of thinking was not always tempered with the balance of humility. A young man with a vision and the energy and training to execute something unexplored sometimes speaks loudly.

Still, even as he took chances with images millennia old, he sought to respect the integrity of the design form and to honour the meaning behind the aesthetics while making images none had seen before. Those early canvases drew me. They declared there was a path I could take which didn't depart from the continuum of history, but which enabled one to awake from the inhibition of colonialism with little fear. This was a path that was utterly new, yet as old as the hills.

We learn in many ways and from many teachers. From his first canvases Lawrence Paul Yuxweluptun was a teacher. And now, there is growing maturity and, fortunately, the boldness has not faded. The risk with responsibility is understood and, like us all,

Yuxweluptun continues to learn, and I am still drawn to his work.

*The teachings were not given to me to become an artist. They were given to me so that I could pass them on to the next generation.*

That is what Rena Point Bolton said when she spoke in a film I directed (*Hands of History*). Mrs Point Bolton is a basket-weaver and blanket-maker and an important leader in her community. I've heard it said in other ways by others: *I was not taught this so I could become a medicine woman. I was not taught this so I could become a chief.*

And the teachings were not taught to Yuxweluptun so he could become an artist, or a shaman, or an activist. No, the teachings were taught so that Yuxweluptun could be a human being and protector of the land and the life it sustains. The teachings make up the philosophy of Aboriginal people, a philosophy that requires that we live in balance and harmony with the land. If we take we put back and we always give thanks to the Creator.

From these teachings, from our thanksgiving, have come our artists, our chiefs, our medicine people. As the old people have said: *The land is the culture.*

Yuxweluptun's work contains the teaching that the land is the culture. Even as his work encompasses the art, history and tradition of the West, because after all we are all *human beings* and we interact with other human beings. Yuxweluptun is part of a continuum of artists, of visionaries, of healers that work to protect the land. He paints the masks and the crests on the land on the mountains, in the sky and on the trees. He demarcates time and space with art, recognizing that the land is the culture.

The idea of landscape in art is often discussed when referring to Yuxweluptun's work. In Canadian art the landscape reappears over and over again, from literature to painting, from installation to National Film Board documentary or Canadian Broadcasting Corporation drama.

I don't feel it is unfair to Yuxweluptun's work to examine its relationship to Canadian landscape, as opposed to the more general landscape of Western culture. I know there is a rush to place Yuxweluptun's work in the international sphere, to find its place within Western art history, and justifiably so. There are few Aboriginal artists whose work is examined in relationship to other Western artists. It is an arena I'd rather leave to the experts, but it is an important development in Aboriginal art discourse.

To return to the Canadian landscape, there is fear that accompanies the aura and the narrative of the land, which is well documented. A terror that inhabits the imagination of Euro-Canadians and helps create what Northrop Frye refers to as the garrison mentality: Canadians, it is said, carry terror in their souls.

The land and the subject in the land is framed, reframed or framed by being frameless, whether shown from the outside or inside. Yet the land is always outside the human experience: In the Canadian story and image, if the protagonist is rash enough to venture into the countryside alone ... he has a harrowing experience ... he heads straight back to town ... there is nothing else – no new horizon, no beyond.

The Canadian experience of this landscape requires the fundamental split between inside/outside, safety/fear. It is the age old Western cultural dichotomy: mind and body. In this dichotomy there is an interior and an exterior self. The interior self is the site of the authentic, the exterior the site of that which is false, that which is constructed.

Yuxweluptun's work is cognizant of these Canadian landscapes. Aboriginal people are affected everyday by the ideas that permeate the Canadian – the Western – idea of the land, the body and the soul. Everyday. Everyday the Indian Act perpetuates apartheid. Everyday there are fewer fish, fewer moose, fewer

berries. Everyday there are fewer of us who can feed ourselves as we always fed ourselves. Everyday, even as more children are born, there is cultural genocide.

Yuxweluptun lets the Western ideas of the land exist in the landscapes of his canvases, just as they exist in our lives. He adapts Western art styles, infuses his work with synthetic colours, uses the Renaissance perspective. This is not to say this is why he uses Western art technique and history. This is to say that when I see his art I see many worlds inhabiting the same space, with tragic consequences. (This doesn't mean that I am advocating separate states and existences. No, this means that there are ideas about the land, about the world, about other cultures that cause environmental and social damage.)

In these places he creates, we can see the horizon of the Canadian who has ventured out into the countryside, alone, afraid. The horizon is a long way off, unseeable, impossible to reach. The clouds are made with geometrical dimensions and surface, like something from the Group of Seven, or Jack Shadbolt.

I marvel at the mechanical quality of the ground surface of Yuxweluptun's landscapes. I imagine the surface to be like a conveyor belt, or a giant stage set that can be rotated. This is the landscape of Dali-land. Here is an arbitrary space, manufactured, theatrical. It is the space created by the drama of ecological disaster. A place where the white world fixes the hole in the sky like it is so much fabric, climbing on top of itself, never noticing the space around, who is watching and the futility of the restoration.

But Yuxweluptun taunts this Canadian fear and the landscape it conjures. It is there, we all live with it, whoever we are. But, in the places he creates there is something more powerful than the Canadian fear of the land and of Aboriginal people. It is the consequence of that fear that is more fearful: the hole in the sky, the tears on the moon, the poisons in the water.

In Yuxweluptun's landscapes there is a lot of space, just as it may appear to the citizens of this country. In Canada, there are endless hills and mountains, blue threads of rivers, streams that weave everywhere across the map and lakes wide enough to take days to cross. There is a trust that the land, water and air will go on forever.

In the Canadian imagination, because the land is unknowable it is limitless and vice versa. The citizens can turn their attention to the more important pursuit of the interior self – even if that consists primarily of escapist entertainment – and leave the management of the land to bureaucrats, party politics, corporate interests and those who do not live on these lands. Or they can leave the clean-up to a few hapless scientists, because technology is the innovation of the superior interior self, and sooner or later it will prevail.

In Aboriginal culture there is also a trust that the land and the life it sustains will go on forever, but for different reasons. These reasons have to do first and foremost with the Creator. Since we did not create ourselves, but were created, just like everything else in the world, we give thanks for our creation and recognize the relationship we have to the rest of creation.

I have heard some critics and viewers remark on the shamanistic quality of Yuxweluptun's work. But it has become too easy to link Native art with shamanism, to see Native artists as shamans. Plus, I'm not sure what most critics mean when they refer to shamanism. Do they mean a healer? Do they mean a dreamer? Do they mean a visionary? Do they mean a madman? What do they mean? If the shaman is at work in Yuxweluptun's work he is there to restore the relationships of people to one another and to the land. In this, his paintings have a transformative power.

His work has also been cited as drawing from the Western

tradition of Surrealism – dreaming with your eyes open – but as his work embodies First Nations consciousness, it ultimately shares more with transcendentalism than with Surrealism. Besides, Surrealists drew heavily from their interpretation of Native consciousness.

But the transcendental in art and in cinema is influenced by its cultural framework. In the West and the East, there is the desire to be liberated from the terrestrial. In Aboriginal culture the transcendental is to remind us of the sacred in the terrestrial.

In Aboriginal philosophy there is no interior and exterior dichotomy, not because Aboriginal culture never progressed into the Cartesian theatre of a mind/body or an interior/exterior duality, but because instead there is a belief that everything is related.

The old teachings remind us that the culture revolves around acknowledging the relationships between the mind and body, between the land and the culture. When Yuxweluptun puts the same design on the sun, the water, the rocks, the figures, he's speaking from the Native understanding that the same spirit lives in all the creatures and objects of nature. His art gives thanks for the creation. And since the Native view is that giving thanks also means giving respect and protection – to all of creation – then Yuxweluptun's art speaks to the essential idea that every person is a steward of creation, there to enjoy its bounty, but also responsible to protect it.

In this glimpse of the transcendental in his art, he shares more with the *satori* of Eastern than with the formalism of Western transcendentalism.

* * * * * *
Reprinted from Loretta Todd, "Yuxweluptun: A Philosophy of History," in *Lawrence Paul Yuxweluptun: Born to Live and Die on Your Colonialist Reservations*, ed. Charlotte Townsend-Gault, Scott Watson, and Lawrence Paul Yuxweluptun (Vancouver: Morris and Helen Belkin Art Gallery, 1995), 45–8.

# Lawrence Paul Yuxweluptun

SCORCHED EARTH, CLEAR-CUT LOGGING
ON NATIVE SOVEREIGN LANDS, SHAMAN
COMING TO FIX, 1991

RED MAN WATCHING WHITE MAN TRYING
TO FIX HOLE IN SKY, 1990

# Mike MacDonald

*BUTTERFLY GARDEN, 1996–2006*

Checkerspot on Senecio

Milbert's Tortoiseshell on Thistle

Fritillary on Thistle

Tiger Swallowtail on Blackberry

Black Swallowtail on Pentas

Polygonis on Joe Pye Weed

## Chapter 1 | Wilderness Myths

### Introduction

**1** Arthur Lismer, in "Art in Canada," *Twentieth Century* 2, no. 1 (November 1933): 30, spoke for his associates when he stated, "Wilderness ... is a source of power."

**2** Margaret Atwood, "Death by Landscape," in *Wilderness Tips* (Toronto: McClelland and Stewart, 1991), 108.

**3** The relationship of literature and visual art to northernness in Canada has been investigated by Sherrill E. Grace in *Canada and the Idea of North* (Montreal: McGill-Queen's University Press, 2001).

**4** These observations were underscored at a symposium, "The Transnational Circulation of Landscape Narratives and Nation Building" (History Department, University of Texas, Austin, 15 April 2005), organized by Jorge Cañizares-Esguerra. Canada was one of the countries under discussion.

**5** Robert Bringhurst, "The Persistence of Poetry and the Destruction of the World," in *The Tree of Meaning: Thirteen Talks* (Kentville, Nova Scotia: Gaspereau Press, 2006), 40.

**6** Fredric Jameson, "Periodizing the 60s," in *The 60s without Apology*, ed. Sonja Sayres et al. (Minneapolis: University of Minnesota Press, 1984); Homi K. Bhabha, *Nation and Narration* (London: Routledge, 1990); Arjun Appadurai, *Modernity at Large: Cultural Dimensions of Globalization* (Minneapolis: University of Minnesota Press, 1996).

**7** See Richard Cavell, *McLuhan in Space: A Cultural Geography* (Toronto: University of Toronto Press, 2002).

**8** Charles C. Hill, *The Group of Seven: Art for a Nation* (Ottawa: National Gallery of Canada, 1995), and David Silcox, *The Group of Seven and Tom Thomson* (Toronto: Firefly Books, 2003). The first book written on the Group and nationhood was F.B. Housser's classic parable, *A Canadian Art Movement: The Story of the Group of Seven*, in 1926.

**9** See Jody Berland, "Space at the Margins: Colonial Spatiality and Critical Theory after Innis," *Topia*, no. 1 (spring 1997): 55–82.

**10** Pierre Elliott Trudeau, "Announcement of Implementation of Policy of Multiculturalism within Bilingual Framework," *House of Commons Debates*, 7 October 1971, 8545–8.

### PETER WHITE

**1** See Margaret Wente, "Masses, Classes and the AGO," *Globe and Mail*, 9 December 2003.

**2** In an article about *The OH! Canada Project* controversy in the *Globe and Mail*, Kim Heinrich Gray quoted the reactions of two *Globe* critics, John Bentley Mays and Robert Fulford. Mays, she wrote, considered *OH! Canada* "less about art and more about the 'boogie-woogie, lift-and-separate business of pop culture.'" Fulford's view was that the Group of Seven paintings, obscured by "clutter," were diminished by their inclusion in a project he described as not unlike a "midget Disneyland without the rides." See Gray, "They Came, They Saw, They Liked It," *Globe and Mail*, 6 May 1996.

**3** The exhibition included 179 works, almost all by the Group of Seven. The publication is 374 pages long.

**4** For an academic version, see Nicola A. Lisus and Richard V. Ericson, "Authorizing Art: The Effect of Multimedia Formats on the Museum Experience," *Canadian Review of Sociology and Anthropology* 35, no. 2 (1999). For a popular version, see Ellie Tesher, "Who Says an Art Exhibit Can't be Fun?" *Toronto Star*, 11 March 1996, A2.

**5** The Tom Thomson catalogue is 386 pages long, *The Group of Seven in Western Canada* is 208. Both are trumped by *The Group of Seven and Tom Thomson*, which runs to 441 pages. For full citations, see the bibliography published in this book.

**6** Partha Chatterjee, "The Sacred Circulation of National Images," in *Traces of India: Photography, Architecture, and the Politics of Representation, 1800–1900*, ed. Maria Antonella Pelizzari (Montreal: Canadian Centre for Architecture, 2003), 276.

**7** This is Partha Chatterjee's felicitous articulation of Anderson's central idea. See Chatterjee, *The Nation and Its Fragments: Colonial and Postcolonial Histories* (Princeton: Princeton University Press, 1993), 4.

**8** J. Russell Harper, *Painting in Canada: A History* (Toronto: University of Toronto Press, 1966).

**9** *The Group of Seven* (1970), at the Art Gallery of Ontario, the National Gallery of Canada, and the Montreal Museum of Fine Arts.

**10** Ann Davis, "An Apprehended Vision: The Philosophy of the Group of Seven" (PhD dissertation, York University, 1973).

**11** Dennis Reid, *A Concise History of Canadian Painting* (Toronto: Oxford, 1973).

**12** Barry Lord, *The History of Painting in Canada: Toward a People's Art* (Toronto: NC Press, 1974).

**13** Northrop Frye, *The Bush Garden: Essays on the Canadian Imagination* (Toronto: House of Anansi Press, 1971).

**14** Andreas Huyssen, *Twilight Memories: Marking Time in a Culture of Amnesia* (New York: Routledge, 1995), 5.

**15** This is the title of a recent book by Huyssen. See Andreas Huyssen, *Present Pasts: Cultural Memory in the Present* (Stanford: Stanford University Press, 2003).

**16** The gallery's founder and defender, Robert McMichael was buried adjacent to the Group after he passed away in 2003.

**17** See, in particular, Ann Bermingham, *Landscape and Ideology: The English Rustic Tradition, 1740–1860* (Berkeley and Los Angeles: University of California Press, 1986).

**18** W.J.T. Mitchell, "Space, Place, and Landscape," in *Territories*, ed. Anselm Franke, (Berlin: KW – Institute for Contemporary Art, 2003), 173.

**19** Marshall McLuhan, *Understanding Media: The Extensions of Man* (1964; Boston: MIT Press, 1994), 64–6.

**20** Huyssen, *Present Pasts*, 23-4.

### JOHN O'BRIAN

**1** I can find no better term than "wildercentric" to describe the organizing beliefs and values of the Group of Seven and their apologists in the first decades of the twentieth century.

**2** Even in the New World, the major debates about the expressive potential of landscape occurred mostly in the nineteenth rather than in the twentieth century. See Graciela Silvestri, "River Plate Landscapes: The Construction of 'Empty Space'" (paper delivered at the Transnational Circulation of Landscape Narratives and Nation Building symposium, History Department, University of Texas, Austin, 15 April 2005); Alexandra Kennedy-Troya, "La percepción de lo propio: paisajistas y científicos ecuatorianos del siglo XIX," in *El Regreso de Humbolt*, ed. Frank Holl (Quito: Museo de la Ciudad, 2001); D. Graham Burnett, *Masters of All They Surveyed: Exploration, Geography, and a British Eldorado* (Chicago: University of Chicago Press, 2000); Raymond Craib, "Time Passages: Nature, Nation, and History in Mexico" (University of Texas 2005 symposium); and Angela Miller, "The Imperial Republic: Narratives of National Expansion in American Art, 1820–1860" (PhD dissertation, Yale University, 1985).

**3** Lawren Harris, "Revelation of Art in Canada," *Canadian Theosophist* 7, no. 5 (15 July 1926); 85–6.

**4** Frank H. Underhill, "The Season's New Books," *Canadian Forum*, December 1936, 27.

**5** Marshall McLuhan, *Understanding Media: The Extensions of Man* (Toronto: McGraw-Hill, 1964).

**6** See Fredric Jameson, "Periodizing the 60s," in *The 60s without Apology*, ed. Sonja Sayres et al. (Minneapolis: University of Minnesota Press, 1984).

**7** Benedict Anderson, *Imagined Communities: Reflections on the Origin and Spread of Nationalism* (London: Verso, 1983). Homi K. Bhabha, *Nation and Narration* (London: Routledge, 1990), argues that Anderson's concept of the nation as an "imagined community" fails to take

adequate account of the performance of personal ritual.

**8** Charles Comfort, "Painting," in *Royal Commission on National Development in the Arts, Letters, and Sciences* (Ottawa: Government Publications, 1949-51), 408; quoted in Dot Tuer, "The Art of Nation Building: Constructing a 'Cultural Identity' for Post-War Canada," *Parallélogramme* 17, no. 4 (1992): 26.

**9** Wyndham Lewis, "Canadian Nature and Its Painters," *The Listener*, 29 August 1946; reprinted in *Wyndham Lewis on Art: Collected Writings 1913-1956*, ed. Walter Michel and C.J. Fox (London: Thames and Hudson, 1971), 429.

**10** This estimate was provided to me in 1996 by Walter H. Klinkhoff, the Montreal dealer who had represented A.Y. Jackson. In the same year Naomi Jackson Groves reported to me that she had made three thousand entries in her ongoing A.Y. Jackson inventory.

**11** Benedict Anderson, *Imagined Communities*, 6. Writing in the 1930s, John Dewey made a similar point in *Art as Experience* (New York: Capricorn Books, 1958), 81: "Works of art that are not remote from common life, that are widely enjoyed in a community, are signs of a unified collective life ... They are also a marvelous aid in the creation of such a life."

**12** Reesa Greenberg, "Defining Canada," *Collapse* 3 (1997): 107-13.

**13** One of the leaders of the Group of Seven, Lawren Harris, studied art in Berlin from 1904 to 1908. There is no evidence that he read Weber while in Germany, but he did encounter the landscape school in Bavaria, which attempted to produce "home-feeling" in its work.

**14** The exhibition, titled *Society of Canadian Painter-Etchers; J.E.H. MacDonald, A.R.C.A., Lawren Harris and Frank H. Johnston; William Cruikshank*, was held at the Art Museum of Toronto, 26 April to 19 May 1919.

**15** "Marilyn Monroe Quotations," http://www.memorablequotations.com/monroe.htm, 23 May 2004.

**16** The blindness to ongoing debates in the field of art and art history continues. In November 2005, the *Literary Review of Canada* listed the catalogue for the exhibition, written by Charles C. Hill, among the one hundred most important Canadian books ever published. The inclusion of the catalogue in the list should be accompanied by a qualifying asterisk.

**17** Lynda Jessup inserts the interrogative into her article "Art for a Nation?" *Fuse Magazine* 19, no. 4 (1996): 11-14.

**18** Women artists, notably Emily Carr, were invited to exhibit with the Group of Seven but were not invited to become members. By the time the Group disbanded in 1932, three new members had been added and one had resigned.

**19** A.Y. Jackson, *A Painter's Country: The Autobiography of A.Y. Jackson* (Toronto: Clarke, Irwin & Co., 1958), 56.

**20** Albert Laberge, "Superbe travail des artistes canadiens," *La Presse* (Montreal), 22 November 1918; translated in Charles C. Hill, *The Group of Seven: Art for a Nation* (Ottawa: National Gallery of Canada, 1995), 309.

**21** The narrative continues to have currency. A full-page advertisement on the back of the review section of the *Globe and Mail* on 26 February 2005, paid for by the Art Gallery of Ontario, illustrates *The West Wind* (1917) by Tom Thomson. The illustration is accompanied by a blurb from the mayor of Toronto, David Miller: "I know it's perhaps not the hippest choice but this painting is special to me. I have spent hundreds of hours in Algonquin Park. It is where, on a quiet lake, in a canoe, I feel most in touch with the timeless quality of Canadian nature. Tom Thomson's work has always evoked for me the many moods of the park. Looking at *The West Wind*, I can smell the campfire, taste the clean water, and feel the incredible peace than I feel anytime I'm in the park."

**22** Samuel Beckett, *Waiting for Godot* (New York: Grove Press, 1954), 40.

**23** In a landmark exhibition, Roald Nasgaard included work by all the artists in this list, with the exception of Margaret Preston. See *The Mystic North: Symbolist Landscape Painting in Northern Europe and North America 1890-1940* (Toronto: Art Gallery of Ontario, 1984).

**24** "Studio Talk," *The Studio* 57, no. 238 (1913): 335-336; and A. Branting, "Modern Tapestry Work in Sweden," *The Studio* 58, no. 239 (1913): 88; cited in Robert Stacey, "A Contact in Context: The Influence of Scandinavian Landscape Painting on Canadian Artists before and after 1913," *Northward Journal*, no. 18/19 (1980): 56n 30.

**25** Lawren Harris, "The Group of Seven in Canadian History," in *The Canadian Historical Association, Report of the Annual Meeting Held at Victoria and Vancouver, June 16-19, 1948; with History Papers*, ed. A. Preston (Toronto: University of Toronto Press, 1948), 31.

**26** J.E.H. MacDonald, "Scandinavian Art," *Northward Journal*, no. 18/19 (1980): 9-35. The lecture was delivered at the Art Gallery of Toronto.

**27** Harris, "Revelation of Art in Canada," 85-6.

**28** Leo Marx, *The Machine in the Garden: Technology and the Pastoral Ideal in America* (New York: Oxford University Press, 1964).

**29** Ansel Adams, *Examples: The Making of 40 Photographs* (Boston: Little, Brown, 1983).

**30** For an analysis of McLuhan's ideas and their significance for artists, see Richard Cavell, *McLuhan in Space: A Cultural Geography* (Toronto: University of Toronto Press, 2002).

**31** Michael Snow, "La Région Centrale" (1969), in *The Collected Writings of Michael Snow* (Waterloo: Wilfrid Laurier University Press, 1994), 53.

**32** Pierre Elliott Trudeau, "Announcement of Implementation of Policy of Multiculturalism Within Bilingual Framework," *House of Commons Debates*, 7 October 1971, 8545-8.

**33** J. Russell Harper, *Painting in Canada: A History* (Toronto: University of Toronto Press, 1966); Peter Mellen, *The Group of Seven* (Toronto: McClelland and Stewart, 1970); and Dennis Reid, *The Group of Seven/Le Groupe des Sept* (Ottawa: National Gallery of Canada, 1970).

**34** Dennis Reid, *A Concise History of Canadian Painting* (Toronto: Oxford University Press, 1973), and Barry Lord, *The History of Painting in Canada: Toward a People's Art* (Toronto: NC Press, 1974). The reviewer who referred to Lord's book as "evangelical" was Charlotte Townsend in "Review of *The History of Painting in Canada: Toward a People's Art*," *Studio International*, March-April 1975, 162-3.

**35** Harold Town and David P. Silcox, *Tom Thomson: The Silence and the Storm* (Toronto: McClelland and Stewart, 1977); Jeremy Adamson, *Lawren S. Harris: Urban Scenes and Wilderness Landscapes 1906-1939* (Toronto: Art Gallery of Ontario, 1978); and Doris Shadbolt, *The Art of Emily Carr* (Vancouver: Douglas & McIntyre, 1979).

**36** Michael Pollan, *The Botany of Desire: A Plant's-Eye View of the World* (New York: Random House, 2001), xxii.

**37** W.J.T. Mitchell, ed., *Landscape and Power* (Chicago: University of Chicago Press, 1994).

**38** Simon Schama, *Landscape and Memory* (Toronto: Vintage Canada, 1995), 9.

**39** W.H. New, *Land Sliding: Imagining Space, Presence, and Power in Canadian Writing* (Toronto: University of Toronto Press, 1997). In *Canada and the Idea of North* (Montreal and Kingston: McGill-Queen's University Press, 2002), Sherrill Grace also takes landscape as a prime reference point.

**40** Malcolm Andrews, *Landscape and Western Art* (Oxford: Oxford University Press, 1999).

**41** F.B. Housser, *A Canadian Art Movement: The Story of the Group of Seven* (Toronto: Macmillan, 1926), 119.

**42** John Ruskin, "On the Novelty of Landscape," discussed by Mitchell in "Imperial Landscape," in *Landscape and Power*, 18-19.

**43** John Berger, *Ways of Seeing* (New York: Viking Press, 1972), 106-8.

**44** Northrop Frye, *Globe and Mail*, 18 October 1977.

**45** Scott Watson, "Race, Wilderness, Territory and the Origins of Modern Canadian Landscape Painting," *Semiotext(e)* 6, no. 17 (1994): 96.

**46** This contradiction is discussed by Allan John Fletcher, "Industrial Algoma and the Myth of Wilderness: Algoma Landscape and the Emergence of the Group of Seven, 1918-1920" (MA thesis, Department of Fine Arts, University of British Columbia, 1989).

**47** Cole Harris, "How Did Colonialism Dispossess? Comments from an Edge of Empire," in *Annals of the Association of American Geographers* (Malden, Mass.: Blackwell, 2003), 165-82.

**48** Robert Houle, "The Spiritual Legacy of the Ancient Ones," in *Land, Spirit, Power: First Nations at the National Gallery of Canada*, ed. Diana Nemiroff, Robert Houle, and Charlotte Townsend-Gault (Ottawa: National Gallery of Canada, 1992), 60-1.

**49** Underhill, "The Season's New Books," 27.

**50** Elizabeth Wyn Wood, "Art and the Pre-Cambrian Shield," *Canadian Forum*, February 1937, 13.

**51** Ibid.

**52** Of the same generation as the Group of Seven, David Milne applauded its contribution to national identity, even if he could not endorse its aesthetic program. Anna Hudson, "Art and Social Progress: The Toronto Community of Painters, 1933-1950" (PhD thesis, University of Toronto, 1998), has examined a subsequent generation of painters whose socially conscious work also departed from the Group of Seven's aesthetic program.

**53** See Angus McLaren, *Our Own Master Race: Eugenics in Canada, 1885-1945* (Toronto: Oxford University Press, 1990).

**54** Eric Brown, *Winnipeg Free Press*, 2 July 1921, quoted in Hill, *The Group of Seven*, 29.

**55** Eric Brown, "Landscape Art in Canada," in *Art of the British Empire Overseas* (London: The Studio, 1917), 4.

**56** Brown, in the *Winnipeg Free Press*, is referring specifically to Tom Thomson's work in this passage, though it summarizes what he admired generally in "northland" painting.

**57** Paul H. Walton, "The Group of Seven and Northern Development," *RACAR* 17 (1990), and John Wadland, "Tom Thomson's Places," in Dennis Reid, ed., *Thomson* (Toronto: Art Gallery of Ontario, 2002), both analyze the industrialization of the "near-north" of Ontario.

**58** The connections between early twentieth-century Canadian landscape painting and English landscape traditions are discussed in Leslie Dawn, *National Visions, National Blindness: Canadian Art and Identities in the 1920s* (Vancouver: UBC Press, 2006).

**59** Mitchell, "Imperial Landscape," in *Landscape and Power*, 5.

**60** Barker Fairley, "Canadian Art: Man vs. Landscape," *Canadian Forum*, December 1939, 286.

**61** Bernard Smith, *Place, Taste and Tradition: A Study of Australian Art since*

1788 (Sydney: Ure Smith Pty, 1945). For an analysis of the book's significance, see John O'Brian, "Bernard Smith's Early Marxist Art History," *Thesis Eleven*, no. 82 (August 2005): 29–37.

**62** Lewis, "Canadian Nature and Its Painters," 427.

**63** Anthony Ashley Cooper, Third Earl of Shaftesbury, "The Moralists," in *Characteristics*, 1711, cited in Andrews, *Landscape and Western Art*, 67.

**64** Jack Bush quoted in Dennis Reid, "Jack Bush: The Development of a Canadian Painter," in *Jack Bush*, ed. Karen Wilkin (Toronto: McClelland and Stewart, 1984), 13.

**65** On the theorization of social space, see Henri Lefebvre, *The Production of Space* (1974; Cambridge, Mass.: Blackwell, 1991), and Michel de Certeau, *The Practice of Everyday Life* (Berkeley: University of California Press, 1984).

**66** A.Y. Jackson. "The Birth of the Group of Seven," CBC Radio talk, aired 7 June 1950, printed in *Our Sense of Identity: A Book of Canadian Essays*, ed. Malcolm Ross (Toronto: Ryerson Press, 1954), 229.

**67** In her essay in chapter 4, Rosemary Donegan investigates industrial landscape paintings of Copper Cliff and the Sudbury Basin executed between the 1920s and the 1950s.

**68** Allan Sekula, in *Geography Lesson: Canadian Notes* (Vancouver and Cambridge, Mass.: Vancouver Art Gallery and MIT Press, 1997), found and photographed wilderness paintings by A.Y. Jackson in each of these locations.

**NANCY SHAW**

**1** For a discussion of everyday life, see Henri Lefebvre, *Everyday Life in the Modern World* (New Jersey: Transaction Publishers, 1984), and Guy Debord, "Perspectives for Conscious Alterations in Everyday Life," in *Situationist International Anthology*, ed. Ken Knabb (Berkeley: Bureau of Public Secrets, 1981), 68–75.

**2** Marie Fleming, *Baxter²: Any Choice Works* (Toronto: Art Gallery of Ontario, 1982), 10–11.

**3** See Scott Watson, "Art in the Fifties: Design, Leisure and Painting in the Age of Anxiety," in *Vancouver Art and Artists 1931–83* (Vancouver: Vancouver Art Gallery, 1983), 77, for an analysis of modernist artists, architects, and patrons who were committed to such utopian ideals of suburban living in the 1950s.

**4** Fleming, *Baxter²*, 29.

**5** Unless otherwise noted, all information is from conversations with Ingrid and Iain Baxter in 1992.

**6** Lucy R. Lippard, "Art within the Arctic Circle," *Hudson Review*, February 1970, 666–74.

**7** See Alexander Wilson, *The Culture of Nature: North American Landscape from Disney to the Exxon Valdez* (Toronto: Between the Lines, 1991), 282–9, for a discussion of competing ideological conceptions of Northern landscape.

**8** *The N.E. Thing Co. Ltd. Book* (Vancouver and Basel: NETCO and the Kunsthalle Basel, 1978), unpaginated.

**9** *Trans-VSI Connection NSCAD-NETCO*, 15 September – 5 October 1969 (Halifax: Nova Scotia College of Art and Design, 1970).

**10** Anne Rosenberg, "N.E. Thing Company Section: Interview," *Capilano Review*, no. 8/9 (fall 1975/spring 1976): 178.

**JOHANNE SLOAN**

**1** Michael Snow, "La Région Centrale," in *The Collected Writings of Michael Snow* (Waterloo, Ont.: Wilfrid Laurier University Press, 1994), 53. This text is part of a proposal Snow presented to the Canadian Film Development Corporation in March 1969.

**2** Wieland was present during every stage of the making of *La Région Centrale* in 1970; she was the one who came up with the title for the work, and she took the well-known photographs of Snow in situ with his camera. The following year, Snow helped Wieland as she prepared the *True Patriot Love* exhibition at the National Gallery, and he was even part of a rather comical three-way conversation between Wieland, exhibition curator Pierre Théberge, and Snow that was published as an insert in Wieland's book-work.

**3** Robert Smithson, "A Provisional Theory of Non-Sites" (1968), in *Robert Smithson: The Collected Writings*, ed. Jack Flam (Berkeley: University of California Press, 1996), 364.

**4** F.B. Housser, *A Canadian Art Movement: The Story of the Group of Seven* (Toronto: Macmillan, 1926), 119.

**5** Richard Shiff, *Cézanne and the Ends of Impressionism* (Chicago: University of Chicago Press, 1984), 66.

**6** Michael Snow and Bruce Elder, "Conversation," *Afterimage* (London), no. 11 (winter 1982/83): 34.

**7** I have written about Wieland's engagement with nationalism in "Joyce Wieland at the Border: Nationalism, the New Left and the Question of Political Art in Canada," *Journal of Canadian Art History* 26 (2005).

**8** Marie Fleming, *Joyce Wieland* (Toronto: Art Gallery of Ontario, 1987), 85.

**9** James Laxer, *The Energy Poker: The Politics of the Continental Resources Deal* (Toronto and Chicago: New Press, 1970).

**10** On how the Canadian "North" measures up to the American idea of "West," see Sherrill Grace, "Comparing Mythologies: Ideas of West and North," in *Borderlands: Essays in Canadian-Amer-*

*ican Relations*, ed. R. Lecker (Toronto: ECW Press, 1991).

**11** Lawren Harris, quoted in Roald Nasgaard, *The Mystic North* (Toronto: Art Gallery of Ontario and University of Toronto Press, 1984), 167.

**12** See Joyce Zemans, "Establishing the Canon: Nationhood, Identity and the National Gallery's First Reproduction Programme of Canadian Art," *Journal of Canadian Art History* 16, no. 2 (1995).

**13** Lauren Rabinowitz, "The Far Shore: Feminist Family Melodrama," in *The Films of Joyce Wieland*, ed. Kathryn Elder (Toronto: Cinematheque Ontario Monographs, 1999), 123 (originally published 1987).

**14** The catchphrase "reason over passion" was borrowed from Prime Minister Trudeau and became the title of a film, while Wieland also produced a pair of matching bilingual quilts, *Reason over Passion* and *La raison avant la passion* (both 1968), one of which hung in the prime minister's official residence.

**15** Scott Watson, "Disfigured Nature: The Origins of the Modern Canadian Landscape," in *Eye of Nature*, ed. D. Augaitis and H. Pakasaar (Banff: Walter Phillips Gallery, 1991), 107. The quotation is from Housser.

**16** Wieland's book-work was included as one of a few Canadian examples in an international survey of influential Conceptual Art, for instance. See *Global Conceptualism: Points of Origin, 1950s to 1980s*, ed. Jane Farver and Claude Ginz (New York: Queen's Museum, 1999).

**17** Dave Hickey, "Earthscapes, Landworks and Oz," *Art in America*, Sept./Oct. 1971, 45.

**18** Lewitt, quoted in Benjamin Buchloh, "Conceptual Art 1962–1969: From the Aesthetic of Administration to the Critique of Institutions," *October* 55 (winter 1990): 115.

**19** Thierry de Duve, for example, says that with *La Région Centrale*, "Snow's inquiries into the conditions of experience" are gathered into "the unity of a masterpiece." See Thierry de Duve, "Michael Snow and Deictics of Experience," *Parachute*, no. 78 (spring 1995), 33. Paul Virilio, commenting that Land Art was the last true "art of inscription," suggests that Snow's work is a "masterpiece" in this respect. See Paul Virilio, "Interview with Catherine David," in *Documents for Documenta* (Kassel, 1996), 55.

**20** Smithson characterized the machine this way: "It is interesting to see Snow now moving into the actual landscape with a delirious camera of his own invention." See "Art through the Camera's Eye" (c. 1971), in *Robert Smithson*, 374.

**21** Snow finally chose a site approximately a hundred miles north of Sept-Îles. Wieland's unpublished diaristic fragment, titled "We are looking for the site of Mike's film,"

indicates the degree of her involvement in the project, while also pointing to the issues of pollution and gender relations she was attuned to on the trip. See York University Archives, Joyce Wieland Fonds, call no. 1999-003/005 (02).

**22** The religiosity of Poussin's and Corot's landscapes is perhaps not so irrelevant, though. Indeed, Snow commented, "It's embarrassing to say it, but within the terms of my work I had in the back of my mind great religious works like Bach's St. Matthew Passion, B Minor Mass, St. John Passion, Ascension oratorio." See "Converging on *La Région Centrale*: Michael Snow in Conversation with Charlotte Townsend," in *The Collected Writings of Michael Snow*, 58 (originally published 1971).

**23** Structural film in Snow's hands has been defined as "a 'process' orientated endeavour, eschewing content, narrative and illusionistic techniques." See Michael O'Pray, "Framing Snow," *Afterimage* (London), no. 11 (winter 1982/83): 53.

**24** Georges Riviere wrote, "This landscape which so delighted Renoir, other painters saw it in less cheerful colours. They noted only *terrains vagues* strewn with rubbish, scabby grass trodden by inhabitants in rags." Quoted in T.J. Clark, *The Painter of Modern Life* (New York: Alfred Knopf, 1985), 184.

**25** De Duve, "Michael Snow," 34.

**26** Alain Fleischer, "Michael Snow's Cinemachine," in *Michael Snow Panoramique* (Brussels: Société des Expositions du Palais des Beaux-Arts de Bruxelles), 1999, 53–4.

**27** Michael O'Pray had pointed the discussion in this direction when he remarked that "there remains the hint of another reading ... that is romantic, poetic, and at odds with the structural project." See O'Pray, "Framing Snow," 56.

**28** Snow, "La Région Centrale," 56.

**29** *National Geographic* 138, no. 6 (December 1970).

**30** Marshall McLuhan, "Technology and Environment," *artscanada* 24, no. 2 (February 1967): 5.

**31** Wieland, in "Interview with Joyce

Wieland," 28 March 1971, presented as an insert in the *True Patriot Love* bookwork/catalogue.

**32** While *Man Has Reached Out and Touched the Tranquil Moon* has aged rather badly, becoming yellowed and brittle-looking, the original sheen and newness of the plastic envelopes, reminiscent of the glossy allure of packaged commodities, was evidence of Wieland's continued engagement with the vocabulary of Pop Art.

**33** "Conversation with Robert Smithson," (1972), edited by Bruce Kurtz, in *Robert Smithson*, 268. Smithson's *Spiral Jetty* can also be considered a counter-environment in McLuhan's terms.

**34** Richard Cavell, *McLuhan in Space: A Cultural Geography* (Toronto: University of Toronto Press, 2002), 190.

**35** "Remediation," defined as "the representation of one medium in another," has been identified as an important concept in new media studies. See Jay David Bolter and Richard Grusin, *Remediation* (Cambridge, Mass.: MIT Press, 1999), 45.

**36** Joseph Leo Koerner, *Caspar David Friedrich and the Subject of Landscape* (London: Reaktion Books, 1990), 239–40.

**37** See Bernard Comment, *The Painted Panorama* (New York: Harry Abrams, 1999).

## JODY BERLAND

**1** M.W. Helms, *Ulysses' Sail: An Ethnographic Odyssey of Power, Knowledge, and Geographical Distance* (Princeton University Press, 1988), 224–6. Helms notes, "A form of paradise already held Western connotations prior to the discoveries, but the attribution of wilderness and its qualities to the West was new and clearly part of the effort to create and identify a new cosmological locale" (226). Tracing the same history in a more worldly context, Steven Greenblatt reminds us of the powerful association of wonder and greed with which Columbus met – and wrote of – the New World.

**2** Ibid., 260.

**3** R. Shields, *Places on the Margin: Alternative Geographies of Modernity* (New York: Routledge, 1991), 175.

**4** Harold Innis, *Staples, Markets and Cultural Change*, ed. D. Drache (Montreal: McGill-Queen's University Press, 1995), 4.

**5** Ibid., 5.

**6** C. Acland (in "Traces and Spaces: Harold Innis and Canadian Cultural Studies," in *Harold Innis in the New Century: Reflections and Refractions*, ed. C. Acland and W. Buxton, [Montreal: McGill-Queen's University Press, 1999]) summarizes the argument put forward by Robin Neill in "Imperialism and the Staple Theory of Canadian Economic Development: The Historical Perspective," in *Culture, Communication and Dependency: The Tradition of Harold Innis*, ed. W. Melody et al. (Norwood: Ablex, 1981).

**7** Innis, *Staples, Markets*, 72.

**8** Shields, *Places on the Margin*, 29.

**9** Ibid., 182–3. Shields cites a 1970 essay by the influential historian W.L. Morton: "the ultimate and the comprehensive meaning of Canadian history is to be found where there has been no Canadian history: in the north."

**10** Industry, Science and Technology Canada, *Science and Technology Economic Analysis Review (*Ottawa: Minister of Supply and Services, Government of Canada, 1990), 1.

**11** Ibid., 5. Significantly this is not the case with electronics, aerospace, or computer industries, all areas of expertise Canada has developed without damage to its branch-plant relationship to U.S. industry. J. Todd, *Colonial Technology: Science and the Transfer of Innovation to Australia* (Cambridge: Cambridge University Press, 1995), offers an illuminating description of a comparable gap in research bridging scientific knowledge and technological innovation in nineteenth-century Australia. Agents of local science were active in "the process of assimilation of new technologies into local production systems," she writes. "What they were not generally doing was carrying out research aimed at direct solution of technological problems by means of

domestic research activity ... Whether through lack of interest or lack of confidence, the ready availability of overseas technology seems indeed to have pre-empted, or displaced, local research programs aimed at development of new home-grown technologies to solve an acknowledged industry problem" (224–5). She concludes that Australia's willingness to appropriate and choose technological options from diverse sources contributed to growing technological sovereignty, if not independence; that full achievement of this goal has been blocked by the failure to achieve critical mass in the dynamic interaction between receivers and producers, or "firms, industries, sectors and colonies"; and that dependency theory explains much, but not all, of the structural imbalances of Australian science and technology.

**12** See R.E. Babe, *Telecommunications in Canada* (Toronto: University of Toronto Press, 1990), and J. Berland, "Angels Dancing: Cultural Technologies and the Production of Space," in *Cultural Studies*, ed. L. Grossberg, C. Nelson, and P. Treichler (New York: Routledge, 1995), for further discussion of satellites and the Canadian space industry.

## DENNIS REID

**1** Arthur Lismer, *A Short History of Painting with a Note on Canadian Art* (Toronto: Andrew Bros., 1926).
**2** Arthur Lismer, *Canadian Picture Study* (Toronto: Art Gallery of Toronto, 1930).
**3** F.B. Housser, *A Canadian Art Movement: The Story of the Group of Seven* (Toronto: Macmillan Company of Canada, 1926), 15.
**4** A.Y. Jackson, "The Tom Thomson Film" (December 1943, address by A.Y. Jackson on the occasion of the first showing in Toronto of the Tom Thomson film *West Wind*, Dr James MacCallum being present as the guest of honour; typescript in the library of the Art Gallery of Ontario, Toronto), 3.

## ANN DAVIS

**1** See, for example, J.R. Harper, *Painting in Canada: A History* (Toronto, 1966), 304; Dennis Reid, *The Group of Seven*, exhibition catalogue (Ottawa: National Gallery of Canada, 1970), 170; F.B. Housser, *A Canadian Art Movement* (Toronto, 1926), 79; Vincent Massey, *What's Past Is Prologue: The Memoirs of The Right Honourable Vincent Massey* (Toronto, 1963), 87. Only Maud Brown, *Breaking Barriers* (Toronto, 1964), 73, makes more than a passing suggestion to the institutional dispute.
**2** National Gallery of Canada, Jackson Papers, A.Y. Jackson to Eric Brown, Montreal, 12 March 1913.
**3** Ibid, Brown to Jackson, copy, 4 April 1913.
**4** A.Y. Jackson, "Lawren Harris: A Biographical Sketch," in Art Gallery of Toronto, *Lawren Harris Paintings 1910–1948*, exhibition catalogue (1948), 9; A.Y. Jackson, *A Painter's Country* (Toronto, 1967), 28.
**5** Reid, *The Group of Seven*, 69 n 13.
**6** Ibid, 67–8.
**7** Jackson, "Lawren Harris," 9.
**8** Maud Brown, *Breaking Barriers*, 12–13.

**9** A thorough examination of movements which influenced the Group of Seven is a serious lack in Canadian art historiography. Some initial work has been done by R.H. Hubbard, *The Development of Canadian Art* (Ottawa, 1963), and Reid, *The Group of Seven*.
**10** *Catalogue of Highly Important Old and Modern Pictures and Drawings*, estates of Chester D. Massey, Sir William Mackenzie, Sir Edmund Walker, public sale (Toronto: B.M. and T. Jenkins Co., 1927).
**11** It has also been suggested that Brown and Walker, both Christian Scientists, sympathized with the unorthodox religious views espoused by many Group members.
**12** George Parkin de Twenebroker Glazebrook, *Sir Edmund Walker* (London: Oxford University Press, 1933), 91.
**13** Art Gallery of Toronto, *The Group of Seven*, exhibition catalogue (1920), Foreword.
**14** "Report of the Board of Trustees of the National Gallery of Canada, 1914–15," in Canada, *Sessional Papers*, no. 19, 61.
**15** Hector Charlesworth, "The National Gallery, a National Reproach," *Saturday Night* 38, no. 6 (9 December 1922): 3.
**16** "Canada's National Gallery: A letter from Sir Edmund Walker and a Reply by Mr. Charlesworth," *Saturday Night*, 38, no. 10 (23 December 1922).
**17** J.A.B. McLeish, *September Gale* (Toronto, 1955), 78–80.
**18** Charlesworth, "The National Gallery."
**19** F.H. Gadsby, "The Hot Mush School," *Toronto Daily Star*, 12 December 1913, 6.
**20** Carl Ahrens, *Toronto Daily Star*, 11 March 1916; Hector Charlesworth, "Pictures That Can Be Heard," *Saturday Night* 29, no. 23 (18 March 1916): 5.
**21** See Reid, *The Group of Seven*.
**22** RCA Papers, Motion Book, 23 November 1923, proposed by Williamson, seconded by Cullen, and passed.
**23** Ibid, motion 3, 19 May 1923, proposed by Maxwell, seconded by Simpson, and carried; Fisher Rare Book Library, University of Toronto, Walker Papers, E. Brown to B.E. Walker, 4 June 1923.
**24** National Gallery Papers, quoted in H.O. McCurry to J.W. Beatty, Jan. 1933.

**25** John Douglas Sutherland Campbell, Duke of Argyll, *Memories of Canada and Scotland: Speeches and Verses by the Marquis of Lorne* (Montreal: Dawson, 1884), 254.
**26** National Gallery By-Laws, 16 December 1913.
**27** National Gallery Papers, H.O. McCurry to J.W. Beatty, draft, c. January 1933.

## DOUGLAS COLE

**1** Dennis Reid, *The Group of Seven* (Ottawa: National Gallery of Canada. 1970), 9.
**2** Library and Archives Canada, J.E.H. MacDonald Papers, MacDonald, "Scandinavian Art," a lecture at the Art Gallery of Toronto, 7 April 1931, 2.
**3** The American influence is deliberately ignored here though it was of great importance. See Roderick Nash, *Wilderness and the American Mind* (New Haven: Yale University Press, 1967), and Peter J. Schmitt, *Back to Nature* (New York: Oxford University Press, 1969), for excellent treatments of the American wilderness movement. One might even view the Group's work as a Canadian analogue to American regionalist painting.
**4** The American statutory definition of wilderness is an area "Where the earth and its community of life are untrammelled by man, where man himself is a visitor who does not remain." This kind of definition tends to the absolute. I am writing more of an idea than of an ideal and, hence, using "wilderness" rather loosely. For discussions of definitions see Nash, *Wilderness and the American Mind*, 1–7, and Douglas H. Pimlott, "Wilderness Values in the Twentieth Century," in *Why Wilderness?* ed. Bruce M. Littlejohn and Pimlott (Toronto: New Press, 1971), 13–16. On Canadian attitudes to nature at the beginning of the century, see George Altmeyer, "Three Ideas of Nature in Canada, 1893–1914," *Journal of Canadian Studies* 2, no. 3 (August 1976): 21–35.
**5** The 1891 and 1921 figures for Montreal: 219,616 and 618,566; for Toronto: 181,215 and 521,893; for Winnipeg: 25,639 and 179,087. See *Canada Year Book*, 1932 (Ottawa: The King's Printer, 1933), 103.
**6** J.S. Woodsworth, *My Neighbour* (1911; Toronto: University of Toronto Press, 1972), 11.
**7** The homes featured in the pages of *Canadian Homes and Gardens* for the half-dozen years after its 1925 inception reflect this "country" lifestyle.
**8** Walter S. Johnson, "By Canoe," *Canadian Magazine* 23 (June 1904): 125.
**9** Ibid.
**10** J.A. Cooper, "Canada and the Tourist," *Canadian Magazine*, 15 (May

1900): 4.
**11** See Roy I. Wolfe, "Recreational Land Use in Ontario" (PhD thesis, University of Toronto, 1956); his "Summer Cottagers in Ontario," *Economic Geography* 22 (January 1951): 10–32; and "The Summer Resorts of Ontario in the Nineteenth Century," *Ontario History* 54 (September 1962): 149–61.
**12** *Canadian Magazine* 15 (May 1900): 4.
**13** *The Madawaska Club, Go-Home Bay, 1898–1923*, 15.
**14** See Donald B. Smith, "Grey Owl," *Ontario History* 63 (September 1971): 161–76; Lovat Dickson, *Wilderness Man* (Toronto: Macmillan of Canada, 1973).
**15** Grey Owl, *Pilgrims of the Wild* (1935; Toronto: Macmillan of Canada, 1968), 185, 178, 203.
**16** Interview of Grey Owl by W.A. Deacon, in *Mail and Empire* (Toronto), 1936, cited in Ottelyn Addison, *Tom Thomson: The Algonquin Years* (Toronto: Ryerson, 1969), 44.
**17** Blodwen Davies, *Tom Thomson* (1935; Vancouver: Mitchell Press, 1967), 10; J.M. MacCallum, "Tom Thomson: Painter of the North," *Canadian Magazine* 50 (March 1918): 378.
**18** Augustus Bridle, *The Story of the Club* (Toronto: Arts & Letters Club, 1945), 16, quoted in Peter Mellen, *The Group of Seven* (Toronto: McClelland and Stewart, 1970), 219.
**19** Perhaps this picture of Thomson as wilderness man was drawn less by Thomson than by later admirers who made Thomson something he never pretended to be. Most of the literature has been written by those who either never knew him or met him only after 1912 – notably Blodwen Davies, F.B. Housser, and A.Y. Jackson. "The friends of Tom Thomson" did not recognize him in such "stagey lightings," wrote one of them, probably MacDonald: "Instead of their daily comrade at the designing bench, working side by side, and going on week-end sketching trips together – a matured man leaning towards his forties, experienced in drawing and design, and influenced by reading and association with highly-trained prize-winning intimates – we have the young man suddenly appearing out of the northern woods with his wild art slung behind him." See anon., "Books of Pictures," *Canadian Forum* 6 (July 1926): 313. Harold Town and David Silcox, *Tom Thomson* (Toronto: McClelland and Stewart, 1977), is a useful counter.
**20** A.Y. Jackson, *A Painter's Country* (Toronto: Clarke, Irwin, 1958), 56.
**21** Quoted in Reid, *The Group of Seven*, 34.
**22** See Barker Fairley, *Georgian Bay Sketches* (Toronto: University of Toronto Press, 1957).
**23** Merrill Denison, *The Unheroic North: Four Canadian Plays* (Toronto: McClelland and Stewart, 1923), 68.
**24** H.M. Lamb, "The Royal Canadian Academy of Art," *International Studio* 61

(March 1917): 33.

**25** Lamb, letter to the editor, *Montreal Star* (?), 28 November 1918, in Lamb scrapbook, volume 2, Vancouver Public Library (copy).

**26** F.B. Housser, *A Canadian Art Movement: The Story of The Group of Seven* (Toronto: Macmillan of Canada, 1926), 14.

**27** Milne to Donald W. Buchanan, 1936, quoted in Buchanan, "David Milne as I Knew Him," *Canadian Art* 11 (Spring 1954): 90. Milne, however, misses the inseparability of association and appreciation in landscape art. In fact, the Group was part of a general revolution in Canadian landscape aesthetics which brought the unpeopled and "unhistoric" wilderness to the forefront. The creation of a Canadian wilderness aesthetic, the product of writers, artists, and recreational users of the landscape, is a subject for another article. Sandra Djwa's "'A New Soil and a Sharp Sun': The Landscape of a Modern Canadian Poetry," *Modernist Studies* 2 (1977): 3–17, touches upon a literary aspect of the problem, and Maria Tippett and Douglas Cole, *From Desolation to Splendour: Changing Perceptions of the British Columbia Landscape* (Toronto: Clarke, Irwin, 1977), deals with a regional and artistic aspect.

**28** "The Group of Seven," *Canadian Forum* 7 (February 1927): 136.

**29** Art Museum of Toronto, *Exhibition of Paintings by the Group of Seven* (1921), Foreword, reproduced in Harry Hunkin, *There Is No Finality ...* (Toronto: Burns & McEachern, 1971), 99.

**30** Lawren Harris, "The Group of Seven in Canadian History," in Canadian Historical Association, *Annual Report*, 1948, 37–8.

**PAUL H. WALTON**

**1** Census figures show that from 1921 to 1931 the number of artists rose by 86 per cent compared with the previous decade, whereas the population increased by only 18 per cent during the same period (Mary Jean Vipond, "National Consciousness in English-Speaking Canada in the 1920s" [PhD diss., University of Toronto, 1974], 33).

**2** Peter Mellen, *The Group of Seven* (Toronto and Montreal, 1970), 217.

**3** "Future Is One of Bright Promise," in *Half Century Anniversary Number of the Daily Mail and Empire, 1872-1922: The Story of Fifty Years of a Great Newspaper with a Review of Canadian History and Progress* (Toronto), 30 March 1922, 97–8.

**4** Lawren Harris, "Creative Art and Canada," in *Yearbook of the Arts in Canada, 1928-1929*, ed. Bertram Brooker (Toronto, 1929), 182.

**5** Frank Underhill, review of *Yearbook of the Arts in Canada, 1936*, ed. Bertram Brooker, *Canadian Forum*, December 1936, 27.

**6** Donald Kerr and Deryck W. Holdsworth, eds., *Historical Atlas of Canada* (Toronto, 1990), 3, 13–15, 29–30.

**7** Sir Edmund Walker, "Shall Canada Go Money-Mad? ... (From the Toronto Globe)," *Busy Man's Magazine*, August 1910, 22–3. For Walker's relationship with the Group of Seven and the National Gallery of Canada, see Charles C. Hill, "The National Gallery, a National Art, Critical Judgement and the State," in *The True North: Canadian Landscape Painting 1896-1939*, ed. Michael Tooby, exhibition catalogue, Barbican Art Gallery (London, 1991), 65–83.

**8** For a description of the commercial art scene in Toronto before World War I as experienced by immigrants like Lismer, see Michael Tooby, *Our Home and Native Land: Sheffield's Canadian Artists*, exhibition catalogue, Mappin Art Gallery (Sheffield, 1991), although the author is reticent about the history and nature of the industrial development that sustained "artist workers" in both Sheffield and Toronto.

**9** H.V. Nelles, *The Politics of Development: Forests, Mines and Hydro-Electric Power in Ontario, 1849-1941* (Toronto, 1974), 51.

**10** Joan Murray, *The Art of Tom Thomson*, exhibition catalogue, Art Gallery of Ontario (Toronto, 1971), 23.

**11** Marjorie Bridges Lismer, *Arthur Lismer's Pen and Pencil: A Border of Beauty* (Toronto, 1977), 16.

**12** Arthur Lismer, "Canadian Art," *Canadian Theosophist*, February 1925, 177, and Lawren Harris, "Winning a Canadian Background," *Canadian Bookman*, February 1923, 37.

**13** Dennis Reid, "Photographs by Tom Thomson," *Bulletin of the National Gallery of Canada* 16 (1970).

**14** E.g., J.E.H. MacDonald, *By the River (Early Spring)* (1911, Government of Ontario Art Collection, Queen's Park, Toronto), and Lawren Harris, *The Drive* (1912, National Gallery of Canada, Ottawa).

**15** A.Y. Jackson, "The Birth of the Group of Seven," in *Our Sense of Identity*, ed. Malcolm Ross (Toronto, 1954), 226.

**16** A.Y. Jackson, "Foreword," in Blodwen Davies, *Tom Thomson: The Story of a Man Who Looked for Beauty and for Truth in the Wilderness*, rev. ed. (Vancouver, 1967), 5.

**17** Ottelyn Addison, *Early Days in Algonquin Park* (Toronto, 1974), 9–28, 71–99. See Thomson's *Tea Lake Dam* (1916, National Gallery of Canada) for logging and *Little Cauchon Lake* (1916, National Gallery of Canada) for tourism, among others.

**18** For an early description from 1908 of how Algonquin Park was transformed by logging, see G.D. Garland, ed., *Glimpses of Algonquin: Thirty Personal Impressions from Earliest Times to the Present* (Whitney, Ont., 1989), 73.

**19** A.Y. Jackson was the first to make a distinction between Thomson's works "showing a low shore line and a big sky" and those "finding happy color motives amid [the] tangle and confusion" of "his waste of rock and swamp" (A.Y. Jackson, "Foreword," in *The Arts Club Montreal: Exhibition of Works by the Late Tom Thomson* [Montreal, 1919], [2]).

**20** James Barry, *Georgian Bay: The Sixth Great Lake* (Toronto and Vancouver, 1968), and G. Wall, "Recreational Land Use in Muskoka," in *Recreational Land Use: Perspectives on Its Evolution in Canada*, ed. Geoffrey Wall and John S. Marsh (Ottawa, 1982), 143–4.

**21** "Canada and the Tourist" (editorial), and W.R. Bradshaw, "The Georgian Bay Archipelago," *Canadian Magazine*, special "Tourist Number" (May 1900), 3, 23.

**22** Charles Comfort, "Georgian Bay Legacy," *Canadian Art* 8 (1951): 106–9; Dennis Reid, *The Group of Seven*, exhibition catalogue, National Gallery of Canada (Ottawa, 1970), 46–7, 153; and Pierre B. Landry, *The MacCallum-Jackman Cottage Mural Paintings* (Ottawa: National Gallery of Canada, 1990).

**23** C. Price-Green, "Toronto's Progress – The Advent of the Canadian Northern," *Canadian Magazine*, January 1907, 31.

**24** Douglas Cole, "Artists, Patrons and Public: An Enquiry into the Success of the Group of Seven," *Journal of Canadian Studies* 13 (1978): 69–78.

**25** For a useful discussion of the origins of the Group of Seven's "poster-esque" style, their connections with commercial art, and the background of tourism, see Robert Stacey, "The Myth – and Truth – of the True North," in *The True North*, 52–8. A somewhat different treatment of metropolitanism and the Group of Seven has been given by Allan Smith, "Farms, Forests and Cities: The Image of the Land and the Rise of the Metropolis in Ontario, 1860–1914," in *Old Ontario: Essays in Honour of J.M.S. Careless*, ed. David Keane and Colin Reade (Toronto, 1990), 71–94.

**ROSEMARY DONEGAN**

**1** The Canadian War Records program from the First World War includes a number of paintings and drawings documenting the industrial "war at home." Most are now in the collection of the Canadian War Museum, Ottawa. See H. Mabel May, *Women Making Shells*; George Reid, *Forging 4-Inch Shells* (1918); Francis Loring, *The Rod Turner* (1919); and Florence Wyle, *Munitions Worker* (1919).

**2** See Lynda Jessup, ed., *Antimodernism and Artistic Experience: Policing the Boundaries of Modernity* (Toronto: University of Toronto Press, 2001).

**3** It is not until the 1950s that the generic term "designer" (as in graphic designer) comes to prominence and supersedes and separates from the more generic usage of the term "artist" (as in commercial artist, applied artist). At the Ontario College of Art until well into the 1950s, whether working in the fine arts, craft, or design, faculty and students were generally referred to as artists.

**4** Elizabeth Wyn Wood, "Art and the Pre-Cambrian Shield," *Canadian Forum*, February 1937, 13–15, and Paraskeva

Clarke with G. Campbell McInnes, "Come Out from behind the Pre-Cambrian Shield," *New Frontier* 12 (April 1937), 16–17.

**5** Wyn Wood, "Art and the Pre-Cambrian Shield," 13.

**6** Clarke, "Come Out from behind the Pre-Cambrian Shield," 16.

**7** Wyn Wood, "Art and the Pre-Cambrian Shield," 14.

**8** Ibid.

**9** Ibid.

**10** This essay has evolved from research and exhibitions produced over a twenty-year period, originating in my catalogue essay and exhibition *Industrial Images/Images industrielles* (Art Gallery of Hamilton, 1987), which explored the imagery of Canadian industry from the 1880s to the 1950s. Subsequent exhibitions and catalogues have included *Work, Weather and the Grid: Agriculture in Saskatchewan* (Dunlop Art Gallery, Regina, 1991); *Ford City/Windsor* (Art Gallery of Windsor, 1994); *Sudbury: The Industrial Landscape* and *The Sudbury Basin: Industrial Topographies* (Art Gallery of Sudbury, 1998/99); and *Aboveground: Mining Stories* (Art Gallery of Greater Victoria, 2002).

**11** See Paul H. Walton, "The Group of Seven and Northern Development," *RACAR* 17, no. 2 (1990): 171–9.

**12** In 1993 Naomi Jackson Groves, Jackson's biographer and niece, commented on how unusual the painting was within Jackson's larger body of work: "It was an extraordinary experiment this picture of a Sudbury mine – for him to try out pointillism" (*Sudbury Star*, 17 May 1993).

**13** Extracts from Charles Comfort's unpublished memoirs "Sketches from Memory" (copyright: Estate of Louise Irine Comfort, Ottawa), Library and Archives Canada, Ottawa.

**14** Ibid.

**15** After the 1937 World's Fair, Comfort's mural *Romance of Nickel* appears to have been returned to the Department of Mines in Ottawa, and by the 1950s it was hanging in the Physical Metallurgy Laboratories on Booth Street. The mural is now in the National Gallery of Canada and is often installed in the Canadian historical galleries. The *Romance of Nickel* was exhibited in Sudbury for the first time in the exhibition *Sudbury: The Industrial Landscape* (Art Gallery of Sudbury, July 1999).

**16** Comfort used a strikingly similar spatial design and narrative structure in the eight interior murals and the horizontal exterior stone frieze he was simultaneously working on for the new Toronto Stock Exchange (currently the Toronto Design Exchange). The inverted Y figure was identical to the repeated figure forms in the horizontal stone frieze and the interior vertical wall paintings on the Trading Floor. See Rosemary Donegan, "Legitimate Modernism: Charles Comfort and the

Toronto Stock Exchange," in *Designing the Exchange: Essays Commemorating the Opening of the Design Exchange* (Toronto: The Design Exchange, 1994), and "Mural Roots: Charles Comfort and the Toronto Stock Exchange," *Canadian Art* 4, no. 2 (summer 1987): 64–9.

**17** See John B. Lang, "One Hundred Years of Mine Mill," in Mercedes Steedman et al., *Hard Lessons: The Mine Mill Union in the Canadian Labour Movement* (Toronto: Dundurn Press, 1995), 14.

**18** The Orenstein mural was implicitly an attempt by Mine Mill to counter the McCarthyite anti-communist smear attacks and union raiding by the United Steelworkers and the campaign of the local Roman Catholic Church. However, the content of the mural avoids any direct reference to the issues of the Cold War. See Steedman et al., *Hard Lessons*.

**19** Paul Duval, "Murals – A Political Art," *Royal Architectural Institute of Canada Journal*, January 1949, 9.

**20** Charles Comfort, *Chimneys*, c. 1928, oil on cardboard, 25 x 30 cm (private collection, Toronto), and Henry Orenstein *Stacks, Copper Cliff*, 1956, oil on board, 40.6 x 30.5 cm (Art Gallery of Sudbury Permanent Collection).

**21** The Group of Seven and their associates may not fit the later linear Greenbergian development of abstraction, but it is clearly apparent that the paintings of Harris, Lismer, Varley, MacDonald, Jackson, Carr, and Thomson were categorically different from the established work of the earlier generation of Horatio Walker, Homer Watson, and Maurice Cullen. Within their immediate context of Canada between the 1910s and the 1930s, they were modern and perceived to be so by the public and the critics of the time.

**22** Lawren Harris's *Miners' Houses, Glace Bay*, c.1925 (Art Gallery of Ontario Collection), in its oblique forms and dramatic palette, elucidates the crisis of the Cape Breton coal-mining industry in the early 1920s.

**23** See Lynda Jessup, "Art for a Nation?" and Rinaldo Walcott, "Lament for a Nation: The Racial Geography of 'The OH! Canada Project,'" *Fuse* 19, no. 4 (summer 1996), 11–23 and 97–103. See also Lynda Jessup, "Bushwhackers in the Gallery: Antimodernism and the Group of Seven," and Benedict Anderson, "Introduction – Staging Antimodernism in the Age of High Capitalist Nationalism of Seven," in *Antimodernism and Artistic Experience*, ed. Jessup, 130–52.

**24** Anderson, "Introduction," 100.

**25** Pearl McCarthy, "OSA Giving Show of Little Pictures," *Mail and Empire*, 6 December 1935.

## CAROL PAYNE

**1** In focusing on photo-stories, I am acknowledging the format in which most viewers of the time experienced Still Photography Division images and texts. The period from 1955 to 1969 has been selected because during these years the Division produced production-ready layouts. This practice was discontinued in the early 1970s. In addition, these years – spanning the Division's autonomy from the NFB's various film production divisions and the flurry of activity surrounding Expo 67 – arguably mark the most vital period in its history.

**2** W.J.T. Mitchell, "Introduction," in *Landscape and Power*, ed. W.J.T. Mitchell (Chicago: University of Chicago Press, 1994), 2.

**3** For a detailed study of the history of the Division, see Carol Payne, *A Canadian Document: The National Film Board of Canada's Still Photography Division* (Ottawa: Canadian Museum of Contemporary Photography, 1999).

**4** Gary Evans, *John Grierson and the National Film Board: The Politics of Wartime Propaganda* (Toronto: University of Toronto Press, 1984), 52.

**5** "National Film Act: An Act to Create a National Film Board" (Ottawa, 1939), 103, RG 53, box 1, National Film Board of Canada Papers, Library and Archives of Canada, Ottawa. Typically, the NFB is thought of as an agency designed, at least intially, to respond to the crisis of the Second World War. In this respect, it mirrored other governmental initiatives, such as the National Gallery's Reproduction Programme of Canadian Art, in explicitly promoting icons of Canadian identity. In fact, the National Film Act of 1939 clearly established the agency to address, first, anxieties over Canadian unity and then, secondarily, the dramatic events of war. See Joyce Zemans, "Establishing the Canon: Nationhood, Identity and the National Gallery's First Reproduction Programme of Canadian Art," *Journal of Canadian Art History* 16, no. 2 (1995): 6–36.

**6** Renate Wickens-Feldman, "The National Film Board of Canada's Still Photography Division: The Griersonian Legacy," *History of Photography* 20, no. 3 (autumn 1996): 271–7.

**7** Grierson first used the term in a 1926 review of Robert Flaherty's film *Moana*. However, some scholars suggest – and Grierson himself alludes to this possibility – that he may have been using the term in the French sense (*documentaire*), meaning a travelogue. See Ian Aitken, *Film & Reform: John Grierson and the Documentary Film Movement* (London: Routledge, 1990), 79–80. As I have argued elsewhere, although "documentary" is now often employed in a broad trans-historical manner, Grierson's original use of the term was rooted in

the cultural climate of the 1920s and 1930s. In particular, it reflected a thirst among contemporary audiences for supposedly factual evidence and the burgeoning practice of social control and planning by governments, social scientists, and industry. See William Stott, *Documentary Expression and Thirties America* (New York: Oxford University Press, 1973); John M. Jordan, *Machine-Age Ideology: Social Engineering and American Liberalism, 1911–1939* (Chapel Hill and London: University of North Carolina Press, 1994), 4–6, 13, 155–84; Payne, *A Canadian Document*, 14.

**8** As Grierson stated in 1942, "The materials of citizenship today are different and the perspectives wider and more difficult; but we have, as ever, the duty of exploring them and of waking the heart and will in regard to them. That duty is what documentary is about. It is, moreover, documentary's primary service to the state." See John Grierson, "The Documentary Idea: 1942," *Documentary News Letter* (London, 1942), reprinted in *Grierson on Documentary*, ed. Forsyth Hardy (London & Boston: Faber and Faber, 1979), 113. See also Peter Morris, "Re-Thinking Grierson: The Ideology of John Grierson," in *Dialogue: Canadian and Quebec Cinema*, ed. Pierre Veronneau, Michael Dorland, and Seth Feldman (Montreal: Mediatexte, 1987), 21–56.

**9** As Tagg states, "Claiming only to 'put the facts' directly or vicariously, through the report of 'first hand experience,' the discourse of documentary constituted a complex strategic response to a particular moment of crisis in Western Europe and the U.S.A. – a moment of crisis not only of social and economic relations and social identities, but, crucially, of representation itself: of the means of making the sense we call social experience." See John Tagg, *The Burden of Representation: Essays on Photographies and Histories* (Amherst, Mass.: University of Massachusetts Press, 1988), 8. In addition, documentary's authority rests in what Bill Nichols refers to as its kinship to "discourses of sobriety … the vehicles of domination and conscience, power and knowledge, desire and will," including those of science, politics, education and religion. See Bill Nichols, *Representing Reality: Issues and Concepts in Documentary* (Bloomington and Indianapolis: Indiana University Press, 1991), 3–4.

**10** As Carol Crawshaw and John Urry have argued, photography was also crucial to the nineteenth-century "autonomization of vision" in consumer culture. See Carol Crawshaw and John Urry, "Tourism and the Photographic Eye," in *Touring Cultures: Transformations of Travel and Theory*, ed. Chris Rojek and John Urry (London and New York: Routledge, 1997), 182. See also Jonathan Crary, *Techniques of the Observer: On Vision and Modernity in the Nineteenth Century*

(Cambridge, Mass.: MIT Press, 1999), 13.

**11** See Margaret Iversen, "Saussure versus Peirce: Models for a Semiotics of Visual Art," in *The New Art History*, ed. A.L. Rees and F. Borzello (Atlantic Highlands, NJ: Humanities Press International, 1986). Within Peircian semiotics, the photograph also functions as an iconic sign; that is, it resembles its referent. But it is its presumed indexical character, a factor that met favour with positivist notions of knowledge, which has historically invested the medium with tremendous influence.

**12** Establishing a clear definition for "documentary" photography proves to be a sticky problem. Indeed, a leitmotif of much photographic scholarship over the past twenty years has been the debate over documentary's status. While within the related field of cinema, distinctions between documentary and fiction film are inscribed relatively clearly, even in a digital age most people tend to experience *all* still photographs as works of non-fiction. Indeed, until the early twentieth century, a designation for non-fiction photographs would have seemed absurd to most photographers and students of photography; its documentary character was considered ontological.

**13** Photographic literature since the 1970s has been preoccupied with problematizing photography's privileged relationship to the "real." Two key texts, among many others, are Roland Barthes, "The Photographic Message," in *Image, Music, Text* (New York: Farrar, Straus and Giroux, 1977), 15–31; and Allan Sekula, "The Invention of Photographic Meaning," in *Photography in Print*, ed. Vicki Goldberg (Albuquerque: University of New Mexico Press, 1981), 452–73.

**14** As the filmmaker and theorist Trinh T. Minh-ha states, in documentary "what is put forth as truth is often nothing more than *a* meaning." See Trinh T. Minh-ha, "Documentary Is/Not a Name," *October* 52 (spring 1990), 77.

**15** *Grierson on Documentary*, 11.

**16** The deployment of the photograph – and the discourse of photographic

authority – in the service of the Canadian government, of course, has a long history. For a discussion of aspects of this history, see Carol Payne, "Through a Canadian Lens: Discourses of Nationalism and Aboriginal Representation in Governmental Photography," in Sheila Petty, Annie Gérin, and Garry Sherbert, eds., *Canadian Cultural Poesis: An Anthology* (Waterloo: Wilfrid Laurier University Press, 2006), 421–42.

**17** The Division's emphasis on photostories may have been a direct response to a confidential report Grierson tabled at a 1943 Board meeting. There, he reported – rather surprisingly – on a study suggesting that newspapers and radio were more effective means of reaching the public than film. While Grierson's commitment to the production of motion pictures is assumed, he clearly took more than a passing interest in the effectiveness of other media. His encouragement of greater involvement in print and audio media indicates that his principal concern was, in fact, for managing public opinion. By gearing its production toward print media – rather than exhibitions, for example – the Still Photography Division developed a vehicle to reach and influence a wide spectrum of the Canadian population as well as international audiences. See Payne, *A Canadian Document*, 16.

**18** Photo-stories, prepared entirely by the Still Photography Division staff, were a decidedly collaborative product. Although staff and freelance photographers, shooting in relative isolation in the field often hundreds of miles from Ottawa, enjoyed a good degree of autonomy, their work went through a number of hands. "Producers" selected topics for shoots, often responding to demands from specific government agencies, and assigned photographers. Once the assignment was shot, negatives were returned to Ottawa, where picture editors selected a fraction of those shot for publication and writers – who often had never ventured to the site of the story – wrote copy. It would therefore be inaccurate to speak of the assignment photographer as the direct and unproblematic author of a photo-story. Instead, their authorship is institutional. Job titles in the Division – including an executive producer, producers, editors, and writers reflected the ongoing influence of the film industry in their work as noted above.

**19** For example, photo-story 15 on Hutterites appeared in the *Canadian Geographic* magazine, as well as in American newspapers through the Associated Press; a photo-story entitled "Winter on the Farm" appeared in the 9 January 1954 issue of *Weekend Picture Magazine*; and photo-story S-5, on furniture-making, appeared in the *Calvinist Contact* on 12 June 1963. See NFB archival material, Canadian Museum of Contemporary

Photography, Ottawa; Martha Hanna, *Walter Curtin: A Retrospective* (Ottawa: Canadian Museum of Contemporary Photography for the Corporation of the National Museums of Canada, 1985), 16.

**20** Models proposed by film studies for discussing documentary cinema are, I suggest, particularly appropriate to this body of work in which, as argued above, motion picture terminology and organization remains a point of orientation. See Carol Payne, "'A Land of Youth': Nationhood and the Image of the Child in the National Film of Canada's Still Photography Division," in Loren Lerner, ed., *Depicting Canada's Children* (Waterloo: Wilfrid Laurier University Press, forthcoming). See also Julianne Burton, "Toward a History of Social Documentary in Latin America," in *The Social Documentary in Latin America* (Pittsburgh: University of Pittsburgh Press, 1990), 3–6; and Nichols, *Representing Reality*, 32–75.

**21** Some notable texts are Ann Bermingham, *Landscape and Ideology: The English Rustic Tradition, 1740–1860* (Berkeley: University of California Press, 1986); Mitchell, *Landscape and Power*; Deborah Bright, "Of Mother Nature and Marlboro Men: An Inquiry into the Cultural Meanings of Landscape Photography," in *The Contest of Meaning: Critical Histories of Photography*, ed. Richard Bolton (Cambridge: MIT Press, 1989), 125–43.

**22** Mitchell, "Imperial Landscape" in Mitchell, *Landscape and Power*, 9.

**23** Catherine Lutz and Jane Collins, *Reading National Geographic* (Chicago: University of Chicago Press, 1993), 187–216.

**24** For another discussion of landscape and imperialist representation in Canada, see Jonathan Bordo, "Jack Pine – Wilderness Sublime: On the Erasure of Aboriginal Presence from the Landscape," *Journal of Canadian Studies* 27, no. 4 (winter 1992): 98–128.

**25** Homi K. Bhabha, "The Other Question: Stereotype, Discrimination and the Discourse of Colonialism," in *The Location of Culture* (London: Routledge, 1994), 67.

**26** See, for example, the 29 November 1955 photo-story "Canada's Northern Citizens" and the 1962 photo-story "At Play in the Land of the Long Day." See Payne, *A Canadian Document*, 28.

**27** Robert Houle, "The Spiritual Legacy of the Ancient Ones," in *Land/Spirit/Power*, ed. Diana Nemiroff, Robert Houle, and Charlotte Townsend-Gault (Ottawa: National Gallery of Canada, 1992), 61.

**28** Joan M. Vastokas, "Landscape as Experience and Symbol in Native Canadian Culture," in *Perspectives of Canadian Landscape: Native Traditions*, ed. Joan M. Vastokas (Toronto: Robarts Centre for Canadian Studies, York University, 1990), 59.

## MEL WATKINS

**1** We lived on the road to Callandar, where the Dionne quintuplets drew tourists each summer like flies.

**2** Simon Schama, *Landscape and Memory* (New York: Knopf, 1995), 61.

**3** The Monterey Bay Aquarium, now the most popular public aquarium in the United States, is a former sardine-packing factory, according to the *Toronto Star* (Catalina Ortiz, "On Cannery Row," 19 October 1996). This information is to be found where it should be, in the Travel Section of the paper.

**4** Newt Gingrich, *To Renew America* (New York: HarperCollins, 1995), 192. Let it not be said that I did not do serious research for this essay – even risking damage to my brain.

**5** "I have always liked the way Eleanor Bond's paintings have unsettled me. I have never known how much was fact or fiction, why I experienced spatial and temporal disorientation, why I simultaneously felt anxious and amused." See Joan Borsa, "Peopling Uninhabitable Sights," in *Social Centres: Eleanor Bond* (Winnipeg: Winnipeg Art Gallery 1993), 33–7.

**6** See John Bentley Mays, *In the Jaws of the Black Dogs* (Toronto: Viking/Penguin, 1995).

**7** John Bentley Mays, *Globe and Mail*, 16 December 1988; in Eleanor Bond file of the National Gallery, Ottawa.

**8** In his review of William Leach's *Land of Desire*, Paul Levine notes that for Leach, "perhaps Times Square becomes the symbol of all that we find fascinating and depressing in American consumer culture; and [Leach] pointedly reports G.K. Chesterton's first reaction to the neon advertising signs on Broadway: 'What a magnificent spectacle,' wrote Chesterton, '… for a man who cannot read.'" See Paul Levine, *The Nation*, 3 January 1994.

**9** Arthur Kroker, *Technology and the Canadian Mind: Innis/McLuhan/Grant* (Montreal: New World Perspectives, 1984).

**10** Naomi Klein, "Why I Brought My Boogie-Woogie to AGO," *Toronto Star*, 9 March 1996, 53.

**11** Gary Michael Dault, "Bondville," *Canadian Art*, 13, no. 3 (fall 1996): 86–91.

## The National Gallery of Canada

### ANNE WHITELAW

This essay was written prior to Charles Hill's 1995 exhibition *The Group of Seven: Art for a Nation*. The quote in the title is taken from Housser's celebratory history of the Group of Seven, *A Canadian Art Movement: The Story of the Group of Seven*, 49.

**1** Foreword, *A Portfolio of Pictures from the Canadian Section of Fine Arts: British Empire Exhibition* (London, 1924).

**2** In 1951, in a report that has largely shaped the form of Canadian cultural legislation, the Massey Commission emphasized the essential role played by cultural institutions in the maintenance and promotion of a distinctly Canadian cultural identity. The fundamental role of these institutions was to restrict the flow of cultural commodities from the United States and thereby their influence on Canadian life, while at the same time providing centralized sites for the production of distinctly Canadian works of art and culture. In the wake of recent debates over national identity, the policies put forward in the Massey Commission Report continue to resonate in more recent documents produced by the federal government, particularly as Canada's political and cultural autonomy is seen to be under threat from the U.S. (for example, with the Canada – U.S. Free Trade agreements and NAFTA). A recent example is the 1992 Report of the Standing Committee on Communications and Culture drafted in preparation for the Charlottetown Constitutional Accord, *Culture and Communications: The Ties That Bind*, a document which in its support of the continued protection of national culture through support of centralized federal institutions reiterates many of the recommendations put forward by the Massey Commission.

**3** This quest for a distinct Canadian aesthetic can also be found in art historical survey texts on Canadian art.

**4** Although Tom Thomson died in 1917 (appropriately while sketching in Algonquin Park), before the official formation of the Group of Seven, he painted and sketched with them often and is credited in Canadian art history as being a major influence on the works of the Group.

**5** This is roughly delimited as 1920–26. May 1920 marks the date of the Group's first official exhibition at the Art Museum of Toronto; 1926 signals the moment at which individual members began to strike out on their own, and the Group lost its cohesiveness. It is also the date of publication of F.B. Housser's paean to the Group, *A Canadian Art Movement*. The Group did not formally disband until 1933, although their last exhibition was in 1931. See J. Russell Harper, *Painting in Canada: A History*, 2nd ed., (Toronto: University of Toronto Press, 1977) for a brief chronology of the Group's activities, and Dennis Reid, *The Group of Seven* (Ottawa: National Gallery of Canada, 1970) for a detailed analysis of their lives and works.

**6** Housser, *A Canadian Art Movement*, 143–4.

**7** See, for example, Peter Morris's *Embattled Shadows: A History of Canadian Cinema 1895–1939* (Montreal: McGill-Queen's University Press, 1978) for reference to early Canadian filmmaking, and Margaret Atwood's *Survival* (Toronto: Anansi Press, 1972) for the theme of the land in Canadian prose and poetry.

**8** J.M. Millman, quoted in Harper, *Painting in Canada*, 288.

**9** Annie E. Coombes describes this process as follows: "Through transformations in marketing and policy, the museum has become both a vital component in the reclaiming and defining of a concept of collective memory on the local level and, on the national level, an opportune site for the reconstituting of certain cultural icons as part of a common 'heritage' – a 'heritage' often produced as a spectacle of essentialist national identity with the museum frequently serving as the site of the nostalgic manufacture of a consensual

past in the lived reality of a deeply divided present." See "Inventing the 'Postcolonial': Hybridity and Constituency in Contemporary Collecting," *New Formations* 18 (winter 1992): 39–52, 41.

**10** An early function of the National Gallery was to serve as the depository for the diploma works of members of the Royal Academy; hence the Academy's stake in the evolution of the gallery's acquisition policies.

**11** Michael Tooby, "Orienting the True North," in *The True North: Canadian Landscape Painting 1896–1939*, ed. Michael Tooby (London: Barbican Art Gallery, 1991), 18.

**12** National Gallery of Canada Act, 1913.

**13** See Michael J. Ettema, "History Museums and the Culture of Materialism," in *Past Meets Present: Essays about Historic Interpretation and Public Audiences*, ed. Jo Blatti (Washington and London: Smithsonian Institution Press, 1987).

**14** This rhetoric was recently used by the gallery to justify the expense of purchasing Barnett Newman's *Voice of Fire* and Mark Rothko's *No. 16*.

**15** Cited in Charles Hill, "The National Gallery, A National Art, Critical Judgement and the State," in *The True North*, ed. Tooby, 70–1.

**16** The other three national museums are the Canadian Museum of Civilization (includes the Canadian War Museum), the National Museum of Natural Sciences, and the National Museum of Science and Technology (includes the National Aviation Museum), all located in the Ottawa area.

**17** Bill C-12.

**18** The evidence submitted by the National Gallery was in the context of *Culture and Communication: The Ties That Bind*, a document on national identity and unity drafted by the Standing Committee on Communications and Culture in preparation for the Charlottetown Accord, which was signed by representatives of all ten provinces, the two territories, and the Assembly of First Nations in August 1992. The accord was subsequently put to a national referendum and was rejected by Canadian voters.

**19** Government of Canada, "Evidence Submitted to the Standing Committee," 6.

**20** Following anthropologist Victor Turner's research, Duncan and Wallach describe this as a process in which citizens enact a symbolic ritual that reinforces the state's ideological position. Although this essay is very useful in unpacking the physical and symbolic mechanisms through which the museum constructs meaning, I would rather see the visitor's activity in the museum as a process of reading, thereby suggesting an active engagement with the material objects on display, rather than the passive following of an ideo-

logical script as Duncan and Wallach seem to suggest. See Carol Duncan and Alan Wallach, "The Universal Survey Museum," *Art History* 3, no. 4 (December 1980): 448–69.

**21** Duncan and Wallach trace out their argument through analyses of the Louvre and the Metropolitan Museum of Art in New York. Both these institutions are more properly "universal survey" museums because their collections begin with the works of the ancient world (Egypt, Greece) and cover all major periods of art, with important works from their nations' artists. Although the National Gallery of Canada does not have the wealth of objects of the Louvre or the Metropolitan, similar concerns with providing a complete "history of art" govern the organization of the works on display.

**22** Douglas Crimp has discussed the legacy of Hegel's aesthetic philosophy in the discourse of traditional art history. The view of the history of artistic production as a linear development from the functionalist to the wholly spiritual was taken from Hegel and adapted to a notion of art history as stylistic succession. This linear and evolutionary conception of the history of art underscores the organization of the traditional museum (and as Crimp argues, is evident in the design of the prototypical art gallery, the Berlin Altes Museum) and can also be found in contemporary art, specifically Alfred Barr's schematic outline of the genealogy of modern art in the catalogue for the 1936 MOMA exhibition, Cubism and Abstract Art. See Douglas Crimp, "The Postmodern Museum," in *On the Museum's Ruins* (Cambridge, Mass.: MIT Press, 1993).

**23** Reid, *The Group of Seven*, 13–14.

### JOYCE ZEMANS

**1** National Gallery of Canada Archives, 1.8 Reproductions of Paintings (1.8 RP), Sampson-Matthews Ltd. Note that Sampson-Matthews letterhead varies; occasionally the firm's name is written Sampson, Matthews Ltd, and on other occasions, Sampson-Matthews Ltd. I am using the hyphenated version as it is most commonly used in written documents concerning the firm and this project. Unless otherwise noted, archival material referred to in this paper is in the collection of the NGC Archives. I am indebted to Cindy Campbell, Archivist at the National Gallery, for her assistance.

**2** 1.8 RP, Sampson-Matthews, Letter to H.O. McCurry from Peter Haworth, 5 February 1943, Sampson-Mathews would sell the work and invoice clients. An excerpt from a letter from McCurry

dated 16 November 1942, and included in the Sampson-Matthews promotional literature, reads, "The National Gallery cordially welcomes the generous offer of a number of artists to design and donate for reproduction by your 'Colour Craft' process suitable pictures which might be distributed ... to the armed forces of Canada." As well, "Each picture which is presented for sponsorship has been submitted to the Curator of the National Gallery in Ottawa." The Gallery wrote Sampson-Matthews that the text that appeared with the reproductions should read, "Produced in Co-operation with the National Gallery of Canada."

**3** Dennis Reid, *The Group of Seven: Selected Watercolours, Drawings and Prints from the Art Gallery of Ontario* (Toronto: Art Gallery of Ontario, 1989), 23.

**4** Jean Sutherland Boggs, *The National Gallery of Canada* (Toronto: Oxford Press, 1971). Boggs credits McCurry, then Director of the Gallery, with the implementation of these projects.

**5** Fisher Rare Book Library, University of Toronto: Walker [Sir Edmund] Papers, Manuscript Collection 1, box 12, file 11, Brown to Walker, 14 December 1913. Brown also wrote: "There is a very excellent profit to be made upon the sale of reproductions both large and small and I have found a way by which we can order the necessary large numbers of prints yet not be hindered with either the cost or the material."

**6** 1.8 RP Walker to Brown, 15 December 1913.

**7** NGC, Meetings of the Board of Trustees, vol. I, 102.

**8** Ibid., 105. In a note dated 9 June 1914, the Director, observing the 1912 introduction of copyright law in England, noted: "We must have the copyright with every picture we possess and in future must be careful to mention the fact when we buy." Correspondence from Brown to Walker, 1 April 1914 (Walker Papers, box 12, file 11) indicates that the total cost for the first edition was $978. The wholesale price was 7.25 cents to be retailed at 50 cents each; the postcards cost half a cent each and sold at two for five cents. "So the profit is considerable," Brown writes, "I am anxious to demonstrate the value of the reproductions to the National Gallery."

**9** Walker Papers, 30 September 1914, box 27B, file 21. A complete set of the postcards was on sale and "being bought freely" by the end of October (29 October 1914).

**10** 1.8 RP, Vandyck Printers Ltd, 22 September 1921; reply dated 3 February 1922. They recommended printing large sheets of images and cutting and tipping the pictures, which were engraved on a copper cylinder rather than plates.

**11** *The National Gallery of Canada Annual Report of the Board of Trustees for the Fiscal Year 1921–22* (Ottawa: The King's Printer, 1922). This annual report offers evidence

of the interest shown in the Medici print collection. That year it had circulated in whole or part to, among other places, public schools in Ottawa, the art galleries of Hamilton and Toronto, the Tillsonburg Library, Collingwood, Port Arthur, Fort William, Regina, Medicine Hat, and Vancouver's B.C. Art League.

**12** Arthur Lismer, "Art Appreciation," *Yearbook of the Arts in Canada, 1928–29*, ed., Bertram Brooker (Toronto: Macmillan, 1929), 64.

**13** Hansard, vol. 65, 36-1930-2 1/2 (Friday, 11 April 1930): 1557. A western MP recommended that "the Gallery should cooperate with some of the large departmental stores throughout western Canada," noting that the T. Eaton Co. was "responsible for most of the art which appears upon the walls of our homes." It was noted that "Those stores are being stocked with etchings [sic] at a very reasonable price with a view to encouraging and fostering interest in Canadian art."

**14** *The Royal Commission on National Development in the Arts, Letters and Sciences 1949–1951* (Ottawa: The King's Printer, 1951), 78–9. The report submitted by the National Gallery to the Massey Commission describing the first reproduction programme contained inaccuracies. For example, the Massey submission implies that the Gallery was responsible for the Sampson-Matthews project, but in fact, while it worked in co-operation with them and lent its imprimatur to the project, its direct contribution of works was limited. Documents suggest that the Gallery wanted to limit the appearance of responsibility for the venture. Despite the fact that these prints remained in distribution into the post-war years, the programme was never fully documented.

**15** In *The Publications and Reproductions Program of the Metropolitan Museum of Art: A Brief History* (New York: Metropolitan Museum, 1981). Regina Maria Colourman notes that by 1920 colour reproductions of paintings by several firms were being sold on a commission basis. Postcard-size colour-collotype prints of objects in the Museum were produced by 1927. In 1928 the programme was extended to included 8" x 10" prints. These were also issued in a series of eight portfolios, each containing six prints at $6.00 per portfolio. The first in this series, *Metropolitan Museum Color Prints*, was offered in 1928.

**16** "In the Galleries," *Toronto Globe and Empire*, 18 December 1926. Rous and Mann, along with numerous other agents, became distributors for the National Gallery's 1927 Canadian reproduction series and the works were listed in their catalogue.

**17** NGC, *Annual Report*, 1921–22, 7.

**18** Ibid.

**19** NGC, *Annual Report*, 1925–26, 5.

Charles Hill confirms that the annual reports were written by Eric Brown.

**20** Arthur Lismer, *Canadian Picture Study* (Toronto: Art Gallery of Toronto, 1930), written in conjunction with the Art Gallery of Toronto's reproduction programme. The most widely circulated reproductions of Canadian art, other than those of the National Gallery, were those of the Art Gallery of Toronto, which Dent and some of the other companies also marketed. In 1929, the AGT advertised a set of twelve coloured reproductions of Canadian work at $1.00 per set (75 cents for teachers) and the availability of larger images, sold individually, including Paul Peel's popular *The Tired Model*. In 1950 the AGT introduced its Canadian Picture Study set.

**21** 1.8 RP, Sampson-Matthews Ltd, files 1–12. This file includes correspondence and public relations statements regarding the silkscreen project. An undated public relations statement titled "Art Reproduction of Canadian Pictures" notes that "in selecting both the artists and their subjects, the committee has taken care to see that all parts of Canada were covered. The collection as a whole (predominantly landscape) reflects different types of scenery ... the East is represented ... [there is] a study of maritime fisherfolk ... the far West ... the North and other districts ..." A letter from Jackson to McCurry, 15 April 1943 discusses the unevenness of the submissions and the problem of sponsors who want calendar art; an excerpt from a letter from Jackson to McCurry 27 April 1943 reads, "We need a good western one badly ..."

**22** In the *Yearbook of the Arts in Canada, 1928–29*, 89. Fred Housser described the work of Yvonne McKague: "Her compositions have masculine strength and intellectuality, showing much intelligent feeling and consideration for structure, design, form and spatial qualities."

**23** NGC, *Annual Report*, 1921–22, 7.

**24** Carol Duncan, "Art Museums and the Ritual of Citizenship," in *The Poetics and Politics of Museum Display*, ed. Ivan Karp and Steven D. Lavine (Washington: Smithsonian, 1991), 90–1.

## LESLIE DAWN

**1** National Gallery of Canada, Press Comments on the Canadian Section of Fine Arts, British Empire Exhibition, 1924 (Ottawa, 1924), and National Gallery of Canada, Press Comments on the Canadian Section of Fine Arts, British Empire Exhibition 1924–1925 (Ottawa, 1925).

**2** NGC file 1927, Exposition d'art canadien, Doc/NG EV, 11 April–10 May 1927, contains two volumes of clippings.

**3** Graham McInnes, *Canadian Art*

(Toronto: Macmillan, 1950), 60, states: "The zenith of the Group's achievement occurred during the years 1924–1925 and at Paris in 1927. Here the dash, brilliant colour and decorative ability found a ready response among critics and public alike." He cites the Wembley responses but not the Parisian reviews. J. Russell Harper, *Painting in Canada: A History* (Toronto: University of Toronto, 1966), 304, states: "Undoubtedly the high point in interest, and the assurance of their final acceptance and triumph in Canada, was inspired from abroad as a result of London's Wembley Exhibition in 1924 and 1925." He excludes the Jeu de Paume exhibition, as does Dennis Reid, *A Concise History of Canadian Painting* (Toronto: Oxford University Press, 1973).

**4** See also Ann Davis, "The Wembley Controversy in Canadian Art," *Canadian Historical Review* 54 (March 1973): 48–74.

**5** Pierre Bourdieu has demonstrated that audiences must be versed in the complex codes by which works of art are constructed in order to decipher them, that a group identity can be maintained by having exclusive access to those codes, and that acquisition of those codes accrues over time through repeated exposure. See Pierre Bourdieu, *The Field of Critical Production* (New York: Columbia University Press, 1993), and *Distinction: A Social Critique of the Judgement of Taste* (Cambridge, Mass.: Harvard University Press, 1984).

**6** Maud Brown, *Breaking Barriers: Eric Brown and the National Gallery* (s.l.: The Society for Art Publications, 1963), 12–13, Charles Hill, "The National Gallery, a National Art, Critical Judgement and the State," *The True North: Canadian Landscape Painting 1896–1939*, ed. Michael Tooby (London: Lund Humphries, 1991), 64–83. Hill cites Maud Brown in claiming that Eric Brown had studied art in England.

**7** In 1911 Walker "led the way" in bringing down the Laurier government for its proposed policy of continental reciprocity, which it was felt "put continentalism ahead of the British connection" and "would weaken the ties which bind Canada to the Empire." See J.L. Finlay and D.N. Sprague, *The Structure of Canadian History* (Scarborough: Prentice-Hall, 1979), 231.

**8** In 1913 "the National Gallery of Canada bought works by Harris, Jackson, Lismer, MacDonald and Tom Thomson. Walker had already been instrumental in persuading the government of Ontario to buy a Thomson, a Lismer and a MacDonald." See Peter Larisey, *Light for a Cold Land: Lawren Harris's Work and Life – An Interpretation* (Toronto: Dundurn Press, 1993), 30.

**9** British Empire Exhibition, *Canadian Section of Fine Arts Catalogue* (1924).

**10** Charles Hill, *The Group of Seven: Art for a Nation* (Ottawa: National Gallery of Canada, 1995), 143.

**11** British Empire Exhibition, *Canadian Section of Fine Arts Catalogue*.

**12** All selections are from National Gallery of Canada, *Press Comments*, 1924.

**13** All reviews are from the National Gallery of Canada, *Press Comments on the Canadian Section of Fine Arts, British Empire Exhibition 1924–1925*.

**14** Charles Harrison, "The Effects of Landscape," in W.J.T. Mitchell, ed., *Landscape and Ideology: the English Rustic Tradition, 1740–1860* (Berkeley: University of California Press, 1986), 58. Compare this comment with Fred Housser's claim for Thomson: "His master was nature." See F.H. Housser, *A Canadian Art Movement: The Story of the Group of Seven* (Toronto: Macmillan, 1926), 118.

**17** Bermingham, *Landscape and Ideology*.

**18** Malcolm Andrews, *The Search for the Picturesque: Landscape Aesthetics and Tourism in Britain, 1760–1800* (Aldershot: Scholar Press, 1989), 24.

**19** Mitchell, "Imperial Landscape," in *Landscape and Power*, 17.

**20** Malcolm Andrews, *Landscape and Western Art* (Oxford: Oxford University Press, 1999), 157–8 and 162; Robert Young, *Colonial Desire: Hybridity in Theory, Culture and Race* (London: Routledge, 1995), 169–74.

**21** Reid, *A Concise History of Canadian Painting*, 135.

**22** An exhibition waiting to occur would bring together the pre-1911 landscapes of Thomson and the Group. Such a collection would demonstrate the persistence of picturesque conventions not only in Britain but also in Canada by showing that they were all deeply imbued with these codes up to the point of their sudden change in style and conversion to the idea of an autochthonic Canadian national landscape derived from an unmediated experience of the "wilderness."

**23** Northrop Frye, "Canadian and Colonial Painting," in *Documents in Canadian Art*, ed. Douglas Fetherling (Peterborough: Broadview Press, 1987), 91–2.

**24** Anne Whitelaw, "'Whiffs of Balsam, Pine, and Spruce': Art Museums and the Production of a Canadian Aesthetic," in *Capital Culture: A Reader on Modernist Legacies, State Institutions, and the Value(s) of Art*, ed. Jody Berland and Shelley Hornstein (Montreal: McGill-Queen's University Press, 2000), 123.

**25** Ibid., 134 n 4.

**26** Housser, *A Canadian Art Movement*, 61. See also Robert Stacey, "The Myth – and Truth – of the True North," in *The True North: Canadian Landscape Painting 1896–1939*, ed. Michael Tooby, (London:

Lund Humphries, 1991), 45–6, for further suggestions that the "northland" constituted and was perceived as the Canadian equivalent to the English Lake District, which was the site of picturesque pursuits. See also Paul H. Walton, "The Group of Seven and Northern Development," *RACAR*, 17, no. 2 (1990): 173. Neither Stacey nor Walton follows up on his suggestions that the chosen areas of the Group constituted picturesque locales.

**27** Leonard Richmond, "Canadian Art at Wembley," *Studio* 89 (1925), 16–23.

**28** Lawrence Weaver, "Introduction," *Catalogue of the Palace of Arts British Empire Exhibition*, 8.

**29** Brown's original proposal limited his contribution to fifteen works.

**30** Eric Brown, "La jeune peinture canadienne," *L'Art et les artistes* 75 (March 1927): 181–195; Eric Brown, "Quelque mots sur l'histoire de l'art canadien," *Exposition d'art canadien* (Paris, 1927), 11–12. See also Thiébault-Sisson, "Une exposition d'art canadien au Jeu-de-Paume," *Le Temps*, 25 March 1927; and "La première exposition d'art canadien à Paris," in *Exposition d'art canadien*, 13–16. Thiébault-Sisson was the NGC's hired critical gun.

**31** This and the following quotations taken from the NGC file.

**32** Homi Bhabha, *Nation and Narration* (London: Routledge), 1990.

## The McMichael Canadian Art Collection

### RICHARD WILLIAM HILL

A highly condensed and somewhat different version of this essay appeared as a "Short FUSE" in *FUSE Magazine* 23, no. 2 (2000), under the title "Indian Givers: The McMichaels' Revenge on Contemporary Art."

**1** Jean Fisher writes of "the necrophilous codes of the museum" in "Jimmie Durham," in *Matoaka Ale Attakulakula Anel Guledisgo Hnihi* (exhibition catalogue; London: Matts Gallery, 1988).

**2** My friend Kenneth Hayes is always threatening to write an essay on the use of boulders as placeholders for public art in Canada. It's quite true. Once he mentioned it, I began seeing them everywhere.

**3** Christopher Hume, "Saving McMichael Collection by Destroying It Bound to Fail," *Toronto Star*, 30 September 2000, M8.

**4** A lesson that the Art Gallery of Ontario chose to ignore in its relationship with new best buddy Ken Thomson, who was also promised curatorial control over his new wing as well as the mother of all tax breaks.

## Emily Carr

### MARCIA CROSBY

**1** Mike Featherstone discusses the new circumstance of the globalization of art and the effect of enlightenment on other cultures. What is established is a new situation for the artist, product and consumer – polycultural art. Because polyculturalism weakens the established Western hierarchies of cultural taste, the intellectuals must adopt a new role as interpreters in order to maintain their place in the social and art hierarchies. Featherstone describes the exchange value of goods as controlled by the intellectuals, who together with the media have established a monopoly in defining legitimate taste, setting themselves up as interpreters, thus reinforcing their established positions. In doing so, they are free to create a scarcity of goods by responding to consumer demands for cultural diversity and legitimized good taste. The criteria for marketing these new polycultural goods may be summarized as follows: the religious, political, and mythological "use value" of objects within a contextual setting is replaced by "exchange value which privileges the physical and marketable value; 'diversity' is encouraged as a marketable asset, but that difference must be socially recognized and legitimized; legitimation must come from the intellectuals to establish high market value; popularity and expansion of a commodity can lead to devaluation." See Mike Featherstone, "Lifestyle, Theory, and Consumer Culture," *Theory, Culture and Society* 4 (1987): 55–70.

**2** The term "Indian" was first legally defined "by statute of May 26, 1874," through "an act providing for the organization of the Department of the Secretary of State of Canada, and for the management of the Indian and Ordinance Lands, S.C." See *Native Rights in Canada*, ed. Peter Cummings, Neil H. Mickenberg, et al. (Toronto: General Publishing, 1970), 6. This act was preceded by the 1850 Land Act and the 1857 and 1859 Civilization and Enfranchisement Act, whose objectives were ostensibly to protect the Indians and the land until the Indians were considered "civilized" enough to do so themselves (*The Historical Development of the Indian Act*, Policy, Planning and Research Branch, Department of Indian and Northern Affairs, January 1975). These acts eventually became what is known today as the Indian Act, which defines the parameters of those who could be legally defined and recognized by the Canadian government as *Status Indians*; at the same time, the government defined Indians as *non-persons*. Those who did not meet the criteria

were defined as *non-status*. The purpose of the legal designation had to do with the intention of the government to assimilate all aboriginal people into European-Canadian society. It is a paradox that in order to make Indians the same as Euro-Canadians, it was necessary to define indigenous people as separate and apart from that society. The Indian Act not only legislatively defines all First Nations people as a homogeneous whole, but wedges us into the confines of a carefully constructed legal system, historical setting, and geographical place – reserves. The laws pertaining to the many nations contained within the large geographical area now called Canada address an imaginary singular Indian. Yet, despite our national differences, we are bonded together in shared resistance to colonial hegemony. Michael Asch draws attention to one of the ways in which the breadth of diversity in Native cultures is signalled vis-à-vis a change in the name of a national organization to an international one. The National Indian Brotherhood was changed to the Assembly of First Nations, symbolizing a confederation of distinct, national entities, to counter the legislative language of the Indian Act. However, I recognize the accepted usage of the term "Indian" by many First Nations people and respect the right of self-definition. See Michael Asch, *Our Home and Native Land* (Agincourt: Methuen Publications, 1984).

**3** "Kayaks with their occupants, often whole families, were unceremoniously picked up in open waters by ships of Christian seafaring nations and brought home to be first interviewed about their native land and then displayed as self-confessed man-eaters to a grateful public. Of an Eskimo [sic] woman and child brought on a tour to Bavaria in 1566 (after the husband and father had been killed), two handbills announcing their appearance survive ... Live displays of [Inuit] remained a common sight in Germany if we may judge from comments by a seventeenth-century German novelist about recurrent showings of 'Greenlanders and Samoyeds,' and from evidence documenting the practice well into the nineteenth century." See Christian F. Feest, "From North America," in *Primitivism in Twentieth-Century Art: Affinity of the Tribal and the Modern* (New York: Museum of Modern Art, 1984), 86.

**4** James Clifford, "Of Other Peoples: Beyond the Salvage Paradigm," in *Discussions in Contemporary Culture*, ed. Hal Foster (Seattle: Bay Press, 1987), 122.

**5** Emily Carr to Dr H.E. Young, Minister of Education, Victoria, BC, British Columbia Archives and Records Service (BCARS), Victoria.

**6** "Soon, soon the old villages will be a thing of the past ... they used to be and

now are not" (Phyllis Inglis Collection, BCARS).

**7** Paula Blanshard, *The Life of Emily Carr* (Vancouver: Douglas & McIntyre, 1988), 293.

**8** D.C. Scott, Evidence to Commons Committee to consider Bill 14, 1920. Although it was the Canadian government's intention to absorb all Indians into the body politic, when Carr stopped travelling to the villages in 1930, it was the time of the Great Depression for all Canadians. It was a time of massive collapse of First Nations wage labour. However, it was certainly not a time of total despair. There was a resurgence of Native self-identification: in 1932 the Native Brotherhood was formed, and as a defence measure to the economic collapse, the Pacific Coast Native Fisherman's Association was also formed. See Rolf Knight, *Indians at Work: An Informal History of Native Indian Labour in British Columbia, 1858–1930* (Vancouver: New Star, 1978).

**9** Emily Carr to Dr. H.E. Young, Minister of Education, BCARS.

**10** Emily Carr, in two notebooks, BCARS.

**11** An entry from Jack Shadbolt's journal, 24 February 1985, quoted in Marjorie Halpin, *Jack Shadbolt and the Coastal Indian Image* (Vancouver: University of British Columbia Press, 1986), 25.

**12** Scott Watson, *Jack Shadbolt* (Vancouver: Douglas & MacIntyre, 1990), 209, 219.

**13** Ibid., 7, 129, 164, 209, 219.

**14** Barbara Williamson, "The Pizza Syndrome," *Project North B.C. Newsletter*, fall 1989, 1–2.

**15** See Roland Barthes, *Mythologies*, trans. Annette Lavers (London: Paladin, 1957).

## GERTA MORAY

**1** Emily Carr, *Klee Wyck* (Toronto: Oxford University Press, 1941). The period Carr covers in the book is from the 1880s to the early 1930s.

**2** In British Columbia, few treaties for the surrender of land had been made with the aboriginal peoples, who were disenfranchised when the province entered the Canadian Confederation in 1871. A federal Special Joint Committee of the Senate and House of Commons in Ottawa delivered a final rejection of the British Columbia Native peoples' claims to aboriginal land title in 1927. See Wilson Duff, *The Indian History of British Columbia* (Victoria: British Columbia Provincial Museum, 1965), 69; and E. Brian Titley, *A Narrow Vision: Duncan Campbell Scott and the Administration of Indian Affairs in Canada* (Vancouver: University of British Columbia Press, 1986), 154–9. The political implications of the 1927 National Gallery exhibition have been fully discussed by Ann K. Morrison, "Canadian Art and Cultural Appropriation: Emily Carr and the 1927 Exhibition of Canadian West Coast Art, Native and Modern" (master's thesis, University of British Columbia, 1991). They will be further explored later in this paper.

**3** For museum collecting, see George W. Stocking, ed., *Objects and Others: Essays on Museums and Material Culture* (Madison: University of Wisconsin Press, 1985); George W. Stocking, *Victorian Anthropology* (New York: The Free Press, 1987); Douglas Cole, *Captured Heritage: The Scramble for Northwest Coast Artefacts* (Toronto: Douglas & McIntyre, 1985). For artistic primitivism, see Robert Goldwater, *Primitivism in Modern Art* (1938; reprint. New York: Vintage Books, 1967); William Jackson Rushing, *Native American Art and Culture and the New York Avant-Garde* (Ann Arbor: University Microfilms International, 1990); Molly H. Mullin, "The Patronage of Difference: Making Indian Art 'Art, Not Ethnology,'" in *The Traffic in Culture: Refiguring Art and Anthropology*, ed. G. Marcus and F. Myers (Berkeley:

University of California Press, 1995); and James Clifford, *The Predicament of Culture: Twentieth-Century Ethnography, Literature, and Art* (Cambridge, Mass.: Harvard University Press, 1988).

**4** Paul Greenhalgh, *Ephemeral Vistas: The Expositions Universelles, Great Exhibitions and World's Fairs, 1851–1939* (Manchester: Manchester University Press, 1988); Robert Rydell, *All the World's a Fair: Visions of Empire at American Expositions, 1876–1916* (Chicago: University of Chicago Press, 1984).

**5** Marcia Crosby, "Construction of the Imaginary Indian," in *Vancouver Anthology: The Institutional Politics of Art*, ed. Stan Douglas (Vancouver: Talonbooks, 1991), 276–7.

**6** For a discussion of Carr's legend, see Stephanie K. Walker, *This Woman in Particular: Contexts/or the Biographical Image of Emily Carr* (Waterloo, Ont.: Wilfrid Laurier University Press, 1996).

**7** A detailed study of Carr's work in its social and historical contexts (on which this paper draws) can be found in Gerta Moray, "Northwest Coast Native Culture and the Early Indian Paintings of Emily Carr, 1899–1913" (PhD dissertation, University of Toronto, 1993).

**8** Mullin, "The Patronage of Difference," 167.

**9** See Kirk Varnedoe, "Gauguin," in William Rubin, ed., *"Primitivism" in 20th Century Art: Affinity of the Tribal and the Modern* (New York: Museum of Modern Art, 1984).

**10** *Province* (Vancouver), 3 April 1912.

**11** British Columbia Archives and Records Service, Carr Papers, "Growing Pains" (MS, not paginated).

**12** On the colonial power relations and sexual fantasies that underlay Gauguin's Tahitian images, see Abigail Solomon-Godeau, "Going Native," *Art in America* 77 (July 1989): 118–22.

**13** The representation of Native peoples in Canada has been discussed by, among others, Terry Goldie, *Fear and Temptation: The Image of the Indigene in Canadian, Australian and New Zealand Literatures* (Kingston and Montreal: McGill-Queen's University Press, 1989); Robin Fisher, *Contact and Conflict: Indian-European Relations in British Columbia, 1774–1890* (Vancouver: University of British Columbia Press, 1977); François-Marc Gagnon, *Ces hommes dits sauvages* (Montreal: Libre expression, ca. 1985); Heather Dawkins, "Paul Kane and the Eye of Power: Racism in Canadian Art History," *Vanguard*, September 1986, 24–7; Crosby, "Construction of the Imaginary Indian"; Maureen Ryan,

"Picturing Canada's Native Landscape: Colonial Expansion, National Identity, and the Image of a 'Dying Race,'" *RACAR* 27 (1990): 138–9; and Daniel Francis, *The Imaginary Indian: The Image of the Indian in Canadian Culture* (Vancouver: Arsenal, 1992).

**14** Emily Carr, *Growing Pains: The Autobiography of Emily Carr*, 2nd ed. (Toronto: Clarke, Irwin, 1966), 211.

**15** Modernist aesthetics have privileged the development of formal possibilities in pursuit of an original style as the criterion for the best art. Consequently, Carr's documentary paintings of 1912 were dismissed as artistically immature by the principal writers on her work. See Lawren Harris, *Emily Carr: Her Paintings and Sketches* (Toronto: Oxford University Press, 1945), 19; and Doris Shadbolt, *The Art of Emily Carr* (Vancouver: Douglas & McIntyre, 1979), 30, 38–40.

## COLE HARRIS

**1** Carl Berger, "The True North Strong and Free," in *Nationalism in Canada*, ed. Peter Russell (Toronto, 1966), 3ff.
**2** Frank Watt, "Nationalism in Canadian Literature," in *Nationalism in Canada*, 238–46.
**3** William Morton, *The Canadian Identity* (Madison and Toronto, 1961), 4–5.
**4** M.L. Hansen, *The Mingling of the Canadian and American Peoples* (New Haven and Toronto, 1940).
**5** J.B. Brebner, *Canada* (Ann Arbor, 1960), ix.
**6** Harold Innis, *The Fur Trade in Canada* (New Haven, 1930).

## ROALD NASGAARD

**1** Richard Bergh, "Den nationalla konsten," 1902, in *Om Konst och annat* (Stockholm: Albert Bonnier, 1908), 168.
**2** Arthur Lismer, "Art in Canada," *Twentieth Century* 11, no. 1 (November 1933).
**3** F.B. Housser, *A Canadian Art Movement: The Story of the Group of Seven* (Toronto: Macmillan, 1926), 63.
**4** Housser, "The Amateur Movement in Canadian Painting," in *Yearbook of the Arts in Canada, 1928–1929* (Toronto: Macmillan, 1929), 83–4.
**5** A.Y. Jackson, Introduction to *Exhibition of Paintings by the Late Tom Thomson* (Montreal: The Arts Club, 1919); cited in Peter Mellen, *The Group of Seven* (Toronto: McClelland and Stewart, 1970), 45.
**6** Ann Davis, "An Apprehended Vision: The Philosophy of the Group of Seven" (PhD dissertation, York University, Toronto, 1973), 184.
**7** Robert Stacey, "A Contact in Context: The Influence of Scandinavian Landscape Painting on Canadian Artists before and after 1913," *Northward Journal*, no. 18–19 (1980): 53.
**8** Reprinted in *Northward Journal*, no. 18–19 (1980): 9–35.
**9** C.W. Jefferys, "MacDonald's Sketches," *The Lamps* (December 1911);
cited in Dennis Reid, *The Group of Seven* (Ottawa: National Gallery of Canada, 1970), 29.
**10** Lawren Harris, "The Group of Seven" talk delivered in the Vancouver Art Gallery, April 1954, cited in Mellen, *The Group of Seven*, 23; and "The Group of Seven in Canadian History," in *The Canadian Historical Association: Report of the Annual Meeting Held at Victoria and Vancouver June 16–19, 1948*, ed. A. Preston (Toronto: University of Toronto Press, 1948), 31.

## ROBERT STACEY

**1** Robertson Davies, "Party of One: The Northern Muse," *Holiday*, April 1964, repr. in *The Well-Tempered Critic: One Man's View of Theatre and Letters in Canada*, ed. J.S. Grant (Toronto: McClelland & Stewart, 1981), 133–7.
**2** Margaret Atwood, "Death by Landscape," *Harpers* 281 (August 1990): 49.
**3** J.E.H. MacDonald to F.B. Housser, 20 December 1926 (unsent); photocopy in J.E.H. MacDonald Papers, Library and Archives Canada, Ottawa.
**4** C. Lewis Hind, "Life and I," *Daily Chronicle*, 30 April 1924: excerpted in *Press Comments on the Canadian Section of Fine Arts, British Empire Exhibition 1924–25* (Ottawa: National Gallery of Canada, 1925), 9.
**5** Sir John Douglas Sutherland Campbell, Marquis of Lorne, "The Opening of an Art Institute of Montreal in 1879," in *Memories of Canada and Scotland: Speeches and Verses* (London: Sampson Low, Marston, Searle & Rivington, 1894), 220.
**6** Lawren S. Harris, "Revelation of Art in Canada: A History," *Canadian Theosophist*, 1926, 86.
**7** Brian S. Osborne, "The Iconography of Nationhood in Canadian Art," in *The Iconography of Landscape*, ed. Denis Cosgrove and Stephen Daniels (Cambridge: Cambridge University Press. 1988, repr. 1989), 172.
**8** Reid MacCallum, "The Group of Seven: A Retrospect," in *Imagination*

*and Design and Other Essays*, ed. William Blissett (Toronto: University of Toronto Press, 1953), 163. Originally published in 1933.
**9** P.G. Konody, "The Palace of Arts at Wembley," *Observer*, 24 May 1925; quoted in *Press Comments on the Canadian Section of Fine Arts*, 9.
**10** F.B. Housser, *A Canadian Art Movement: The Story of the Group of Seven* (Toronto: Macmillan Co. of Canada, 1926; repr. Toronto, 1974), 162.
**11** Ibid., 14.

## GRANT ARNOLD

**1** John Vanderpant, "Tradition in Art," *Photographic Journal* 68 (November 1928): 448.
**2** Ibid., 447.
**3** See Charles C. Hill, *John Vanderpant Photographs* (Ottawa: National Gallery of Canada, 1976), 85.
**4** Andrew C. Rodger, "So Few Earnest Workers, 1914–1930," in *Private Realms of Light: Amateur Photography in Canada 1839–1940*, ed. Lilly Koltun (Markham: Fitzhenry & Whiteside, 1984), 80.
**5** John Vanderpant, "Danger of the Photographic Salon," *Camera Craft* 5, no. 33 (November 1926), 510–1.
**6** Harold Mortimer-Lamb, "Pictorial Photography in Canada," in *Photograms of the Year 1913*, cited in Rodger "So Few Earnest Workers," 80.
**7** Arthur Goss, "Pictorial Photography in Canada" in *Photograms of the Year 1920*, cited in Rodger, p. 81.
**8** Alfred Brooker Klugh, "Landscape Photography in Canada," *Amateur Photographer & Photography* 29 (April 1925), cited in Rodger, p. 81.
**9** While most art museums did not exhibit photography during the first two decades of this century, there were a few exceptions to the rule. The Albright Gallery in Buffalo, for example, mounted a major photography exhibition in 1911. The exhibition was selected by Alfred Stieglitz and included the work of Canadians Sydney Carter and J.P. Hodgins. See Lilly Koltun, "Arts Ascendent/1900–1914," in *Private Realms of Light*, 46.
**10** From the foreword to the catalogue of the third Group of Seven exhibition, 1922, cited in Peter Mellen, *The Group of Seven* (Toronto and Montreal: McClelland and Stewart, 1970), p. 217.
**11** Vanderpant, "Tradition in Art," 447.
**12** Ibid.
**13** Ibid., 448.
**14** Ibid.
**15** See Rodger "So Few Earnest Workers"; also Helga Pakasaar, "Formulas for the Picturesque: Vancouver Pictorialist Photography 1930–45," in *Vancouver: Art and Artists 1931–1983*, exhibition catalogue

(Vancouver: Vancouver Art Gallery, 1983).
**16** F.B. Housser, *A Canadian Art Movement: The Story of the Group of Seven* (Toronto: Macmillan Company of Canada, 1926) 151.
**17** Ibid., 154–5.

## SCOTT WATSON

**1** F.B. Housser, *A Canadian Art Movement: The Story of the Group of Seven* (Toronto: Macmillan Company of Canada, 1926), 32.
**2** Lawren Harris, "Revelation of Art in Canada," *Canadian Theosophist* 7, no. 5 (15 July 1926): 85–6.
**3** Joseph Schull, *Ontario since 1867* (Toronto: McClelland and Stewart, 1978), 43.
**4** See Allan John Fletcher, "Industrial Algoma and the Myth of Wilderness: Algoma Landscapes and the Emergence of the Group of Seven 1918–1920" (MA thesis, Department of Fine Arts, University of British Columbia, 1989).
**5** Reasons for judgment of the Honourable Chief Justice Allan McEachern, no. 0843, Smithers Registry in the Supreme Court of British Columbia, dates of trial: 374 days between 11 May and 30 June 1990, 193. It is quite clear that in this legal judgment territory is empty, must be empty, when the Gitskan and Wet'suwet'en claim it as theirs, but it can become full when thought of in terms of logging leases and mining permits.

## REESA GREENBERG

**1** Reesa Greenberg, "Unframing the Canadian Frame," *Vanguard*, February 1984, 35.
**2** Stephanie White, "Museums and Their Buildings: Our National Galleries," *Vanguard*, February 1985, 10.

## ESTHER TRÉPANIER

**1** François-Marc Gagnon, "La peinture des années trente au Quebec," *Journal of Canadian Art History/Annales d'histoire de l'art canadien* 3, nos. 1 and 2 (1976): 2–20.
**2** Nigog: "mot d'origine sauvage designant un instrument à darder le poisson et particulièrement le saumon" (Sylva Chapin, *Dictionnaire canadien-français*: quoted in no. I of *Le Nigog*, January 1918). Concerning this cultural avant-garde journal which appeared in Montreal in 1918, see the joint publication of the Archives des Lettres canadiennes VII, *Le Nigog* (Montreal: Fides, 1987).
**3** Fernand Préfontaine, "Le sujet en art," *Le Nigog*, no. 2 (February 1918): 44.
**4** Jean Chauvin, "A l'atelier d'Edwin Holgate," *La Revue populaire* 20, no. 2 (February 1927): 9. For an analysis of the status of Chauvin, see my article "Deux portraits de la critique d'art des années vingt Albert Laberge et Jean Chauvin," *Journal of Canadian Art History/Annales d'histoire de l'art canadien* 12, no. 2 (1989): 141–73.
**5** Jean Chauvin, "Chez le peintre Marc-Aurèle Fortin," *La Revue populaire* 20, no. 9 (September 1927): 7. Chauvin was also aware of the question of the influence of Scandinavian painting on the Group of Seven. He emphasized it several times and returned to it in an article he published, "L'influence de la peinture française sur la peinture canadienne," *La Revue populaire* 30, no. 8 (April 1937): 5 and 50.
**6** Jean Chauvin, *Ateliers, Études sur vingt-deux peintres et sculpteurs canadiens* (Toronto, Montreal, New York: Louis Carrier et Cie, Les Éditions du Mercure, 1928), 210.
**7** N.S. [Albert Laberge], "Exposition de paysages par Lawrin [sic] Harris au Arts Club," *La Presse*, 3 March 1924, 2.
**8** Chauvin, *Ateliers*, 81.
**9** Ibid., 135.
**10** Ibid., 184.
**11** Ibid., 214.
**12** Pierre Bourcier, "Notre Salon d'Automne," *La Revue nationale* 11, no. 1 (January 1921): 8.
**13** Jean Chauvin, "La Societe des Sculp-teurs du Canada," *La Revue populaire* 22, no. 6 (June 1929): 8.
**14** For the 1930s, see, among others, the catalogue by Charles C. Hill, *Canadian Painting in the Thirties* (Ottawa: National Gallery of Canada, 1975), and the text quoted in note 1 of F.-M. Gagnon, which is the article I edited, "La peinture des années trente au Québec," for the issue "Esthétiques des années trente" of the journal *Protée* 17, no. 3 (autumn 1989), Université du Québec à Chicoutimi.

## ROBERT LINSLEY

**1** Christopher Varley, *F.H. Varley* (Edmonton: Edmonton Art Gallery, 1981), 134–6.
**2** Harold Innis, *The Fur Trade in Canada* (Toronto: Toronto University Press, 1962); cited in Patricia Marchak, *Green Gold* (Vancouver: University of British Columbia Press, 1983), 23: "The economic history of Canada has been dominated by the discrepancy between the centre and the margins of Western civilization. Energy has been directed toward the exploitation of staples products and the tendency has been cumulative … Agriculture, industry, transportation, trade, finance and governmental activities tend to become subordinate to the production of the staple for a more highly specialized manufacturing community."
**3** Marchak, *Green Gold*, 29.
**4** G.M. Grant, *Ocean to Ocean* (Toronto: James Campbell & Son, 1873); quoted in Michael Bell, *Painters in a New Land* (Toronto: McClelland and Stewart, 1973), 202.
**5** "Sometimes the essential experience is one of ecstasy – the experience of identity with all creation." See Doris Shadbolt, *The Art of Emily Carr* (Vancouver: Douglas & McIntyre, 1979), 140.
**6** Ibid.

## JONATHAN BORDO

**1** *Voyageurs and Canoemen of the Assiniboine and Saskatchewan Exploring Expedition*, 2 June 1858, photograph by Humphrey Lloyd Hime, Library and Archives Canada (C-4574); henceforth abbreviated to *Voyageurs and Canoemen*.
**2** Hime accompanied the Hind expedition, which is chronicled in Henry Youle Hind, *Narrative of the Canadian Red River Expedition of 1857 and of the Assinniboine and Saskatchewan Exploring Expedition of 1858* (Edmonton: M.G. Hurtig, 1971).
**3** *Portaging a Canoe and Baggage, Illustrated London News*, 16 October 1858, Library and Archives Canada (C-61755).
**4** *Le Petit Robert* (Paris, 1972).
**5** *The Oxford Universal Dictionary* (1933).
**6** By Euro-Canadian I want to distinguish between the American and Canadian concepts of the wilderness. Both have a source in the European landscape tradition. The position I am developing seeks to elucidate the difference between these wilderness traditions, and the method and approach reflects that difference. Thus, Euro-Canadian might be useful to impose a barrier on the imperial American ecosophy, but it is far too vague to account for the almost invisible and local sources of subjectivity in an area which might be called the Laurentian shield. Hence, sometimes I will refer to Tom Thomson and the Group of Seven as Euro-Laurentian wilderness painters.
**7** John Wadland, "Wilderness and Culture," in *Nastawgan: The Canadian North by Canoe & Snowshoe: A Collection of Historical Essays*, ed. Bruce W. Hodgins and Margaret Hobbs (Toronto: Betelgeuse Books, 1985), 223. See also Terry Goldie, *Fear and Temptation* (Montreal: McGill-Queen's University Press, 1989).
**8** I follow Peter Burger and T.J. Clark in this conceptualization, but without ideological zeal.
**9** *Indians Crossing Georgian Bay* refers to the painting that has just been renamed *A Wind-swept Shore*.
**10** When I speak about the tree figure in Tom Thomson's painting entitled *The Jack Pine*, I will refer to it with the definite article as *The Jack Pine*, but when I speak more generically of the tree figure in so much as it appears in other Laurentian paintings and in the work of other artists, I shall refer to his more general object without the definite article, as *Jack Pine*.
**11** See, for example, John K. Howat, *American Paradise* (New York: Metropolitan Museum of Art, 1988), and especially Barbara Novak, *Nature and Culture* (New York: Oxford University Press, 1980), B.J. Wolf, *Romantic Revision* (Chicago: University of Chicago Press, 1982). Dennis Reid, in *Lucius O'Brien: Visions of Victorian Canada* (Toronto: Art Gallery of Ontario, 1990), discretely suggests tentative connections between the Hudson River School and Lucius O'Brien without much analysis of the importance of the influence.

## DOT TUER

**1** Northrop Fyre, "The Narrative Tradition in English Language Poetry," in *The Bush Garden: Essays on the Canadian Imagination* (Toronto: Anansi, 1971), 146.

**Adams, Steven**, and **Anna Gruetzner**, eds. *Gendering Landscape Art*. Manchester: Manchester University Press, 2000.

**Adamson, Jeremy**. *Lawren S. Harris: Urban Scenes and Wilderness Landscapes 1906-1939*. Toronto: Art Gallery of Ontario, 1978.

**Anderson, Benedict**. *Imagined Communities: Reflections on the Origin and Spread of Nationalism*. London: Verso, 1993.

–"Staging Antimodernism in the Age of High Capitalist Nationalism." In *Antimodernism and Artistic Experience: Policing the Boundaries of Modernity*, ed. Lynda Jessup. Toronto: University of Toronto Press, 2001.

**Andrews, Malcolm**. *Landscape and Western Art*. Oxford: Oxford University Press, 1999.

**Angus, Ian**. *A Border Within: National Identity, Cultural Plurality, and Wilderness*. Montreal and Kingston: McGill-Queen's University Press, 1997.

**Appadurai, Arjun**. *Modernity at Large: Cultural Dimensions of Globalization*. Minneapolis: University of Minnesota Press, 1996.

**Arnold, Grant**. "The Terminal City and the Rhetoric of Utopia." *Collapse* 5 (2000): 31–93.

**Atwood, Margaret**. *Survival: A Thematic Guide to Canadian Literature*. Toronto: Anansi, 1972.

–*Wilderness Tips*. Toronto: McClelland and Stewart, 1991.

**Augaitis, Daina**, ed. *Stan Douglas*. Vancouver: Vancouver Art Gallery, 1990.

**Augaitis, Daina**, and **Helga Pakasaar**, eds. *Eye of Nature*. Banff: Walter Phillips Gallery, 1989.

**Bannerji, Himani**. *The Dark Side of the Nation: Essays on Multiculturalism, Nationalism and Gender*. Toronto: Canadian Scholar's Press, 2000.

**Beer, Ruth Sulamith**. "Landscape and Identity." PhD thesis, University of British Columbia, 1999.

**Berger, Carl**. "The True North Strong and Free." In *Nationalism in Canada*, ed. Peter Russell, Toronto: McGraw-Hill, 1966.

**Berger, Thomas R**. *Northern Frontier Northern Homeland: The Report of the Mackenzie Valley Pipeline Inquiry*. Rev. ed. Vancouver and Toronto: Douglas and McIntyre, 1988.

**Berland, Jody**. "Space at the Margins: Colonial Spatiality and Critical Theory after Innis," *Topia* 1 (spring 1997): 55–82.

**Bermingham, Ann**. *Landscape and Ideology: The English Rustic Tradition, 1740-1860*. Berkeley and Los Angeles: University of California Press, 1986.

**Bhabha, Homi K**. *Nation and Narration*. London: Routledge, 1990.

**Bice, Megan**. *Light and Shadow: The Work of Franklin Carmichael*. Kleinburg: McMichael Canadian Art Collection, 1990.

**Bordo, Jonathon**. "Jack Pine – Wilderness Sublime or the Erasure of the Aboriginal Presence from the Landscape." *Journal of Canadian Studies/Revue d'études canadiennes* 27, no. 4 (1992–93): 98–128.

–"Picture and Witness at the Site of Wilderness." *Critical Inquiry* 26 (winter 2000): 225–47.

**Burnett, D. Graham**. *Masters of All They Surveyed: Exploration, Geography, and a British Eldorado*. Chicago: University of Chicago Press, 2000.

**Butler, Cornelia**. "Outnumbered by the Trees: The Canadianness of Rodney Graham." In *Rodney Graham: A Little Thought*, ed. Grant Arnold, Jessica Bradley, and Cornelia Butler. Vancouver/Toronto/Los Angeles: Vancouver Art Gallery/Art Gallery of Ontario, Los Angeles Museum of Contemporary Art, 2005.

**Cavell, Richard**. *McLuhan in Space: A Cultural Geography*. Toronto: University of Toronto Press, 2002.

–"Theorizing Canadian Space: Postcolonial Articulations." In *Canada: Theoretical Discourse/Discours théoriques*, ed. Terry Goldie, Carmen Lambert, and Rowland Lorimer. Montreal: Association for Canadian Studies, 1994.

**Cole, Douglas**. "Artists, Patrons and Public: An Enquiry into the Success of the Group of Seven." *Journal of Canadian Studies* 13, no. 2 (summer 1978): 69–78.

**Cook, Ramsay**. "Landscape Painting and National Sentiment in Canada." *Historical Reflections* 1, no. 2 (1974): 263–83.

**Cosgrove, Dennis**, and **Stephen Daniels**, eds. *The Iconography of Landscape*. Cambridge: Cambridge University Press, 1998.

**Crosby, Marcia**. "Construction of the Imaginary Indian." In *Vancouver Anthology: The Institutional Politics of Art*, ed. Stan Douglas. Vancouver: Talon Books, 1991.

**Culley, Peter**. "A Bustle in Your Hedgerow: Long Beach, Led Zeppelin and the West Coast Sublime." In *Public 28: Satan Oscillate My Metallic Sonatas*, ed. Reid Shier and William Wood. Vancouver and Toronto: Contemporary Art Gallery and Public Access, 2003.

**Curnoe, Greg**. "Amendments to Continental Refusal/Refus Continental." *20 Cents Magazine* 4 (April 1970).

**Davis, Ann**. *The Logic of Ecstasy: Canadian Mystical Painting, 1920–1940.* Toronto: University of Toronto Press, 1992.

–"The Wembley Controversy in Canadian Art." *Canadian Historical Review* 54, no. 1 (March 1973): 48–74.

**Dawn, Leslie**. *National Visions, National Blindness: Canadian Art and Identities.* Vancouver: UBC Press, 2006.

**Deadman, Particia**, and **Paul Seesequasis**. *Staking LAND Claims.* Banff: Banff Centre Press, 1993.

**Dempsey, Ranger Shawna**, and **Ranger Lorri Millan**. *Lesbian National Parks and Services Field Guide to North America: Flora, Fauna & Survival Skills.* Toronto: Pedlar Press, 2002.

**Derksen, Jeff**. "Fugitive Spaces – Jin-me Yoon." Vancouver: Catriona Jeffries Gallery, 2004. www.catrionajeffries.com/b_jm_yoon_texts.html.

**de Duve, Thierry**. "Michael Snow and Deictis of Experience." *Parachute* 78 (spring 1995): 28–41.

**Donegan, Rosemary**. *Industrial Images/Images industrielles.* Hamilton: Art Gallery of Hamilton, 1987.

**Dorland, Michael**. "A Thoroughly Hidden Country: Ressentiment, Canadian Nationalism, Canadian Culture." In *Sightlines: Reading Contemporary Canadian Art*, ed. Jessica Bradley and Lesley Johnstone. Montreal: Artextes editions, 1994.

**Douglas, Stan**, ed. *Vancouver Anthology: The Institutional Politics of Art.* Vancouver: Talon Books, 1991.

**Duffek, Karen**, and **Tom Hill**. *Beyond History.* Vancouver: Vancouver Art Gallery, 1988.

**Duval, Paul**. *The Tangled Garden: The Art of J.E.H. MacDonald.* Toronto: Cerebrus/Prentice-Hall, 1978.

**Edelstein, Susan**. "A Transfer of Power." In *Unbidden – Jin-me Yoon.* Kamloops: Kamloops Art Gallery, 2004.

**Ferguson, Bruce W**. "Northern Noises." In *Sightlines: Reading Contemporary Canadian Art*, ed. Jessica Bradley and Lesley Johnstone. Montreal: Artextes editions, 1994.

**Fetherling, Douglas**. *Documents in Canadian Art.* Peterborough, Ont.: Broadview Press, 1987.

**Fischer, Barbara**, ed. *General Idea Editions 1967–1995.* Mississauga: Blackwood Art Gallery, 2004.

**Flam, Jack**, ed. *Robert Smithson: The Collected Writings.* Berkeley: University of California Press, 1996.

**Fleming, Marie**. *Baxter²: Any Choice Works.* Toronto: Art Gallery of Ontario, 1982.

–*Joyce Wieland.* Toronto: Art Gallery of Ontario, 1987.

**Fletcher, Allan John**. "Industrial Algoma and the Myth of Wilderness: Algoma Landscape and the Emergence of the Group of Seven, 1918–1920." MA thesis, Department of Fine Arts, University of British Columbia, 1989.

**Foss, Brian**. "'Synchromism' in Canada: Lawren Harris, Decorative Landscape and Willard Huntington Wright, 1916–17." *Journal of Canadian Art History* 20, no. 1 (1999): 66–90.

**Francis, Daniel**. *Myth, Memory, and Canadian History.* Vancouver: Arsenal Pulp Press, 1997.

**Frye, Northrop**. *The Bush Garden: Essays on the Canadian Imagination.* Toronto: House of Anansi Press, 1971.

**Fulford, Robert**. "The Trouble with Emily." *Canadian Art*, winter 1993, 33–9.

**Gagnon, François-Marc**. "Painting in Quebec in the Thirties." *Journal of Canadian Art History* 3, no. 1/2 (fall 1976): 2–20.

**Grace, Sherrill**. *Canada and the Idea of North.* Montreal and Kingston: McGill-Queen's University Press, 2002.

–*Inventing Tom Thomson: From Biographical Fictions to Fictional Autobiographies and Reproductions.* Montreal and Kingston: McGill-Queen's University Press, 2004.

**Greenberg, Reesa**. "Defining Canada." *Collapse* 3 (1997): 95–118.

**Grenville, Bruce**, ed. *The Post-Colonial Landscape.* Saskatoon and Edmonton: Mendel Art Gallery and Edmonton Art Gallery, 1997.

**Gu Xiong**. *Gu Xiong: Yellow River/Blue Moon.* Kamloops: Kamloops Art Gallery, 2002.

**Gu Xiong** and **Andrew Hunter**. *Ding Ho/Group of 7.* Kleinburg: McMichael Canadian Art Collection, 2000.

**Harper, J. Russell**. *Painting in Canada: A History.* Toronto: University of Toronto Press, 1966.

**Harris, Cole**. "How Did Colonialism Dispossess? Comments from an Edge of Empire." In *Annals of the Association of American Geographers.* Malden, Mass.: Blackwell, 2003.

–"The Myth of the Land in Canadian Nationalism." In *Nationalism in Canada*, ed. Peter Russell. Toronto: McGraw-Hill, 1966.

**Henry, Karen**, and **Karen Love**. *Variations on the Picturesque.* Kitchener, Ont.: Kitchener-Waterloo Art Gallery, 2005. www.kwag.on.ca/user_files/images/File/Catalogues/votp_cataloguefeb06lores.pdf.

**Hill, Charles C**. *Canadian Painting in the Thirties.* Ottawa: National Gallery of Canada, 1975.

–*The Group of Seven: Art for a Nation.* Ottawa: National Gallery of Canada, 1995.

**Hill, Charles C**., **Johanne Lamoureux**, and **Ian M. Thom**, eds. *Emily Carr: New Perspectives on a Canadian Icon.* Vancouver: Douglas & McIntyre, 2006.

**Hudson, Anna**. "Art and Social Progress: The Toronto Community of Painters, 1933–1950." PhD thesis, University of Toronto, 1998.

**Hunter, Andrew T**. *The Other Landscape.* Edmonton: Edmonton Art Gallery, 2003.

**Hurtig, Annette**. *The Culture of Nature: Art and its Practices (An Investigation of Contemporary Art).* Kamloops: Kamloops Art Gallery, 1996.

**Ipellie, Alootook**. "The Colonization of the Arctic." In *Indigena: Contemporary Native Perspectives*, ed. Gerald McMaster and Lee-Ann Martin. Hull: Canadian Museum of Civilization, 1992.

**Igloolik Isuma Productions**. "A Proposal to Telefilm Canada for Nunavut 1993." In *Video re/View*, ed. Peggy Gale and Lisa Steele. Toronto: Art Metropole and V Tape, 1996.

–*Igloolik Video by Artists.* Igloolik: Igloolik Isuma Productions and Amait Video Productions. www.atanarjuat.com/media_centre/catalog_LR.pdf.

**Jackson, W. Rushing, III**. "Beautiful Object = Paradigm of Power: Robert Houle from A to Z." In *Robert Houle: Subject over Sovereignty*, ed. Shirley Madill. Winnipeg: Winnipeg Art Gallery, 1999.

**Jameson, Fredric**. "Periodizing the 60s." In *The 60s without Apology*, ed. Sonja Sayres et al. Minneapolis: University of Minnesota Press, 1984.

**Jessup, Lynda**, ed. *Antimodernism and Artistic Experience: Policing the Boundaries of Modernity.* Toronto: University of Toronto Press, 2001.

–"Art for a Nation?" *Fuse Magazine* 19, no. 4 (1996): 11–14.

–"The Group of Seven and the Tourist Landscape in Western Canada, or The More Things Change …" *Journal of Canadian Studies* 37, no. 1 (spring 2002): 144–79.

**Johnstone, Lesley**. "Building Images into Houses." In *Michel Saulnier: Recent Work.* Lethbridge: Southern Alberta Art Gallery, 1986.

**Kennedy-Troya, Alexandra**. "La percepción de lo propio: paisajistas y científicos ecuatorianos del siglo XIX." In *El Regresso de Humbolt*, ed. Frank Holl. Quito: Museo de la Ciudad, 2001.

**Kroker, Arthur**. *Technology and the Canadian Mind: Innis/McLuhan/Grant.* Montreal: New World Perspectives, 1984.

**Landry, Pierre B**. *The MacCallum-Jackman Cottage Mural Paintings.* Ottawa: National Gallery of Canada, 1990.

**Langford, Martha**. "Lost Horizons, or the Gates Close at Sunset: Doubtful Realisms and Paradisiacal Gains." In *Image & Imagination*, ed. Martha Langford. Montreal: McGill-Queen's University Press, 2005.

**Lefebvre, Henri**. *The Production of Space.* Cambridge, Mass.: Blackwell, 1991.

**Linsley, Robert**. "Landscapes in Motion: Lawren Harris, Emily Carr and the Heterogeneous Modern Nation." *Oxford Art Journal* 19 (1996): 80–95.

–"Painting and the Social History of British Columbia." In *Vancouver Anthology: The Institutional Politics of Art*, ed. Stan Douglas. Vancouver: Talon Books, 1991.

**Lord, Barry**. *The History of Painting in Canada: Toward a People's Art.* Toronto: NC Press, 1974.

**MacDonald, Mike**. *Butterfly Garden.* http://snac.mb.ca/projects/butterfly_garden/.

–"Mike MacDonald Interviewed by Tom Sherman." In *Mike MacDonald: The Seven Sisters.* Toronto: Mercer Union, 1991.

**Mackey, Eva**. *The House of Difference: Cultural Politics and National Identity.* London and New York: Routledge, 1999.

**McGregor, Gaile**. *The Wacousta Syndrome: Exploration in the Canadian Langscape.* Toronto: University of Toronto Press, 1985.

**McLuhan, Marshall**. "Technology and Environment." *artscanada*, no. 105 (February 1967): 5–7.

–*Understanding Media: The Extensions of Man.* Toronto: McGraw-Hill, 1964.

McMaster, Gerald. *Edward Poitras: Canada XLVI Biennale di Venezia*. Hull: Canadian Museum of Civilization, 1992.

McMaster, Gerald, and Lee-Ann Martin. *Indigena: Contemporary Native Perspectives*. Hull: Canadian Museum of Civilization, 1992.

Manning, Erin. *Ephemeral Territories: Representing Nation, Home, and Identity in Canada*. Minneapolis: University of Minnesota Press, 2003.

Manore, Jean L. "Wilderness and Territoriality: Different Ways of Viewing the Land." *Journal of Canadian Studies*, no. 2 (summer 1998): 77–83.

Marx, Leo. *The Machine in the Garden: Technology and the Pastoral Ideal in America*. New York: Oxford University Press, 1964.

Mastin, Catharine M., ed. *The Group of Seven in Western Canada*. Calgary and Toronto: Glenbow Museum and Key Porter, 2002.

Mellen, Peter. *The Group of Seven*. Toronto: McClelland and Stewart, 1970.

Metcalfe, Robin. "Marlene Creates." *CV Photo* 43 (summer 1998): 15–28.

–"Mike MacDonald: Digital Garden." In *Mike MacDonald: Digital Garden*. Halifax: Mount Saint Vincent University Art Gallery, 1997.

Miller, Angela. *Empire of the Eye: Landscape Representation and American Cultural Politics*. Ithaca: Cornell University Press, 1992.

Mitchell, W.J.T., ed. *Landscape and Power*. Chicago: University of Chicago Press, 1994.

–"Space, Place, and Landscape." In *Territories*, ed. Anselm Franke. Berlin: KW–Institute for Contemporary Art, 2003.

Monk, Philip. "Models, Maps and Signs," *C Magazine* 39 (fall 1993): 43–55.

Moray, Gerta. "Emily Carr and the Traffic in Native Images." In *Antimodernism and Artistic Experience: Policing the Boundaries of Modernity*, ed. Lynda Jessup. Toronto: University of Toronto Press, 2001.

–*Unsettling Frontiers: First Nations Imagery in the Art of Emily Carr*. Vancouver: UBC Press, 2006.

Nasgaard, Roald. *The Mystic North: Symbolist Landscape Painting in Northern Europe and North America 1890–1940*. Toronto: Art Gallery of Ontario and University of Toronto Press, 1984.

–"Roots and Promise." In *Changing Visions: The Canadian Landscape*. Toronto and Edmonton: Art Gallery of Ontario and the Edmonton Art Gallery, 1976.

Nash, Roderick. *Wilderness and the American Mind*. New Haven: Yale University Press, 1967.

Nelles, H.V. *The Politics of Development*. Toronto: Macmillan, 1974.

Nemiroff, Diana, Robert Houle, and Charlotte Townsend-Gault, eds. *Land, Spirit, Power: First Nations at the National Gallery of Canada*. Ottawa: National Gallery of Canada, 1992.

New, W.H. *Land Sliding: Imagining Space, Presence, and Power in Canadian Writing*. Toronto: University of Toronto Press, 1997.

Novak, Barbara. *Nature and Culture: American Landscape and Painting 1825–1875*. New York: Oxford University Press, 1980.

O'Brian, John. *David Milne and the Modern Tradition of Painting*. Toronto: Coach House Press, 1983.

–ed. *The Flat Side of the Landscape: The Emma Lake Artists' Workshops*. Saskatoon: Mendel Art Gallery, 1989.

–"Iconic Carr." In *Gasoline, Oil, and Paper: The 1930s Oil-on-Paper Paintings of Emily Carr*, ed. David Alexander and John O'Brian. Saskatoon: Mendel Art Gallery, 1995.

–"Memory Flash Points." In *Geography Lesson: Canadian Notes*, ed. Allan Sekula. Vancouver and Cambridge, Mass.: Vancouver Art Gallery and MIT Press, 1997.

Oleksijczuk, Denise. *Lost Illusions: Recent Landscape Art*. Vancouver: Vancouver Art Gallery, 1991.

Osborne, Brian S. "The Iconography of Nationhood in Canadian Art." In *The Iconography of Landscape*, ed. Denis Cosgrove and Stephen Daniels. Cambridge: Cambridge University Press, 1998.

Payne, Carol. *A Canadian Document/Un document canadien*. Ottawa: Canadian Museum of Contemporary Photography, 1999.

Pepall, Rosalind, and Brian Foss, eds. *Edwin Holgate*. Montreal: Montreal Museum of Fine Arts, 2005.

Porter, John. *The Vertical Mosaic*. Toronto: University of Toronto Press, 1965.

Pratt, Mary Louise. *Imperial Eyes: Travel Writing and Transculturation*. London: Routledge, 1992.

Pugh, Simon, ed. *Reading Landscape: Country-City-Capital*. Manchester and New York: Manchester University Press, 1990.

Randolph, Jeanne. "Product and Territory." *C Magazine* 24 (December 1989): 40–4.

Reid, Dennis. *A Concise History of Canadian Painting*. Toronto: Oxford University Press, 1973.

–*The Group of Seven*. Ottawa: National Gallery of Canada, 1970.

–ed. *Tom Thomson*. Toronto and Ottawa: Art Gallery of Ontario and the National Gallery of Canada, 2002.

Roelstraete, Dieter, and Scott Watson, eds. *Intertidal: Vancouver Art and Artists*. Antwerp and Vancouver: Museum van Hedendaagse Kunst and Morris and Helen Belkin Art Gallery, 2005.

Schama, Simon. *Landscape and Memory*. Toronto: Vintage Canada, 1995.

Schwartz, Joan M. "Constituting Places of Presence: Landscape, Identity and the Geographical Imagination." In *Marlene Creates: Places of Presence: Newfoundland Kin and Ancestral Land, Newfoundland 1989–1991*. St John's: Killick Press, 1997.

Scott, Kitty, ed. *Peter Doig*. Vancouver: Morris and Helen Belkin Art Gallery, 2001.

Sekula, Allan. *Geography Lesson: Canadian Notes*. Vancouver and Cambridge, Mass.: Vancouver Art Gallery and MIT Press, 1997.

Shadbolt, Doris. *The Art of Emily Carr*. Vancouver: Douglas & McIntyre, 1979.

Shaw, Nancy, and William Wood, eds. *You Are Now in the Middle of a N.E. Thing Co. Landscape*. Vancouver: UBC Fine Arts Gallery, 1993.

Shields, Rob. *Places on the Margin: Alternate Geographies of Modernity*. New York: Routledge, 1992.

Short, John Rennie. "Wilderness." In *Imagined Country: Society, Culture and Environment*. London: Routledge, 1991.

Silcox, David P. *The Group of Seven and Tom Thomson*. Toronto: Firefly Books, 2003.

–*Painting Place: The Life and Work of David B. Milne*. Toronto: University of Toronto Press, 1996.

Sloan, Johanne. "Eleanor Bond's Social Centres: Natural Sights and Millenial Landscapes." In *Social Centres: Eleanor Bond*, ed. Shirley Madill. Winnipeg: Winnipeg Art Gallery, 1993.

–"Hallucinating Landscape, Canadian-Style." In *Peter Doig*, ed. Kitty Scott. Vancouver: Morris and Helen Belkin Art Gallery, 2001.

Snow, Michael. "La Région Centrale" (1969). In *The Collected Writings of Michael Snow*. Waterloo: Wilfrid Laurier University Press, 1994.

Solnit, Rebecca. "Elements of a New Landscape." In *Visions of America: Landscape as Metaphor in the Late Twentieth Century*. Denver: Denver Art Museum, 1994.

Stacey, Robert. "A Contact in Context: The Influence of Scandinavian Landscape Painting on Canadian Artists before and after 1913." *Northward Journal*, no. 18/19 (1980): 36–56.

–"The Myth – and Truth – of the True North." In *The True North: Canadian Landscape Painting 1896–1939*, ed. Michael Tooby. London: Lund Humphries and Barbican Art Gallery, 1991.

Taylor, Charles. *Reconciling the Solitudes: Essays on Canadian Federalism and Nationalism*. Montreal and Kingston: McGill-Queen's University Press, 1993.

Teitelbaum, Matthew. *Edward Poitras: Indian Territory*. Saskatoon: Mendel Art Gallery, 1989.

–"Sighting the Single Tree, Sighting the New Found Land." In *Eye of Nature*, ed. Daina Augaitis and Helga Pakasaar. Banff: Walter Phillips Gallery, 1989.

–ed. *Paterson Ewen*. Vancouver and Toronto: Douglas & McIntyre and Art Gallery of Ontario, 1996.

Thom, Ian. *A.J. Casson: Early Works*. Kleinburg: McMichael Canadian Art Collection, 1984.

–*Emily Carr: Drawing the Forest*. Victoria: Art Gallery of Greater Victoria, 2001.

Thompson, John Herd, and Allan Seager. *Canada 1922–1939: Decades of Discord*. Toronto: McClelland & Stewart, 1985.

Todd, Loretta. "Yuxweluptun: A Philosophy of History." In *Lawrence Paul Yuxweluptun: Born to Live and Die on Your Colonialist Reservations*. Vancouver: Morris and Helen Belkin Art Gallery, University of British Columbia, 1995.

**Tooby, Michael**. *Our Home and Native Land: Sheffield's Canadian Artists*. Sheffield: Mappin Art Gallery, 1991.

–ed. *The True North: Canadian Landscape Painting 1896-1939*. London: Lund Humphries and Barbican Art Gallery, 1991.

**Town, Harold**, and **David P. Silcox**. *Tom Thomson: The Silence and the Storm*. Toronto: McClelland and Stewart, 1977.

**Townsend-Gault, Charlotte**. "The Salvation Art of Yuxweluptun." In *Lawrence Paul Yuxweluptun: Born to Live and Die on Your Colonialist Reservations*. Vancouver: Morris and Helen Belkin Art Gallery, University of British Columbia, 1995.

**Tousley, Nancy**. "Into the Woods." In *Liz Magor*. Toronto and Vancouver: Art Gallery of York University and Contemporary Art Gallery, 2000.

**Trépanier, Esther**. "The Expression of a Difference: The Milieu of Quebec Art and the Group of Seven." In *The True North: Canadian Landscape Painting 1896-1939*, ed. Michael Tooby. London: Lund Humphries and Barbican Art Gallery, 1991.

**Trudeau, Pierre Elliott**. "Announcement of Implementation of Policy of Multiculturalism within Bilingual Framework." In *House of Commons Debates*, 7 October 1971, 8545-8.

**Tuer, Dot**. *Mining the Media Archive: Essays on Art, Technology, and Cultural Resistance*. Toronto: YYZ Books, 2005.

–"Performing Memory: The Art of Storytelling in the Work of Rebecca Belmore." In *Rebecca Belmore: 33 Pieces*, ed. Barbara Fisher. Toronto: Blackwood Gallery, 2001.

**Varley, Christopher**. *F.H. Varley: A Centennial Exhibition*. Edmonton: Edmonton Art Gallery, 1981.

–Letter to the Editor. *Globe and Mail*, 10 October 2000.

**Vastokas, Joan M.**, ed. *Perspectives of Canadian Landscape: Native Traditions*. Toronto: Robarts Centre for Canadian Studies, York University, 1990.

**Vigneault, Louise**. "Le Groupe des Sept et après." Actes du colloque de l'Association française d'études canadiennes, Strasbourg. In *Études canadiennes/Canadian Studies* 54 (2003): 83-91.

–*Identité et modernité dans l'art au Québec: Borduas, Sullivan, Riopelle*. Coll. Les Cahiers du Québec, Montréal: Hurtubise HMH, 2002.

**Vipond, Mary**. "The Nationalist Network: English Canada's Intellectuals and Artists in the 1920s." *Canadian Review of Studies in Nationalism* 7, no. 1 (spring 1980): 32-52.

**Wall, Jeff**. "About Making Landscapes." In *Jeff Wall*. London: Phaidon, 1996.

**Wallace, Keith**. "Sites & Place Names." In *Christos Dikeakos: Sites & Place Names*. Vancouver: Contemporary Art Gallery.

**Walton, Paul H**. "The Group of Seven and Northern Development." *RACAR* 17, no. 2 (1990): 171-9.

**Watkins, Mel**. "Reflections on Being Born in a Group of Seven Canvas That Is Magically Transformed into a Sensuous Eleanor Bond Painting." *University of Toronto Quarterly* 66, no. 2 (spring 1997): 411-16.

**Watson, Scott**. "Disfigured Nature: The Origins of the Modern Canadian Landscape." In *Eye of Nature*, ed. Daina Augaitis and Helga Pakasaar. Banff: Walter Phillips Gallery, 1989.

–"Race, Wilderness, Territory and the Origins of Modern Canadian Landscape Painting." *Semiotext(e)* 17 (1994): 96-104.

**White, Peter**. *Culture's Nature: Landscape in the Art of Gerald Ferguson, Douglas Kirton, Jeffrey Spalding and David Thauberger*. Regina: Dunlop Art Gallery, 1986.

–"David Thauberger's Paintings: Popular Myths/Cultural Realities." In *David Thauberger: Paintings 1978-1988*. Regina: Mackenzie Art Gallery, 1987.

–*It Pays to Play: British Columbia in Postcards 1950-1980s*. Vancouver: Arsenal Pulp Press and Presentation House Gallery, 1996.

**Whitelaw, Anne**. "'Whiffs of Balsam, Pine, and Spruce': Art Museums and the Production of a Canadian Aesthetic." In *Capital Culture: A Reader on Modernist Legacies, State Institutions, and the Values of Art*, ed. Jody Berland and Shelley Hornstein. Montreal: McGill-Queen's University Press, 2000.

**Williams, Raymond**. *The Country and the City*. New York: Oxford University Press, 1973.

**Wilson, Alexander**. *The Culture of Nature: North American Landscape from Disney to Exxon Valdez*. Toronto: Between the Lines, 1991.

**Woodcock, George**. "There Are No Universal Landscapes." *artscanada*, no. 222/223 (October/November 1978): 37-42.

**Young Man, Alfred**. "The Savage Civilian and the Work of Rebecca Belmore." In *Between Views and Points of View*, ed. Daina Augaitis and Sylvie Gilbert. Banff: Walter Phillips Gallery, 1991.

**Zemans, Joyce**. "Establishing the Canon: Nationhood, Identity and the National Gallery's First Reproduction Programme of Canadian Art." *Journal of Canadian Art History* 16, no. 2 (1995): 7-35.

–"What Would the Group of Seven Say?" *Globe and Mail*, 9 October 2000.

# CONTRIBUTORS

BENEDICT ANDERSON, Professor Emeritus of International Studies at Cornell University, is author of *Java in a Time of Revolution* (1972), *Imagined Communities: Reflections on the Origin and Spread of Nationalism* (1983), and *The Spectre of Comparisons: Nationalism, Southeast Asia and the World* (1998).

GRANT ARNOLD is the Audain Curator of British Columbia Art at the Vancouver Art Gallery. He has organized more than thirty exhibitions of historical, contemporary, and modern art, including *Rodney Graham: A Little Thought* (2005) and *Fred Herzog: Vancouver Photographs* (2007).

REBECCA BELMORE's work addresses history, place, and identity through the media of installation, video, and performance. She is Anishinabe and was born in Upsala, Ontario. In 2005 she represented Canada at the Venice Biennale. She currently lives in Vancouver.

JODY BERLAND is Associate Professor of Humanities in Atkinson College, York University. She has published widely on cultural studies, Canadian communication theory, music, radio and video, feminist bodies, cultural environmental studies, and social space and is the editor of *Topia: Canadian Journal of Cultural Studies*. She is currently completing a book on culture, technology, and space.

ELEANOR BOND is a Winnipeg artist known for her large-scale paintings of urban and architectonic space and the representation of social and economic transition. She has exhibited extensively in Canada and internationally. She currently teaches at Concordia University in Montreal.

JONATHAN BORDO has published and lectured widely on landscape, art, and the history of cultural theory. His publications include "Picture and Witness at the Site of the Wilderness" (2002), "The Keeping Place" (2003), and "The Wasteland – An Essay in the Photographs of Edward Burtynsky" (2006). He teaches at Trent University in Peterborough, Ontario.

DOUGLAS COLE (1938-1997) was professor of history at Simon Fraser University in Burnaby, British Columbia. He wrote numerous scholarly articles and books, including *From Desolation to Splendour* (with Maria Tippett), *Captured Heritage*, and *An Iron Hand upon the People* (with Ira Chaikin).

MARLENE CREATES lives in Portugal Cove, Newfoundland. Since the 1970s her work has explored the relationship between human experience, memory, language, and the land and has been presented extensively both nationally and internationally. She is represented in numerous public collections, including the National Gallery of Canada.

MARCIA CROSBY is a writer and an instructor at Malaspina University-College in British Columbia, where she has been teaching Native Studies and English for ten years. For the exhibition catalogue *Emily Carr: New Perspectives on a Canadian Icon* (2006), she wrote "A Chronology of Love's Contingencies."

GREG CURNOE (1936-1992) was known for his nationalism and for his focus on subjects associated with London, Ontario. He was a founding member of the Nihilist Spasm Band and Forest City Gallery, and he also helped to establish Canada Artists' Representation (CARFAC).

ANN DAVIS is director of the Nickle Arts Museum, Calgary, and director of the Programme in Museum and Heritage Studies at the University of Calgary. She completed her doctorate in 1974 at York University and has written many books on Canadian art and abstract painting.

LESLIE DAWN is a professor in the Department of Art at the University of Lethbridge. His book *National Visions, National Blindness: Canadian Art and Identities in the 1920s* was published in 2006.

SHAWNA DEMPSEY and LORRI MILLAN have been artistic collaborators since 1989. Catapulted into the national spotlight with the performance piece *We're Talking Vulva*, they have toured and exhibited their film and video works extensively in Canada and abroad. They are based in Winnipeg.

CHRISTOS DIKEAKOS moved to Vancouver from his native Greece in 1957. His photographs, assemblages, and publications have been exhibited at major public art institutions in Canada as well as internationally. In 2000 he completed *Lookout*, a public art sculpture in Vancouver, with architect Noel Best.

For PETER DOIG, who was born in Britain, the experience of growing up in Canada has been a touchstone for a body of paintings that filter the aura of iconic Canadian themes through contemporary cultural references. A Turner Prize nominee (1995) whose work has been widely exhibited internationally, he now lives in Trinidad.

ROSEMARY DONEGAN is associate professor, assistant dean of the Liberal Studies Faculty, and chair of the Criticism and Curatorial Studies program at the Ontario College of Art and Design. Her research interests as an independent curator have focused on Canadian urban and industrial visual culture.

STAN DOUGLAS is an artist whose work explores social histories played out through a complex cinematic and televisual language. His interest in the implementation of Western ideas of progress, particularly utopian philosophies, is located in their often divisive political and economic effects. He lives in Vancouver.

PATERSON EWEN (1925-2002) had been a well-established abstract painter when in the 1970s he began making works by gouging plywood with a router. These strongly material paintings representing landscape and celestial phenomena continue to be highly regarded and are represented in major museums and public galleries throughout Canada.

ROBERT FONES is a visual artist, teacher, and writer. He lives and works in Toronto and is represented by the Olga Korper Gallery.

NORTHROP FRYE (1912-1991) rose to international prominence as a result of his first book, *Fearful Symmetry* (1947). His lasting reputation rests on a series of influential studies, including *Anatomy of Criticism*, one of the most important works of literary theory published in the twentieth century.

ROBERT FULFORD is a widely read columnist, critic, and author. He was the editor of *Saturday Night* magazine from 1968 to 1987 and delivered the Massey Lectures in 1999. He writes frequently on Canadian art and artists.

GENERAL IDEA was a group of three artists – Felix Partz, Jorge Zontal, and AA Bronson – who were active from 1969 to 1994. Their conceptual and media-based art inhabited and subverted forms of popular and media culture. From 1987 through 1994 General Idea addressed the AIDS crisis in particular. Both Partz and Zontal died in 1994. Bronson continues to work and exhibit as an independent artist.

RODNEY GRAHAM is internationally recognized for a conceptual art practice that ranges from photography, film, video, and music to sculpture, painting, and books. His work often investigates the specific roots of modernism as well as the creative potential of splicing fact together with fiction. He lives in Vancouver.

REESA GREENBERG was a professor of art history at Concordia University in Montreal from 1971 to 1999. In addition to publishing essays on contemporary Canadian art and artists, she has written extensively on the theory and practice of exhibition experience in the contemporary museum. She co-edited *Thinking About Exhibitions* (1996).

GU XIONG is a multimedia artist from China now living in Vancouver. The focus of his work is cultural identity and hybridity, encompassing the dynamics of globalization, local culture, and shifts of individual identity. He has exhibited widely in Canada and internationally and is an associate professor in the Department of Art History, Visual Art, and Theory, University of British Columbia.

COLE HARRIS was a member of the Department of Geography at the University of British Columbia and is the author or editor of many books about British Columbia and Canada, including the first volume of *The Historical Atlas of Canada*, for which he was the editor, *The Resettlement of British Columbia*, and *Making Native Space*.

RICHARD WILLIAM HILL is an independent curator and writer of Cree heritage currently completing a doctorate at Middlesex University. He has taught at York University and has been an associate editor of *FUSE* Magazine and a curator at the Art Gallery of Ontario. He recently curated *The World Upside Down* for the Walter Philips Gallery in Banff, Alberta (2006).

ROBERT HOULE is an artist, writer, curator, and educator. Widely recognized for his own art, he has also participated in the organization of major exhibitions of First Nations artists, including *Land, Spirit, Power: First Nations at the National Gallery of Canada* in 1992. He lives in Toronto.

ANDREW HUNTER is an artist, writer, and curator who has produced exhibitions, publications, and writings on Canadian art for institutions across Canada, the United States, and Europe. He is currently director/curator of Render at the University of Waterloo.

LYNDA JESSUP teaches in the Department of Art at Queen's University in Kingston, Ontario. She has published numerous articles focusing on Canadian visual culture, museum representation, and tourist art and is the editor of *Antimodernism and Artistic Experience: Policing the Boundaries of Modernity* (2001) and *On Aboriginal Representation in the Gallery* (2002).

ZACHARIAS KUNUK is a filmmaker and co-founding president of Igloolik Isuma Productions, Canada's first independent Inuit production company. Following a series of videos that represented traditional Inuit life, he made the widely acclaimed film *Atanarjuat* (2001). His second feature film, *The Journals of Knut Rasmussen*, was released in 2006.

JOHANNE LAMOUREUX is professor and director of the Département d'histoire de l'art et d'études cinématographiques at the Université de Montréal. Her many publications on visual art, in which linguistic questions figure prominently, include *L'art insituable* (2001) and *Doublures* (2003). She co-curated the exhibition *Emily Carr: New Perspectives on a Canadian Icon* (2006).

ROBERT LINSLEY is an artist currently teaching at the University of Waterloo, Ontario. He has exhibited in North America and Europe and recently at Felix Ringel in Düsseldorf and has written about both contemporary art and the history of art.

BARRY LORD is president of Lord Cultural Resources. He was editor of *artscanada* in the late 1960s and is the author of *The History of Painting in Canada: Toward a People's Art* (1974). With Gail Dexter he published *Planning Our Museums* (1983) and *The Manual of Museum Management* (1999).

MIKE MACDONALD (1941-2006) was a multimedia artist who also created gardens using traditional Native medicine plants to attract butterflies on the grounds of galleries and museums across Canada and in Europe. The recipient of the first Aboriginal Achievement Award for New Media (2000), he was particularly proud of his mixed heritage, which included Mi'kmaq, Beothuk, and European ancestry.

MARSHALL MCLUHAN (1911-1980) was a professor of English literature, literary critic, and communications theorist. His work is viewed as one of the cornerstones of the study of media ecology. McLuhan is well-known for coining the expressions "the medium is the message" and the "global village."

LIZ MAGOR's sculpture, installations, and photo-based work have been exhibited widely in Canadian public art galleries and museums as well as abroad. She was Canada's representative at the Venice Biennale in 1984, exhibited in Documenta in 1987, and received the Governor General's Award in Visual Arts in 2001. She lives in Vancouver.

GERTA MORAY, Professor Emerita at the University of Guelph, has published on Canadian art, women artists, and feminist perspectives on art history. Her new book, *Unsettling Encounters: First Nations: Imagery in the Art of Emily Carr*, reconsiders Carr's work in the light of its historical contexts.

ROALD NASGAARD is Professor of Contemporary Art, Abstraction, at Florida State University. Among the many exhibition catalogues he has

authored are *The Mystic North* (1984), *Gerhard Richter: Paintings* (1988), and *Pleasures of Sight and States of Being: Radical Abstract Painting since 1990* (2001). His most recent book is *Abstract Painting in Canada: A History* (2007).

N.E. THING COMPANY, active from 1966 to 1978, was the vehicle for the Vancouver-based conceptual art practice of Iain and Ingrid Baxter. Its projects reflected new ways of seeing consumer and corporate culture, landscape, and technology and were widely recognized and exhibited in Canada and abroad. IAIN BAXTER&, who also maintained his own practice, has continued to work as an artist. Now living in Windsor, Ontario, he recently changed his name to include the ampersand.

JOHN O'BRIAN is Professor of Art History at the University of British Columbia. His books include *David Milne and the Modern Tradition of Painting, Ruthless Hedonism* and *Clement Greenberg: The Collected Essays and Criticism*, which he edited. His current research is on photographic responses to nuclear threat and destruction since 1945.

CAROL PAYNE is a professor in the School for Studies in Art and Culture, Carleton University. She has curated exhibitions, including *A Canadian Document* for the Canadian Museum of Contemporary Photography (1999), and written scholarly articles on photography for anthologies and journals such as *Visual Studies* and *Visual Resources: An International Journal of Documentation*.

EDWARD POITRAS is a member of the Gordon First Nation and resident of Treaty Four Territory, Saskatchewan. Since the early 1970s he has been actively engaged in art production and has been included in many important Canadian and international exhibitions. In 1995 he represented Canada at the Venice Biennale.

DENNIS REID is Director, Collections and Research, at the Art Gallery of Ontario and Professor of Art History at the University of Toronto. He has curated many exhibitions in Canada and abroad and has published extensively on Canadian art subjects, including *A Concise History of Canadian Painting, Krieghoff: Images of Canada*, and *Tom Thomson*.

MICHEL SAULNIER has a master's degree in art history from the Université de Montréal. His work has been presented in one-person exhibitions in Canada, the United States, Germany, and Japan. He lives and works in Saint-Jean-Port-Joli, Quebec.

NANCY SHAW (1962-2007) was a cultural critic, poet, and visual arts curator. Her most recent book of poetry was *Busted* (2001), written in collaboration with Catriona Strang. She served on the boards of Vancouver New Music and the Kootenay School of Writing and taught in the School of Communication at Simon Fraser University.

JOHANNE SLOAN teaches in the Department of Art History at Concordia University in Montreal. She has written about transformations of the landscape genre in the work of Eleanor Bond, Peter Doig, and Lynne Marsh.

MICHAEL SNOW makes films, video and sound installations, photographic and holographic works, sculpture, music (performances and recordings), paintings, drawings, and books. His works have been presented worldwide and are in the collections of the Musée national d'art moderne at the Centre George Pompidou in Paris, the National Gallery of Canada, the Museum of Modern Art in New York, and many others. He lives in Toronto.

ROBERT STACEY is a Toronto-based independent curator, writer, and editor who has published extensively on Canadian artists and designers, including C.W. Jefferys (his grandfather), J.E.H. MacDonald, Tom Thomson, and Allan Harding MacKay.

DAVID THAUBERGER's themes are closely allied with the landscape and its place in the collective conscious. His use of iconic images from popular culture is also reflected in his employment of impersonal techniques, unmodulated colour, and elements from the commercial world ( such as postcards and glitter). His paintings have been widely exhibited and collected both in Canada and abroad. He lives and works in Regina.

LORETTA TODD, an award-winning film director, writer, and producer, is Métis-Cree and originally from northern Alberta. Her films and videos include *The People Go On* (2003), *Today Is A Good Day – Remembering Chief Dan George* (1999), and *Forgotten Warriors* (1997).

ESTHER TRÉPANIER is a professor in the department of art history at the Université du Québec à Montréal and since 2000 has been director of its École supérieure de mode de Montréal. Her numerous publications focus on early twentieth-century Quebec and Canadian art and include *Peintres juifs et modernité: Montréal 1930-1945* (1987) and *Peinture et modernité au Québec, 1919-1939* (1998).

DOT TUER is a writer, cultural historian, and professor at the Ontario College of Art and Design. She divides her time between Toronto and Corrientes, Argentina.

CHRISTOPHER VARLEY is an art dealer, writer, and curator. He has organized many exhibitions of Canadian art, including *F.H. Varley: A Centennial Exhibition* (1981), and has been instrumental in facilitating others.

JEFF WALL is widely recognized as one of the most inventive artists of his generation. Recent exhibitions at the Museum of Modern Art in New York, the Tate Modern in London, and the Schaulager in Basel have investigated his work from the late 1970s to the present, tracing the evolution of his principal themes and pictorial strategies.

PAUL H. WALTON is Professor Emeritus at McMaster University. He is the author of *Master Drawings by John Ruskin: Selections from the David Thomson Collection* (2000).

MEL WATKINS is Professor Emeritus, Economics and Political Science, at the University of Toronto, and Adjunct Professor at the Institute of Political Economy, Carleton University. He is an iconic figure in the development of the "new" political economy in Canada and since the 1960s has combined scholarly writing with political activism on a range of issues.

SCOTT WATSON is a professor in the Department of Art History, Visual Art, and Theory at the University of British Columbia, where he is also director of the Morris and Helen Belkin Art Gallery. He has written extensively on contemporary Canadian art.

PETER WHITE is an independent curator and writer. He has organized many exhibitions of contemporary and historical art, including *Out There Is Somewhere: The Arctic in Pictures*, and is the author of *It Pays to Play: British Columbia in Postcards, 1950s-1980s*. He lives in Montreal.

ANNE WHITELAW is Associate Professor, History of Art, Design, and Visual Culture, at the University of Alberta. Her research focuses on cultural institutions in Canada and popular discourses of art history in North America. She is completing a book on the exhibition of Canadian art at the National Gallery of Canada between 1980 and 1995 and is co-editing an anthology of new writing on Canadian art history.

JOYCE WIELAND (1931-1998) was an influential artist and cultural activist whose concern with issues of Canadian national identity was intertwined with a feminist perspective on gender and power. Initially a painter and filmmaker, she also made a series of significant works using traditional media such as quilts and sewn collages.

JIN-ME YOON's photographic and video-based installations, investigating the complex relationship between identity, place, and the collective imaginary, have been extensively exhibited across Canada as well as in Korea, Turkey, the United States, and other countries. She lives in Vancouver and teaches in the Visual Arts Area at Simon Fraser University's School for the Contemporary Arts.

LAWRENCE PAUL YUXWELUPTUN makes large-scale paintings incorporating Coast Salish cosmology, Northwest Coast formal design elements, and the Western landscape tradition to document and promote change in contemporary indigenous history. His work has been exhibited extensively both in Canada and abroad. In 1998 he was the recipient of the Vancouver Institute for the Visual Arts Award (VIVA).

JOYCE ZEMANS is University Professor at York University, and from 1988 to 1992 she was director of the Canada Council. She has written extensively on Canadian art, cultural policy, and arts administration. Her publications include a recent series of articles for the *Journal of Canadian Art History*, as well as *Kathleen Munn and Edna Taçon: New Perspectives on Modernism*.

# CONTEMPORARY ART PAGES

**JEFF WALL**
*Landscape Manual*, 1969
Artist book

**MICHAEL SNOW**
*Plus Tard*, 1977
25 framed Ektacolour prints
National Gallery of Canada

**GREG CURNOE**
*View of Victoria Hospital, First Series: Nos. 1-6*, 1968-69
Stamp pad ink and latex on canvas
National Gallery of Canada

**IAIN BAXTER**
*Landscape with Tree and 3 Cirrus Clouds*, 1965
Acrylic paint on vacuum-formed butyrate plastic

**N.E. THING COMPANY**
*Simulated Photo of the Moon's "Sea of Tranquility..." Filled with Water and the N.E. Thing Company's Sign Placed Beside It, August 1969*, 1969
Felt pen on silver print

**JOYCE WIELAND**
*True Patriot Love*, 1971
Book-work

**RODNEY GRAHAM**
*Illuminated Ravine*, 1979
Projection (gas-powered generators and arc lights), Burnaby, BC

**PATERSON EWEN**
*Night Storm*, 1973
Acrylic and metal on gouged plywood
Vancouver Art Gallery

*Iceberg*, 1974
Acrylic and metal on gouged plywood
Winnipeg Art Gallery

**GENERAL IDEA**
*Pharm@cology*, 1994
Acrylic on found offset poster

**ELEANOR BOND**
*Later, Some Industrial Refugees from Communal Settlements in a Logged Valley in B.C.*, 1987
Oil on canvas
Agnes Etherington Art Centre, Queen's University

*The Women's Park at Fish Lake Provides Hostels, Hotels and Housing*, 1990
Oil on canvas

**GU XIONG AND ANDREW HUNTER**
*Ding Ho/Group of 7*, 2000
Book-work made in conjunction with exhibition at the McMichael Canadian Art Collection

**ROBERT FONES**
*Natural Range of Bur Oak*, 1984
Woodblock print on paper

*Natural Range of Canada Plum*, 1984
Woodblock print on paper

*Natural Range of Shagbark Hickory*, 1983
Woodblock print on paper

*Natural Range of White Oak*, 1984
Woodblock print on paper

**LIZ MAGOR**
*Cabin in the Snow*, 1989
Installation with fabric and model log cabin
National Gallery of Canada

**PETER DOIG**
*Canoe-Lake*, 1997-98
Oil on canvas

*Figure in a Mountain Landscape*, 1998
Oil on canvas

**MICHEL SAULNIER**
*Le Groupe des Sept 1*, 1983
Mixed media

*Le Groupe des Sept 2*, 1983
Mixed media

*Le Groupe des Sept 3*, 1983
Mixed media

*Le Groupe des Sept 4*, 1983
Mixed media

*Le Groupe des Sept 5*, 1983
Mixed media

*Le Groupe des Sept 6*, 1983
Mixed media
Canada Council Art Bank

*Le Groupe des Sept 7*, 1983
Mixed media
Musée national des beaux-arts du Québec

**STAN DOUGLAS**
*Nu·tka·*, 1996
Video installation

**ROBERT HOULE**
*Premises for Self-Rule: The Royal Proclamation, 1763*, 1994
Oil on canvas, photo emulsion on canvas, and laser cut vinyl
Museum of Contemporary Canadian Art, Toronto

*Premises for Self-Rule: British North America Act, 1867*, 1994
Oil on canvas, photo emulsion on canvas, and laser cut vinyl

*Premises for Self-Rule: Treaty No. 1, 1871*, 1994
Oil on canvas, photo emulsion on canvas, and laser cut vinyl
Winnipeg Art Gallery

*Premises for Self-Rule: Indian Act, 1876*, 1994
Oil on canvas, photo emulsion on canvas, and laser cut vinyl
Canada Council Art Bank

*Premises for Self-Rule: Constitution Act, 1982*, 1994
Oil on canvas, photo emulsion on canvas, and laser cut vinyl

**JIN-ME YOON**
*A Group of Sixty-Seven*, 1996
135 framed C prints
Vancouver Art Gallery

**EDWARD POITRAS**
*Offensive/Defensive*, 1988
Outdoor installation: Gordon Indian Reserve, Saskatchewan (left), and Mendel Art Gallery, Saskatoon, Saskatchewan (right)

**DAVID THAUBERGER**
*Slough*, 1979
Acrylic and glitter on canvas

*Lake Reflecting Mountains*, 1982
Acrylic on canvas

**MARLENE CREATES**
*Entering and Leaving St. John's, Newfoundland 1995*, 1995
15 pairs of azo dye (Cibachrome) colour photographic prints
Government of Newfoundland & Labrador, Art Procurement Program

**SHAWNA DEMPSEY AND LORRI MILLAN**
*Lesbian National Parks and Services*, 1997 to the present
Performance with print and video components

**CHRISTOS DIKEAKOS**
*ch'e chée lmun*, 1992 (detail)
Selection from *Boite Valise, Sites and Place Names,Vancouver*, 1991-94
Valise of cherry wood containing 43 C-print panorama photographs
Museum of Contemporary Canadian Art, Toronto

*Wanuskewin Park, Mike Vitkowski's Farm, Saskatoon, Saskatchewan*, 1993
Chromogenic print, glass with sandblasted text
Mendel Art Gallery, Saskatoon

**ZACHARIAS KUNUK**
Video and location stills, Igloolik Isuma Productions, 1990s

**REBECCA BELMORE**
*Ayum-ee-aawach Oomama-mowan: Speaking to their Mother*, 1991-92
Performance

**LAWRENCE PAUL YUXWELUPTUN**
*Scorched Earth, Clear-Cut Logging on Native Sovereign Lands, Shaman Coming to Fix*, 1991
Acrylic on canvas
National Gallery of Canada

*Red Man Watching White Man Trying to Fix Hole in Sky*, 1990
Acrylic on canvas

**MIKE MACDONALD**
*Butterfly Garden*, 1996-2006
Site installation and web project

# ACKNOWLEDGMENTS

## WE WOULD LIKE TO THANK

the many artists and writers who have contributed to this book: Benedict Anderson, Grant Arnold, Iain Baxter&, Rebecca Belmore, Jody Berland, Eleanor Bond, Jonathan Bordo, AA Bronson (General Idea), the estate of Douglas Cole, Marlene Creates, Marcia Crosby, the estate of Greg Curnoe, Ann Davis, Leslie Dawn, Shawna Dempsey, Christos Dikeakos, Peter Doig, Rosemary Donegan, Stan Douglas, the estate of Paterson Ewen, Robert Fones, the estate of Northrop Frye, Robert Fulford, Rodney Graham, Reesa Greenberg, Gu Xiong, Cole Harris, Richard William Hill, Robert Houle, Andrew Hunter, Lynda Jessup, Zacharias Kunuk, Johanne Lamoureux, Robert Linsley, Barry Lord, the late Mike MacDonald, the estate of Marshall McLuhan, Liz Magor, Lorri Millan, Gerta Moray, Roald Nasgaard, N.E. Thing Company, Carol Payne, Edward Poitras, Dennis Reid, Michel Saulnier, the late Nancy Shaw, Johanne Sloan, Michael Snow, Robert Stacey, David Thauberger, Loretta Todd, Esther Trépanier, Dot Tuer, Christopher Varley, Jeff Wall, Mel Watkins, Paul H. Walton, Scott Watson, Anne Whitelaw, the estate of Joyce Wieland, Jin-me Yoon, Lawrence Paul Yuxweluptun, and Joyce Zemans.

We also wish to acknowledge those who lent support to the endeavour at various times from its conception to its realization: David Alexander, Gisele Amantea, Ken Anderlini, Bruce Anderson, Dorothy Barenscott, Ashley Belanger, Iain Boal, Cyndy Campbell, Aaron Clark, Jorge Cañizares-Esguerra, Richard Cavell, Linda Chin-Fen, Sheila Curnoe, Patricia Deadman, Ramsay Derry, Andrea Dixon, Jacques Doyon, Whitney Friesen, Terry Glavin, Tania Godoroja, Sherrill E. Grace, Bruce Grenville, Annabel Hanson, Charles C. Hill, Natalie Horne, Katherine Irngaut, Scott Livingstone, Marie-Josée Jean, Angela Johnston, Alexandra Kennedy-Troya, Jean-François Leblanc, Elizabeth Legge, Ian McLean, Talyn Martin, Galit Mastai, the late Judith Mastai, Angela L. Miller, Christian Monks, Magdalena Moore, Hughena Morrison, Pari Nadimi, Helen O'Brian, Melanie O'Brian, Nina Øverli, Tony Pearse, Amy Pedersen, Lisa Quirion, Dan Ring, Sadira Rodrigues, Douglas Sigurdson, David Silcox, Bernard Smith, Siobhan Smith, Terry Smith, Trevor Smith, Matthew Teitelbaum, Ian M. Thom, Alan Tully, Diane Vanderkooy, Christine Wallace, Suzanne Wolfe, and Tanya Zhilinsky.

We are also pleased to acknowledge Elizabeth Hobart of Zab Design, who designed the book, Elizabeth Hulse, who edited the book, Ann Macklem, who prepared the index, Deanna Ferguson, who organized the acquisition of illustrations, and the staff at McGill-Queen's University Press with whom we worked: Philip Cercone, Jonathan Crago, Susanne McAdam, Joan McGilvray, Susan McIntosh, and Roger Martin. Valuable financial support was received from the following institutions: the Canada Council for the Arts, including the Millennium Arts Fund and Visual and Literary Arts sections; the Social Sciences and Humanities Research Council of Canada; and the University of British Columbia.

Finally, we are grateful to several institutions for providing us with a forum to test our ideas about national identity and landscape narratives: Concordia University, Montreal; the History Department, University of Texas, Austin; the National Museum of Women in the Arts, Washington, DC; the Sichuan Fine Arts Academy, Chongqing; Trinity College, University of Toronto; the University Art Association of Canada Annual Conference, Toronto; the University of British Columbia; the University of Rajasthan, Jaipur; and the University of Victoria, British Columbia.

The Editors

# IMAGE CREDITS

THE EDITORS AND PUBLISHER wish to express their thanks to the following sources of illustrative material and/or permission to reproduce it. Notice of any errors or omissions in this regard will be gratefully received and correction made in any subsequent editions.

Archives of Ontario: 128 (right). Art Gallery of Greater Victoria: 216, Anonymous Gift. Art Gallery of Hamilton: 199, Bequest of H.S. Southam, Esq., 1966. Art Gallery of Nova Scotia, Halifax: 196. Art Gallery of Ontario, Toronto: 2-3, Arthur Lismer Papers (file 19), Edward P. Taylor Research Library and Archives; 10; 23; 58, photo ©Estate of Don Vincent; 100, Gift from the J.S. McLean Collection, Toronto, 1969, donated by the Ontario Heritage Foundation, 1988; 103; 114, Bequest of Miss Kate E. Taylor; 127, Gift of Dr Lorne Pierce, Toronto, 1958, in memory of Edith Chown Pierce (1890–1954); 140, Gift of Walter C. Laidlaw, Toronto, 1937. Photo David Barbour: 174. Courtesy Rebecca Belmore: 342-3. Courtesy Eleanor Bond: 161; 167; 168-9; photography Ernest Mayer. Courtesy John Boyle: 17, ©CARCC, 2007. British Columbia Archives and Records Services, Victoria: 218-19, PDP02145. Courtesy AA Bronson: 139. Courtesy *Canadian Art*: 223. Canadian War Museum, War Art Collection, Ottawa: 244, ©Estate of Kathleen G. McKay. Center for Creative Photography, University of Arizona, Tucson: 28, ©The Ansel Adams Publishing Rights Trust. Courtesy Corkin Shopland Gallery, Toronto: 34, ©Iain Baxter&; 70, ©Iain Baxter&. Courtesy CV Photo: 322-3, Marlene Creates ©CARCC, 2007. Dalhousie Art Gallery, Halifax/SODRAC: 56. Courtesy Shawna Dempsey and Lorri Millan: 325-6, photography Don Lee (The Banff Centre), Gareth Pammenter, Sheila Spence, illustrations Daniel Barrow. Courtesy Christos Dikeakos: 88-9; 328-9. Courtesy Stan Douglas: 273-5. Fitzwilliam Museum, Cambridge: 197. Courtesy Robert Fones: 242; 243. Courtesy of the Estate of the late Dr Naomi Jackson Groves: 20-1. Courtesy

Gu Xiong/Andrew Hunter, McMichael Canadian Art Collection, Kleinburg: 208-9, ©Estate of Lawren Harris, gift of Keith and Edith MacIver (208), gift of Mr. R.A. Laidlaw (209). Courtesy Rodney Graham: 94-5. Hart House Art Collection, University of Toronto: 276, ©Estate of Lawren Harris. Courtesy Richard Hill: 210; 211; 213; 214. Igloolik Isuma Productions Inc.: 336-7. Kenderdine Art Gallery, University of Saskatchewan, Saskatoon: 7, ©Estate of Arthur Lismer. Library and Archives Canada, Ottawa: 116; 330. Estate of Mike MacDonald: 352, ©CARCC, 2007. Courtesy MacKenzie Art Gallery, Regina: 314; 315; ©David Thauberger, photography Don Hall. Magna International: 37, Courtesy of the Estate of the late Dr Naomi Jackson. Courtesy Liz Magor: 255-7, photography Robert Keziere. The Robert McLaughlin Gallery, Oshawa: 190, Gift of Isabel McLaughlin, 1987, photo Tom Moore, Courtesy of the Estate of the late Dr Naomi Jackson Groves. McMichael Canadian Art Collection, Kleinburg: 142, Gift of Mrs A.J. Latner, ©Estate of Franklin Carmichael; 316, ©Estate of F.H. Varley; 332, Gift of Mrs E.J. Pratt, ©Estate of F.H. Varley. Courtesy Victoria Miro Gallery, London: 5; 247-8; ©Peter Doig. Musée d'art contemporain de Montréal: 312. Musée national des beaux-arts du Québec, Quebec: 307, ©Succession Adrien Hébert; 310, ©Succession Maurice Perron. National Gallery of Canada, Ottawa: 25, courtesy of the Estate of the late Dr Naomi Jackson Groves; 30; 32, Bequest of Mrs J.P. Barwick (from the Douglas M. Duncan Collection), 1985, ©Estate of Elizabeth Wyn Wood; 60-1; 76-7, 86-7, gift of the Estate of Joyce Wieland; 108, ©Estate of Lawren Harris; 120, ©Estate of Arthur Lismer; 122, gift of Mrs S.J. Williams, Mrs Harvey Sims, Mrs T.M. Cram, and Miss Geneva Jackson, Kitchener, Ontario, 1943, ©Estate of F.H. Varley; 147, ©Estate of Charles Comfort; 149, loan from Natural Resources Canada, Ottawa, ©Estate of Charles Comfort; 152; 157; 158; 179; 180; 186; 192-3; 195; 202, ©Estate of Kathleen Munn; 238, The Milne-Duncan

Bequest, 1970, ©Estate of David B. Milne; 262; 302; 305; 349, ©Lawrence Paul Yuxweluptun. Nationalmuseum, Stockholm: 250. Northwest Territories Archives: 12. Private Collection: 144, ©Estate of Arthur Lismer; Courtesy Riding National Park: 128 (left). Courtesy Saskatchewan Arts Board: 301-2, ©Edward Poitras. Courtesy Michel Saulnier: 265; 266; 267, photography Denis Farley. Estate of Jack Shadbolt: 221, ©Estate of Jack Shadbolt. Courtesy Michael Snow: cover; 50, photo Joyce Wieland; 53-5; 80; 81. Stockphoto, Montreal: 13, photo Robert Frechette. Sudbury Mine Mill and Smelter Workers' Union Local 598/CAW: 150, ©Henry Orenstein. Courtesy TBWA/Toronto: 14. Vancouver Art Gallery: 112, Gift of J. Ron and Jacqueline Longstaffe, ©Mary Handford; 229, Emily Carr Trust, photo Robert Keziere; 268, photo Teresa Healy; 318, photo Teresa Healy. Courtesy VOX image contemporaine: 62, ©Iain Baxter&; 71, ©Iain Baxter&. Courtesy Jeff Wall: 43-5; 309. Winnipeg Art Gallery: 113, ©Mary Handford, photo Ernest Mayer; 284; 285; ©Robert Houle, photography Ernest Mayer. Courtesy Jin-Me Yoon: 291-3. York University, Toronto, and Estate of Joyce Weiland: 72. Courtesy Lawrence Paul Yuxweluptun: 350-1.

# INDEX

*Note:* Page numbers in **bold** refer to illustrations.

ARTS INSIGHTS, a new series from McGill-Queen's University Press, showcases current research in the social sciences, humanities, and social work.

Arts Insights, an initiative of McGill's Faculty of Arts, brings together research in the Social Sciences, Humanities, and Social Work. Reflective of the range of expertise and interests represented by the Faculty of Arts at McGill, Arts Insights seeks manuscripts that bring an interdisciplinary perspective to the discussion of ideas, issues, and debates that deepen and expand our understanding of human interaction, such as works dealing with society and change, or languages, literatures, and cultures and the relationships among them. Of particular interest are manuscripts that reflect the work of research collaborations involving McGill faculty and their colleagues in universities that are part of McGill's international affiliation network.

Arts Insights will publish two titles a year in English. The editors prefer original manuscripts but may consider the English language translations of works that have already appeared in another language.

Series editors: Nathalie Cooke, Richard Schultz, Wendy Thomson